Praise for *The Loft Generation*

"[Schloss] weaves an intricate micro-history of an unprecedentedly energized and interconnected artistic community . . . The selections in [*The Loft Generation*] are restless in both form and content, migrating from urban history, art monograph, and elegy to the more traditional narrative and psychological territories of memoir . . . *The Loft Generation* is fast-paced and deeply funny . . . tossing the reader into the postwar mêlée of a rapidly shapeshifting New York."

—Jamie Hood, *Vulture*

"Schloss is enamored by the minutiae of her subjects, and the exactness and delicacy of her details ripple out like water. Trying to focus on one aspect of the book would be to let the entire thing go . . . What Schloss understood in her writing is that the miracle of art is not the thing itself, but the practice."

—Irene Lee, *The Rumpus*

"Edith Schloss's diaristic account of New York City's post-war bohemia is indispensable reading . . . [*The Loft Generation*] is remarkable and engrossing."

—Jonny Diamond, *Literary Hub*

"I am tempted to say Edith Schloss's *Loft Generation* is remarkable, but remarkable seems inadequate to describe it. Schloss's memoir of life in New York during the heyday of the Abstract Expressionist movement and her subsequent expat years in Italy is wise, witty, and wild in equal measure. Writing from the position of the ultimate insider about a world that we are only beginning to understand and fully appreciate, she introduces readers to the artists and writers and composers who became part of her life—Willem and Elaine de Kooning, Rudy Burckhardt, Edwin Denby, Paul and Jane Bowles, John Cage, and Frank O'Hara, among many others. And she describes the romance that is the life of the artist, despite poverty, monstrous political and social turmoil, and changing artistic fortunes. By the end of her story, which is so intimate and so true, we are left feeling as though we are part of

that world, too. Quite simply, Schloss transports us, and that is the most any writer can hope to do. No, remarkable does not begin to describe her memoir. *The Loft Generation* is superb."

—Mary Gabriel, author of *Ninth Street Women: Lee Krasner, Elaine de Kooning, Grace Hartigan, Joan Mitchell, and Helen Frankenthaler; Five Painters and the Movement that Changed Modern Art*

"This indispensable eyewitnessing of a crucial period in American culture is wonderfully alive, entertaining, and beautifully written, with a dazzling mix of the personal and the aesthetic. Warmly honest, perceptive, and humane, Edith Schloss's memoir is itself a work of art."

—Phillip Lopate, author of *The Art of the Personal Essay*

EDITH SCHLOSS

THE LOFT GENERATION

Edited by Mary Venturini

Edith Schloss (1919–2011) was an observant member of the Abstract Expressionist movement and the New York School. She created paintings, assemblages, collages, watercolors, and drawings and worked as an art critic and writer until her death. Her paintings were shown in galleries all over the world and are in many prominent collections, and her writing has appeared in *ARTnews*, the *International Herald Tribune*, *Art in America*, and many other publications.

Mary Venturini was Edith Schloss's editor for more than twenty years at *Wanted in Rome*, a magazine for expats in Rome that she cofounded in 1985.

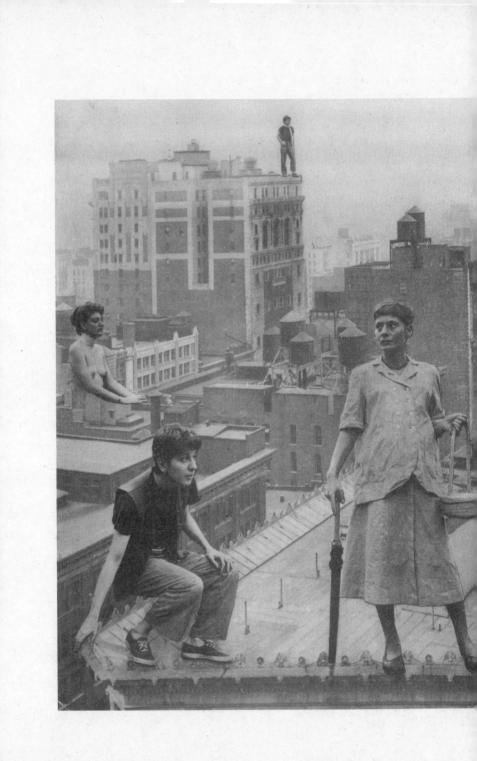

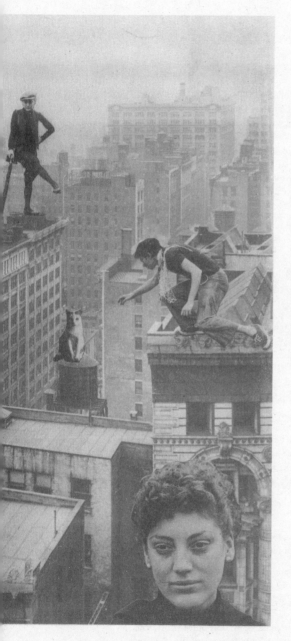

THE LOFT
GENERATION

FROM THE
DE KOONINGS
TO TWOMBLY
———
PORTRAITS AND
SKETCHES
1942–2011

EDITH SCHLOSS

EDITED BY MARY VENTURINI

PHOTO EDITING BY
JACOB BURCKHARDT

PICADOR
FARRAR, STRAUS AND GIROUX
New York

Picador
120 Broadway, New York 10271

Printed in the United States of America
Originally published in 2021 by Farrar, Straus and Giroux
First paperback edition, 2023

Illustration credits can be found on pages 311–12.

The Library of Congress has cataloged the Farrar, Straus and Giroux
hardcover edition as follows:
Names: Schloss, Edith, 1919–2011, author. | Venturini, Mary, editor.
Title: The loft generation : from the de Koonings to Twombly : portraits
 and sketches, 1942–2011 / Edith Schloss ; edited by Mary Venturini.
Description: First edition. | New York : Farrar, Straus and Giroux, 2021.
Identifiers: LCCN 2021025297 | ISBN 9780374190088 (hardcover)
Subjects: LCSH: New York school of art. | Art and society—New York
 (State)—New York—History—20th century. | Art and society—
 Italy—Rome—History—20th century.
Classification: LCC N6512.5.N4 S35 2021 | DDC 700.9747/1—dc23
LC record available at https://lccn.loc.gov/2021025297

Paperback ISBN: 978-1-250-85872-6

Our books may be purchased in bulk for promotional, educational, or
business use. Please contact your local bookseller or the Macmillan
Corporate and Premium Sales Department at 1-800-221-7945, extension
5442, or by email at MacmillanSpecialMarkets@macmillan.com.

Picador® is a U.S. registered trademark and is used by Macmillan
Publishing Group, LLC, under license from Pan Books Limited.

For book club information, please visit facebook.com/picadorbookclub
or email marketing@picadorusa.com.

picadorusa.com • instagram.com/picador
twitter.com/picadorusa • facebook.com/picadorusa

10 9 8 7 6 5 4 3 2 1

Frontispiece: *Chelsea Girls*, photomontage by Rudy Burckhardt, 1950,
with Lucia Vernarelli, Helen DeMott, Edith Schloss, and the cat Marieli

Contents

Foreword

BY JACOB BURCKHARDT

Edith Schloss could not decide whether she was a painter who writes or a writer who paints. In any case, she was an accomplished writer who wrote many art reviews and memoirs about various people she knew and events in her life. She also wrote at least one unpublished novel.

Usually she began a project by scribbling notes on pieces of paper. Next she would hammer out a draft or two on her Olivetti Lettera 22. She would cut up those drafts and paste the fragments onto clean sheets of paper in new arrangements, writing corrections in the margin or between lines until the final polished version was ready.

When she died, she left many manuscripts in various stages of completion, all the way from folders full of scraps of paper to clippings from publications. *The Loft Generation* was in the form of an early draft.

Although New York is the main location of the memoirs, Italy also had an important influence on Edith's work even before she went to live there in 1962. Many of the friends she made in New York among artists, musicians, and poets in the 1940s and 1950s subsequently arrived in Rome for exhibitions or concerts, or as visiting fellows at the American Academy. Many of the exhibitions she reviewed and the feature articles she wrote when she was living and working in Rome

drew on her formation and background in New York before she left for Rome.

This double influence is reflected throughout her writing, as well as in her painting. Therefore some of the articles she wrote during the five decades she lived in Rome, which were not included in the early draft of her memoirs, have been included in *The Loft Generation*.

Edith's memoirs are often inspired by people, places, exhibitions, concerts, and, sadly, the deaths of her friends. So readers should not expect the usual historical narrative of the genre, but rather a series of portraits and sketches, evidence in itself of how Edith's eye as a painter influenced her work as a writer.

Three editors worked on the initial draft of *The Loft Generation*: Annabel Lee, Simon Pettet, and me. Our principal tasks were correcting errors relating to names, dates, and places; eliminating redundancies; proofreading; and research. My own memory was a key resource. Simon Pettet reviewed the manuscript in its earliest stage and did copyediting and fact-checking. Annabel Lee and I then did a comprehensive proofread and copyedit of the manuscript, a critical close reading, and further revisions in order to hold to Edith's original as accurately as possible after initial corrections had been made. The final draft was edited by Mary Venturini, who was Edith's editor at the magazine *Wanted in Rome* from the mid-1980s until her last article, which featured Cy Twombly and was incomplete at the time of her death, in December 2011. Twombly, who died in Rome only a few months before Edith, became as much of an influence on her later work as both Willem de Kooning and Fairfield Porter were earlier.

At the end of the book the reader will find a glossary of the names of those in the book, with brief biographical profiles; as well as a list of the images included and their sources.

Many people have generously advised, assisted, and supported us in our research and in other ways, including Jason Andrew, John Ashbery, Dore Ashton, Mariateresa Barbieri, Jacopo Benci, Hugh Burckhardt, Steve Clay, William Corbett, Robert Cornfield, Betty Cuningham,

Alvin Curran, Tom Damrauer, Mary Daniels, Rackstraw Downes, Hermine Ford, Mary Gabriel, Mimi Gross, Haidee Becker Kenedy, Albert Kresch, Elizabeth Kresch, Laura Kuhn of the John Cage Trust, Susan Levenstein, Phillip Lopate, Julie Martin, Barbara Mayfield, Ron Padgett, Peter Rockwell, Gary Roth, Fred Schloss, Ruthellen Schloss, Justin Spring, Silvia Stucky, the Cooper Union, Zelda Wirtschafter, and Nathan Kernan and Thomas Whitridge of Ink, Inc.

For illustrations, many individuals and organizations have been generous, including John Cohen and L. Parker Stephenson, the Artists Rights Society, Eric Brown, Andrew Arnot, the Tibor de Nagy Gallery, the Art Students League, Katie and Elizabeth Porter on behalf of the Estate of Fairfield Porter, Yvonne Jacquette and Tom Burckhardt on behalf of the Estate of Rudy Burckhardt (of which I am part), Shari Steiner, David Carter, the Wadsworth Atheneum, Paul Linfante, Thomas Micchelli, Alex Katz, Vincent Katz, Colby College, Yoshiko Chuma, David White of the Robert Rauschenberg Foundation, and David Joel of the Larry Rivers Foundation.

"Conversations with Giorgio Morandi" was first published as "You Can Paint Anything If You Want To" in *891 international artists' magazine* in 1986, and "Francesca Woodman" was published as "The Fierce Poetry of Francesca Woodman" in 2000 in the magazine *Italy, Italy*. The article on Cy Twombly was published in *Wanted in Rome* in 2012, after Edith's death.

To anyone who has been inadvertently left out of these lists, we thank you as well and profusely apologize.

New York, 2021

Introduction

BY MIRA SCHOR

One fine summer afternoon in 1961, the artist and writer Edith
Schloss sets out alone, without appointment or introduction, on a pil-
grimage to visit the painter Giorgio Morandi in the mountain village
in the north of Italy where he has a summer home. On the way, she
stops to pick wildflowers along the dusty roadside, when she becomes
aware that someone is looking at her through a spyglass from the up-
stairs window of a house above her.

It is, of course, Morandi, who then welcomes her into his home.
One senses that he has espied through his glass not just a lovely
woman but also a keenly observant spirit akin to his own, one taking
as intense a delight in nature as she does with everything she sees in
his home. Schloss's driving interest in art and her quality of openness
and detailed attention to what comes her way underlie *The Loft Gen-
eration*, her memoirs of her years in the New York art world in the
1940s and 1950s and of the many important artists, writers, poets,
and composers she knew well in the five decades she was active in the
arts in America and Italy.

The Abstract Expressionist era and the New York art world
after World War II to the 1960s are among the more thoroughly dis-
cussed, analyzed, documented, and canonized periods in art history.
The number of meticulously researched major museum exhibition

catalogues, biographies of Jackson Pollock and Willem de Kooning, histories, critical analyses, as well as memoirs by the art critic Irving Sandler and collected writings by artists of the period such as Barnett Newman, Ad Reinhardt, Jack Tworkov, and Mark Rothko, would make it seem like a time from which there is nothing left to excavate. And yet in *The Loft Generation*, Schloss opens doors to some of the most iconic spaces of this history and brings her reader inside in a way that is perhaps the closest to the experience of what it would have been like to be there, as observed by a very perceptive, intelligent person with incredible recall, gifted with an excellent visual, literary, and narrative memory.

Schloss takes us into these legendary studios that we have heard so much about, that we really wish we could have been in ourselves: what did the furniture look like, what did the room smell like, what did each person look like, what were their concerns, what were their flaws—though any such revelations, which are after all what many crave in such memoirs, are always matched by respect and admiration. She writes about a community of artists and how important art emerges not only from the work of solitary geniuses but also from the way such "geniuses" work within a fertile, competitive, interdisciplinary community. Beyond crucial portraits of individuals and their living and working spaces, this community is the subject of *The Loft Generation*.

It bears repeating that the history of this period has been largely about male artists and that the canon formation has been accomplished mainly by male writers, whether the artists themselves or the critics, theorists, and art historians surrounding them in what was at the time a relatively small art scene. There was a lot of jostling to be a hero as well as to be the first one to recognize that hero. Only in recent years has attention begun to be paid in a more serious way to the women artists of the time.

The few women who figured in these histories, such as Lee Krasner or Elaine de Kooning, had to struggle to be seen as artists in their own

right, not merely in relation to the famous men they were married to. Schloss, who by all accounts did not specifically align herself with the feminist movement in the 1970s, nevertheless brings a specificity of focus on the significance of the women artists of the New York School that is in its own way a feminist statement. This is declared in the prologue to the memoirs, a "letter" to Elaine de Kooning, which begins, surprisingly, "Dear Elaine, In the beginning I didn't even like you." This prologue, which is in fact a declaration of love and friendship written in sorrow after news of Elaine's death—crowning her "The Queen of the Lofts," "the figurehead that steadily led the New York art fleet sailing into the wind"—still has an astonishing ability to surprise. On our way into a book where we expect we will meet Bill de Kooning, even today we do not expect something that is in effect an impediment to our progress into such a fetishized male domain. It says, no, there were other people there who had tremendous importance.

These memoirs teem with a large cast of sharply observed characters from the interlocking art worlds where she lived, in New York and later in Rome, including Willem de Kooning, Edwin Denby, Rudy Burckhardt, Fairfield Porter, John Cage, Frank O'Hara, Tom Hess, Larry Rivers, Giorgio Morandi, Meret Oppenheim, Francesca Woodman, Cy Twombly, and many others of note and fame, but also artists like her best friends Helen DeMott and Lucia Vernarelli, collectively dubbed with Schloss "the Chelsea Girls" by Denby long before Warhol used that as a title.

The glossary of names that Jacob Burckhardt has compiled is a very useful addition to the book because it emphasizes the way in which a true portrait of any art world, or set of interlocking art worlds, includes so many people who contributed to it. Most histories of famous periods in art or of famous artists present a world where only a few actors play at the front of the stage and the rest of the cast are glancingly mentioned or are nameless extras whose reminiscences are folded into a synthetic account by an author who was not a participant. In fact, and

with no disrespect meant, in such histories Schloss might herself be one of those nameless extras—indeed she was one of the hundreds of people interviewed by Mark Stevens and Annalyn Swan for their 2004 biography *de Kooning: An American Master*. Yet she was a perceptive and active agent among interlinked worlds, bringing great intelligence and activism to her participation and to her memoirs.

These memoirs have a cinematic feel, with a basically forward-moving chronological approach in the New York chapters, at first dominated by Willem de Kooning and Edwin Denby, then, as happens in life, spiraling outward and into the social world of art in New York as it continued to expand—not just for her, but in itself, welcoming new generations—and finally yielding to a more impressionistic artist-by-artist focus toward the end. Her cinematographic style also includes flashbacks that enrich our understanding of a character, and she goes in for tight close-ups, where one face, such as that of John Cage, fills the screen. Sharp dialogue and visual detail enriched by informed interpretation—these are the hallmarks of her writing.

Edith Schloss was born in Offenbach, Germany, in 1919, to a prosperous Jewish family. When she was a teenager, her family sent her to France and Italy to learn languages and extend her cultural education. In 1936 she spent time in Florence, working as an au pair and viewing art in the country she would often return to, where she would spend the last fifty years of her life. In 1938, still a teenager and impatient to leave the political and cultural atmosphere of Germany even before the war, she moved alone to London, where she studied English, took classes in drawing, and visited museums while forming acquaintances among German political refugees and British left-wing thinkers. Back in Germany, her family was almost rounded up on Kristallnacht but was eventually able to join her in England. In 1941, during the Blitz, she left England in a convoy for the United States. After a short time in Boston she settled in New York City in 1942,

working at all kinds of odd jobs while studying at the Art Students League and plunging into the city's intellectual and cultural life. She lived in New York until 1962.

The memoirs in this book are significantly framed and generated by two forced migrations: the first, as a young woman, leaving Germany for London and then during the Blitz leaving London for the United States; the second when, as a mature woman apparently more traumatized by a painful divorce than she had been by the onset of World War II, Schloss moved to Rome, where she spent the rest of her long life, for many years living with the composer Alvin Curran, painting and writing art criticism, active until the very end. The writings in this book, begun and worked on in the mid-1990s, mostly focus on the middle New York period—a time of her early adulthood, exciting friendships, marriage, motherhood—at what then seemed to be the center of the art world after the fall of Paris.

It is important to consider, when cities like New York continue a process of gentrification that make them unlivable for most artists and intellectuals, that the community Schloss describes was to some extent brought into being by a number of radically different circumstances: first, immigration—in some cases, such as de Kooning, illegal, and in others, such as Schloss, forced by war and politics—and second, the existence in post–Great Depression New York of cheap rents for run-down spaces that no one other than artists would consider or would be able to make not just livable but eventually fashionable.

And so, on one "grim winter morning" in Chelsea as it was in 1943, sparsely inhabited and run-down, not the shiny neighborhood it is now, one finds oneself with Schloss, "an art student in a red hat," and the painter and writer Fairfield Porter, climbing steep wooden stairs up to a small door that was eventually opened by Bill de Kooning, then utterly unknown to all but a few downtown people. He welcomes them.

The conversation that day was about the issues at the core of the concerns of the artists who became known as part of the Abstract

Expressionist movement: the validity of abstraction after the social realism sanctioned by the left along with the admiration, as expressed by de Kooning that day, for Renaissance artists such as Rubens, Titian, and Tintoretto and for the moderns, especially Soutine, an artist also admired by Jack Tworkov, another respected member of this circle who would write a notable essay about Soutine for *ARTnews* in 1950. And then a detail no one else could tell you: "And though there were many canvases of Bill's and his friends, I saw no art reproductions except one—Masaccio's *Adam and Eve*. Two figures, naked, woman and man, mouths open, were running, running from Paradise."

This life-transforming day had begun with Schloss first meeting Fairfield Porter at a loft at 116 West Twenty-First Street, one block from de Kooning's studio. It included a darkroom used by the Swiss-born photographer Rudy Burckhardt. That same night, after the studio visit, Schloss joined the de Koonings and Porter for dinner at the Automat, a cafeteria on Twenty-Third Street, from which they could see one lighted window, which, according to the others at the table, meant that Rudy was working. Soon Schloss met Rudy, and eventually they began living there together.

Accounts of that period talk of all the parties, at first fueled mainly by coffee and conversation rather than by alcohol (for most, that came later, with the influx of money and the benefits and pressures of market success), and dancing, with abandon if not skill. Evenings might begin with an art, theater, or dance event—many of these now legendary in ballet, dance, or avant-garde art and theater history—followed by a party, followed by an after-party, with the closest of friends talking deep into the night in their loft, heated by fires fed by broken-up vegetable crates. Schloss writes of one after party that ends with her dancing with Franz Kline and de Kooning: "We got up and danced the way painters did, any old way, bumping into the Motherwells' chic, plump couches, bumping into each other. I danced the tango with Franz, I danced the polka with Bill. The Action Painters

were not the world's greatest dancers, but there was nothing more fun than dancing with them. Paint is thicker than water, we used to say. The next day I was black-and-blue."

The most challenging aspect of writing an introduction to Schloss's book is the temptation to quote huge portions of the text. She is an astute observer, with an ability to recall the tone and content of meaningful conversations and telling anecdotes, yet her approach to her work as a writer is characteristically not merely modest but almost flippant. She presents the occasion of her proposing to Tom Hess, the influential *ARTnews* editor and personal friend, that he hire her in order to get her son, Jacob, into nursery school, which she could do only if she was considered a "working mother." In fact, she loved the job of editorial assistant and monthly art critic, learning a great deal about writing and editing from Hess, who "expected clipped, gutsy reviews, and he got them. It was superb training." She saw her visits to art galleries in fairy-tale terms, writing that she "felt like Little Red Riding Hood going out into the woods with a basket, hunting for mushrooms." She also learned about the curious—and, for a painter/writer, frustrating— relationship to power that being an art critic gives you. At that time, the favored image of the artist was of an inchoate force of nature—like Pollock—or a Delphic source of cryptic, sharp asides in conversation— like de Kooning. In fact many of the artists who were members of the Artists' Club, in which Schloss was a rare female participant, were excellent writers, much valued by the community for that capability while also held suspect. Helen Carter, the wife of the composer Elliott Carter, responds with casual snobbism to Schloss's news about writing: "One day, asking us to a party . . . Helen said, 'How are you?' 'Fine,' I replied, 'I'm working for *ARTnews*. I just wrote my first review.' I was so proud. 'Oh,' said Helen coldly, 'how sad.'"

At the time, reviews in *ARTnews* were signed with only the writers' initials to give a slight protection of anonymity, although Schloss's

name also appeared on the masthead as Edith Burckhardt, the only time she used her married name professionally. Schloss learned quickly that gallerists who were very interested in the reviewer "E.B." were rather less welcoming of the woman artist Edith Schloss trying to get them to look at her work. She lived with the problematics of that fraught dual identity and continued to write until the end of her life, moving on from *ARTnews* to writing for the *International Herald Tribune* and later as the art critic for *Wanted in Rome*. As a reviewer, her descriptive language was sharp and clear, and she situated the works in art history with authority; she remained current, writing the first review of Francesca Woodman, a personal friend despite their vast difference in age, taking notice of Jean-Michel Basquiat's work early, and writing knowledgeably about Anselm Kiefer as late as 2005, taking a critical view that aesthetically and historically was consistent with those of some of the most distinguished art historians and critics of the period.

If Tom Hess, Edwin Denby, and Fairfield Porter were her writing mentors and exemplars, Schloss as a painter, despite her deep admiration for de Kooning, moved toward a composite style that usually had some representational anchors, whether landscape or still life—where her admiration for Fairfield Porter's simplified, gentle approach to representation of daily life was evident—and also with some abstracted figuration and mythological narratives as influences, especially in later years, in the work she did while living among the antiquities of Italy. Schloss also collected ephemera of all kinds, which she assembled into small boxes: she and Rudy met Joseph Cornell in the 1950s, and she often had long telephone conversations with him, especially on wintry days as the snow fell, intimate moments based on the traits she shared with him, a love of the intricacies of gossip, with a more private and intense love of detail and the privacy of deeply felt aesthetic experience.

In 2010, Schloss's son, Jacob Burckhardt, filmed *A Guided Tour of Edith's Apartment*, where the first impression of a crowded, dusty

mess unfolds into a *Wunderkammer* of treasured artworks and found natural objects, some set into Cornell-like boxes. At age ninety-one, Schloss had one of those memories that is not just intact but encyclopedic, exhaustive, and even exhausting, and her enthusiasm not just for the objects but also for all the history and literature they embody and for language itself was intense. Every object she touches in the film, every artwork she points to, evokes detailed memories of history, materiality, location, and etymology. That this was part of her deepest character is evident in what she chose to include in her memoirs.

Thus her task as a memoirist must have been daunting: what to include, what to censor. She did cut certain things when asked: in her archive—the Edith Schloss Burckhardt Papers 1962–2011 at the Rare Book & Manuscript Library of the Columbia University Libraries—a letter to Anne Porter indicates that she made cuts requested by Anne to one of Schloss's chapters on Fairfield Porter. If, in this instance at least, she was mindful of the feelings of the living, in a larger way she exercised self-discipline with her own deepest emotions.

Her authorial approach is interesting in the way she treats herself as a protagonist. We get occasional glimpses of her as mirrored by others: Lotte Lenya calls her *Eichkätzerl*, or squirrel, which gives us a sense of her diminutive, fugitive physicality and her curiosity and activism in the social world. However, she does not indulge in self-analysis or promotion, and she does not spend her time bemoaning her fate or analyzing why she or anyone else behaved a certain way, as one might expect, and as might make for more prurient writing.

She does not go into detail about sexual relationships. Her observation is clinical, slightly amused, like the script of a Billy Wilder movie, an analogy that is fitting given Schloss's similar roots in German culture between the wars, where dry wit and mordant observation were possibly national characteristics. She is at times revealing about the less pleasant aspects of the people she really admired and loved, but generally you don't learn much about how she "felt," or about who specifically slept with whom, even though she recalls a moment late

one night when Jane Bowles stops a party of twenty or so friends cold with the following realization: "'I know that everyone here has slept at one time or other with someone or another in this loft.' We stared at one another, old lovers, new husbands, this one having lived with that, secretly or not, summer or winter, in rain or shine—Bill, Elaine, Edwin, Fairfield, Anne and Anne, Jean, Ruth, Pit, Larry, Milton, Alex, Tess, Walter, Paul, Fritz, Nell, Ilse, Marisol, Bob, Jimmy, Jane, Joe, Rudy and me. It was uncanny. It was true." Schloss brings to that moment European sophistication and even pride about such matters, yet she casts a cold eye on the incestuousness and genuine pain of these relationships.

Most important, given the traditions of the genre, although Schloss is frank in observations that are sometimes critical or even damning, she does not use the memoir to settle scores. This is most evident when one considers the extensive and complex treatment of the dance writer and poet Edwin Denby, as protagonist/rival in her marriage to Rudy Burckhardt, as the sometimes not so beneficent center and arbiter of a social circle, and as a teacher and mentor whose views she respected and whose approval she treasured when given. The dynamics of the legendary friendship between Denby and Burckhardt provide the central drama of her story. Yet her husband's character is addressed glancingly, peripherally, while she is at her most probing and complex in her assessment of Denby. The portrait of Denby is thorough and nuanced, and though she deeply admired him and greatly desired his approval, we get glimpses of a darker, more cruel personality.

Her unpublished private notes suggest another memoir entirely—one that Schloss perhaps did not even consider writing, one that she might even have been contemptuous of as maudlin or self-indulgent—that is, not just the tale of the heartbroken woman but also the story of the tough, talented, ambitious, and whip-smart survivor. What goes into a woman like her making the bold decisions she made in her life? One can only infer the answers from the brilliance of her writing and her qualities of sharp observation and understanding. There are in

fact few models for what that other memoir might have been: few visual artists over the centuries, female or male, have written artistic and personal autobiographies—and a woman artist would most likely always have to deal with a double standard of judgment; although salacious details may help insert the author into the story, they have the potential of detracting from the seriousness of her subjects' artistic purpose.

Nevertheless, artists' writings have been a vital source of information about the ideology and values of art movements; and given the richness of Schloss's memory and observations and the historical significance of her circle of friends, hers is a disciplined choice and a very wise one: by looking back with more delight and fondness than bitterness, she gives her readers direct access to the people, the spaces, the art, and the events that made enormous impressions on her, that she understood and remembered so perceptively, which are of great continued historical interest to us.

That her subject is a world of interconnected artists dedicated to art making—not only as a realm of ideas and a way of life but also as a calling that extends beyond their own time—is made clear in one of the final chapters of *The Loft Generation*, after Schloss visits Morandi in Bologna, where he lives under the bourgeois dictatorship of his sisters. This sly coda is masterfully structured like a short story whose plot twists I will leave for the reader's enjoyment. However, toward the end of the book, in the chapter on Morandi, Maccari, and Loffredo, we find Morandi with fellow artist Silvio Loffredo in the Uffizi Galleries, referring to the artworks in its collection as "our friends," a telling anecdote signaling that the book is not just about a group of artists in a specific time, but about the whole history of art as a conversation among artists, the living and the dead.

PART I
—
NEW YORK

Prologue

Dear Elaine,

In the beginning I didn't even like you. You had a way of eliminating other women from the room. You could be blithely opinionated, you could carelessly ignore people. But you were never a snob. The confident way you sailed through life despite the blows it dealt you, your beautiful magnanimity, clear trust, and lively mind in the end were endearing.

In a postcard you wrote me from Paris in 1977 you said you had seen an art review in the *Trib* deploring commercialism in art and you wrote, "I thought, Aha! A friend! And there was your byline."

Yes dear, we became friends in the thick and thin of it from the 1940s to the 1980s—when you were the figurehead that steadily led the New York art fleet sailing into the wind.

You were always serenely sure of your choices. You chose to be a painter, you chose to marry the best painter of all, you chose to cherish him to the end. You chose not to cook and slave as a wife, but to dedicate yourself to art and the art world, which was your reign, no matter what. You chose to be fearless and undaunted with grace.

You told me that when you lived with another woman in Provincetown one whole summer, when everybody was depressed once in a while about their work, when people had hangovers and made bad

gossip about each other, you went on cheerfully painting and party-ing. Your companion was exasperated. At the end of the summer she asked you, "How do you do it? When does it ever hit you?"

"Never," you replied. You would not let it.

Just as you took men's admiration as your just due, so you never let your estrangement with Bill cut into your stride. When he had a baby with another woman you brought her flowers. When feminism and hippieism were the vogue you figured out your own solutions with your own intelligence. When there were discussions about atomic war and the destruction of the world you said in all seriousness: "Only artists can save the world. Only Bill can save the world."

When I heard you had kept your illness a secret I knew that this was in keeping with the rest. The beauty of our "Elainchen," as the Hofmanns, the Alberses, and Frederick Kiesler used to call you, was that you took life on the chin.

In New York, no one like Elaine de Kooning ever had such style and courage.

When I heard about your death in 1989 my first thought was: how could you do this to us, leave us like that, without your fearless bubbly presence, leave us, keeping the secret of how you maintained your spirit forever? "Corny!" you would have said right here. Right, silence is a way of saying goodbye. Still, but . . . you would have gone on and on about a dear departed friend. So allow me too this way of mourning—this telling all I know about you and your world, you, the Queen of the Lofts.

I had the news in Rome and it was bitter. No more Elaine, no more Elaine. But that it was an abstract remote hurt came to me a month later in New York when I sat in a Mexican diner off Canal Street with my son, Jacob, who told me about the funeral. And there, among the truck drivers, handymen, and shoppers, in a funky Hispanic New Yorkese eating place, everyone shaking off the rain, ordering, eating, hollering over the music and static, in all that steaminess, you could have easily been with us at the same table, regaling us, in your twangy

articulated Brooklynese, with your sharp wit and observation, with yet another titbit of absurd gossip from the "New York World of Oart." And we would all have been laughing together there in the noise and mess of the other high and low New Yorkers—in your own territory—but no! It came blindingly home to me: Elaine will never be sitting with us anymore.

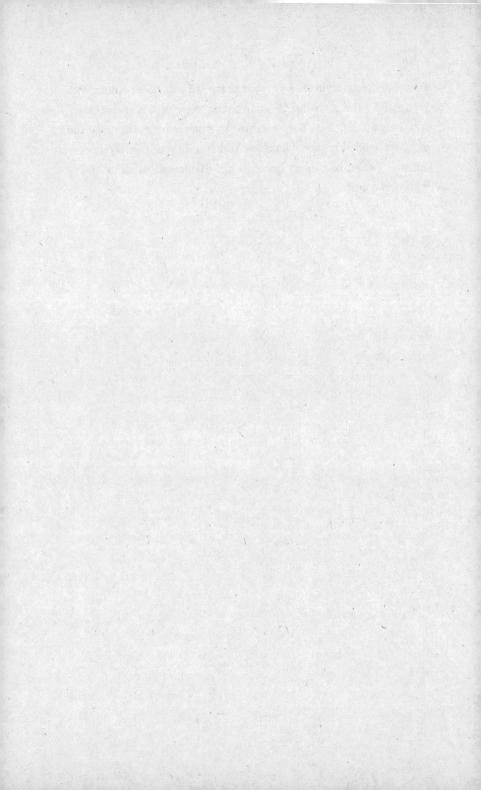

BILL AND ELAINE'S LOFT

When I first met her, I did not recognize her. The truth is, I did not even care for her. It was in Elaine and Bill's loft—in 1943 or 1944—on an icy New York winter's day. I was going to the Art Students League. Bill was about forty, she and I were in our twenties, and I had just come from the first loft I had ever laid eyes on, which I then had no idea I would ever call my own.

Coming from Europe, I believed in abstraction. The Art Students League and the few galleries up and down Fifty-Seventh Street showed figuration—pensive and sad or acid and lurid, of men and women in sweatshops, in subways, and on farms, the exploited exhausted by the Depression—or modern French masters. But the first art show I ever saw in my life had been a Paul Klee exhibition in the Buchholz Gallery on Fifty-Seventh Street, where they also showed the severe, neat Cubism of Juan Gris. I was hungry for more abstraction.

Then, at a party of political refugees in a farmhouse in New Jersey near Flemington Junction that had been renovated by the German sociologist Fritz Henssler, I saw a small painting. It was green and gray and black. In it leaned a curvilinear shape like a number eight, or two sliced 0s, egg-like shapes snugly fitting. There was something still and clear about the little thing. The small abstraction was beautiful. I'd

never seen anything like it. Fairfield Porter found me staring at it. "Would you like me to take you to the man who did that?" he asked. I was thrilled. To get to know the man who had painted such a picture, to go to an artist's studio, to see more of his pictures, was wonderful.

Fairfield said we should meet the next Sunday on Twenty-First Street, where he had once shared a loft with the photographer Ellen (Pit) Auerbach. It was a grim winter morning, and harsh, cold sunlight flooded the street, pitilessly outlining the rows of factory windows as well as each pebble on the pavement. There were no pedestrians. Sundays were melancholy in Chelsea, I was to learn later. In the bright emptiness a gust of sharp wind lifted a rag, a shred of newspaper. "Just like Odessa," said Fairfield as he walked me across the gritty sidewalk to the next block, to a loft building on Twenty-Second Street. I was impressed. He said it so lightly. He had been to legendary Russia.

We climbed up the wooden staircase, steeper than usual, to the second and top floor. Here we found a small door. We knocked. We knocked and knocked. We knocked for a long time.

When the door was finally opened, the man who stood there looked aghast at Fairfield and me. He was obviously quite disappointed. But then he caught himself and with quick, cheerful politeness asked us inside.

The strange disappointment was explained later. When Bill de Kooning worked, he worked. He would paint without ceasing for hours and hours. He would bear no interruption of any kind, would open the door to no one. Fairfield, a figurative painter but a good friend and patron, had planned to help the then poor and unrecognized Bill by bringing the critic Paul Rosenfeld to appraise his work. Some Sundays before, Fairfield had taken the critic by the scruff of the neck and brought him downtown. Bill was in a fury of work. Fairfield and Rosenfeld knocked and knocked. Neither Bill nor Elaine would open. Nor did they suspect that a respected critic, who could do any number of things for them, was on the other side of their door. When Fairfield

explained to them later what had happened, they were crushed. They promised they would be good and open the door the next time. But the next time, when Bill finally stopped work and opened the door, there was Fairfield all right, but with him there was no critic, only an art student in a red hat, me. Still, mild and good-humored, the painter quickly got over his shock and made us welcome in his studio.

It was like nothing I had ever seen before. Everywhere were surfaces lashed with paint—flows and drips and spatters of paint, linear demarcations and gashes, like frontiers and ghostlike empty spaces, where a canvas had been attacked. On canvases there were waterfalls of paint and wide swaths of cancellations. On the floor, bits of drawings on cut-out tracing paper and newsprint used to mask spaces lay on gritty boards spattered with paint.

There was a large, long table loaded down with oil paint tubes, jars of enamel paint, plate glass covered with mounds of paint, coffee cans full of paint, knives, scrapers, sandpaper, rolls of masking tape, and brushes of every size and shape laid out in rows—a veritable landscape of paint and materials.

To the right, toward Twenty-Second Street, a large factory window of frosted glass muted the northern light. Bits of tape, tracing paper, and newsprint, comics and magazine cutouts were stuck to it. There were canvas racks and shelves on which stacked canvases looked in and out. Opposite this drama was an old armchair, bulging, its springs half broken, covered with yellowish-brown velours. This was where the painter sat down to stare at what he had just created.

While I am writing this, I realize that today such a setup, the large painting walls, the homemade easel, the large table flooded with materials, is perfectly ordinary in a painter's loft. But what is a common style now was invented then by Bill and his friends to fill their new needs. At the time, it astounded me.

There was the smell of fire and brimstone in the air: here epic struggles had taken place. A man had been measuring himself against the gods with nothing but a stick covered with paint in his hand. A

small man standing in front of a big, messy flatness offering itself to his truth.

When I was little, I saw a Hollywood movie about a storm at sea. The ship plunged into giant troughs, then wobbled and climbed up, only to have three-story-high waves hurl it down again. In all this foaming stood the skipper: sou'wester and slicker dripping wet, legs wide, straddling the deck, his hands on the helm mastering the bucking wheel. With every part of his body at play, the skipper was giving all he got. He was all there. He was measuring his power against another power.

So Bill would stand in front of his painting. The emptiness there was a force of nature to be overcome. The painter took it on, took on his own painting. Wide-legged, he stared at his past, his present, his enemy, his friend. There was abandon here, and joy and pain; it was daunting and it was exhilarating. How could you ever achieve anything like that?

Years later, my daughter-in-law, Yoshiko Chuma, went to visit Bill in East Hampton. She is a dancer, and I don't know how much she understands about art. But she too was caught by that sense of Bill's power, the same feeling that had overwhelmed me decades earlier.

"Wow," she said. "That man, just standing there in his studio, wow!"

The man standing there so exposed was compact and not very tall. A shock of straight blondish hair sometimes fell over one eye and then was flicked back. He had a way of narrowing his eyes and squinching his wide, sensual lips sideways when looking hard at things, when thinking hard, and when he was embarrassed. He was courteous but would say the truth, brutal or not. Most of all, there was his voice. I can hear it right now: high, chirpy, with a Dutch accent that made it even more endearing. His "how are ye?" and his "still painting?"— which from anyone else would be taken as a put-down but from him was an encouragement—still ring in my ears. Funny and disarming, there was a sober, working-class consideration in all he said, and he was quick and alert. He looked away, seeing things, seeing new pic-

tures, while his singsong voice followed you. We were all strongly at-
tracted to him, so small and solid, with his handsome smile and that
squeaky voice that went to the heart of things.

There was an inner room, soothing after the thin air of the big
paint-inhabited studio. It was a dark, square cubicle, like a Pompeiian
dining room, and was painted in satiny purplish grays. There were
touches of yellow. There were solid chairs, their backs made of two
curved iron rods. The chairs, a big square table, a double bed like a
big box, all stood on iron rods. They looked like the basic symbols of
chairs, of a table, of a bed, they were so starkly themselves. It was a
shipshape, scrubbed interior, made by Bill. It was basic and simple but
glowed like a jewel box.

We all sat down around the table. Beyond this room there must have
been more space, a kitchen and the usual loft factory windows and fire
escape over the empty lot on Twenty-Second Street. From there, sud-
denly someone appeared. Had she been there all along, or had she just
come in? She had bangs and wore elegant scotch plaid slacks. Without
a word, she handed coffee mugs to each of us with an air so aloof I
thought she was a patron of Bill's who had just come downtown from
her Park Avenue apartment to give a hand to the poor artist.

A man in an army greatcoat joined us, Milton Resnick, a follower
of Bill's, a soldier who had until recently been stationed in Iceland.
He and Bill and Fairfield were all looking up at the pretty woman.
She moved among them with graceful assurance. The atmosphere had
changed. Who was this, speaking so brightly, who was this, so ad-
mired by all these men for the way she spoke and moved? And then it
dawned on me—it was Bill's wife, Elaine.

We must have drifted back into the studio. There were shelves
with paintings stacked on them. A small one looked out; it was a Pi-
cassoid woman wrapped up and hooded with a kerchief, holding her
bundled-up son. Both had big black eyes and funny snowball-like
hands—unfinished areas of painting. I saw it again decades later in
the Whitney Museum. It was by Arshile Gorky, a friend of Bill's. A

similar painting by Milton was near it. Gorky was much in the con-
versation, a loved presence. I thought his paintings were too much
like Masson and Picasso, and I dared to voice this and began talking
about my other preferences. But then, when I said I liked Calder, I was
finally put in my place.

"All that stuff moving!" Bill exclaimed impatiently. "He makes me
nerfous."

I have never liked Calder since.

I was assistant to the assistant at Meyer Schapiro's slide lectures at
the New School, and I told Bill how Schapiro could often be inspiring.

"Yes." He nodded. "He knows everything. If after an atomic war
there'll be just Meyer Schapiro left in a cave, all will be saved. He will
tell the Martians everything, he knows all they ever wanted to know
about our culture."

Later he said something no one had yet said in those early 1940s—
that Marx and Freud and Einstein had led us astray.

"They want to change everything, those three wise Jews. It's the
sinuses who are destroying the world." The sinuses? He meant the
scientists.

"And there'll be nothing left but insects," and he described a vast
landscape of burnt stone over which crept horny brown things in the
lurid shine of a purple sun.

When I said something about the Mexican mural painters Harry
Sternberg at the Art Students League had told us to study, he put them
down.

"They think they know all about the people." He said he knew a
man, the husband of the dancer Marie Marchowsky, who had fought
in the Lincoln Brigade in the Spanish Civil War and was now a suc-
cessful radio executive, who thought he knew about the people. "Those
guys, they think they know all about the people. When they wake up
in the morning and want coffee, they holler *coffee for the people, let the
people have coffee!*"

But painting was about the painting of paintings, not about the

needs of the people. I found out later that this disillusionment with left political ideas was a strain that ran through all the conversations of the early Abstract Expressionists, who, to a man, had been starry-eyed fellow travelers until yesterday.

Even harder for me to swallow was the constant talk about the Renaissance, Rubens, the Venetians, and their brushstrokes, their brushstrokes, no one could do better brushstrokes. I was dismayed. I too had seen the Renaissance in Florence as a teenager and had been so awed by it I believed nothing could come after. But Bill's own clear little painting I had seen in New Jersey had been a revelation to me. It was abstraction—severe, clean, shining abstraction, its own story. And now Rubens, Titian, Tintoretto. I could not understand Bill's

treachery. Those rains of bodies, those cascades of thick and bulging pink flesh, those masses of heaped-up drapery, those complicated compositions so hard to disentangle. But Bill said they were about nothing but painting, traces and traces made up by hand, which built up unending movement. And he added, "It was the burchers behind it," and nodded his head with grim nostalgia, "nothing but the burchers." He meant the commissioning burghers of Holland and Venice.

Of all modern artists, only Soutine came up. And though there were many canvases of Bill's and his friends, I saw no art reproductions except one—Masaccio's *Adam and Eve.*

Two figures, naked, woman and man, mouths open, were running, running from Paradise.

I sat there in shock. Bill's untoward

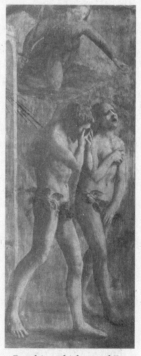

Expulsion of Adam and Eve from Eden before its 1980 restoration, by Masaccio, circa 1425

opinions had taken my breath away. But his paintings and stance as a painter were even more shocking. Later that week I went back to the Art Students League full of the extraordinary man downtown. I wanted to write about him in the *Art Students League Bulletin*, to clear it all in my head and for others as well. I had found a great painter like no one else. But Helen DeMott and Cicely Aikman, who ran the little paper, did not take my word for it, did not believe. It is a silly fact of history that they published instead an article on the Swiss surrealist Sonja Sekula, a nice person, but not such a good artist. If I had been allowed to write my tale of de Kooning, I would have been the first ever to write about him.

After that first long session in Bill and Elaine's loft, we all went to eat at the Automat, a cafeteria on Twenty-Third Street. Elaine talked to Fairfield, Milton, and Bill, but not to me. Neither in the loft nor in the cafeteria did she acknowledge me. Who was this art student who had come instead of the all-important critic? As we all sat there munching our meat and potatoes, she suddenly looked out the plate glass window. Across the street was one of those turreted little office buildings still left over from the 1890s. High on its brick sidewall over an empty lot was a lighted window. Elaine pointed to it.

"Look! Rudy is in!" she told everyone brightly.

When I timidly asked, "And who is Rudy?" she noticed me at last. She gave me one devastating look. Not to know who Rudy was? How could I have guessed she counted him, along with Milton, Fairfield, Edwin Denby, Tom Hess, and Charlie Egan, as one of the most trusted admirers at her court. After the long, haughty stare, I was dismissed once more.

116 WEST TWENTY-FIRST STREET

I met Rudy Burckhardt in 1945, when I began taking my things down-town to Pit Auerbach's loft at 116 West Twenty-First Street, where I

had first waited for Fairfield to take me to visit Bill. I was to share the loft with Pit, but she would keep only the darkroom, which she shared with Rudy, a photographer, filmmaker, and painter, and she would go to live next to her husband, Walter, in a cold-water flat on the Lower East Side.

Walter Auerbach still had the key to the loft after I moved in, and he sometimes went there when I was out. He would leave little bits of paper attached to a painting just started on the easel, with words like "I like this!" or "The green in the left-hand corner is beautiful!" or would even tie a balloon to the easel. It made me uncomfortable. It seemed as if God were looking over my shoulder.

One day when I walked in, there was Rudy. I had my "Matisse" plant in my arms, the tropical plant with the wide, shiny leaves that so often appears in Matisse's paintings, which we all included in our still lifes then. Rudy helped me carry it to the window. He wore a white linen suit, which was very crinkled. His face was also a bit creased for such a young man and it was mobile and nervous. With that boyish charm he never lost, he stood in his typical leaning attitude. Just released from a quite unpleasant stint in an army hospital, he seemed low and unhappy. I could never live with anybody so nervous, was my first thought. But as he walked me to the subway, we talked about the lovely still life Pit had hanging over her fireplace.

It was of fruit with purple grapes lying in a crooked, almost floating, very white compote. Rudy told me that the gentle, sweet thing had been painted by a huge, clumsy Greek, Aristodimos Kaldis, another important presence in the de Kooning circle. Our liking for that little painting was our first link.

Later I went to see Rudy in his small loft in the Victorian building on Twenty-Third Street, next to Fairfield's, where he set up still lifes of beer bottles, artificial daisies, nails, matchboxes, and postcards, using these incongruous objects to compose beautiful still photographs and paintings. He kept a darkroom in Edwin Denby's

loft, at 145 West Twenty-First Street, where he had once lived, as well as at 116 West Twenty-First, where Pit lived. Eventually he came to live with me in Pit's loft, where we ended up getting married, raising a child, and spending eighteen years together.

116 West Twenty-First Street was in a row of brownstone houses probably built in the mid-nineteenth century, when well-to-do people of the type who moved in Henry James's and Edith Wharton's novels lived all over Chelsea. They shopped in the emporiums on Sixth Avenue when the area above Washington Square was still considered uptown. Joseph Cornell, one of the pioneers of assemblage, told me that even when he was little, Twenty-Third Street was still considered uptown. His father would take him to the emporiums, the department stores there, at Christmas, and he remembered the wonder of these lofty halls with their high iron columns and chandeliers filled with the holiday glitter of toys and gifts, forever.

These one-family houses were modeled on Victorian houses in London and had several floors with two rooms on each. At street level and under the stoop was the kitchen and the servants' quarters, the "downstairs" or belowstairs, as in England. Once up the stoop, you entered the main door and the reception and dining room, at least two large spaces. The second floor had the fanciest spaces, the living room or parlor, perhaps also used for dancing, and the library or the study of the master of the house. The bedrooms and nurseries were on the top floors. All rooms had a fireplace, which was the only heating system. Jutting from the flat roof, which in our time was reached by the fire escape, you could still see the chimney flues, most of them now cemented up.

Before the loft, I had lived in similar brownstones, which had been built a bit later and had now been converted into seedy rooming houses. They were in the West Seventies and Eighties between Broadway and Central Park. Each floor had been subdivided into two or three independent rooms, most with a recess in which there was a sink and a hot plate for cooking, sometimes even a little icebox. But

usually there was a padlocked icebox at the end of the corridor, which all the tenants shared, next to a communal shower room and the toilet. Some rooms had no amenities and only windows on the corridor, and the middle room on the top floor had a skylight. The superintendent or the owner lived in the basement. This is where a wall telephone was kept. How often I had to skip all the way down, over the threadbare plush runners precariously held in place by brass rods, down the creaky balustraded stairs, to pick up a call. All these houses were full of plush and velvet, heavy Victorian armchairs and curtains and heavy brown beds, to which the smell of greasy cooking and the flit-gun clung forever. The rent was from $5 to $15 a week per room.

Probably all this applied to the "Penn Zone" too, a row of rooming houses opposite us on Twenty-First Street where derelicts and old Social Security recipients lived, one lonely old woman or man to a room. But gradually, Puerto Ricans rented single rooms and then smuggled in whole families. The houses became full to bursting, and at night their life overflowed into the street. The sidewalks, once so lonely on Sundays, became crowded and full of music and constant baseball playing.

Under urban renewal, the uptown brownstones ceased to be rooming houses. They were emptied and sold to be restored to their original state. In most cases they became single-family dwellings once again. I was often a guest in such a house in the West Seventies off Amsterdam Avenue, beautifully and cozily restored by the painter Philip Pearlstein for his family.

Around the turn of the century, or just before World War I, the middle class had moved farther and farther uptown. Slowly the brownstones of Chelsea became derelict. Then small industries, sweatshops and such, moved in. The walls were broken down to accommodate machinery, so one floor could stretch through from the street side all the way to the back—the yard side—and become one long loft. The back windows, once looking on gardens, now gave onto fire escapes and were fitted with frosted or wired glass panes. Of the old amenities,

only the wooden stairs with their turned banisters and the niches on each floor for ornamental statuary were left. The ceilings were covered with embossed tin sheets in Grecian designs, today still a feature in the poorer lofts or defiantly left in the chic ones, and below that was a maze of pipes for a fire alarm system, which was never tested.

Probably after the Depression, when most industries expanded, some of the brownstones were torn down, and regular factories grew in their midst. All the time we lived on the second floor of 116 there was a small industrial manufacturing business called Acme Tool and Die, owned by two Greek brothers, on the stoop floor. A signboard proclaimed that they manufactured "Clicker Dies," which Rudy joked could serve as a newspaper headline for the death of a photographer. The thumping of their machinery shook the house at irregular intervals, so irregular that it was infuriating and nerve-racking. When I was breast-feeding my son, Jacob, I was particularly apprehensive, always worrying about when the next thump would come. Also once or twice a week the company was supplied with iron gas containers. When these were delivered they made hollow clanging sounds, which remained with me, especially in Rome, where I lived over the shop of a *carbonaio*—charcoal seller—who also dealt in gas containers, *bombole*, for heating purposes.

Most of the factories around us had iron shutters because of a fire law, but they were hardly ever secured, their locks rusted away long ago. So on winter nights the wind would batter them around, making them swing open and shut with loud, crashing sounds. Sometimes, somewhere a fire or burglar alarm would go off for no reason at all. Once you've lived through those long Chelsea nights, you'll never forget the eerie sound of clanging iron mixed with the long whirring of bells.

Then there was the intermittent swish of cars down Sixth Avenue, like long sighs, sometimes punctuated by a hollow clang when they unbalanced a manhole cover, and the far shudder of subway trains running under the avenues. The most peaceful event was the bell from the Metropolitan Life tower on Twenty-Fourth Street, deeply tolling the hours, making us long for the churches of Italy.

One of the worst sources of noise was in the middle of the night. Exactly opposite us was a garage belonging to the Hershey Chocolate Corporation for the trucks arriving and unloading from Pennsylvania. It was their terrible custom to start back around four in the morning. In the winter it took some time to warm up the engine, so a driver would turn it on and then leisurely stroll off to have his cup of coffee in a far-off open diner, leaving the truck to grate and rattle and shake for a good twenty minutes of horrendous sound. When he came back and took off he added an extra roar.

If you were left sleepless after this nightly ordeal, the smell of roasting coffee wafting over from Bickford's on Twenty-Third Street added to your discomfort before the merciless clatter of the early garbage trucks took over. Sometimes in the small hours something like a fairy-tale noise occurred: the soft clip-clop of a horse. For years I did not look out to see what it was, for fear it would disappear. But after Jacob was born and I sometimes nursed him before dawn, I finally discovered what it was: a milk truck drawn by a white horse. Later I found there were still stables for these horses on Thompson Street, and that old-fashioned glass milk bottles had been left on some stoops. That cozy clip-clop remained a comfort to us for years, until even the dear old horse, as ghostly as dawn, finally disappeared.

To the east was a little cemetery. It had been created for early Spanish and Portuguese Jewish immigrants and was already full to capacity in the 1920s. Now its little iron gate was permanently closed. From the street you could just make out on the weathered markers that some-one had been born in a village in Bavaria, another had come from the Waterkant, the North Sea coast of Germany. The melancholy place was a valuable piece of real estate, but no one could do anything about it. It was filled with not only blurred headstones and ivy but beer cans thrown down from the surrounding factory windows. Mysteriously we found it open on Decoration Day, when some of the graves were bedecked with little American flags. Rudy and Edwin secretly climbed over its railings one night to bury their cat, Marieli. On freezing January nights all the

cats in Chelsea did their courting there. The fierce meows and screams, added to the cacophony of shutters and the steady tinkle of forlorn bells, became a Chelsea winter symphony never to be forgotten.

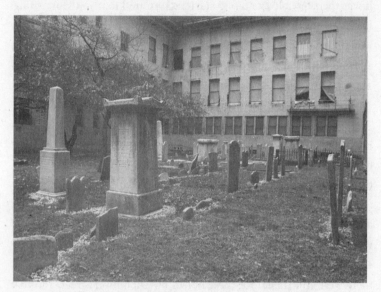

A 2005 photo of the Third Cemetery of the Spanish-Portuguese Synagogue on Twenty-First Street. The only things missing are the steel shutters on the loft building in the back. Photograph by Jacob Burckhardt

At the tail end of the Depression in the early 1940s many lofts stood empty after the original families had left and many of the sweatshops had moved out. Without regular bathrooms and in a run-down area they were not good living spaces for ordinary people. It was then that the painters took over.

There were two reasons. The first of course was that they were so cheap. For instance I had shared a modern one-room apartment—with skylight and kitchenette—off Amsterdam Avenue in the West Seventies with my boyfriend Heinz Langerhans for the astoundingly high sum of $75 a month. Later, just after I had put down $40 for the first month in a tiny cold-water flat off Christopher Street in the

Village, I was presented with the offer to share Pit's loft. Even if it was to be only partially mine, the space seemed immense compared with everything I had had before. I said yes at once. Now I paid $10 a month for half of a big loft. Later, when it became all mine, I paid $25 under OPA (Office of Price Administration) rulings. I believe that when I left in 1962, all we paid was something like $150.

The other reason painters took to the lofts was space. Despite the lack of ordinary comforts, and sometimes of daylight, here was ample space in which to paint and to live, with unheard-of space for storage. The lofts were huge stages for work and for a whole new free way of living.

Fairfield took 116 West Twenty-First to use just as a studio while he lived uptown in a town house on the East Side. Pit told us how Fairfield and Anne, his wife, had painted everything. "She stood there in her bare feet," said Pit, "reaching up to paint the walls white." The early lofts were painted white not only to offset the gloom—because of the height of the neighboring factory buildings little daylight came in— but also because the white was a perfect and neutral ground, a foil to offset the color of finished paintings. The cold loft white set a fashion, and art spaces were painted white for decades. In our loft, all the wood around the windows, the doors, and especially the floorboards was painted battleship gray by Fairfield—literally, with navy surplus paint—and remained gray forever. There was the staccato flicker of neon tubes that Fairfield hung from chains over the painting area near the front windows, which let in only muted light. He may also have built the shelves and the benches that masked the radiator in the nook next to the fireplace in the back of the loft.

It was not one through-space from front to back as most lofts were, but was broken by an enclosed space in the middle. This had been Pit's darkroom, then Rudy's. When we were living together, Rudy used his darkroom at Edwin's down the street at 145 again, and the enclosed space became our walk-in closet. Years later Rudy surprised a burglar there when he briefly came into town one summer from Southampton, Long Island, where we were staying with the Porters. The intruder,

razor in hand, pushed him into the closet. Rudy was so embarrassed that he stayed there when he could easily have broken the feeble lock. But of course it was the wise thing to do under the circumstances. The burglar made off not only with all his cameras, but with some freshly shot film, which hurt the most.

Burglars—sometimes little neighborhood punks who had been befriended by our summer tenants—swarmed up the fire escape and forced the windows so often that eventually no insurance company would cover Rudy's photo equipment. And every time we called the cops, they lumbered in, looked around rudely, then shrugged their shoulders: "Whadda ya expect, living in a dump like this?"

The "dump" was very pretty. In the back I had painted the cowl over the fireplace and the benches and shelves near it a bright sun-yellow to offset the eternal dimness. The kitchen was eventually hidden by a curtain made of striped mattress ticking, at that time not used for this kind of thing. In the front I had put up flower-sprigged English wallpaper and a little antique lamp in the corner between the racks and the painting area, near our double bed and the little night table built by Rudy. Later Jacob too had a corner, facing the street, with a brass bed from Maine and a Haitian chest for his precious comics. I used to say that I didn't know if we slept in my studio or if I painted in our bedroom. The furniture consisted of antiques picked up at garage sales in Maine, pieces found in the Chelsea streets, or handmade pieces by Rudy, Bill, or friends. There was an armchair made by Alex Byer, who lived upstairs.

Alex and his family lived above us on the third floor. Relations were not always serene. They complained about our cat's footfalls on the roof above them, while their whole family tromping downstairs made enough noise to raise the dead. Once, in a dispute over stair cleaning, his wife, Augusta, called me "a slob and a snob." Alex had been a painter, and before he finally threw in the sponge to become a professional decorator he made his own furniture.

Whether made by Alex, Rudy, or Bill, the typical furniture made

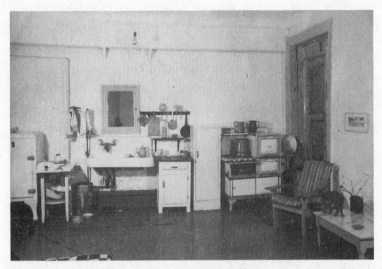

The kitchen area of the loft at 116 West Twenty-First Street (facing east). Photograph by Rudy Burckhardt, 1946

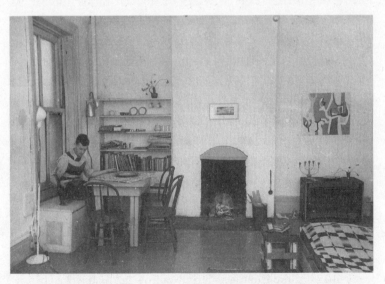

The living room area of the loft at 116 West Twenty-First Street (facing west), Rudy Burckhardt sitting by the window. Photograph by Edith Schloss, 1946

by loft dwellers was inventive all right, but it was always heavy, a bit on the clumsy side, a bit too durable. When the Byers became prosperous and bought ready-made modern, we inherited the great easy chair Alex had made. Impressive but not too comfortable, we made do with it for years. When we finally threw it out, it wasn't immediately picked up by the garbage collectors, and the Puerto Ricans from the rooming houses opposite used to lounge on it through the hot spring nights. Then it disappeared. But one fine Sunday, when Rudy and I were taking the sun among the fishermen on Washington Market pier, we saw a strange sight, a surrealist vision: there was the old armchair, royally sitting on the water, floating down the Hudson on its way out to sea.

To come back to the disadvantages of the loft. It was a winter dwelling. In the summer, like all the painters, we went to the country, to Maine, where we did most of our work. It could easily be said that for decades, seventy-five percent of the best work exhibited in the New York galleries was produced in the country in the summer. So in the winter heating was all-important, and seeing to it was a chore. The radiators hissed and clanged ferociously when they worked, but all too often they didn't work at all. After a drinking weekend, the superintendent went to sleep it off up in Harlem and we had to make do with an Aladdin stove, which left a slight but pungent smell. Helen DeMott, my friend from the Art Students League, used to say that in Chelsea we prayed to Santa Kerosena.

Once this stove burst into flame, so I quickly ran into the street with it, waiting for the fuel to burn out. As I stood there warming my hands, Nell Blaine and Bob De Niro came along, and we all chatted around the fire, calmly gossiping about the art world. Rudy, on his way home, was startled to see us from afar, three people in the middle of the sidewalk on a freezing winter evening, standing around something like a cauldron, our faces luridly lit from below. It looked like an eerie scene from a surrealist movie. He said we were lucky the stove hadn't exploded.

Because of the erratic heating, the strange open spaces of the loft, and the loneliness of the neighborhood at night, my mother, who lived in Washington Heights, refused to babysit. Visiting Swiss relatives returned to Basel and told everyone that Rudy and Edith lived such an amusing life, with furniture found in the street. It was true. We used cable spools for coffee tables. In those days there were really useful and handsome bits of wood discarded everywhere in the streets.

Like everyone else in New York, we had our cockroaches and the occasional rat. And aside from the toilet in the hallway, there was the problem of the stairs. They were wooden and old. Sometimes a bum came in from the cold and went to sleep on them, forgetting to put out his cigarette. This was a terrible hazard for sometimes we left Jacob alone with our dog, Lupa. A fire started by a wino could have had unthinkable results. Once, when we came home from the movies, we found Augusta Byer from upstairs sitting with Jacob, tapping her foot, saying, "What kind of parents are you?" Jacob had woken up crying, she said, glaring at us in disgust.

Nor was there a large or pleasant park. The nearest was Madison Square Park, dwarfed and made nearly sunless by the towering buildings around it. The roar of traffic, the absence of children, and the lingering retired people and bums made it anything but cheerful. But for me, if not for Jacob, there were compensations: the soaring line of the Flatiron Building and its giant shadow. And a graceful Palladian building with lovely statues, which, like a true New Yorker, I took for granted, though I enjoyed it. Only decades later in a foreign land did I learn that it was the Supreme Court of the State of New York and a *Gesamtkunstwerk* at that. On the southwest corner sat a bronze Victorian in a bronze chair gazing at a bronze page. A more intriguing sculpture was a relief on the uptown side of the park, the monument to Admiral Farragut by Augustus Saint-Gaudens, its wavy Belle Epoque ornaments and the waves themselves made pretty by trembling leaves half hiding it and a few coins of sunshine. There were no sandpits or swings for children. Though these are there today and quite a few neighborhood

children play there, for a long time the drug addicts and the litter made this little city wilderness a melancholy place.

At first we had no bathtub in the back part of the loft, which was both kitchen and living room. But there was an imposing shower stand right next to the entrance—a raised wooden box lined with zinc, from which pipes and showerhead rose uncompromising and bare. It was reached by three wooden steps and was far sturdier than necessary. Bill had built it lovingly for Pit with a precise and generous workman's hand. The whole shower edifice was painted in the same bright oranges, greens, and yellows that Bill used in his paintings at that time. Taking a shower was almost a performance. When we later installed a more comfortable and less exposed bathtub, we had a hard time ripping out the too solidly built contraption. To Pit's chagrin it ended up with the garbage collectors. If we had kept it, today it would be a hallowed art object with exaggerated market value.

Both Pit and Walter Auerbach were photographers, but Pit was probably the more dedicated. They had come from Germany as refugees, and their first job in America had been to photograph the Rosenwald collection in Philadelphia. Pit was full of black humor and, loving word games, would translate English into German quite literally, with hilarious results for those who knew both languages. Fairfield Porter's name would become Schoenfeld Gepaecktraeger. An energetic and intelligent woman, Pit dressed with simple elegance, and she was much more sensitive and sentimental than she let on. She thought she was not affected by Walter's other involvements, believing herself to be a modern woman, but she suffered deeply from these, and from the affairs of her own that resulted from them.

She first shared 116 with Fairfield, then with Rudy, then went to live next door to Walter on the Lower East Side, seeing his affairs from up close and pretending not to mind. Always on the lookout for new solutions for dealing with contemporary life and for new creeds, she became involved in Freudian analysis, then Wilhelm Reich, cybernetics, and Scientology. Together with John Cage, she attended the D. T.

Suzuki lectures on Zen at Columbia. Later she followed other oriental beliefs and, who knows, may have become a Buddhist. Witty, vulnerable, frugal, faultlessly dressed, with her fine, beaky nose and curious eyes, discreet in her relationships with men, she became the admired "older woman" to "us girls," and we hoped to grow older as gracefully as she did. But she was not a happy person. When she finally got divorced from Walter she said people approved and told her it had been the nice and clean thing to do. "But I feel neither nice nor clean," she smiled bravely.

Walter acted the bemused amateur throughout. He loved to think himself "a rebel against society," but he was the astute and benign observer at all times. Besides politics and photography, he dabbled in art. He was prematurely bald, and protected himself by affecting a wide-eyed, guileless manner, which charmed a lot of girls but put me off. The Italian painter Domenico Gnoli, who knew him in his declining years in Majorca, once said to me in Rome, "Walter stood by at the birth of most of the movements of this century."

As a teenager in Berlin, he watched the wild *Spartakusbund*, which led to radical Communism and the founding of the German Communist Party. He was there when the Nazis came to power. In New York he stood by when de Kooning and his friends made their first alarming breakthroughs. In the 1950s, when Robert Rauschenberg and Cy Twombly went to Rome and both lived in a cheap pensione practically on top of the Colosseum, he was there. Walter rode the stone lions spouting water under the obelisk on Piazza del Popolo while the first Italian abstract painters met and made their deals in the Caffè Rosati nearby. He attended Rauschenberg's first solo show ever, in Rome. He studied the graffiti on the walls together with Cy Twombly. He sent me a little etching he had made of a Roman wall, complete with penises and *Viva La Madonna* marks. He lived with an American trade unionist in Barcelona, and later, when he was quite ill in Deià, Majorca, he was taken care of by an English flower child.

Pit and Walter were still a couple when they met their neighbor

de Kooning, who was a wonder and an illumination. They immediately knew they had to buy de Kooning's work, and scraping money together from their first jobs, they collected many of his early small paintings, done mostly in enamel. These were on the walls of 116 when I first laid eyes on the loft. Next to them the Auerbachs had hung toys, puppets, diabolo games, and the boxes for figs and Turkish delight, which they had collected in the Greek and southern Italian grocery stores on Eighth Avenue in the 1930s. The most arresting thing about these bits of popular art was their color. The tart Eastern colors on the white of the boxes and toys were close to Bill's paintings. Clear lemon yellow was next to ship's cerulean; red-persimmon, pomegranate, rose, or flesh pink were next to night-sky ultramarine. There were apple greens and butter yellows. It also reminded you of the candy-stripe barber poles and other Pop Art objects of the neighborhood, like the shiny iron jockeys in front of Cavanagh's steak house on Twenty-Third Street.

Most of all, it was the tangy taste of Mediterranean color that cut into your senses, to stay there forever. I found it again in the cube houses and wayside shrines in the fishing villages of Puglia, in southern Italy, and in Greece. I found it again on the painted models of Greek temples in museums. The temples had never been white but were painted in the most outrageous contrasts of red, black, blues, and yellows. I found it again in Siena on the panels of the medieval painters, and I embraced it there as if meeting old friends.

Later, newer paintings of Bill's, which Rudy collected, were hung up. And of course my own and Rudy's were added.

A big portrait that Bill painted of Rudy, with his photographic equipment but with his face left unfinished, had been temporarily lent to Martin Craig and was in his loft above Twenty-Third Street. One night, when we had dinner at the Craigs', it came to me that it was time for Bill's portrait of Rudy to come back to our loft. Rudy did not care one way or another—those paintings had no special value then—and he thought that since Craig enjoyed the painting, why not let him

keep it for a while. But I must have convinced him to the contrary, for I have a vivid picture of Rudy and me being stared at while crossing the traffic at Twenty-Third and Seventh Avenue, carrying a big, bare pinkish canvas through the hot summer night. (See *Rudy Burckhardt*, by Willem de Kooning, figure 2 in the color insert.)

On cold winter nights, people always ended up in our loft at 116 West Twenty-First. We would pick up vegetable crates and other wood, abundant in the Chelsea streets at the time, to take upstairs. There we jumped on them until they split and splintered with tearing noises, much to the annoyance of the Byer family upstairs. Then I would take the plaster foot by the sculptor Ibram Lassaw out of the fireplace. The white thing in the sooty, dark recess had scared Jean Arp when he came to visit. He said it reminded him of the Huguenots hiding in fireplaces to escape slaughter on Saint Bartholomew's Night. Then the fire was started, and drink and talk went on until dawn. Voices droned on, the fire crackled, the iron factory shutters banged in the wind. I sat in the corner, listening and dreaming. Elaine lay stretched on the couch in a beautiful harlequin skirt made of lozenges of orange, pink, and black velvet. She lounged, prettily enunciating, asking the men wide-awake questions.

There was a Mondrian show at the Museum of Modern Art in 1945 which had shaken us all up. When I was in Florence as a teenager, the Renaissance painters in the Uffizi had awed me to such a degree that I felt hopeless: after such perfection, how could there be anything else? How could I ever dare to paint? Mondrian had the same effect. Everything was so honed down to essentials, so perfect in balance and light and paint, it was difficult to imagine going on from there. We all discussed the show endlessly. Elaine made many bright remarks, and Edwin encouraged her to write them down and offered to help her get them published. She brought her manuscripts to the Automat when we all met. They were in bits and pieces, long, sometimes so collaged together as to be illegible, sometimes rambling, and some of her assertions seemed too far-fetched to me. But Edwin was pleased. He helped

her rewrite and edit. Both of them spent hours poring over papers for other articles for the *New York Herald Tribune* and then for *ARTnews*.

Helen DeMott, Lucia Vernarelli, and I were best friends, and we looked at everyone else, especially other women painters, with a raised brow. All these men thought Elaine was so bright. She was attractive in a way we could never hope to be, and she made flashy remarks with such conviction. But slowly we became friends.

Helen and other people from the Pyramid Group we belonged to, which provided exhibition opportunities for artists, often got together at 116 to spend long afternoons posing for and drawing one another, which was much more fun than drawing anonymous art school nudes, models we did not know well and unnaturally bare bodies.

We roasted marshmallows in the fire to go with our coffee and

Helen DeMott (left) and Lucia Vernarelli, who with Edith were the original "Chelsea Girls." Photograph by Rudy Burckhardt, circa 1950

played parlor games. One was to guess a personality, present or not, by asking certain leading questions. When Elaine was the secret subject and someone wanted to know what kind of book this person might read, she could not help crying out, "Any kind of book. I devour any kind of book that comes along, I eat it up." I also swallowed every half-decent book in Western literature, anything. For the first time, Elaine seemed endearing.

The kitchen at 116 was hidden by a curtain of mattress ticking and some shelving Rudy had built. So we used it as a stage, stepping out from behind the curtain. We had poetry readings, our own or that of others. We had concerts, doing improvisations with pots and pans and anything else at hand. We acted charades. We grouped ourselves or took poses from paintings by famous masters, which the others had to guess. Once, Elaine stepped out wearing a beret squished into the shape of a Phrygian cap, a broom held high in one hand, leading Rudy by the other. She was Marianne in the painting by Delacroix, the spirit of the French Revolution leading the French to liberty.

After our drawing sessions we would bring work for the others to see, in order to be criticized and encouraged by our peers. When Elaine and Bill were more comfortably off, she encouraged me in the best way anyone could: she bought a painting. The tide had turned—Elaine was nice, Elaine was generous.

At 116 there was good food occasionally, but we had mostly talking parties. Some "beatniks" came to dinner and stayed for weeks. Other people spent the night or were there for the summer while we were in Maine or Europe. Some of the people passing through were famous already, for instance Jean Arp. And once Joan Miró came, looking for a loft in which to execute a mural commission. Without a word, in a few brisk, even strides, he paced the loft from one end to the other to take its measure. Then he shook his head—it was not long enough. Noticing purring Graykin, our cat, on her chair, he gave her a long

look and finally opened his mouth. *"Quel beau chat,"* he said, then
rapidly shook hands and left.

Sometimes people came to have their paintings photographed by
Rudy, sometimes he shot his films here. At the parties, some people
were my own old friends, some were Rudy's, but most often they were
both of ours; and later, quite a few of these got "married, rich, or fa-
mous," as Rudy put it. Jane Bowles was at one of these parties. She had
already written *Two Serious Ladies*, a beautiful, haunting, and eerie
novel of the 1940s. The small, dark lady, wearing fluffy mittens, sud-
denly sat up and raised her head like a plump garden snake.

"Wait a minute," she hissed, looking around with bright eyes.
"Everybody be quiet. Let me think. I have a strange feeling about all
of you here." She looked at us, twenty-odd people, friends of ours or of
each other, heterosexual or not.

"I know that everyone here has slept at one time or other with
someone or another in this loft." We stared at one another, old lovers,
new husbands, this one having lived with that, secretly or not, sum-
mer or winter, in rain or shine—Bill, Elaine, Edwin, Fairfield, Anne
and Anne, Jean, Ruth, Pit, Larry, Milton, Alex, Tess, Walter, Paul,
Fritz, Nell, Ilse, Marisol, Bob, Jimmy, Jane, Joe, Rudy, and me.

It was uncanny. It was true.

EDWIN'S REALM

Edwin Denby was one of the pioneers of loft life. After I had known
Rudy for some time and I had spent nights in his small loft on West
Twenty-Third Street and he had been to mine, he took me to a loft
across the street, a few houses down from 116, at 145 West Twenty-
First Street.

It was a long, white, softly shining place in which lived a slim, el-
egant man. An unfinished painting of Rudy's stood on an easel near

the front windows, and he also had a darkroom there, but I had no idea that Rudy had lived there. When he walked me back to 116, I asked him innocently, "Do you like this Edwin?"

He drew himself up and, raising his voice a little, said, "I should say I do. He's my best friend." Oops! I thought, and shut up.

When Edwin dropped out of Harvard in December 1920, together with his friends John Becker and Frank Safford, he went to Vienna, where he saw Freud. Then he became a dancer in Berlin during the death throes of the Weimar Republic. When he left Berlin, he went to Basel, Switzerland, to visit a fellow dancer. Needing a passport photograph for his return to America, he had it taken by Rudy, the son of an old Basel family, who had just begun to practice photography after dropping out of medical school in Geneva. The two of them went to Paris together. Rudy took photographs of the rooftops, and they had champagne for breakfast. When Rudy's father died suddenly and he came into an inheritance, he crossed the ocean first-class, cabin trunk and all, and went to join Edwin in New York.

There they set up loft life at 145 West Twenty-First Street, becoming friends with all the most interesting and lively people in the late 1930s: actors from the Mercury Theatre, dancers, writers, and composers. Rudy made his first movies using friends from their circle as actors, all still young and unknown. And he began to paint New York City.

Rudy's family sent Swiss embassy people to check out the loft life of the two bachelors, and so word reached Basel that the offspring of one of its finest families lived in squalor among the bohemians of Greenwich Village. Early one afternoon, just after Rudy and Edwin had gotten up, Kurt Weill, Lotte Lenya, and some other German movie and theater people descended on them. *"Wie wunderbar. Die Unterhosen auf dem Bett!"* They were delighted. The underpants on the unmade bed reminded them deliciously of their own carefree past, before they arrived in Hollywood.

Edwin Denby and Cläre Eckstein in Eckstein's *Ein Höherer Beamter*. Photograph
by Hans Robertson, Berlin, 1930

Rudy then went to Haiti and lived there for a year with a young
Haitian woman, Germaine. He had adventures in Harlem and began
to like women all too well. Though women were no longer oppres-
sive presences, as they had seemed to him in the past, he took care to
choose girls who came from different backgrounds from his, so that it
was always he who could take care of them. He had three sisters and
was raised in a household of women (with a mild father and a little
brother), and overwhelmed by women while growing up, he took a bit
of a distance from the opposite sex.

Like many other European adolescents, he had allowed himself to be introduced to sexual life by his own gender because it was less scary and abrupt, but Edwin was not his first lover. He told me that one day he discovered that "girls are like kittens, they are cuddlier, softer, and sweeter." Edwin stepped back. He loved Rudy and wanted him to do what he liked best. Edwin handled it with grace, and in the end, he liked people who had ordinary drives. Rudy began living on his own on Twenty-Third Street, and then with me at 116 West Twenty-First Street, but he kept his darkroom in Edwin's loft until years after Edwin died.

The bottom loft at 145 West Twenty-First Street was occupied by a roofing company. Their signboard, proudly declaring "Atlas Protexit—Between the World and the Weather," greeted you on entering. I found this such a bracing phrase that I later used it as a title for an abstract painting. Then you started to climb up those stairs. Oh, those stairs, black and rickety and creaking and tilting to starboard. After you climbed all five flights of crooked steps, holding on to the old banisters, you lost any sense of balance, as if you were on board a ship. This tilt kept increasing over the years, but nobody ever did anything about it. Every time I came back from Europe and climbed up, it occurred to me that sometimes the New World seemed older than the Old World.

At the top, on the fifth floor, you finally arrived at Edwin's door. On the landing were bits of disassembled furniture, among them a mahogany table from Haiti, which I took later and put in 116, and some mops, and the usual fire bucket. The wall next to the door was full of graffiti and messages left by friends who had come and knocked and found Edwin not at home. There was a drawing of a little Martian, or a fairy-tale king in a ballet skirt like a flying saucer, with feathery feelers on its head, which in all probability had been left by the California Surrealist Clifford Wright. When I visited the last time, in the early 1980s, I was cheered to see the little manikin and all those numbers and messages still there, little bits of our own history.

Once you were inside the loft, the first things that struck you were the space and the mild great light that filled it from front to back. Facing the street and the south was a wall of windows covered with drawn white shades. The filtered sunlight ran over the gray paint of the floor and made it shiny. In the back was a small kitchen space and a clothes closet that separated it from the shower and toilet room. There was the fire escape window and immediately next to it Rudy's darkroom. Near the entrance door was a skylight. There was little furniture. In the

The graffiti in Edwin Denby's hallway. Photograph by Jacob Burckhardt, circa 1975

front, a double bed covered with a paisley throw; a couch to the side, not far from the gray space heater with its black stovepipe leading to the roof. There was no central heating in this loft. The large, long table with legs made of metal piping had been built by Bill, and a canvas director's chair and some solid wooden office chairs stood around it. The papers and books and the typewriter on it were removed when people came for dinner or for drinks.

Against the west wall stood a tall, narrow bookcase with rows of works by Greek and Roman historians, playwrights, and poets, Thucydides, Aeschylus, Homer of course, Ovid, and Virgil. There were many volumes of Defoe, Proust, and Gertrude Stein; a great deal of poetry from throughout the ages; and some ballet and music reviews. Apart from a Jane Bowles novel, I don't think I saw many other novels or contemporary English writing.

Then there were all the plays of Eugène Labiche, the French writer who so good-naturedly poked fun at small ambitions and household sins. Rudy loved him, and when I first met him, he was seldom without a volume of Labiche, a finger between the pages. His *Un Chapeau de paille d'Italie* (*An Italian Straw Hat*) had been translated by Edwin into English and produced by the Federal Theatre Project as *Horse Eats Hat*, with Orson Welles and Joseph Cotten in the leads. Around that time Edwin also wrote the libretto for Aaron Copland's *The Second Hurricane*, an opera for high school students. The bookcase was tidy and to the point. There were a few Mexican toys on some of the shelves. Over the years, nothing much had been added to it, and it was plain that the volumes were in constant use.

In the big, half-empty space, the few paintings came into their own. They were unusually large for those times, two big ones by Bill and one large one by Gregorio Valdes. Some small de Kooning and Valdes paintings were scattered around, Arab prayer posters from Morocco and postcards, which Rudy always tacked up with four pins.

Bill's large abstraction was in dark yellows and manila pink, with

white shapes turned inside out, billowing up in some sort of floaty balance. The less abstract painting was of a lady in yellows and pinks against sap green, big-breasted, with sloping shoulders and big, starry eyes looking skyward, as in an Annunciation. Some small early panels of bemused men emerging from silver gray ground, resembling both Bill and Edwin, were casually dispersed. Indeed, these little panels were so carelessly leaning against books and shelves—so little did anyone think of the value of paintings then—that when Jane Freilicher was staying at the loft, a friend of hers put an iron down on one of the paintings that had been left accidentally on the ironing board. It left a burn mark, which had to be restored.

The large Valdes painting was a tour de force. Edwin had befriended Valdes, the Cuban primitive painter, in Key West. The portrait was of a young woman, copied and enlarged from a Japanese postcard. Half dressed, she had a dainty, heart-shaped face and delicately stilted hands. In the greenish painting there was a great deal of detail, lovingly described, shawls, slippers, fan and all. Valdes had also painted the touching little scene of three white men in white linen suits standing under three palm trees in front of a white house. The men were the three friends, John Becker, Frank Safford, and Edwin, who had dropped out of Harvard together. The painting was framed by Valdes himself with a strip painted blue. A strip painted red framed his portrait of Marieli the cat, the plump, demure creature who ruled the loft. The real Marieli, on her shelf near the phone, paws folded under and blinking, would watch Edwin talking for hours.

Near the kitchen in the back was Rudy's darkroom, a place apart, his own indispensable space in Edwin's bosom that he always came back to. It was his domain in the white loft. The sliding door, with its nasty, grating sound, revealed Rudy in his intimate realm, absorbed in shifting peculiar liquids in pans and handling mysterious bottles and mechanical equipment. The darkroom had its own unforgettable smell of chemicals. It was not only festooned with negatives and films dangling from clotheslines, but decorated with art nudes and girlie

John Becker, Edwin Denby, and Frank Safford (left to right) in Key West, painted to order by Gregorio Valdes, early 1940s

pictures. There was something sexy about this private place, exciting but also extremely excluding. I have always been very jealous of the work spaces of the men I lived with.

In the daytime, the street noises filtered by the white shades, the usual New York traffic hum blended with the faint purr of the space heater and the tapping of the typewriter. In those pre-television days, there was neither a radio nor a record player. At night the voices of the taxi drivers echoed from their central garage across the street. They drove in and out, changing shifts, and bits of their conversation and cussing drifted up in intermittent shreds, sometimes mixed with the giggle of a street girl or the argument of a drunk. In the late 1950s, Puerto Rican voices and their radio music from the nearby rooming houses were added to the fabric of Twenty-First Street night sounds.

Edwin took us all to the ballet and after the ballet to parties. Trying to teach us the social graces, he declared that from every cocktail party

you were supposed to come away with at least two new phone num-
bers: one for business and one for bed.

Many after-ballet parties took place at Oliver Smith's, who did a
lot of theater sets. He had a crowded little apartment on Eleventh or
Twelfth Street between Fifth and Sixth Avenues, with the most extrava-
gantly overstuffed and tasseled Victorian furniture. George Balanchine
and some of his dancers, John Cage and Merce Cunningham, Paul and
Jane Bowles, and other writers and composers were there, but Bill and
Elaine and Rudy and I were the only painters. The four of us always
stayed to the end. "Well," Bill sighed, "it's always the most unimportant
people who are the last to leave."

Edwin had become the dance critic for the *New York Herald Tri-
bune* when its regular critic, Walter Terry, went to fight in World War II.
Edwin wrote mostly on Balanchine, whom he adored, and became the
best dance critic of any kind. His prose was limpid and fluid, as easily
read as if it had been spoken, though in fact it had been built with
care and adamantine discipline. It was prose that was poetry just like
Gertrude Stein's, who had greatly influenced him. With his ear for
everyday language, Edwin used it and chiseled it into something both
easy and illuminating without your noticing it. I have tried it in my
art reviews ever since.

Edwin's poetry was another matter. When his *In Public, In Pri-
vate* came out (which he published with his own money, with illus-
trations by Bill and Rudy), there was little critical response. One
critic wrote that Edwin was like a sculpin (a very prickly fish,
which was a word we had to look up). At the time the poems
seemed staccato, even labored compared with the freshness of the
ballet reviews. But time has taken care of that, sloughed off an-
gles, and now, with their insights and definite flavor, they too stand
out as the finely constructed pictures of an era. More than forty
years later, a Californian poet came to me in Rome to borrow my
copy of Edwin's *Collected Poems*. In her enthusiasm she underlined
long passages in my book with ink, but I didn't mind, as they

were my favorites too. And she said, "Edwin Denby is one of our finest poets."

Edwin's writing can give you only a pale idea of his spirited presence, it is only a rose pressed in an album. He squandered his amazing reasoning in the moment of immediate contact with his listeners, his friends. The sparkle of his mind was fugitive; it could no more be evoked with words than the quick, cool flash of his blue eyes could ever be caught by the camera. His voice was sibilant, gurgling; he spoke in a hesitant undertone because of his reserve and the need to think clearly. He was too self-conscious to read his poems well. He believed he was unsure of himself, but he wasn't. It was just that he could not bear to sound pompous. (See *Edwin Denby*, by Alex Katz, figure 3 in the color insert.)

Everyone came to Edwin's realm. Everyone ventured through these half-deserted streets and up those creaking, splintering stairs. There were George Balanchine and Tanaquil Le Clercq, Lincoln Kirstein, Jerry Robbins, Kurt Weill and Lotte Lenya, Arthur Gold and Robert Fizdale, Virgil Thomson and Maurice Grosser, Ned Rorem, Isamu Noguchi, the poets Kenneth Koch, John Ashbery, Frank O'Hara, and Jimmy Schuyler of course. There were Aaron Copland, John La Touche, Jane Bowles and Paul Bowles, Helen Carter and Elliott Carter, Larry Rivers, Jane Freilicher, Joe Hazan, and Alex Katz. There were Anne and Fairfield Porter and most often Elaine and Bill de Kooning, and lots of others.

Edwin sometimes received in bed, a purring cat under his hand. Sometimes he left his own dinner party to jump into a taxi to go up to Bloomingdale's to fetch a head of lettuce. But he bought most of his food from the Gudis brothers, who had a grimy Greek grocery store around the corner on Seventh Avenue. Or he would venture out after midnight to buy a delectable junk-food cake in one of the sleazy delicatessens near Twenty-Third Street, not dangerous then, which

were open to sordid customers all through the night. In the small hours, after the guests were gone, he would sit at Riker's or another greasy spoon with a cup of coffee to listen to the talk of bums or truck drivers. Sometimes he complained to Rudy, "I am really too tired to concentrate on falling asleep."

When he was among friends, Edwin sat by the table in his director's chair, dangling his knobby dancer's foot over the side, idly turning his hand. Eyes shining, blinking under his graying thatch, he listened, made jokes, threw out bewitching ideas and fiendish, bewildering proposals. He made everyone sit up, batting you down like a naughty kitten one minute, buoying you up the next.

His accent wasn't as ordinary and American as he wanted it to be, and though it was not upper-class English, it was still upper-class mid-Atlantic American. After all the years in New York, his New Yorkese still did not sound quite natural, but rather put on, and when he used slang words he had learned from the young and the people he liked to meet in diners and bars, they stood out as if in quotes. He liked to use Gertrude Steinish words, like "pleasant," like "agreeable." "Disagreeable" was quite bad. When he was depressed, he said he felt "gloomy," or said the weather was "gloomy." When, with a great smile, he said something was "a pleasure," he didn't mean superficial fun, but something quite enchanting.

Elliott Carter came to the loft around the time he had composed music for the ballet *The Minotaur*, for which Esteban Francés had made sets in vivid *Krazy Kat* landscape colors. Helen Carter gave cocktail parties for *le tout* New York and was the best hostess downtown. She had been a sculptor. "I stopped," she said, "because there was already too much stuff in the world." She once showed me a delicate bronze head she had made of her friend Marcel Duchamp. She told me that he had held a little mousetrap filled with mothballs close to her, but she had pushed away the offered gift and cried, "Take that out of here

before I sneeze!" Later she found out that the little assemblage became a Dada classic called *Why Not Sneeze Rose Sélavy?*

One day, asking us to a party on the phone, Helen said, "How are you?"

"Fine," I replied. "I'm working for *ARTnews*. I just wrote my first review." I was so proud.

"Oh," said Helen coldly, "how sad."

Her just and dry comments have often been quoted by John Cage in his writings. When other composers snubbed Cage in the early days, Elliott and Helen thought it a duty to sit through his concerts.

Portrait of Marcel Duchamp by Helen Carter, 1936

After a performance of Elliott's music in Vienna, when I told Helen that I thought it sometimes evoked Charles Ives, she said, "Please understand, we are not close to him." The comparison had been made once too often. Another time, when I was bubbling over about Maurice Ravel, she swept him away with "Well, we don't think so much of him, you know." When Elliott was asked in a television interview if he thought folk music should be an influence on modern music, he said, "We are not shepherds. We are not coming out of the hills. We are not folk."

In those days there were Elliott Carter concerts all over Europe but hardly any in his hometown, New York. If a performer chose to feature pieces of this eminent contemporary composer, the organizers of the program would always oblige her or him to insert them among, say, Monteverdi, Bach, Schubert, Brahms, Chopin. This usage was unfair. As Elliott said, "Imagine an art show in which you have Fra Angelico, Titian, Rembrandt, van Gogh, Picasso, or de Kooning hanging side by side. It's hardly possible."

In 1962 Elliott became composer in residence at the American Academy in Rome—the same year I arrived in Rome on my own with Jacob. Helen often came downtown to visit Jacob and me, to walk and shop together. After she had hung some of my paintings in their rooms at the Academy, she told me, "It's funny, you know, your pictures aren't for the mediocre. It's the extremes who like them—it's either the cleaning woman or Nabokov."

Dear Helen, she bought some of them, and she tried to make a lady out of me, getting me to have suits made to measure and making me go to a hairdresser. I was now divorced, and she introduced me to composers.

Sometimes when I visited New York from Rome, I stayed with the Carters in their apartment in a downtown building off Fifth Avenue that was supposed to have been built by Stanford White. Elliott's studio had a cool blue downtown view. Every day after breakfast he went there and shut the door. Helen guarded his composing time like a

Helen and Elliott Carter, Piacenza. Photograph by David Carter, 1962

lion. The TV set and the radio were permanently out of sight, no noise
came up from the street, and there was only the occasional purring
of the pigeons on the window ledges near the begonias, against the
wide vista of New York water towers. But from the studio small, short
spurts of piano sound came from time to time, drifting through the
rooms like fine shiny wires.

I can see Helen and Elliott side by side at Edwin's, like the figureheads of a ship, like Romans, our kind friends, Americans, facing forward, sailing out into a doubtful world. Elliott, the civilized American who had grown up abroad, felt he was an ambassador to bring American art to the world, traveling to his concerts everywhere and addressing an international public.

One of Rudy's many films featuring Edwin was *145 W. 21*, about the loft, of course. Paul Bowles the composer wrote the music for the film, a little like *Les cinq doigts* by Stravinsky, light and amusingly adequate. Bowles also composed the music for other films of Rudy's, but unfortunately, these recordings have been lost. Paul's music was played by Arthur Gold and Robert Fizdale at the exhilarating first concerts of new American music, along with other brand-new pieces by John Cage.

One day in Edwin's loft Paul declared, "I'm tired of not earning enough money composing music. I think I'll write. I think I'll write a bestseller." And he did. He wrote a novel about his and his wife's adventures in Morocco and called it *The Sheltering Sky*. It was a great success. But when he was holding forth about his troubles with editors and publishers, about his problems as an established writer, while Jane sat by silently, Edwin interrupted him coldly. "Oh come on Paul, come off it." And nodding toward Jane, he declared, "We all know who is the real writer in this family."

Jane was small, plump, dark, and she limped. She seemed so defenseless, she brought out tenderness in everybody. I thought she was marvelous. She was mysteriously lesbian and aloof. I had a crush on her. I had never had a crush on a woman. I loved the way she was sharp, shy, fiendishly observant, vulnerable, and bright. Once, when we all were about to leave a party and go to yet another in the Village, I heard Jane's plaintive voice, "Helvetia, Helvetia, where are you?" Helvetia, the fair symbol of Switzerland—whatever could she mean? She meant a tough middle-aged woman, her companion. Helvetia helped Jane down the

stairs and into her station wagon. I climbed in too and sat in the back with her. Jane was wearing a pair of fluffy mittens, and we held hands all the way downtown.

Of course I was also attracted by Jane's success. In our world she was already quite famous. Every piece of her writing—her short stories, her plays, her novel—had been published immediately. At parties she was sweet or snobbish, sometimes exceedingly friendly, sometimes cutting, sometimes utterly lost.

Who can ever forget the haunting scene of Pacifica on the beach in Panama, in *Two Serious Ladies*, that dark, bewitched novel. It is written in a deadpan register, talking about obscure people set against sophisticated ones, about places that are off-limits. At first reading, I thought it wildly hilarious, only later realizing its wild, strange undertow. It was a new *Alice in Wonderland* for grown-up Alices.

Much later, some of Jane's real-life adventures served Paul well for his own first book. But he had skimmed the cream off the top of his wife's writing, being more fluent, more on the surface, much more obviously perverse. His story was unusual, but his tone was not. The eerie, odd aura that made Jane's writing so extraordinary was utterly missing.

Paul and Jane had probably been a real couple when they were first married. Later, when I knew them, they had separate apartments in the same brownstone downtown, west of Fifth Avenue, one on top of the other. Jane said that they had long telephone conversations at night, telling each other all that had happened to them during the day. She would come down to Paul's parties when they were nearly over. "By that time there were only smeared glasses and dirty ashtrays around," she said, "and all that was left of all those glamorous people were the prints their bottoms had made on cushions and chairs."

While we lived in Italy in 1950 and Rudy went to Morocco with Edwin, the only address he gave me to reach him was Jane's in Tangier. He told me later that she lived in a white tower in the kasbah with an Arab woman. "She was called Jerifa. She had a very severe face, a little like Georgia O'Keeffe," he said, adding, "In the

morning she dressed in a voluminous djellaba and veiled her face in black like any other Arab woman, put a basket of grains on her head, and went to sell them at the market. In the afternoon she came home to Jane and dressed in men's shirts and men's pants and wore her hair straight back in a bun. She made mint tea and bossed Jane around."

When I sent several telegrams to Rudy, care of Jane's address, asking him to come home, Jane got impatient. "Edith is very pretty, isn't she. But she expects too much." I never thought of myself as pretty, and I didn't think it was too much to expect Rudy back.

My relationship with Edwin was never easy. It was as ambiguous as my relationship with Rudy, but in quite a different way. Edwin adored some women—Elaine, Minna Lederman, and of course Balanchine's star dancers—but did not like them in general. Sometimes he liked me—when his guard was down and I offered him also the chance to round someone out, which he could never resist. He involved me in conversations that dazzled me so much I couldn't understand them until later, if at all. He showed me new books, took me to the ballet of course, gave me scarves and slippers from L. L. Bean at Christmas, brought roses to my openings, introduced me to Diaghilev's perfume, Mitsouko. He made me understand the Tiepolos in Madrid and Venice, Caravaggio and the Romans in Rome. Some time later, to my surprise, he even respected my efforts as a painter. But in general he made me feel that under his aegis I wasn't supposed to take painting and writing seriously. He seemed to smile at all this, as if they were harmless hobbies. Mostly I had to be liked because I was Rudy's wife and the mother of Rudy's son, Jacob.

The best time we ever had together was when Rudy left for a trip to Mexico by himself shortly after I met him. Rudy always had a need to get away from relationships that became close. Edwin and I spent long

winter nights at 116, missing him. We sat in the yellow-painted nook by the fireplace, drinking hot milk laced with rum, and read Hölderlin together. Edwin told me about Gertrude Stein, he told me some of his thoughts and patiently listened to mine. He was attentive and as charming as only he could be. Neither of us said anything especially private, but there we were, just the two of us. Later that winter Edwin suddenly took off and followed Rudy to Mexico. Left behind, I became involved with an old friend again, and then with the life in Nell Blaine's loft next door on Twenty-First Street.

Later, Edwin was not sympathetic when Rudy had affairs with other women and I was desperate to talk to someone. This was delicate enough because he was Rudy's friend, but in any case he always shied away from the personal. But one night I could not stand it any longer, and I called him. "Edwin, what shall I do? What shall I do? I'm so upset. I can't sleep."

"Well," Edwin said crisply, "you have some books by Gertrude Stein, haven't you?"

"Why?" I choked.

"Well then, just sit," he said, "and read her. That'll be a comfort."

Of course it wasn't.

When Rudy and I went on trips and stayed in Europe, Edwin followed soon enough and joined us. And after a while he would whisk Rudy off on a side trip to Greece or Morocco while I was left behind with Jacob. This made me unhappy. Once, when we were about to leave for Spain, I made a stand and told Rudy that this time it had to be just us. Somehow Edwin sensed this. "I had a dream," he said, "that someone didn't like me. They wanted me to stay away."

When I met Edwin and Rudy, I still had a vague feeling that I ought to fight for social justice. Since all I really wanted to do was paint, I thought at least it ought to be the kind of painting that would "function" in society. Edwin cured me of that. He had witnessed the bankruptcy of ideas like this firsthand in Berlin. He had danced Expressionist dance

and written Expressionist plays. But after the socially conscious and Expressionist art, he had found Bill and Balanchine in America. One was about power, the other about grace. They both looked at the immediate and saw the virtue of using what was at hand.

At the Art Students League there was a so-called still-life closet, full of dusty vases, compotes, Chianti bottles, candles, mandolins, and lots of drapes. When we pulled out some of these objects, I could do nothing with them, nothing had any character, they did not belong to anyone. Phooey to still-life painting, we said. But when I set up loft living at 116 in Chelsea and started gathering furniture from friends and from the streets, I also found or bought vessels I liked for their shape or use or mysterious past. I have always been acquisitive about small, incongruous objects, an assiduous collector of jugs, jars, china and earthenware, Maine seafarers' antiques, lobster pots in wonderful faded primary colors, curios, shells, bones, plants, and herbs. They were so nicely placed everywhere, together with our paintings, that people, especially children, often exclaimed in delight when they entered the loft. My eye took in the gleaming porcelain, holding fruit or flower, standing in rows on kitchen shelves or in corners, and I let them stare at me and then I took action. From then on, I could never have enough of still-life painting.

But what about their titles? Before Abstract Expressionism, when everyone was painting in their own studio, complete with easel and still life, the going titles were *Metamorphosis* or *In the Studio*. Though I thought this dull, I could think of nothing better. When I was in a group show for the first time and had no ready titles, I went to Edwin as a poet to suggest some. "It's easy," he said. "Take some perfectly ordinary detail in them, some perfectly ordinary time of day, and use that for a title." How funny, how illuminating. I had never thought of that. So we called a picture with some brushes in a jar *Three Brushes*, and another we called *Tuesday Morning*. And after I passed a whole-

sale store window on lower Fifth Avenue with the sign "China and Earthenware" over it, that became a title too. Edwin had taught me to use the near and not the far for poetry.

But it made me sad and sometimes even irritated me that though he could suddenly get excited about people's work in which I could see nothing extraordinary, he was never really interested in mine except as a nice, civilized activity to keep me busy. However he did take notice in 1972 when one of my first shows at the Green Mountain Gallery was a mild commercial and critical success. For a later show I sent him the invitation, on which was printed a watercolor tondo of a little bird sitting in the sunset. "Ah," he gurgled on the phone. "Something new. I see something new on the horizon." Something new? But he hadn't been interested in the old. It was said just to be nice, to be encouraging. For he believed in giving full comfort and solidarity to any working artist. As a family duty, he came to most of my openings and then animatedly discussed a picture with someone, sometimes pointing out an obscure detail I had never meant to stand out. This may sound petty and plodding, but that was the way he could sometimes make you feel.

Edwin had a special attentive way of sitting forward when listening to another person. I watched him in this pose in Nell Blaine's loft when her husband, Bob Bass, said something to him. I caught the older man and the younger man in a painting, the two torsos leaning toward each other with sympathy, heads close. This semiabstract oil, in whites, blues, and reds with black accents—a little Jean Hélion-like, as were all my paintings then—was in my first show, the one I had together with Cicely Aikman in Carl Ashby's frame-shop-cum-gallery on Cornelia Street. I hope Ilse Getz, who bought it, the second picture I ever sold, still has *Bob and Edwin*.

I had routinely applied for citizenship when I landed in America, and now, after five years, a New York court served me notice that my case was to be considered on a certain date. With this letter came a pamphlet

about the laws and the Constitution of the United States, with which every applicant was required to be familiar. I had to pass a test, and it was Edwin who coached me. For many long evenings we sat by the space heater, him asking me questions, me giving answers until I got everything straight. With his guileless new patriotism, he quite enjoyed trying to turn me into a proper citizen. Fairfield Porter and Denise Bell, one of my friends at the Art Students League, came to court with me as my witnesses. They were taken aside to swear that I had never committed moral turpitude nor had ever been a member of the Communist Party. Then I was asked questions. All my answers were correct, and I passed the test. Evidently Edwin had done a good job. I have been a citizen ever since.

In the early days, in a sleepy, self-involved way, I reacted against Edwin's will to guide, to take over, to shape others. But he did shape me. I owe more to his subtle influence than I was aware of then, but now I know it has stayed with me to this day. This is the best he gave me: look at the quotidian, look at the world around you, take what comes next, and celebrate it the best you can. Edwin had a profound influence on anyone who crossed his path, and I was no exception.

After I went to live in Rome, Edwin always felt duty bound to take me out to dinner when I came back to New York. Since I always came back for exhibitions, which were now less and less interesting to him, and going abroad for him was a thing of the past, those evenings were a bit daunting. One of the last times we were together, darling Jacob, now grown up, was a leavening presence. When we all met in front of a French restaurant in the Village, I was surprised by Edwin's outfit. He sported a plaid cap, a limp, old-fashioned raincoat, and clumsy Hush Puppies or big sneakers. It was downright hickey. Later I noticed that Rudy too cultivated this dated look. As usual, with their predilection for square, Depression-style gear and Americana, they were the forerunners of a fashion—the later retro look. But Edwin's disguise fooled no one, least of all the French waiter in the restaurant who served him in the way a gentleman with the manners and accents of a Jamesian

traveler deserved. With good humor and lively remarks, Edwin entertained us all through the meal. He loved the gushy, creamy dessert best, just as, when invited out to dinner, he always brought the most creamy cake he could find for his hosts.

The last time I saw Edwin was in 1983, on a very rainy Sunday, in Carnegie Hall, when Charles Rosen played some of Elliott Carter's music in a piano concert. We were all dressed up for the occasion, but Edwin wore a scruffy sport jacket and jogging shoes.

"Oh my, Edwin," cried Elliott when we all came up to him at the end. "Did you come jogging here all the way from Chelsea?"

This did not amuse Rudy. But Edwin, his shock of silver hair standing out boyishly over his marvelous eyes and jagged profile, made elegant murmurs and shuffled his feet. He made a few curving gestures. His body, a dancer's body, was loose and unusually expressive. Alert with nervous energy, gangly, grand, he stood over us, a luminous presence. But the moment he liked being with us was over. He wanted to leave. He probably took the subway "for a nickel extending peculiar space" (to quote from one of Edwin's poems). He probably stopped for a coffee in a greasy spoon and exchanged a few words about the state of the weather and the city with an anonymous fellow New Yorker. And then he went home to his loft, "sloping and white," to talk to his cat.

AN AVALANCHE OF PAINT

BILL MAKES A CHOICE

When I was living alone in the loft, I often went to eat in the Horn and Hardart Automat, on Twenty-Third Street next to the Hotel Chelsea. I would often meet Rudy there, as he loved to observe the old ladies who would sit for hours nursing a single cup of coffee. At that time the New York City transit system ran an advertising campaign, choosing a "Miss Subways" each month from the pretty secretaries and newcomers to New York. Her smiling photograph and a brief biography were put in all the trains. Rudy chose a "Miss Automat" each month. He bought snacks for the old lady with the flowery hat and sneakers he had chosen secretly, who had to make do with a Social Security pittance. Sometimes the old people put sandwiches in their bags for others. The Automat, with cheap, nourishing food and its slogan "Less Work for Mother," was a home away from home for us loft dwellers as well.

Because Elaine refused to cook, she and Bill always ate at the Automat. One day I saw the two of them alone together there. It was the first time Elaine talked to me. Now she was not the rich patron from uptown, but just Elaine, née Fried, from Brooklyn, the former art student eating her meat and potatoes.

She was a picture of the 1940s. Her bangs were rolled in, as was her shoulder-length pageboy bob, like a movie star's. Her wavy reddish

hair was held back by large white plastic daisies on bobby pins on each side of her face. Under finely arched brows her eyes were attentive and a little prominent. Her full, pretty mouth, always at play, was carefully outlined in lipstick red. She wore a clinging turtleneck sweater, and her waist was held tightly by a wide cinch belt over a ballerina skirt. This tightness and neatness was the style of the times, but not common with art world women. The purple of the high-heeled, all-encasing suede shoes against blue stockings was unusual. She was downtown smart, or street chic as it is called now. And she had poise.

Rudy and Elaine thought this could be put to use. His inheritance had run out, and he was trying his skill as a fashion photographer. But to get a job he needed to show samples and so, naively, he and Elaine went to Klein's on Union Square and bought a batch of fancy dresses. Hiding the price tags in their folds, she posed, nostrils and skirts flaring. Then both of them took the dresses, price tags intact, back to Klein's and got their money back. But there was something not quite right about the photographs. Whether Elaine's haughtiness was too mocking or Rudy had not thought of airbrushing the wrinkles, he never got the job. The strength of Rudy's style has always been its truth. But if these photos still exist, they are a record of Elaine's sharp New York bearing.

Her talk was smart and refined too. She had a way of enunciating carefully with a pronunciation quite her own, which didn't quite cover the Brooklyn accent under it. No one else had that special way of saying "Oartist" or "World of Oart"—meaning the New York world of art, the only one that existed for Elaine—which still echoes in my ears. She spoke with a bright, "cultured," knowledgeable air, which fooled the men who adored her, but not other women. Though I had left school at sixteen, I humorlessly prided myself on my civilized European background. Bill made no bones about being self-taught, but Elaine, who had only gone through high school before a few years of art school, put on such highfalutin intellectual airs that it irritated me. I didn't appreciate her lively mind then.

Only when Bill spoke did Elaine fall silent. She listened demurely. In the Automat that day, their heads were turned toward each other. I see it still. Has there ever been a wife who was never once bored with her husband? She had a wonderful trust and respect that she maintained forever. Her Sylvia Plath hourglass silhouette was conventional, and I thought their marriage was conventional too. Why couldn't they just live together like the rest of us artists did?

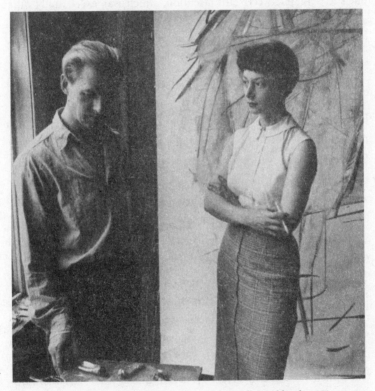

Bill and Elaine de Kooning. Photograph by Rudy Burckhardt, 1950

Rudy told me that Bill had said to him, "When you have a girlfriend, it takes up too much time. You have to talk to her, you have to take her home in the subway—and then you have to ride home yourself—two

hours there, two hours back. Talking at least six hours (lovemaking was implied) and then you paint sixteen hours. So when do you sleep?" But it was not quite like that. Bill was the son of plain Dutch working-class people, Elaine the daughter of honest American immigrants, and both were brought up to do the right thing. Nor did either of them ever want a divorce, despite everything.

In those early days they were devoted to each other. They listened to each other all the time. Elaine remained devoted to Bill all her life, but she demanded constant attention, which was exceedingly difficult for him. Bill in his own particular way also remained devoted: he quoted Elaine's opinions long after they ceased to live with each other, and Elaine quoted his, always.

How much was his in what he said? Wasn't it Elaine who found the poetry in his words? Said raw, they could be puzzling—was it just lack of background, wily playing dumb, or a genuine directness? I was never sure, nor was I supposed to be. But Elaine knew best. Wasn't it Elaine who wrote down all Bill's remarks, and the famous lecture at the Modern in which he defined space as what was between his arms when he spread them lying stretched out? And those great titles of the paintings, didn't they think them up together?

Elaine and Bill were desperately poor in those days because Bill had made a choice. He had been a wonderfully exacting craftsman. The cubicle or inner room of their loft and the famous shower stand at 116 were made with painstaking skill. The pieces were perfectly fitted, the paint put on—layer after layer—and smoothed down to a silken finish. He never took on anything he could not carefully bring to an end and be paid for.

Frank Safford, Edwin's Harvard friend, and his wife, Sylvia, commissioned Bill to do easy chairs for their beach house in Wading River. They were beautifully original, with curving white armrests, like elephant tusks, and surfaces in purple and yellow, in a style postmodern before its time, which Bill had invented. Bill was always a perfectionist. Besides

doing odd jobs as a carpenter, he also did posters and an ad in a glossy magazine for a brand-name gasoline, of faceted windmills in bright greens, oranges, and pinks, which I kept for a long time. Somehow he and Elaine managed to get along on this. Then one day he was asked to do some window displays for a fancy department store. When he finished, they offered him window designing as a steady job, something to the tune of $100 or $150 a week, a tremendous sum then. He and Elaine could have lived off this royally. But he thought about it. "As a window decorator, I would do a good job," he said, "but then how could I do a good job as a painter at the same time?" It was one or the other. He had made a choice. He was a painter, and he would get by. He chose to do painting and did nothing else.

Not everybody was able to make that kind of decision. They painted and had a job on the side too, always an art-related job. Rudy took photographs for galleries, Elaine and I did art reviews. Some people made frames, others transported paintings from loft to gallery and back. In the end, almost everyone became a teacher, which was not always good for them. When someone chose weighty words, pontificated, and took himself too seriously, you knew at once he had become a teacher. Norman Rockwell's son Peter once told me that Norman would not teach, because, as he said, "You give away your secrets."

Just once there was a teaching job Bill was happy to accept. "Guess what," he said excitedly to Elaine when he came home one day. "I got a job teaching. I got a job teaching at jail!"

"That's nice," she said soothingly, and went on painting.

"But aren't you excited?" cried Bill. "It's a job at jail!" She was still not excited. Then he explained it to her carefully—a friend had arranged for him to give a lecture at "Jail University." Afterward he told us about his only teaching experience, at Yale University. "So I stood there and told them about everything, everything I knew and thought about art. I talked and talked to them very sincerely, I went on and on. Then I noticed how quiet they were. I suddenly looked at them. All of

them, they didn't look at me—every one of them was staring out the window. They looked up at the sky with nothing in their eyes, like saints in a Renaissance picture. This politeness, this lack of interest, this total daze . . . it was fantastic."

Another way of getting by was to receive a grant handed out by a benevolent foundation. It gave you prestige but usually only helped out for one year—a one-shot event, not often bestowed on people who deserved and needed them. Those with some kind of academic standing were always preferred. Many great artists never got them. Arnold Schoenberg, for instance, old and struggling in California, never got a Guggenheim. John Cage got one after his twelfth try. And after receiving a grant, many grantees were never heard of again.

It is amazing that a painter like Bill never received a Guggenheim Fellowship. He applied for it once because Buckminster Fuller, who had been told they were looking for avant-garde artists, had brought up his name and told Bill that this was his chance. Bill hated to fill out the forms, but most of all, as he put it, "I hate having to bother decent people. I don't like to waste their time writing those recommendations."

When I wanted to apply for a Guggenheim, I thought of asking Bill, already very famous, to be one of my sponsors. As I didn't have his address, I wrote to Elaine, explaining why. She sent it back with a curt note: "Bill and I never got a Guggenheim so why you. But if you want to fill in all those dreary forms, go right ahead."

But whether you lived off your work or not, "What is necessary is a little recognition," said Elaine, "even a little keeps you going." This came up in regard to the painter Earl Kerkam, who secretly elaborated a Cubism all his own. Embittered by lack of interest in his work, he became a recluse. When he was finally taken up by Tom Hess of ARTnews—because Elaine suggested it—it was too late. Kerkam was arid, old, and ill.

"It's okay not to be pushy," Elaine said, "but a little bit of apprecia-

tion by your peers goes a long way. You have to have a few people see what you are doing once in a while, or else you shrivel up."

If you stuck to your work you had to make do with a loft, but if you stuck to a job you lost the art but had lots of comfort. The new commercial artists despised and envied their former pals.

Bill, long celebrated downtown and now celebrated uptown as well, once met a former painter at a party. The man was now a successful commercial illustrator. He had an easy but not very fulfilling life. That night he was drunk. Elaine saw how he suddenly advanced on Bill, a heavy brass candlestick in his hand.

"You bastard!" he yelled. "It's not just me who has sold out—you, with all your phony stuff! It's easy—you just go on slinging the paint." And he hit him. "Take that, you phony!"

Bill was sitting in an easy chair. He did not move. He sat there, still and silent, blood running down his face while the man went on hitting him. Finally people pulled the crazed attacker away. Elaine said Bill sat there with an utterly astonished face without moving, not believing such white-hot hate could be streaming out at him.

Very few people bought his paintings at first. There were Janice Biala and her husband, Daniel Brustlein, painters themselves. They bought his fine Ingres-like silverpoint drawings and some of the oils. Then there were the Auerbachs, Edwin, and Rudy. Marie Marchowsky, the dancer, gave him a commission for a backdrop, and John Becker showed paintings of Bill's once in a while in his gallery, the only one of modern art in Manhattan in the 1930s. Fairfield would occasionally buy paintings, and Bill just gave to his friends.

The few sales were never enough. Bill sometimes had to come over to our loft at 116 to borrow money for kerosene, or even for food. I didn't like it. Dr. Frank Safford's wife, Sylvia, didn't like it, and once said, "I'd like to see the de Koonings pay in cash once in a while, not always with paintings. After all, who does Bill think he is, Gauguin?" Little did she know.

When visiting Rudy in his studio, I saw Bill come in and unwrap a painting he had brought for Fairfield. It was about ten by twenty inches, in wonderful cadmiums and slashes of green, inhabited by strange, curvy cuttlefish shapes and enigmatic taut insets—half interior, half landscape. Bill laid the piece of paper—beautifully covered with paint—on the table. Fairfield laid his checkbook next to it. Then he bent down and wrote out a sum. It was something like $150. I was thrilled. I had never witnessed such a transaction. It was the first time I saw a real live sale of a real live painting.

Another painter told Peggy Guggenheim about Bill, and she invited him to be in a group show of new talent at her famous Art of This Century gallery on Fifty-Seventh Street. Bill went into a fever of work. To meet the deadline, Bill and Elaine carried the painting uptown when it was still wet. But when Bill got back downtown, he got into a state worrying about it. He was not satisfied with it, and just before the opening he went back, took it off the wall, and brought it home again to work on it some more. In those days it was as difficult for him to finish a painting as it was to start it.

Later, in 1948, Bill's friends convinced Charlie Egan, who had a tiny gallery on Fifty-Seventh Street, in which he slept, to give Bill his first one-man show. Charlie had an eye for what was then unusual. He had shown Yves Tanguy, Isamu Noguchi, and Joseph Cornell, who were not entirely unknown, but were relatively new to the few ordinary gallerygoers.

Bill's first solo show was a wonder to his friends, who kept going back and back again to the smallish intense paintings, now—away from the studio—on clear walls. But there were no buyers, and there were no reviews. In the end, Emily Genauer mentioned the show, perhaps in the *New York Post*. She complained that de Kooning painted "abstractions with brash colors."

"Someday you'll be in the Modern," we used to say to Bill encouragingly. "Oh yeah, you think so?" he asked, and cocked his head. We could not really imagine it, but he knew.

EDWIN AND BILL

Back when Rudy was living with Edwin a little black cat often came to visit from the loft next door. Loud music also came from next door, always the same record, over and over again. It was Stravinsky's *Petrouchka*. I would like to say it was *Le Sacre du Printemps*, which would have been more fitting, but it wasn't. In the end Rudy and Edwin could stand it no longer and, taking the little black cat with them, they found a painter in the loft next door, listening to the record. And what a painter. Bill de Kooning. They all became friends.

Edwin was deeply attracted and fascinated by Bill and all he said. Edwin would sit up nights like a big, gangly, elegant bird, looking out at all of us from bright blue eyes under bushy eyebrows, blinking, fluttering his eyelids flirtatiously, wickedly throwing out impossible conjectures.

The dropout from Harvard, born in the U.S. embassy in China, and the slum boy from Rotterdam were perfect foils for each other. Almost always Bill's sturdy common sense, expressed with poetic plainness, prevailed over Edwin's extravagance. Edwin liked to manipulate all common expected knowledge or facts: those that were black he made seem white, and those white he made seem black. Everything was quickly turned into the opposite of what it had been the moment before. As Fairfield's wife, Anne, said about his apparent contrariness, his not suffering the righteous, "Edwin will make you see the justice in injustice."

With a hypnotizing performance, a fast sequence of ideas to run after, Edwin could get at the kernel of someone's intelligence but could make others seem exceedingly obtuse. He could expose ponderous and pretentious declarations with cool venom and could subvert your ideas until they looked used and heavy. Listening to him, going along with him on a rush of illumination, would make you feel bright and alert and on the crest of understanding. But sometime afterward, after the elation of the moment was lost, you were left with nothing but the

dazzle in your hands. What had actually been concluded? All you re-membered were the fireworks. It was confusing and diminishing, but sometimes the fairness under the brilliance would filter through and grow with you.

The loves of Edwin's life were Rudy, de Kooning, and Balanchine, and later Robert Wilson, the theater director. The work of de Koon-ing and Balanchine may not have appeared to have much in common, and Balanchine's marvelous choreography may have seemed out of place and out of context in New York. I still thought that dancing with bound feet and classical gestures was wildly anachronistic. But after Edwin had taken us to some rehearsals and performances of the dance group at the Needle Trades High School on Twenty-Fourth Street— before the company became the New York City Ballet—the blindfold fell. I saw that beyond the old devices there was a striving for joy and clarity of movement, pure and fine beyond time. Balanchine's dancers made the air electric. Suddenly you were somewhere else but you were also in New York. He used streetwise American bodies to build com-positions made of movement. He had come from the Paris of Picasso, Gris, Dufy, Van Dongen, and Matisse; and the music of Debussy, Ravel, and Stravinsky had served him well. He merged all this with newly discovered American attitudes, weaving magic. Edwin put this into words with astonishing depth and seeming ease. But Balanchine did not like Edwin, despite his exquisite understanding, and adoringly, Edwin kept his distance.

Between Edwin and Bill on the other hand there was affection and friendship. Edwin watched Bill's power up close, was completely caught by his searing directness and clean energy of vision. This was more than enough to make him believe in Bill's painting, which, he confessed, he did not understand until later. Nor was he very inter-ested in the painting of other living people, except Rudy's, finding his most exalted art experiences in Tiepolo and the other Venetians and in Caravaggio. When he took up sponsoring the likes of Larry Rivers and Alex Katz, and later Red Grooms, it was not so much because he ad-

mired their work, but because he was fascinated by the way they acted, the way they managed their own personalities and careers. What was most exciting to him was the way people moved and behaved, how their movement inspired their intelligence, and vice versa. This comes out plainly in the title of one of his essay collections: *Dancers, Buildings and People in the Streets.*

He loved to teach, to mold the rough material of people, to widen their horizon and bring out their best. He tried to manage us all. As Helen DeMott put it, "Edwin is the prince regent." We were all princely children growing up, and Edwin felt he had to guide us, be our all-knowing agent, the prince who spoke for all of us.

Bill and Edwin got on so well because neither of them took anything for granted. Bill was blunt and direct. The proletarian through and through, sometimes he pretended to play the clown to the sophistication of his friend, the aristocratic heavy. All Bill's insights were those of someone who had lived life raw and unsheltered from the beginning. His mother had run a sailor's bar in Rotterdam, and when still a boy he worked as a housepainter, learning about fine arts only at night school. Coming to Hoboken as a stowaway, he worked as a menial for years. He had always lived by his wits, while Edwin came from a fancy family and fine schooling and had moved in the circles of European or American intellectuals. Edwin reveled in Bill's working-class innocence; he tickled it, picked at it, drew it into the limelight. He was the catalyst, and Bill, stimulated and egged on by Edwin, appeared as the more solid of the two. Sometimes Bill's statements were so basic they seemed downright simple. But it was just this rough and sound simplicity, touched with impish mischief, that charmed Edwin and all of us the most.

Edwin often used the word *forthright* in his writing about Bill. He admired Bill for his forthrightness, as if he himself were not. But under all of Edwin's joking and flibbertigibbet ways and perverse wit was a hard, ethical conviction. It was Edwin who was the moralist, while Bill was not. It may be that Edwin saw Bill's forthrightness as

something he could not achieve, a force that was channeled into one thing alone—his painting. It was the city itself that held Bill and Edwin in its thrall. How could you ever forget Edwin's beautiful sentence "I myself like the climate of New York." Bill, Edwin, and Rudy loved it because they came from somewhere else. Elaine didn't have to love it; she *was* New York.

Details come back to me. Bill made Edwin notice the sidewalks— with their cracks and squashed blobs of gum, trodden dog turds, shreds of newsprint, and children's chalk marks—under harsh midday sun or illuminated by the flicker of neon. Bill looked hard at everything the city life had printed on walls and walks. Edwin, whose mind and eyes had been in another sphere, was amazed by the skin of the city. For a painter, especially an abstract painter, this way of noticing was natural. When you've been in your studio all day trying to tackle shapes and marks and lines to put them in some kind of order of your own, when you go out into the streets, you go on seeing forms and lines and spots and blotches in everything, everywhere, underfoot, sideways, and above. You are obsessed with them. Bill also saw those things as something independent. They were his substance for painting what was in New York here and now, under the lurid colors of incidental city lighting and outside the colors of fine art. Bill taught Edwin, who loved observing the gesture and reasoning of every day, to look at the marks of every day. What he taught us all was to discover the writing on the wall.

There was a butcher shop on the corner of Sixth Avenue and Cornelia Street. I had passed it many times without noticing anything special. When we passed it with Bill one day, he stood still. There were the large plate glass shopwindows, covered with sheets of paper through which you could usually glimpse the dead pink meat inside. On each square were the hand-lettered names of the cuts available and their prices. There were big squares, little squares, all kinds of squares, all kinds of handwriting. The patient hand of nameless butchers had left

scribbles, curlicues, spidery letters, shy letters, awkward, unschooled lines, bold and round lines. The crawl of black letters on shreds of white made a grand patchwork. Bill studied it, and then we all did.

I had been blind to the look of the anonymous hand in daily life. I have looked out for it ever since, on walls, on trains, on trees, on ruins—in New York or in Europe—made with crayon, knife, spray paint, or shaving cream. I have watched lines made by human hand anywhere, the lines that are the beams of painting.

Bill said, "We are all primitives. I'm not." He was right. Art today looks out for a kind of un-skill. Fluent brushwork—like that of the Venetians, like the legerdemain of Goya, not to mention the Renaissance and the Gothic smoothness before it or even Matisse's marvelously awkward elegance—was not for us. We had trained ourselves to think not only that facility is of no consequence but that lack of skill should be cultivated, attracted as we were by the delicious gawkiness of Cy Twombly or Philip Guston. But Bill, like Picasso, was born with what the Italians call "a great hand." And he added to it with unashamed, unremitting workman's practice. Just look at the Os in his signature, how perfect they are. Modern Europeans saw in Jackson Pollock the noble savage, the true American. To them, de Kooning's masterliness was suspect because it is too close to home, to their own traditional upbringing. But if Bill's technique was fluent, he fought it too. To spite skill, you had to acquire it first. His vision aimed at total breakup, and like everyone else of our time he wanted to get back to basics. Anne Porter told me how he had once stopped short in front of one of her children's paintings. "Wow!" he cried. "And we have to sweat a lifetime to get back to that!"

He was impatient with the way art was appropriated (little did we know how mildly then). "The *ting*!" he exclaimed one night. "Everybody's got to have the *ting*."

Edwin leaned forward, his eyes bright. "The *ting*?"

"Yes, the *ting*," Bill said with irritation. "Everybody's got to have

one in their living room to show they are artistic. They take this piece of crummy old wood they found on the beach, some branch that the sea or weather has had in its teeth, and there it sits, the old *ting*, all bare on their coffee table. The *ting* from the sea is the *ting*." He shook his head. "And then the coffee table is a *ting*, too. It's kidney shape, it's Arp shape, like a sculpture by Arp. And they have even grabbed Mondrian." He was furious now. "They take a clean Mondrian and make a poster out of it to sell medicines. Everybody is taking art and making a *ting* out of it—furniture, book covers, pot holders. I am making paintings. I want to make paintings they can't use. I want to make paintings that are paintings."

Yet he was always tolerant of art quite different from his own, watching wide-eyed for any phenomenon. It was a lesson to me to see what kind of extraneous things caught his interest. He looked intensely at illustrations and advertising art, which we had been taught in art school not only to disregard but to despise, just the way certain modern composers despise jazz. He shocked us when he said he liked Norman Rockwell. (And when I told Norman Rockwell this years later, he smiled, saying, "I like de Kooning too.") To Bill, commercial art was something alive, something significant, something to learn from. He opened your eyes to any kind of mark in the outside world. In Bill and Edwin's reign there was no such thing as kitsch or good or bad taste. Everything had equal potential.

"Anyway it's all fake," Bill said.

"Yes?" Edwin batted his eyelashes demurely and inclined his head.

"Art is all fake," said Elaine.

"It's all fake because you have to make it," said Bill. "There's nothing there. You put on the paint. It goes this way, it goes that way, and then you think and then you work. The work goes any old way. There's the paint, it runs and spreads with your strokes and you dig into it and you make something out of it. It's what you thought about and what you know about and about what will happen or what should happen. You make something out of nothing, pretending it

was all there in the first place. You believe it, and when you believe it, pretty soon someone else will believe it too."

"Yes," Edwin agreed, "and *you* make it look right." The emphasis was on *you*.

Elaine nodded. This was ruthlessly open. You made something out of nothing because you had the will to do it, that was the wonder.

The most burning question was abstraction.

Bill often told the story about another Dutchman in Hoboken who had never had enough to eat as a child in Europe. Then, in America, when he earned a good living, every payday he bought sacks of stale bread that had been baked for immigrants from all kinds of countries. He broke and crumbled it into little pieces and spread it all over his living room floor. Then he walked on it and walked on it. "Now, wasn't that abstract?" Bill ended the story. And then he began again: "Now take this businessman, this so-called American capitalist. He jiggles figures in his head. I mean he pushes them around in his head. There's nothing you can grab hold of. If he lives well or not, that's the least of it. It's not about material value. It's about playing with the idea of it. He multiplies sums out of nothing. It's numbers in the air. That's abstract too."

When Bill declared, "Painting is a way of beating the system," Edwin asked, "How do you mean?"

"Well," said Bill, "you keep out of its way. Never mind the gallery, the museum, never mind finishing the picture."

I was properly scared now.

"Watch out," he continued. "When you get a job, they make you take out a Social Security card. Then they've got you. Once you got a Social Security number, they got your number." Bill did not even have immigration papers.

Having nothing, the painters were free to be as blazingly independent and anarchic as he was. There were no burghers to commission

them anymore; they were free to question the very fabric of life. Painting was about the inside of yourself and about the inside of painting.

Until recently they all had earned a pittance doing murals for the Roosevelt administration under the WPA (Works Progress Administration), doing frescoes for post offices and airports. These were literal, exhorting, falsely didactic, or pastoral, without a clear style, at most influenced by Picasso. It was the mood of the times. Post offices and airports in Fascist countries—and in Mexico in a more authentic style—were covered with the same large groups of gesturing people in which it was plain who was wicked and who followed the ideal. Everybody had been steeped in left-wing politics, but now things began to change. Arshile Gorky, who was lovingly quoted by everyone, had summed it up. When he was taken to see a new mural at the Needle Trades High School, he shook his head and sighed: "Poor art for poor people."

"Life, the moment it is made into art, is only art," said Bill.

When I was living in Cambridge, my boyfriend Heinz Langerhans had told me that "art must function in society," and I had earnestly studied political cartooning at the School of Practical Arts in Boston. On my very first visit to the Museum of Modern Art, I stood before the Siqueiros painting of the Mexican guerrillas on horseback, their big hats and cartridge belts in slashing zigzag rhythm. But Theo Fried, the Hungarian refugee painter from Paris who had taken me to the museum, pulled me away. He showed me the radiance of the breakfast table by Bonnard, all suffused in sun and dew. "If, in a year from now, you do not like this better than the Siqueiros," he said, "I'll have to give up on you as an artist!" He did not have to.

Bill and his friends felt that the concern for socially conscious issues had been fraudulent, that they had been seduced by false ideals. After his time in Berlin, Edwin turned to Balanchine and Gertrude Stein for depth; Fairfield turned to Vuillard and Bonnard. Bill and his companions plunged into sheer painting. A new independent movement—a great avalanche of paint—broke loose.

FAIRFIELD PORTER

When Heinz Langerhans, Leo Friedman, and I arrived for dinner at the Porter's one-family house on Fifty-Second Street off Third Avenue, Fairfield opened the basement door into the kitchen and led us to the dining room in the back. Being used to delicatessen food and snacks, we immediately fell to. Afterward we all went upstairs to the living room, and the men went on with the political conjectures they had begun at dinner.

Fairfield, who was the first artist I had ever met outside the Art Students League, was fiercely interested in what the two German political refugees had to say; Langerhans had been locked up in several concentration camps, and Friedman spent practically all his time studying *The New York Times*. Although Fairfield had not been as deeply involved as they in the left-wing movement or paid with personal hardship, he had one advantage over them: he had been to the Soviet Union in 1927, in time to do a drawing of Trotsky at a committee meeting before he was expelled from the Communist Party that same year.

Fairfield had grown up in a more than comfortable family in Chicago and gone to Harvard, but his intellectual curiosity, his ethics, and his quest for the solution of philosophical and political questions had led him to left-wing causes. In Chicago he was attracted by a small revolutionary group that called itself Council Communists, whose charismatic leader was Paul Mattick.

In 1942 they conjectured that an infernal weapon was being developed in Germany, a secret invention unimaginably devastating. But they also thought that Hitler, despite everything, would not have the nerve to use it, and that only the nation that would have the imagination to let it loose on the world would win the war. This terrible prophecy fascinated everyone in their circle, and of course Fairfield.

When the political talk marathon was on, I tuned out as usual, to start daydreaming on my own, and I began wandering around the

comfortable house. The bedrooms upstairs were furnished with four-poster beds, tall chests of drawers, some of them antique, all well made. The colors of the walls were unforgettable—painted either a cool milk blue or a raw bluey-pink, colors I had never seen on bedroom walls. These two colors and spriggy flowered wallpaper contrasted with the dark old solid furniture I was to find in all the Porter houses. In one room was the studio. Near Fairfield's palette stood a little pot filled with a fatty emulsion that looked like Vaseline, the Maroger medium, which gave the painting surface a glossy, fluid veneer. It had a special varnishy smell that pervaded the house.

Downstairs in the living room, where the men sat earnestly arguing, was a wide gray couch, deep armchairs, and a fireplace, all with the comfortable looseness of the other rooms. But on the wall hung honest-to-goodness real live paintings.

The one I liked the best, of a row of armed Mexican peasants with large bats and cartridge belts full of sickle-shaped repeats, seemed to "say something" to my socially conscious mind. It was by José Clemente Orozco. Another was a watercolor. Outlined within a jagged shape was a translucent sunset and sails riding an agitated sea, against chunky islands with trees like hairbrushes. Next to this John Marin was a mysterious long oil of a procession of starry-eyed ladies carrying odd vases. It was painted in the same pinks and blues of the walls of this house, but there were chinks of sour green and orange as well. The figures were unfinished, half wiped away, and everything looked vaguely ritualistic, a bit like a weathered Pompeiian mural. But the clash of colors and the ambiguity were completely modern. Later I found out that the puzzling little panel was a de Kooning.

The picture I liked least, dogmatic modern art student that I was, was plainly figurative. It showed a wide arm of land around a little inlet of the sea. In it, against a scatter of white houses on pastured land, swam black and white boats at anchor on pale water. In a row in the background black-green spruces were sticking their sharp tips into a blue evening sky. There was not a single person in the stillness, all as mute as

the scenes in the seafaring books of my childhood. There was something stiff about this oil, yet at the same time its truthfulness was moving.

This was an early version of one of Fairfield's most constant themes, the harbor of Great Spruce Head Island in Maine, a recurrent subject over the years, painted at high tide and low tide, on a bright summer morning or after an autumn storm, in rain or shine, ever more skillfully and succinctly, and in the end of serene simplicity. I saw this painting again many years later, after Fairfield's death, when Anne was going through some of his paintings in the attic of the house in Southampton. The picture, an early step toward all that was to come, still looked awkward, even harsh. But even then I understood its innocence and poetry.

Art student that I was, I was sure of my views. I didn't think much of this older painter's realism. But I admired his professionalism, his well-equipped studio in an empty bedroom upstairs. I was invited again to the house on Fifty-Second Street, but Anne was not around too much. When she was there, she was unobtrusive, though in some conversations she burst through her reticence and—sometimes with a few well-shaped words—came cuttingly to the point.

The only other "real" artist I met at the house was Georges van Houten, a middle-aged Belgian. When he came to dinner with his wife, the talk was not about war news or political theory, but about painting technique. He too used the Maroger medium, with that nice special smell—probably Fairfield learned to use it from him. Not only with van Houten then but with most other painters later, Fairfield was an attentive listener and intent on what he had to say himself. He was clear to the point of being abrupt and he had no use for conversational chitchat.

When he was bored or impatient with nonsense, he did not hide it. Sometimes, distracted by a trend of thought of his own, he seemed to sink into something deep inside himself, and an almost blind expression came over his face. Later, when I saw much of him and Anne together, it was wonderful to watch how funny and ironic he could

become, how phoniness and ugliness brought out just the right biting comment, how his wit would match hers.

Fairfield had known Rudy and me independently, when we did not know each other. Now that we did, he invited us both to visit the island his family owned in Maine.

"How do you get to Great Spruce Head Island?" I asked a fisherman on a street in Rockland, Maine. It was probably 1945, and Rudy and I had been hiking and hitchhiking up from New Hampshire.

The man took his pipe out of his mouth and looked me straight in the eye. "Lady," he said, "if you was Jesus Christ you'd walk straight out there," and with the stem of his pipe he pointed out to sea, to a spread of islands on the far horizon.

Following the relenting fisherman's advice, we took several buses and car rides all around Penobscot Bay, over hills with spectacular views, eventually crossing a great iron bridge to the Deer Isle peninsula. In a straight line from Rockland, as the gull flew, it would not have been too far. But on land it took the better part of the day, and when we got to the village of Sunset it was already late afternoon.

Sunset was a sleepy, empty place then, a handful of trim white houses standing around a church under tall elms near an inlet. A little weathered hut of a store was set apart in deep grass. It was green and dark inside, and there were cans on the shelves, a big yellow wheel of rat cheese under a cloth on the counter, and other perishables in a wire mesh cage. A leg of lamb could be seen through the window of an old-fashioned icebox. No one was there, but a kitten rubbed itself against my leg, making me homesick for the one I had left behind in New York. We rang the bell on the counter.

A young woman came in briskly. She wore jeans, at the time unusual for a countrywoman. Rudy and I bought the leg of lamb from her, a useful present to bring people on an island.

"How do you get to Great Spruce Head Island?" we asked once more.

Wordlessly the young woman wrapped up the meat, shut the till, and tidied up. Then she slung a large canvas bag over her shoulder and, striding out the back door of her store down into a meadow, called, "Follow me!" We followed, through grass up to our hips, right down to the shore, where our leader silently busied herself untying a boat and starting its motor. Once it was revved up, she said, "Jump in!"

The young woman was both storekeeper and mail carrier, and we were in the Sunset mail boat heading for Great Spruce Head Island, traversing the wide bay I later came to love so much, which was edged with rocky islands covered in spruce. We made for the farthest and largest. The water was black-blue and smooth at high tide, our motor the only noise, and when we made fast at the dock, the island was quieter still.

The mailwoman slung her big bag on the dock, helped us get out, said "There you are," and was in gear and away before we knew it.

We looked around. A few boats bobbed at anchor, a lobster buoy glinted, and there were some crabs eating each other under the boards of the dock. As the hum of the mail boat receded, we heard the plop and slap of a wavelet here and there, the squawk of a crow, and the faraway mewing of a fish hawk. But there were no human voices.

We called out, shyly at first, then again and again, and louder, but there was no reply. Then we found a well-worn path leading from the dock past low bushes to cut-grass fields on which stood a white-painted cottage or two and a barn. All were shut. After a rise strewn with slabs of rock and little clumps of sedum we came to a large two-story box of a house, the kind called a "summer cottage" by well-to-do New Englanders. Its unpainted shingles were weathered to silver.

When we called out, again there was no reply, and we heard only the sigh of the wind and the hum of insects. Near a side porch, tin cans on the ground and washing on a line were signs of recent habitation. We went around to the front, which faced the sea. Here there

was a large screened porch with a slab of a wooden table surrounded by wicker chairs. We went past this and into the house, the door slamming behind us.

We stood in an enormous, shadowy cavern. When our eyes got used to the gloom, we saw rafters above and balconies all around, leading to many upstairs rooms. In the hall below, tables, chairs, and settees were hung with afghans, and berrying baskets, books, and chessboards were scattered about. A frayed sneaker peeked out from under a chair.

There was a large fireplace. On its mantel stood a ship's model and on the brick wall above hung a plaster relief of a warrior on his horse, a copy of the Parthenon frieze. The burny smell of old fires, the mustiness of summer clothes left through the winter, a trace of the scent of painting medium hung over everything. Over us floated large silky Chinese lanterns and all around, under the upper balconies, ran a frieze of deep yellow gold over which long red dragons were uncurling.

The oozy summer untidiness below, as if stilled by an unseen wand, in contrast to the exotic decorations above, gave a half-ludicrous, half-sinister air to the scene. Why had all the people vanished? The silence and the gloom in the cavernous room grew steadily thicker. We were stranded where family life had been arrested; we were alone somewhere in the middle of the sea.

Working against the spell, bumbling around, we began to look for light switches, for food. Then we stopped. There were motor sounds, shouts, and a confusion of voices that grew louder and gradually came closer, and a bunch of sunburned children and grown-ups burst in, laden with shopping bags. Everyone was as surprised to see us as we had been to find no one. There were explanations: while we were traveling laboriously by land around the bay, unwittingly bypassing Camden Harbor, the whole Porter clan had crossed the water on a diagonal in their old remodeled lifeboat and spent the day in Camden for the weekly shopping.

A fog, gray and clammy, hung down for the rest of that first summer. "There was also a fog of small children," Edwin said later. There

were family disagreements, and I was bored because I was not paint-ing. When it was pouring rain, or when the wind was so strong it blew the salad leaves from the bowl across the table on the big porch where we ate, we could see only the nearby little shrub pines outlined in black. Sometimes a blank, horizonless sea appeared beyond, or brown mudflats at low tide. There were a few dark accents swimming on white as in a Japanese print. I could not see Maine, which I later came to cherish so much, at all that first summer.

The Porters called it simply "the Island." Fairfield's father, son of a wealthy family that owned the real estate where downtown Chicago was built, had bought the island in the 1920s. There was a farmhouse on it, but he had the huge "cottage" built, with its upstairs and down-stairs porches, its dozen guest rooms, and the cavernous hall with its dragons around the living center. Later, two of his sons and his daughter built smaller houses of their own. But Fairfield did not build, and anyhow he was more comfortable in the old house. He also left his parents' decor, appurtenances of another era, that of the hardy rich.

Fairfield's raggedy guests—strange cuckoos in a nest of regular birds, some at least "interesting" because we were refugees—were con-sidered loose-ended, eccentric, even selfish, by his brothers and sister, as was his refusal to build an island house of his own. That he painted without hope of selling, that he devoured philosophical books and talked about them vividly to anyone who would listen, was odd too. No one in an old, respectable American family, however rich, could take anyone seriously who did not earn his own money. Later, in his critical writings on art, Fairfield often explained why and how artists had never been accepted as an integral part of American society.

His first exhibition was in 1952, at the Tibor de Nagy Gallery, which had opened two years earlier in a long cold-water flat on the ground floor of a brownstone near the Third Avenue El. Tibor de Nagy and Johnny Myers had known Fairfield as a critic. As his loyal friends, I think most of us, including Bill, tried to believe in this show, but it was not easy. It was not so much that it was figurative when most

work in those years was abstract, but much of it was still awkward. Here was a brown four-poster bed in a pink room, a robe thrown over a Victorian chair, Anne nursing a baby, a reading lamp with a green shade over an open book and a vase of flowers, traffic on Third Avenue, and of course the island views—all in muted color.

There was something blunt and brooding about these paintings, but most of all something too rare in those times: they were very honest. In a show years later, when Fairfield's work was in full bloom—when it was clear that he could perceive a scene and put it down and paint it all in one fluent whole—Bill and I remembered that first show. We agreed it had been much better than we secretly thought at the time. Thinking of the old pictures in the light of the new ones, we realized they already carried everything. Fairfield's determined directness and clear sight were always there.

That first summer I was blind to the island, but in the following summers it became more than an island—a swimming, fragrant universe of earth, not only in the sea but in time. The smell of sun-warmed pine needles; the pink of wild roses at North Point; the chanterelles appearing like golden pavements over the avenues of the woods under the crisscross shadows of the tall dark-green firs whose arching branches were like the roof of a Gothic cathedral; the sea hawk mother flying up and whimpering and shrieking, leading us away from her chicks in the nest over the sticky beach of Sea Hawk's Point; the walks with Anne through woods full of bunchberries and Solomon's seal, over the breast of the meadow to High Point, where rainwater among the rocks made a little lake over which swallows skimmed. The Korean War was only words; the mail boat came and went, bringing news, but there was no other world at that moment than this one, full of gamboling porpoises, spruce trees, little wildly living things, pleasant walks, and swimming in the sea.

Inside the silvered, shingled barn of the main house, faded bathing suits and graying summer clothes stirred stiffly in the closets, and weathered Indian baskets with pretty carved handles, oriental crochet

bags, and Panama hats remained slung over the same chairs for years. In the upstairs front guest rooms, with their view of the sea and their golden yellow paint, the beds were unmade, there was a friendly clutter, and their porches were littered with sleeping bags and open books.

The kitchen downstairs was paneled in wood, its shelves graced by an immense set of flowered English china that no amount of breakage seemed to be able to reduce. Over the cozy wood-burning cast-iron stove hung crusted black cooking utensils of every invention. In the icebox on the kitchen porch there were real blocks of ice that had been kept since the winter in a deep, square hole covered with pine branches and sawdust under the icehouse in the woods.

At the oaken slab of a dining table on the front porch, Fairfield presided at meals, distributing food and justice. Difficult children and sometimes difficult friends sat at the wide, shiny table in streaking winds and, while eating, could watch the other islands float, appear, and vanish in tides and fog, themselves tethered to this center, sometimes like islands in a storm.

Just after a shopping trip to Camden, the food was ample. Later, though it was still delicious, it grew ever more sparse. Once, when Jenny, the whitish, untrimmed poodle, had dragged the last roast of lamb from the dining room table and devoured it, Anne told her mildly, "But dear, didn't you remember we are on an island?" It was a long time until the next trip to Camden, and we were reduced to stale biscuits, a few cans of food, and berries gathered in the woods like Hansel and Gretel.

In the daytime, like any painter I've ever known, Fairfield went on steadily with his work. At night he made generous fires in the fieldstone fireplace and amused his children, playing chess with them or reading Sir Walter Scott or Dickens aloud.

Before Katie was born, there were three boys: Johnny, Laurence, and Jerry. On the island Johnny went his own way and Jerry and Laurence played with their cousins, swam, sailed, dissected frogs, and picked berries. At night they played chess or sat reading. Both Laurence and

Jerry were fascinated by snakes. They had contests about who could catch the longest. But since a wiggling snake is a hard thing to measure, they straightened and elongated them by freezing them first on the blocks of ice in the old refrigerator.

I see Fairfield's son Laurence lying back languidly in a basket chair, listening to his father while his eyes follow the movements of his pet garter snake as she curls around his wrist and threads her way in and out of the wicker meshes of his chair; his brother Jerry reading a book of his own; and Anne cuddling their sister Katie on her lap and I with Jacob on mine; and Rudy and the others sitting on the large benches lined with leather cushions and blankets, listening too. At night near the fireplace there weren't too many discussions about art or life—we were too sleepy after a hard day's work of appreciating nature. Afterward, in her upstairs bedroom at one end of the hall, Anne sang Katie to sleep while at the opposite end I sang to Jacob. Anne called it "the Great Spruce Head Lullaby Company."

"Edith should have been born rich," Pit once said of me, observing me on Great Spruce Head. It was true that our leisure was based on others' old wealth, but to me it seemed natural to laze around while land and sea were breathing softly; it was a way of learning.

Anne had written poems about "the smallest creatures, who did not know their names . . ." and about a shell standing ajar: "The light obedient gesture that let go of time." Looking at new flowers, the myriad things growing and devouring one another around us, was a way of taking part. Once, standing still among the ferns under the lichened trees, Anne said softly, "The whole world is a jungle."

My former boyfriend Heinz Langerhans and his wife, Ilse Bloch, were Fairfield's guests. Ilse had come to America straight from a concentration camp. One night, at the communal clambake, some of the Porters questioned her about her experiences. We were on our way back from the Double Beaches, and Ilse was rowing, the water dripping in silver

phosphorescence from the oars. She said in a low voice, "I cannot talk about that anymore. It seems like a bad dream now. It has to be. I do not want to believe my own memory. Otherwise I could not go on living." Under the wide, starry sky, infinities of little creatures glowed all around us in their one night of ecstasy. Despite what we knew of men degrading themselves by degrading their fellow men, the moment seemed harmonious.

After a few summers with Anne and Fairfield on Great Spruce Head, Rudy and I rented a cabin of our own in the village of Deer Isle, but from there we still went to visit the Porters. Later we also went to Southampton and stayed there with the Porters some summers.

Among the many film comedies Rudy made with his friends as actors was *A Day in the Life of a Cleaning Woman*, with a story made up by Anne, whose great ambition had always been to be an ordinary woman. We did the film in 1953, a summer when I also posed for Fairfield. Sometimes he painted me sitting on the lawn, but once, I sat for him in the parlor, one of the most beautiful rooms in the house, where the grandfather clock, the wallpaper, the lace curtain, and the tray with the Neapolitan coffeepot were just as important as the sitter. (See *Portrait of Edith Schloss in the Porters' Southampton Parlor*, by Fairfield Porter, figure 4 in the color insert.)

The friends and guests were now poets and other painters, not political theoreticians anymore. Fairfield began to write sonnets and art reviews. His art criticism for Tom Hess's *ARTnews* and for *The Nation*, in a vital period of American art, was unusual. His sharp observations, pithy comments, and unexpected insights—written tightly without one superfluous word—were exhilarating. No one else was so frank and precise. Even if he could be opinionated and could be devastating when irked by phoniness, he had no snobbish partisanship. Quite settled in

his own pursuit of art, he was totally generous and open in the appreciation of the work of fellow artists. Not only among the first to buy a de Kooning, he was among the first to write about happenings, Rauschenberg, Burri, Larry Rivers, Jane Freilicher, Lichtenstein, Stella, and many others who became stars much later.

In his last years, he particularly loved the innocent and modest small oils of Albert York. I had only seen a black-and-white reproduction of York's work—two fat trees standing near a little pond—and it seemed a bit bland. Fairfield went on talking about York's paintings, he just had to, always totally enthusiastic when something struck his heart. If only I had listened more carefully. When I saw York's little pictures several years later, I understood what Fairfield meant: there was something dear in these oils; they talked without fuss about the nearness of small creatures and plants, about the mystery of innocence.

For a painter who looked at things, nature was part of Fairfield's care and awe. He believed in ecological balance long before the word ecology became common usage. He deplored the increasing divorce from the land brought on by America's exaggerated faith in technology. Decades before such ideas hit the news, he advocated that praying mantises and other natural enemies of plant parasites, and not dangerous chemicals, should be let loose on infested plants. When I too become enthralled with the idea, Anne teased us both gently. "I can just see Fairfield and Edith leading a demonstration across Times Square, carrying banners that say in big letters 'Long Live Ladybugs!'"

After Rudy and I had had a lot of trouble with each other, I went to live in Italy with Jacob, but I came back to the United States from time to time to show my work, and I always went to see the Porters. They came to Italy in 1967: Fairfield, Anne, Katie, who had just graduated from high school, and Lizzie, their youngest child. Fairfield had made reservations at a hotel in Rome, where he had stayed with his mother forty years previously when on the Grand Tour. The hotel was out of the way,

so I found them an apartment to rent on Piazza Navona. The Porters were ill at ease and silent most of the time. I see them sitting all in a row on a couch in Peter Rockwell's house—where I had taken them, mistakenly expecting my old friends to get along with my new friend—a frieze of four people as stiffly frontal as the personages in *American Gothic*.

In Florence, Fairfield had again made reservations in a hotel in which he had stayed with his mother forty years earlier, a smoothly run old place full of sedate old Americans. I was also in Florence at the time, so I called for the Porters in my tiny Fiat station wagon—a Cinquecento Giardiniera—to take them to Rignalla, where I was staying, in the hills outside of town.

At tea under the olive and fruit trees, we sat overlooking the Arno snaking and wandering below in the valley. The landscape was a silver-green intricacy of vineyards and olive groves, accented here and there by a dark cypress or pine, with solid Tuscan farmhouses nearby. Farther on, in a bend of the river, nestled the smokestacks and cranes of an industrial suburb. It was all so convoluted I had never come to grips with it. In my paintings I used it as a green mist dotted with silver for a background in my still lifes.

Fairfield's eye traveled over the fullness before us, organizing it. "Why don't you paint *that*?" he said, itching to do so himself. And had he lived there, he would of course have been able to disentangle it all into one of his smooth views. But he was traveling, moving from subject matter to subject matter. Nothing was steady for long enough for him to become familiar enough to paint it. He wasn't happy. A painter needs to be painting to feel like a painter. Later in Southampton, I suggested to him that they all should come to Europe again for a long stay in one place. He smiled, "The Eastern Seaboard is the Porter habitat."

On the island in Maine, there was a back porch on the way to the woods. Green branches shot with sunlight pressed against its screens, and the occasional cry of a flicker or a crow pierced its silence. On the

porch were one or two chairs, rolled or stretched canvases, paint rags, an open book on the floor, or someone's morning catch—a spray of Solomon's seal, some harebells, and some bunchberries in a glass— and over all of them the pleasant, sticky smell of the Maroger medium.

This was Fairfield's summer studio, a place you could pass through, but you did so with respect. Here people posed, here pictures were

The Dog at the Door, by Fairfield Porter, 1971

finished, here someone worked with regularity, with stubbornness or ease, with an open, intelligent mind.

The paintings: the harbor, with the white lobster boats and the sharp black angles of their cabin roofs and the blue-green reflections of their undersides riding at anchor; the moorings; the landing bridge, the sea stretching clam-chowder beige to the far seal-shaped islands. The brown rubble of the sea bottom next to puddles at low tide, yellow sedum and hawkweed. The dog is at the door, waiting to be let into the farmhouse. In a moment, after he is inside, the door will bang. Outside, the blinding white house, the brightness of the green meadow and its deep shadows, the clear summer sky, and the hallucinatory sharp northern light will remain.

Fairfield's last painting still sat on his easel in Southampton when Anne invited friends to the studio after the funeral. It was a view of Union Square looking uptown, a stream of cars and people and buildings pointing north from the Doric column of the bank in the foreground—an avenue, flushed pink in northeastern weather, stretching toward the opalescent blue blur of Grand Central. It is an epic American painting.

Fairfield had learned conventional painting. Then Vuillard opened his eyes and taught him that you could build figurative views with flat patterns, and Fairfield elaborated on this. Eventually, closeness to the Abstract Expressionists taught him to rely on loose brushstrokes, on improvisation.

The title of one of Fairfield's exhibitions in Boston, *Realist Painter in an Age of Abstraction*, was far more appropriate than the curator ever dreamed. Anne and Fairfield held up something necessary in slovenly times: that civilized living in surroundings full of small things on which you could feast your eye—that painting the corners of your house, your table, your children, your friends, your weather—had the deepest meaning. Showing outer life directly and not searching in the inner self (always in turmoil anyhow) took guts in those times and now.

WILLEM DE KOONING

BILL AND *WOMAN*

The composer Morton Feldman peered at me through the thickest lenses I'd ever seen, his toad face in a grin. "You always say that," he said, "that I don't remember you. But I do." Toads have golden eyes and attract girls who want to be princesses. And they are delicate. Morty composed music made up of little sounds that were like slow drops of luminous rain. We were in the lobby of a theater in West Berlin in 1982, waiting for a concert of new music to begin. We were looking at the program, which had a reproduction of a de Kooning painting—a great scramble of oranges, yellows, and greens on its cover, announcing his imminent retrospective here. Morty squinted at it closely.

"Hmm, hmm," he said. "Bill, yes." He sighed. "Well, you know what? I really liked Bill's Graham period best." I quickly said, "I liked it too." He laughed out loud. "I knew it. I knew you were the only person in Berlin I could say that to, who knew what I was talking about." Well, yes. I was the only one there who knew about Bill's Graham period.

The painter John Graham was really a Russian whose original name, Ivan Gratianovitch Dombrowsky, must have seemed too outlandish to him for use in America. He was said to have been a White Russian officer and an aristocrat. When I knew him he lived on Main

Street in Southampton in a large white mansion with a fine widow's walk on top—at the far end, near the sea and the private beach for millionaires. His wife was a Yugoslav heiress from Fiume (now Rijeka, Croatia), the mother of Ileana Sonnabend, who was then still Mrs. Leo Castelli.

When Graham took a walk to "the village," he sometimes dropped in on the Porters. A monocle in his wicked eye, its black string trailing down over his vest, he wore a beige twill suit, a Panama hat, and had a bamboo cane. I can see him standing in the Porters' parlor—with the grandfather clock and the Turkish carpet—on a Sunday morning. With his mustache, haughty expression, and fine English clothing, he did not look the least like a painter, but this bizarre, slightly daunting personage, his sayings on art, and his pictures were much respected by his peers. His paintings, odd and hilarious, a peculiar form of static Surrealism, were busts of ladies with bulbous bouffant hairdos and longish oval faces on longish submissive necks, set in dark green grounds. They were oblivious to the cuts and other irregularities in their deep blue-pink flesh, and their eyes had little Os around them, with stems, with keys, like lorgnettes. Cross-eyed, they stared at you like beady-eyed birds, still and expressionless.

The *Women* of de Kooning's Graham period were also curvy necked and had a longing to look demure, but their color was live. Charcoal marks of misses and tries and corrections were picture marks, not skin marks—bits of thighs and legs under back-leaning backs in rocking, precarious flow. Sometimes they were cross-legged, but they were never cross-eyed.

"The trouble with women is the way they sit," said Bill. "Foreshortening legs always looks bad. Graham didn't foreshorten them, he just left them out." The colors, reptile green and orange against a blushy red, and snake yellows against improbable chinks of enamel blue were like tastes of peculiar fruit. But those tongues and slices of bluey-violet purple pink, a mixture of madder lake and what else, were something only he knew how to concoct. They sometimes looked smugly skyward,

those women. Their eyes and breasts softly bulging, their laps open, they were Madonnas without babies. But the strings of tension flickering around them like summer lightning were not an outside story, but the war of color and shape within the picture. They seesawed, but were seated serenely in all that sliding paint. One of these Madonnas presided over Edwin's loft, another had been in the Porters' parlor until Fairfield, needing money for his son's college education, parted with it for much too little, selling it to a dealer who posed as a dedicated collector.

At first Bill had made dark, smoky semiabstractions of shapes like ships' funnels, of nests of eggs like Os. John Becker, Edwin's old Harvard friend and the only one on the scene with means, exhibited them in his Park Avenue penthouse gallery. I saw some of these early half-abstract still lifes, well brushed but with a tentative, obscure content, in the house of Marie Marchowsky, an early collector.

Then there were the murals for housing projects for the WPA, shipping lines, and the World's Fair, now lost—long, horizontal Fernand Léger–ish friezes of invented machinery and hominids, cleverly and skillfully painted, but cool. After this came the panels of pensive men and personages resembling Edwin Denby, stroking indeterminate objects, with unresolved and mysterious wiped-out passages in velvety deep interiors. There were also horizontal pictures of women carrying vessels, as in the frescoes in Pompeiian dwellings, in purple grays, old pinks, smoothed yellows, and chips of blue, also oblique and coldly dreamy.

Curiously, at the same time Bill did these undefined dark things in the late 1930s, he also painted those crisp, shiny, whimsical abstractions with the bittersweet Mediterranean colors I had first seen at Fritz Henssler's house in New Jersey. They also graced Pit Auerbach's loft at 116 West Twenty-First Street and were left to hang casually in the beach houses Frank Safford rented out in Wading River. On paper or on pressed wood panels, most were painted with commercial enamels, giving them extra sheen and precision. They were full of teasing spatial questions, answered or not, each impish off-balance

balanced in the end. Like Bill, they were cheerful and deadly serious. Their spell held me. It left a residue in me for years. It was the period of Bill's that most influenced me. I worked for months, using these same house paints, to make neat, confined shapes like petals, like Jean Arp cutouts.

The orangey-green period went on into the 1940s. Part of it was a sort of landscapey abstraction. There was one—with a green shape, like a big pillow or a hippopotamus in the foreground—that belonged to Fairfield, who had lent it to the poet Frank O'Hara. One day Frank was admiring a de Kooning oil at Fairfield's. It was in greens and splinters of orange, a pudgy, hippo-like creature seesawing in the middle, with an unusually mild fairy-tale quality. Fairfield noticed Frank gazing at it. "I'm bored with it," he said abruptly. "Take it." Everyone in those days borrowed paintings from each other or exchanged them. They had no value, they were to study and to enjoy. Sometime later, Fairfield, that most generous of men, discovered the green painting on Frank's wall in Manhattan. "By the way, Frank, bring it back," he said. "It's really quite interesting." Frank was hurt. "But you gave it to me!" There ensued one of the first art world quarrels.

Also part of the same period was the poster with windmills and a Dutch village commissioned by the Container Corporation. The famous shower Bill had built in our loft had also been bright orange and green. Another picture dominated by those two unlikely colors— with big blushes and blooms of Bill's own bluey pink-turning-wetly-to-red—was a sketch on paper for the backdrop done for the dance by Marie Marchowsky. The backdrop itself, painted on a cloth as big as two bedsheets, lay rolled up in storage for years and was pulled out of the closet only when Bill finally became famous. We had casually tacked up the sketch on paper over baby Jacob's changing table. When I changed his diapers and cleaned him and he cried, growing

the same purple-pink as the picture above him, I used to cry, "Look everybody, Jacob is turning de Kooning pink."

In those days, nobody was anybody. Friends were friends, and they brought you their pictures. We exchanged them freely or bought them from each other for very little, threw them into a portfolio or casually pinned them up. Paintings were just paintings by friends, and no one thought of monetary value. It was what friends did. Many years later I saw that orangey-green paper with its big purple pinks, like an outraged baby's arse, in the Museum of Modern Art. It had gone through many hands. Mounted and framed in gold, it sat like an altarpiece, enshrined and safe in a box of clear plastic.

I never ceased to wonder how Bill could go on and on about Rubens, these heaps of pink flesh, and the Venetians with their fluttering draperies: Titian's wine reds, Veronese's white-on-white, Tintoretto's woolly greens, and those sunset clouds of Tiepolo's, as wet and nacreous as the unfurling clouds the northwesters blew from the Hudson over Sixth Avenue. And Rembrandt, and Goya, and then Monet. "You know what? When you step up to them, what do you see?" Bill asked. "Huh? Nothing! You go right up to them, and it adds up to nothing. No lines, no things. It's just paint and painting—marvelous!"

In a subsequent show in Rome I came upon a *Prometheus* by Rubens. With flossy, loose brushstrokes he had laid swath upon swath of that flesh pink called Naples yellow mixed with cadmium red and white. Washes upon washes of it made a surface as glossy and twitching as a newly washed animal pelt. This man's back was a landscape of paint strokes. In other paintings by Rubens, the garlands of rosy women with up-sticking breasts and soft bellies like overripe peaches, those chubby babies' arses—all that meaty texture was nothing but paint. Beyond the obvious subject matter, that was all there was to see. That is what Bill saw. The late Renaissance was made to deal with the

outside of painting, but for its own seeking and pleasure, it went into the inside of it.

When you look at Michelangelo's *Last Judgment*, the first Action Painting, you see something else. It is not just one macho whirlwind of figures descending on you. All this muscular wallowing of human bodies is carefully laid out. The power of the mural is that it makes one grand abstract gesture. Bill knew that too. The epic of the masters was in his blood.

Wholesale abstraction was launched in the mid-1940s. The strokes were big, the colors plain. Fat blacks, beige, spatters of white, in slippery commercial enamels or more muted oils, lashed out onto half-buried newsprint, dripped away after they were thrown down. Huge demarcations were wiped out and then reconstructed. Glimpses and breakthroughs juggled with flats and troughs, flurries and feints of whip strokes and slopping-over shapes leaned out of the big canvases. There only *seemed* to be an agony of indecision; in the end, somehow everything leaning and flying out was poised. These snakes and ladders and avalanches and signs and admonitions were totally new. The marvelous movement of the loaded brush, the flow of paint on paint was the point.

But if paint and structure were the subject matter, these big abstractions also held the grating pulse of New York day and night. Since there were no longer burghers or popes to hand out commissions, the poor anarchic painter in the thrall of the anarchic city was free to dive into its blackness and whiteness, its squalor and vigor and funky grandeur. The sport inside the picture was also the tale of the city.

When Anne Porter first saw Bill's *Attic* and pointed out sweetly, "It's the miracle of the loaves and fishes gone shipwreck," she was right. The whole abstract map was old and new. Growing out of the past, the new present was overwhelming.

Others of Bill's generation, such as Jackson Pollock, Franz Kline, and Philip Guston, were also engaged in this same kind of direction,

this churning, seemingly uncontrolled attack that was dubbed Action Painting much later. Downtown, Bill was its champion. And then, when everyone was happy with what they had worked so hard to understand, Bill turned around. There was color again. There was the figure again. There was *Woman*.

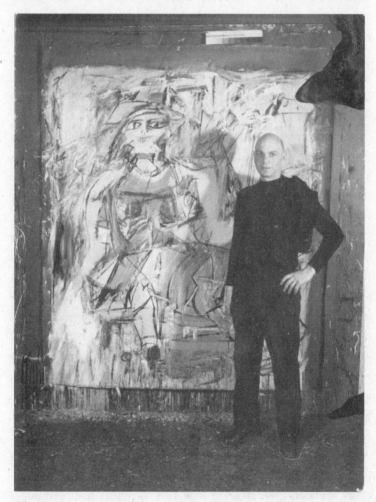

Photographer photographed by painter before painter's painting—Walter Auerbach photographed by Willem de Kooning in front of an unfinished *Woman*. Photograph by Willem de Kooning, 1951

The creature was big, shaggy, and monstrous. Her hair stuck out like the flames around the heads of the hobgoblins advertising Con Edison gas, her toothy mouth cut out from a cigarette poster. The big, strawy thing was like a giant dust kitten made of bales of broomstick swipes and scratches. Fat, writhing fragments of her body split into gaping vaginas, swelled into big breasts like udders and bellies. She stood knock-kneed on legs like fence slats, and when they showed, she had feet like cloven cattle hooves. It was all horribly jolly.

This paint storm, in Grünewald greens, bleeding reds, black squeaky flashes, and spurts of rainbow, was not only an ordinary freak but a mutant of abstraction as well. It was sacrilegious. What was the matter with Bill?

There were silly conjectures. Was *Woman*, this tricked-out crude female, supposed to be a belated rough and cocky Rosie the Riveter, a blowsy, overripe Marilyn Monroe, an Automat lady with a slug too many, or just a dopey Eighth Avenue cloak model cycling in the Hamptons? Was it just some *Déjeuner sur l'herbe* gone haywire?

Bill, who, like Mary Poppins, had deeply distrusted the country because it was "too green and too full of birds," had now been taken there by Elaine and was spending his summers painting in Leo Castelli's garage in East Hampton. In a town where more people were being psychoanalyzed than had ever been in Vienna, one thing was clear: Bill hated women.

He hated Elaine. *Woman* was you, Elaine, brightly in evidence everywhere. He hated his mother-in-law. Mrs. Fried, an Irishwoman, at all times insisting on the rightness of her own opinions and her own wisdom, was relentlessly loquacious. But Elaine was devoted to her, and Bill always listened to her politely. He hated his mother. *Woman* was his mother. Bill's mother, who had single-handedly managed a tough sailor's bar in the harbor of Rotterdam when he was little, suddenly made an appearance in New York after they had been out of touch for decades. Big and formidable, wearing a black hat, she was

the kind of woman you thought had died out after Bruegel and the Renaissance. She sat stolidly gazing at Bill and his friends.

But it was not like that. Whenever someone does something entirely unforeseen after we've studied and gladly understood them, it's too puzzling, and we hate them for it. A strong artist makes a strong turn, and it takes strong insight to follow. Just as when Franz Kline began to work with color again, when Philip Guston left his woolly abstraction for his dreadfully ominous and cheery objects and people on the brink of the flood, this new departure left everyone uncomfortable and unforgiving.

And if this she-devil trying to breathe fire came from Andromeda straddling her whale, Hendrikje drying her bottom, demure Susanna spied on by the elders, a Miss Subways gone through the mill, or was spunky, brave Elaine, today it doesn't matter anymore.

This thing outstaring us, nasty Gorgon or good-natured floozy, this female flesh or fleshy paint, was only painting in new clothes. The toothy frump sitting in a circus of slashes and shapes was part of it all, part of the fabric of the picture. *Woman* was a new stage, was Bill's rebellion.

Bill was a pro like few others. Because he had an innate gift and had made himself undergo disciplined training, he had a precision of line that looked effortless. That perfect *o* of Giotto had something to do with it. If you have an *o* in your name and then, like Giotto, have two *o*s, it oils your wrist without your knowing it. And under that practiced, fluid hand lurked the grand structure, so blissfully studied, of the masters. His open, undecided passages, this willed unfinishedness, had not been enough. The Graham *Women*, the small abstractions, the big epic ones had never been raw enough. In *Woman* he tried to shed all except force. Earth man had painted earth creature, this fling of a primitive thing in an unknown land, something basic and flailing.

After *Woman*, a new openness bloomed enormous, a grace of movement in one sweep. Wide slides of yellows, pinks, and lilacs,

strokes like wires snapped in the wind blew by like highways, like waterfalls at dawn. Old painting was about a moment made into eternity. Bill wanted eternity to be one trampling, kicking wheel of the moment.

BILL AND WOMEN

Small, dapper Bill was always attractive to women. His curtness, his no-nonsense comebacks, the humor lurking in his eye, his quick, precise, small movements, his work clothes—all were irresistible. Then, only workmen wore work clothes. Painters, thinking of themselves as workers, wore denims. We went to the Army Navy stores and wore surplus jeans with glee.

Bill was the first to wear a woolen sailor's watch cap. It was nifty, and what later became a fashion looked exactly right and cute on him. One day he was invited to a cocktail party given by the Rockefellers, or some other fancy collectors. He stepped into a taxi. "To the Waldorf Astoria please," he told the driver. After a while, the taxi stopped at a dingy door. "Hey, I asked you to take me to the Waldorf Astoria," Bill said.

The driver nodded. "This is the Waldorf Astoria. Service entrance."

Bill just sat there. "Take me to the main entrance, will you?" he said firmly.

"You sure?" asked the driver.

"Sure, I'm sure. I'm going to a party."

"Pardon me," said the driver, "I thought you was the help."

"No kidding," said Bill. "And what made you think that?"

The man turned around in his seat and pointed at the watch cap. "The hat, man," he said. "That hat."

A painter who, by the looks of him, could also have been a plumber, Bill was an even, easygoing person, attentive to everyone, man or woman, as long as they had anything worthwhile to say. He had no

come-on, and he spoke to the point, and in a seemingly simple fashion, about very complicated things. He could also be extremely blunt, cold, and ruthless.

One dark afternoon, after Rudy had come back from Mexico, I threw on a scarf Rudy had brought me, put on a beret, and went to Bill's studio on Union Square to cheer myself up. We all dropped in on one another in those days—someone was always working but glad to take a break with a friend. Bill stopped with his painting and let me look at it. Then he got me a drink, and we sat down on the only place there was to sit, the couch.

"Nice colors," he said, fingering my scarf. "Handwoven?"

"Yes." I nodded. "Rudy gave it to me."

He came closer. There was something in the air. He came closer still. It was raining outside now.

"Rudy said the weather was nice in Mexico," I said idiotically.

"Why do you always mention him?" Bill said roughly, putting his arm around me. I sat still. I didn't know what to do. I adored this man as a great painter and leader but had not thought of him for a minute as someone to go to bed with, even if I had come there dressed up prettily. I believed in living with one man at a time and was quite in love with Rudy. And he was one of Rudy's oldest and closest friends. Now he wanted to make out with Rudy's wife—he who had such a sturdy and fine relationship with his own? What was all this? Bill sat there with his arm tight around me for a while. I was extremely uncomfortable. When I tried to edge away, he moved too. It was so awkward. It rained harder outside. At last I somehow got myself disentangled. Without looking back, Bill went to his painting and I went out into the rain.

People sometimes now ask if Bill was always a womanizer. It was not that. What he had was some kind of working-class unscrupulousness or realism. The boy from Rotterdam had been washed in all kinds of waters. He took what he wanted where he found it; the rest was false sentimentality. You could always fit in a quickie. I probably balked at that as much as at unfaithfulness.

They were all tightly involved with one another before I came to Chelsea. When Rudy and Edwin met Bill, he was living with Juliet Browner, who right away became Rudy's girl (she later married Man Ray). Rudy told me that at times he had been so attracted to Bill, he dreamed of him. Later he also dreamed about Elaine and for a while was quite crazy about her and wanted her. But after they all had known each other for some time, Rudy thought it was too late—when you became friends with a woman and didn't go to bed with her right in the beginning, later you were just friends.

In Bill's life, after Juliet and before Elaine, there had been Nini Diaz, who was an acrobat. She also became Rudy's girl. Of miniature proportions, she worked for the Barnum and Bailey Circus as a trapeze artist. Later she met Andy, a Czech mechanic who was twenty years her junior. After they were married, they went to live on the Lower East Side. Suddenly, in their cold-water flat, Nini began to paint. Knowing nothing about art—the painterly milieu she had lived in had not rubbed off on her—she was a primitive. She worked on tidy little green landscapes, with ideal thatched cottages flanked by hollyhocks. Once a month, along with the rest of the furniture, she washed these naive little scenes—painted so painstakingly and stiffly until their surfaces became enamel-smooth—with soap and water. A wandering circus girl before, she now had a mania for housekeeping and hominess. She kept her little figure trim, and she never aged. After Andy died, she went back to Florida and trained again with the circus, where she remained until her retirement. One day she made a sudden appearance in New York, dropping in on us in our loft out of the blue, a dainty little lady who must have been in her late fifties but did not look much over thirty. At once she fired all kinds of personal questions at us.

Looking us straight in the eye, she said inquisitively, "So you are still together. Are you still happy?"

Rudy and I stood silently helpless.

"So how does it feel for folks like you to have a kid? Well, Edith, what makes you tick anyhow? So you are both still painting. So how come you didn't make it? Well, Billy made it, but good."

We didn't know where to look.

"So why do you both look so sad? Tell little old Nini everything, don't look so sad."

Of course we looked even sadder. We were too sophisticated for her misplaced sympathy, so folksy and simple. We were embarrassed.

"So brighten up. And for old times' sake, let's get ahold of old Billy and get him to have lunch with us." So that was it.

And one noon we found ourselves amid the dank, sweet beer fumes of the dark Cedar Bar, the hot summer sun blazing over the pavement outside, waiting for Bill to appear. "She has come to claim kin," Rudy whispered to me as she rushed toward Bill.

But it was more than that. After a lot of hugging and several beers, Nini leaned over her pastrami toward Bill. "Come on, Billy, tell us how you did it."

"How I did what?" he asked.

"I mean, can you believe it? You are really a big shot now. They say so even on television. I mean, how did you really do it?"

Bill smiled at her kindly. I squirmed. Then she opened a package and pulled out one of her little green and blue pictures. "Here, Billy. How about it. How about giving us a hand," she said. "It's simple."

Bill cocked his head and considered the little oil. "Nice." He smiled. "Very beautiful."

"I know," Nini said impatiently. "Thank you. But all you have to do is sign it. Put your big name under Nini's little picture for old times' sake, hey Billy?"

It was a funny scene. To the little acrobat lady with a widow's pension and a background like hers—innocent of the machinations of the great art world of our times—it seemed a small favor to ask of an old boyfriend. If he signed those primitive little oils, she could survive for

a long time. Bill must have managed to make her understand that this was impossible. Yet he found a way out by buying some of her work.

There was always Elaine. Their companionship and their understanding were always there. They listened to each other with attention. Elaine recognized Bill's power and believed in it before anyone else had. She was always his student. She was also the artist's wife, smoothing his career and advising him, backing him, probably inventing his titles too. She was also always the artist, refusing to cook and tidy, and also asking her due of admiration as a pretty and neatly poised woman. But, like any companion keeping the man's keel even, she was also the drag anchor. Her constant insistence and sharp observation were not easy to take after their first great affection had waned.

As Bill put it one day, "A wife! Living with a woman all the time, it gets to be like this little machine in the basement, this little machine that goes *tick-tick-tick* all the time. It never stops down there, going *tick-tick-tick* all the time." Still, both from working-class backgrounds, they believed in middle-class values. A marriage was a marriage to the end. But in Italy they say man is always a hunter. Apparently friendly, attentive, and polite to anyone, Bill looked at women quizzically, coolly, like those humble heroes in French movies, and anyone was fair game. His small, chirpy voice, his smile, his sentences so sharp they hurt, were irresistible. And that his real adventure was painting, not women, was irresistible too. He never went out of his way, but almost casually took what was at hand.

There was of course Ruth Kligman, who romped with him in the Hamptons and went to Rome with him on his first trip back to Europe. She had been a model on Seventh Avenue and Jackson Pollock's girl. It didn't matter whether she was bright or not. She was a dark, lush beauty, not lean and modern, but with the fullness and lovely roundness of a Renaissance woman.

Then there was one of the Ward sisters, Joan. We called her the

twin because she had a twin sister who, just like her, was a commercial illustrator and had been a girlfriend of Franz Kline's. She became the mother of Lisa, Bill's only child. To the old-fashioned European man that Bill was at heart, this meant a lot. He, as well as Elaine, respected this tie to the end.

By the time fame overcame him, things got both easier and harder. "Now I can buy as much paint as I want," Bill said, "but I can't wear more than one camel hair coat at a time." While going through tearing painting doubts and crises followed by long drinking bouts, he was also pursued by young art students going wild over this new celebrity. For these pretty young groupies, a night with de Kooning was another feather in their cap. The morning after, some said, they would wander around in his studio, picking up a drawing underfoot here, a little canvas on the floor there.

"Hey, Bill," they would say coyly. "Can I have this? Can I have that?"

Always generous. "Sure, take it," Bill would say.

What a windfall. So with one one-night stand, the smart ones earned more than the best call girl.

Always openhanded with his work, Bill told us how he once gave in to Robert Rauschenberg. "He came to me and said, 'Can I have a drawing of yours?' 'Certainly,' I said, 'what for?'"

"Yes—what for, Bill?" I asked.

He grinned wryly. "He said, 'Bill, can I have a drawing of yours so I can erase it?'"

"Oh, Bill, what did you do?" I asked.

"What could I do? I gave it to him, the son of a bitch."

Years later in a museum I saw a blank page with some faint marks on it. It was signed Robert Rauschenberg and titled *Erased de Kooning Drawing*.

The Artists' Club used to have innumerable panel discussions. Once in late 1961 there was to be a panel on assemblage art. The French

happener Jean-Jacques Lebel, who later staged wild events all over Europe; Sidney Geist, who made strange and witty beasties; and Robert Mallary, among others, were supposed to be on it. I was also invited, having shown a box at *The Art of Assemblage* show at the Museum of Modern Art, which probably set off the whole idea of the panel. Because I was the only one who knew the reclusive and beautiful sculptor Marisol Escobar, it was my task to invite her too. But in her husky, slow South American voice she told me, "No. I am too shy."

"We're all shy," I said. "Come on, it's going to be all right."

She hesitated. "I'm sorry. I'm no good in public. All these people looking at me."

I insisted.

"Well," she said, "okay. But can I come wearing a mask?"

A mask? I wondered. "Sure. Why not?" I also went wearing a mask. It was an ordinary Halloween mask, while Marisol wore a beautiful Japanese geisha mask, oval and white.

There were a lot of arguments. Lebel said things in French that were translated badly and no one could understand. When Mallary asked, "When does junk art become art?" Geist retorted, "You could also ask when do paint and mud become art?" I said frivolously that I was soon going to depart for the biggest assemblage of all, Rome. And so it went: there were wisecracks and repartee. Only Marisol was silent.

Suddenly someone in the back jumped up. "That's enough already," he shouted. "What kind of a game is this? Will those condescending characters please stop hiding behind their masks! Take them off!" We did. I showed my face. But when Marisol took off her pretty mask, there was a gasp. Under the white geisha mask with the black curl and the tiny cherry mouth, she had made up her face to look exactly like it. Now she was its double, her skin wearing a painted mask. It was beautiful.

As soon as this happened, all attention was turned toward the door. A big, dark girl was standing in it, radiant and moist, as if she had just come from her shower, a rounded, rosy Venus stepping from the waves. It was Ruth Kligman, Bill's girl.

Shy no longer, Marisol spoke up: "Next panel should be different. Quite different. I say no more of this stuff about junk art like here, breaking the picture plane," she drawled. "All these men. All these men going on about space, poetry, what Picasso did, music, all that boring thing." Her voice got louder. "No. I say something else. Next panel should be women. I mean all women should discuss who has been in bed with Bill de Kooning."

She had. I had not. For a moment there was a stunned silence. It would have been illuminating. Then all was wiped out by clapping and laughter.

THE WOMAN ON A BICYCLE

One day in 1949 I ran into Bill on Eighth Street. I had been sitting in the Pyramid Group's gallery for an afternoon, guarding our show. The Pyramid was one of the first art cooperatives, and we showed periodically at the Riverside Museum or in hired lofts. After I closed shop, I had bought some groceries and was on my way home, but I invited Bill back to the gallery to see what we were doing. I wanted him to see the efforts of us younger, unknown painters, and he willingly came with me as I went upstairs and unlocked again. Though I knew that basically he was not very interested in the work of contemporaries, I saw him attentively looking at each picture for quite some time. He studied the paintings by Helen DeMott, George Morrison, Cicely Aikman, Louis Finkelstein, myself, and others without comment. But when he came to an intricately constructed and well-brushed Maine landscape by Gretna Campbell, he became really intrigued.

"Wow," he said, "that's by a real master."

When we were downstairs again, I told him that Rudy and I were expecting a baby. He stopped in his tracks and became thoughtful.

"Hey, you know," he said, "that's quite a thing. Think of Rudy. Gee, how does he feel? What a responsibility."

In our world, where painting was so important and living off it so precarious, raising a family was still rare. Babies among all that turpentine and paint rags, the toilet on the stairs, the drunk sleeping it off in the hall, the bad heating to most people was shocking. These certainly were no middle-class comforts.

And now Bill was muttering and musing about babies, the nuisance of it, the father's lot, but never about me, who had to walk behind him, hugging my grocery bag to my stomach, stepping out of the way of people going in the opposite direction. Then something dawned on him. He stood still and looked back. He looked at me, my stomach, my shopping bag, everything, and he broke into a wide grin and stretched out his hands.

"Oh, you must let me help you," he said, reaching for my shopping bag, which wasn't heavy anyway. "You are pregnant, go easy!" The change was disarming. I wasn't the younger painter who had to be humored anymore, or the friend's wife you had to be friendly with, but someone to be treated with respect, and gently.

"So you are going to be a mother," he pronounced, smiling, and happily carried the bag and walked on behind me.

After Jacob was born, I foolishly wanted everybody to see him. Of course I took him to Bill, who at that time shared a studio floor with Jack Tworkov on Third Avenue. I knocked at the door downstairs. Bill had to come down to open it.

"I hope I'm not disturbing you," I said.

"Of course you're disturbing me," said Bill cheerfully. "Come right on up."

Upstairs in the loft, after the new baby—wrapped up like a papoose in blue woollies with only the pink face peeping out—had been duly admired, I was allowed to look at Jack's paintings. They were in the back loft and at the moment were somewhat influenced by the close-

ness of his powerful neighbor. Back in Bill's loft, we sat down, me with the baby in my lap, and talked art.

All through the conversation Bill leaned back in his armchair, some distance from his painting on the wall, narrowing his eyes and mouth, looking at it hard, sizing it up as if it were the enemy.

Jacob crowed, we talked, and Bill was still looking at his painting. There were drawings slashed with charcoal all over the floor, painted newsprint, and drawings on the walls and taped to the wire mesh windows. Masaccio's *Adam and Eve* was still pinned to the wall, the two naked figures running from Paradise, running, running. And over Bill's wet canvas, swaths of paint were running too, banners of paint unfurling, cracking with movement.

In the 1950s, when Jacob began to go to school in the Village, I sometimes took him there on my bicycle. At that time, hardly anyone rode a bicycle in New York, but I did most of my shopping and moving around downtown that way.

One day, as I was merrily pedaling across town on Fourteenth Street, I heard a high-pitched man's voice calling after me. "EE-dit! EE-dit!" I turned and looked back. It was Bill. I got off. He looked at me, smiling, and said, "I thought it was a woman on a bicycle, and then I saw it was you!"

On a fall noon in 1961, when I was walking down Fifth Avenue, I spied Bill sitting in a sidewalk café with Barney Newman and a French art critic, and he invited me to sit down. He was easy but not talkative. Newman was wise, his eyes twinkling through his pince-nez, while the art critic plied both with utterly irrelevant questions.

"You painting?" Bill asked me.

I said yes and told him I was going to Italy. He had recently been to Italy, his first trip to Europe since he had come from there as a stowaway.

"Yeah, I had a good time in Italy," he told me. "You know what? When I got there, everyone said, 'Hey, de Kooning is in Rome. Let's see de Kooning, let's show de Kooning, let's hear de Kooning, let's drive de Kooning,' and so on and so on. 'De Kooning is in Rome!' Too much! And all that kissing and hugging and drinking and people and going to parties all over the place the first night. I never knew how I got back to the hotel. When I finally woke up, it was in some dark room I had never seen before. I didn't have a clue where I was, I didn't know anything. And then I got up and opened the window. And then I opened those shutters. And there it was. The sun was high over all those roofs and cupolas and piazzas. Oh boy. I liked it. Oh, I liked it fine. And then I said, 'de Kooning is in Rome!'"

We walked down the avenue toward the Washington Square Arch. The weather was so bright. People turned and stopped and started. Walking with de Kooning in downtown New York was like walking with Clark Gable in Hollywood. The small, unobtrusive, straightforward man, who once could have been taken for a truck driver or the help at the Waldorf Astoria, was now king. How nice. De Kooning was in New York!

GALLERIES AND THE CLUB

BILL OPENS AT THE JANIS GALLERY

Eventually Bill outgrew the Charles Egan Gallery, and Sidney Janis, one of the shrewdest dealers around, took him on in 1953. Egan had been the first to believe in Bill and to help him on his way, but he was not the ideal dealer. True, with an unusually perceptive eye he had discovered a select group of top artists no one else had even considered, and he had built up their prestige and reputations unaided. Content to live and sleep in the gallery and to gain a minimum for his own subsistence, he had been of little use to the artists from an economic point of view. After Bill was established with Janis, he got it off his chest: "I'm tired of being with a gallery man who believes in art," he declared. "I'd rather have a gallery man who believes in dough."

The Sidney Janis Gallery was a bit west of the Egan Gallery on Fifty-Seventh Street, in a building with many other galleries. Facing the street, it shared a floor with the Betty Parsons Gallery, which was toward the back. Though Betty had nurtured Pollock and had a marvelous eye for genuine talent, she was too plain in her furnishings, too modest in her showings, like a poor relation compared with Janis. You went to see her boys first and then went to Janis for the main course.

Bill was at the zenith of his career: I mean within the very tight circle of the New York art world, not yet with the public at large, which came

later. This was a particularly crowded opening at Janis. The paintings were as wide and fast as ever; what was new were not the bits of newsprint under the paint—he had done that before—but tracks of childish handprints, perhaps by his daughter. Everything looked as grand as before and wilder and more generous.

The art world crowd was thick. It was so thick, the tall black elevator man kept shaking his grizzled old head while riding up and down and manipulating the doors. He had always been there—everyone knew him, he knew everyone—but no one knew his name. After years of politely greeting these strange, wicked people he knew nothing about but somehow respected, he deserved a monument.

"Well, well," he mused, peering down from his dignified height. "I declare. What a crowd. Like never before. There's even more of a crowd than for the one that killed himself. And this one ain't even dead." He meant Arshile Gorky, so singularly unlucky, who had hanged himself before his last Janis opening. (It was never clear whether it was because his wife had left him for the painter Roberto Matta or because he believed he had a terminal sickness.)

Bill stood in the milling crowd, very much alive, smiling amiably at everyone. I was helping Rudy, who was taking photographs of Bill and his fans. This was not Rudy's thing. He liked to take careful aim at paintings and sculptures in studios and galleries, with no one around, or to stalk anonymous people in New York's streets and in Europe, not to record the nervous excitement of an elite art crowd. But he was there with all his gear to do a favor for his friend Bill.

Bill waved a glass at us. "Come on and eat with us after," he cried. "You know, with Franz, Philip, and all, in some steak joint." When we hesitated, feeling that we were the hired help, he smiled. "Come on, Rudy, it's okay. Janis is doing it, but I can invite anyone I want. Janis is doing it. Let him. After all, Janis gets a turd." A turd? A third of the sales is what he meant, which in those happy days—long before dealers got half of the artists' price or even more—still seemed slightly shocking.

The restaurant was on the East Side, somewhere above Blooming-dale's, upstairs, private and austere. The lack of decor and the empha-sis on good food, the black suits of the customers who looked like Italian businessmen, reminded me of another restaurant, on Thomp-son Street in the Village, which also specialized in steaks and the kind of food you get in Italy but rarely in New York's Italian restaurants. It was also spare, its fittings painted thick kitchen white and its floor covered with checkerboard black and white tiles. The tables were solid and the waiters poker-faced, dressed in the same black as the customers they served. Like nurses doting on their favorite patients, they took orders with a solemn diligence and thoughtfully humored their customers. We jokingly called this Thompson Street restaurant our "Mafia place," but were astonished when a mafioso criminal later revealed in *The Valachi Papers* that indeed he and his fellow gangsters had hatched many a plot there.

The Grand Ticino, also on Thompson Street, was similar. Rudy and I were once invited there by Calvert Coggeshall to eat with Jack-son Pollock. Coggeshall, an architect and designer of impeccable taste, also painted small still lifes of cigars and their boxes, matches, stamps, keys, and other objects handled mostly by men. On this occa-sion he had been commissioned to design the lounges of a new luxury ocean liner. Knowing that both Rudy and Pollock could use the pro-motion and the money, he had the idea that Rudy could make large photomurals and Pollock could paint huge black and white oils to go with them. Coggeshall, fastidiously ignoring me, carefully explained his project to the men in his reserved New England voice. Rudy was innocently friendly but not too responsive. Pollock sat glum, wrapped in stolid silence, hunched up and looking straight ahead. An un-derground current of distaste and irritation came from him as he downed beer after beer. Then he got up abruptly and left without a word. Needless to say, the mural never got painted.

The tough uptown place where we went after Bill's opening had the same setup as the Thompson Street restaurants, made for serious

food and serious dealing. But our group was strikingly different from the other diners. For one thing, there were as many women as men. Everyone talked, no one was guarded, and there was lots of laughter. The oddest thing was that no one paid attention to Janis, who sat at the head of the table, though he obviously was the *padrino*, or godfather.

PHILIP GUSTON

There were Philip Guston and his wife, Musa; Wilfrid Zogbaum and his new wife, Betsy; Franz Kline with one of the Ward sisters; and Robert Motherwell, Bill, Elaine, and us. Guston and Motherwell were deep into questions of art and philosophy; Bill and Franz egged each other on into telling ever more outrageous tales and jokes.

Guston sat by, hunched up and thoughtful as usual. I had seen him like this sometimes, sitting in the old Loew's theater on the corner of Twelfth Street and Seventh Avenue with Mike Goldberg and other young studs, seriously considering frivolous Hollywood movies. Unlike the other Action Painters, Guston hung out with younger painters and even looked at our work earnestly. When I was in a "three-man show" at the Tanager Gallery, I discovered him squatting in front of my Maine landscapes, studying them for a long time.

He was always complaining. He enjoyed it. "Today one of the worst things is that you have to have a show," he declared one day. "It's awful. It wastes time. You worry about it before, during, and after." He looked gloomy. "First you spend a month getting ready for it, restretching and retouching canvases, trying to figure out how to frame them, if at all, trying to decide which to show and which not to show—the painful process of looking through all that old stuff. Then you have to think of which photographer to choose, you have to get him to come to your loft, or bring the work to his studio and then transport it back. Then you decide if the prints are good and which ones to use. You have to

make up a mailing list, you palaver with the dealer about prices." He sighed. "Finally you have the show, and the anxiety is terrible. Will everyone come? Who will come? Did they all come? What will they say? Who stayed away? Who can still be asked, what critic, what collector, has every stone been turned? And then the reviews come in and are all wrong. Worst of all, you cringe at all that stuff on the wall staring you in the face. Did I do that?"

He groaned. "And then the show is over and you are back in your studio with all those stacks of canvases, and there you sit for weeks and have no idea of how to begin again. So a show takes up a good three months, you see—one before, one during, and one after. What a life!" He sighed and sighed, and I listened with envy.

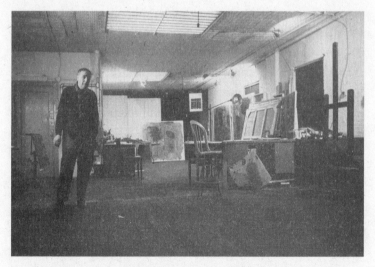

Philip Guston in his studio. Photograph by Rudy Burckhardt, circa 1960

Oh dear, I thought. I should have it so good.

When I delivered his photographs to him in his loft in an old firehouse off Seventh Avenue, the truckers in their garage downstairs were curious about the unassuming artist they saw come and go. "Is he really any good?" one of them asked me. "I mean, tell me, is he really

famous—like does he do stuff that's expensive and crazy enough so he gets on TV?"

Guston was notorious enough in our own world. Not too outgoing, unlike the rest of the boys, not as flamboyant and rough; his work was also suspect.

His dense, gnarly webs of pink, stone white, woolly gray, pomegranate, and indigo strokes made vibrating surfaces that were introspective, hovered rather than moved—while all around him everyone was engaged in the fast, slashing attack. It was a kind of Abstract Impressionism rather than Abstract Expressionism. Some considered it too hermetic and static, too melancholy. Fairfield wrote a devastating review of it in *The Nation*. But in the late 1960s, increasingly uncomfortable with pure abstraction, Guston broke through to a "figurative" painting of his own. It was unforgivable. Hilton Kramer, the avenger of "realism," was offended and wrote something quite nasty in *The New York Times*.

During the Depression, Guston had painted socially conscious Picassoid scenes, with sinister hooded figures, fat Klansmen. He had studied the Renaissance, as well as the pre-Renaissance, Paolo Uccello, and, most of all, Piero della Francesca. The influence of Piero's pale but insistent colors—the sober whites, the robin's-egg blues, and Umbrian pinks—the figures busy with messy life posed in the serene silence of art, never left him. He never abandoned the frontal composition and steadfastness of outline learned from Piero, so diametrically opposed to the flux and speed of Abstract Expressionism. Grünewald's truth, Velázquez's wide, buttery touch, Goya's vision of beauty and horror were also there, as well as the German Expressionists and early de Chirico. And, as in the work of his contemporaries, in his socially conscious days there was also the imprint of the moralist Mexican muralists.

But, unlike them, Guston now did something no one of his generation had dreamed of: beyond the lessons of art history, he turned to the common popular art of his time and place. He took seriously the lu-

rid, empty imaginary landscapes of George Herriman's *Krazy Kat* and the woolly, gawky figures of Robert Crumb. And like Cy Twombly—before Jean-Michel Basquiat—he was reading the writing on the wall. He turned his early symbols of obscure kinkiness and oppression and the sly humor of the funnies into something of his own, gruesomely cheerful. The most commonplace objects—light bulbs, clocks, books, cigar stubs, nailed bats, ladders, hairy hands and knees, lumpy one-eyed heads—appear like emblems on advertising shingles. Dumps of hobnailed concentration camp boots and childishly lashed pairs of eyes lie by dead-bright swamps lit by doomsday suns. This detritus, shimmering, grainy, frontal, is deadpan. It speaks from the corner of its mouth of the tragicomedy of our time, its methods of extinction by gas, fire, or flood—and of survival. It is crazily bracing.

At first no one understood, and the art world was affronted. Any kind of realism was still unacceptable. In New York the feeling against Guston was so disagreeable that in 1971, when he was offered a stay as artist in residence at the American Academy in Rome, he fled to Italy to lick his wounds. There he could work in peace and pay homage to his beloved Piero, whose gospel he would spread to all the poets and painters he was close to later.

That was when I saw Guston again. The director of the American Academy in the early 1970s was Bartlett Hayes, who had agreed to give me a show, but the okay of the artist in residence was needed. When I called Guston to invite him to come down from the Janiculum hill to see my work in my central Rome studio, he balked.

"Oh, no. Don't do this to me. I can't look at modern art now. I've just come back from looking at Piero in Arezzo. No modern painting now, please . . . So when do you want me to come over?"

And he came over the next day, friendly and attentive, studied everything in my apartment—from the small Fairfield Porter oils, to my friend Paul Klerr's airy paper sculptures, to my own paintings—with care, and of course he gave the okay for my show.

An uneasy, witty man, he was thoughtful and moody. He enjoyed

being ornery in the company of other painters and was much more knowledgeable and better read than was then fashionable. In Woodstock, in upstate New York, where he settled later, his best friends were writers, like the poet Clark Coolidge and the novelist Philip Roth. Though he had had more shows and more prizes than most of us, he was always worried. Despite the ups and downs, which tormented him, he was a most assiduous worker.

At the dinner after Bill's opening, Guston had no small talk with the boys, keeping a distance from their style of kidding. Something nibbled at him, and he looked bemused. His wife, Musa, next to him, was silent, but then she always was—reticent, smilingly wistful, and perhaps bored. Like many wives of the famous, she had seen it all, heard it all.

There was the sculptor Zogbaum with his wife, who was pregnant. She was Spanish and had a long, dark face. I said she reminded me of a Jesuit, which of course was not taken kindly. Robert Motherwell was there too, urbane and relaxed. The first time I ever saw him, he was lecturing to some art students at Peggy Guggenheim's Art of This Century gallery. Although he blithely talked over their heads, he was so brightly informative, we were all spellbound. He was of a different class from the other painters: he did not have to live off his work because he came from a well-to-do family. He was traveled and erudite, more fascinated by European art and its condition than most of the others. He had a knack for analyzing paradox and art problems smoothly and resolving complexity with easy brilliance.

The group, high on Bill's bang-up opening and each other's talk and company, had drunk more than they had eaten. In the end, Motherwell asked us to his house for sobering coffee. The town house on the Upper East Side, off Madison Avenue, where he lived with Helen Frankenthaler, was bright and white, with gray surfaces and essential pieces of furniture of a spare elegance. This set off their small works, always so fabulously right. There were also exquisite small examples from the studios of the present company, with a Goya, Rembrandt, or

Picasso etching thrown in. Helen was not there. Bob made coffee and set out a ring of little cups on the low coffee table.

He arranged them under the wide-open legs of a Rodin dancer, the marvelous bronze called *Iris, Messenger of the Gods*. If you took the figure seriously, it tore you up—this terrible splayed movement, the gaping pussy. How could you calmly sip coffee under it, let alone make polite conversation? How could such a passionate piece of sculpture be reduced to a coffee-table ornament? Too naive to understand that the tragically realistic sculpture was put there to display the Motherwells' sophisticated cool, I earnestly insisted on drawing attention to it.

Motherwell, tolerant and affable, began to talk about Camille Claudel, Rodin's companion, who had been his principal assistant and probably the author of many statues signed by him and, after a heartrending life with him, had been put away forever as unstable by her own family—events very few people were aware of at the time. Her tragic interpretations of the female body, exposing inner turmoil in outer gesture, were probably a key to herself, probably self-portraits.

"Everybody does their self-portrait all the time," Bill suddenly said. "That's all everyone ever does."

We were startled. Even abstraction was self-portrait? Even Bill's storms of paint? Even Franz Kline's black beams?

"Take Franz for instance," said Bill jovially. "Take a look at that big black mustache of his and his chunks of black hair." We laughed.

"Yes," Elaine chimed in. "Just look at that straight, unbending back of Ad Reinhardt's head. It's all there. It's as straight and square as those squares in his paintings." The game went on.

"And Mark of course is a benevolent blur," Franz mused. "Every time I see him, he is hovering in full color."

I once went to Mark Rothko's studio with Rudy when he was asked to take photographs. It was in a former police academy's gym, the huge cement-floored recreation room sunk below street level, its small windows high up near the ceiling, level with the sidewalk of the Lower East Side street.

"Tell me," Rothko asked us when we walked in, "what's the weather like up there outside?"

At first I was shocked that an artist could work so cut off from outdoor reality, but later I thought that down there, as isolated as Moses on top of the mountain, he could be the better prophet. Still, he did have an occasional need for the outside world: when he had a large show at the Museum of Modern Art, he behaved like any little painter, eager for anyone's comprehension. He would hover in the cafeteria for whole afternoons, darting out from time to time to accost the attentive visitor.

"Tell me what you think," he would say. "Just tell me what you think—do you like it?"

"So we know about Franz, Ad, Mark," said Elaine to Bill. "So what about Barney Newman with those abstractions with just a fine stripe in the middle. How do they figure as self-portraits?"

"That's easy," he said. "Every time I meet the guy, it's in the Janis Gallery. It's hello and goodbye, and he's just slipping into the elevator. So the last I see of him is this long line going down the middle in the crack of the closing doors. Isn't that like his painted stuff, like a self-portrait?"

And so it went. Guston was pensive and broody, the rest of us animated and gay watching Bill and Franz baiting each other with good-natured affection, Bill less disturbing and ambiguous than usual, open to Franz's straightness. They had a great rapport, their shrewd eyes looking into each other's mischievously. They would kid each other, and then, with a sheepish grin, one would concede victory to the other for a quick repartee.

FRANZ KLINE

Franz Kline was the life of the party, talking with even wit about his past in the coal towns of Pennsylvania, around Scranton where he

grew up, as well as his art world past. With dry American hometown humor and savvy, he had too much sense to ever take himself too seriously. He was practical. He had learned craftsmanship, technique, and a businesslike attitude toward art in the academies and commercial schools in England. He lacked the elite attitude of the other painters in New York who had not been there. They were more Paris-oriented, and even if they had a working-class stance and were dirt-poor, they would show only in a fancy gallery or nothing. Franz had a sober way of dealing with situations in the art world and the ignorance of the public. He had no qualms about showing with the amateurs in the Washington Square sidewalk shows in the spring, or in humble fly-by-night basement galleries, or being hired by restaurant and nightclub owners to decorate their walls.

That night he told us about his first job. "When I was about sixteen," he said, "one day some guys approached me in the poolroom. You an artist, they said. Sure, I said. So we hear you draw good, they went on. Sure, well I guess I do, was my reply. So you want to make money? Why not? Of course I did. They took me to some big room in some crummy part of town. It had a lot of mirrors, but the walls were all mine. So I had me a lot of fun painting and splashing around, taking the nudes from my art class sketch pads and painting them all over the place—dancing and galumphing women, naked ladies carrying on with nude men. And on top of that they gave me fifteen dollars. That was big money in those days, and it was big money for a boy." He chuckled at the memory. "But when I got home, it was a different story. My father was ready to whip me. I'll learn you to hang out with the hoods, he yelled. I'll learn you to paint pictures in the cathouse!"

But of course he did it again and again, painting on all sorts of other common walls. He never slipped into solemn discussion and explanations of his own development or "search," as so many artists did and still do, which in the end all sound alike.

His generous vision, however fast and improvised his paintings

looked, was based on deep painterly wisdom and knowledge. And painting to him was also something made of solid bits and pieces. You kept your faith and thoughts under your belt—it came out anyway, for the viewer to find or not. Franz had no spiel. Of all the "boys," he was the only one who never once said "my work."

He told us how he had once been cornered by an irate man at a cocktail party. "So you're Franz Kline," the man yelled. "You fake! You phony!"

"What's the trouble?" asked Franz.

"So it's you who painted that piece of junk I saw at the Carnegie Institute, that you made them give you good money for. A prize for a piece of garbage." He got close to Franz. "Who do you think you're kidding, Mister. Now come on, smarty, tell us what it means."

Franz was cool. "Did you take a good look at the painting?" he asked.

"I sure did."

"Well then, how wide would you say it was?"

"Hmm, about six feet, I guess."

"And how high?"

"Well, maybe, say three feet five."

"Good. What else?"

"What else? You mean what was on it? Why, it was covered all over with white paint, and on that white paint was a mess of black paint, all schmears and scratches, like made by chicken feet or with a broomstick!"

Franz nodded. "Now, how wide would you say were those black strokes?"

"How wide? Maybe three to four inches, goddamnit!" cried the man in exasperation.

Franz looked him straight in the eye. "A three-by-six-foot canvas covered with three-to-four-inch-wide strokes. And what's wrong with that?"

There was everything right with it. These big black strokes, joined and dovetailing, splintering and cutting, rushing like the force of machines and transcontinental trains, like the wind in the rigging of sailing vessels, like the wake of whales, were put down in a moment of grace, when everything fell into place in one austere and dramatic sweep. This was a thundering kind of painting, mysteriously right. Of all Action Painting, it is the most straightforward and brave.

Franz was mild, but not simple. Unobserved, he was thoughtful. He had a sort of Bogart-like cool and melancholy. You felt amused and comfortable in his company. At one point I found myself talking with him in a corner. All mellow, we talked about our old and new affairs. I knew about Betsy Zogbaum. Elaine had told me that Betsy had once called her to come over to comfort her when she was madly in love with Franz. Elaine found her crying and mute, a glass of whiskey in one hand, the New York telephone directory on her lap, one finger helplessly pointing to Franz's name in the book.

Now Franz was watching one of the Ward "twins"—his present girlfriend—dancing past with Bill. I told him how when I first met Rudy, I had had an old boyfriend too, breaking off with him for good only when his old girlfriend appeared from Europe after some years. "I decided, without knowing it, suddenly, from one minute to the next," I said.

"Yeah," said Franz. "That's the way it goes. It's not so easy to start something new. You only have the guts when you get bounced—I mean the best way to start something new I think is on the rebound, don't you?"

We got up and danced the way painters did, any old way, bumping into the Motherwells' chic, plump couches, bumping into each other. I danced the tango with Franz, I danced the polka with Bill. The Action Painters were not the world's greatest dancers, but there was nothing more fun than dancing with them. Paint is thicker than water, we used to say. The next day I was black-and-blue.

THE ARTISTS' CLUB, JACK TWORKOV, AND PHILIP PAVIA

The same kind of unfocused dancing—artists dancing all kinds of old-fashioned steps or inventing crazy new ones—also took place at the Club. Not much is said about the wild dancing or the parties there, only of its talks, which were not always so very intellectual at that. The dancing was needed by people who were intensely busy alone with their own work all day and did not mix too much in ordinary society.

To get to the Club, you walked up a wooden staircase, its banisters with turned Victorian knobs. Nothing had been waxed since the families lived there. Each step, creaking and splintery, was worn in the middle and held together by metal rods that grated under your feet. Huddles of fat dust and cigarette butts were heaped in the corners. Sticks of neon light shed a gritty glare on everything. And then you heard a surf of voices from behind a door painted red. You opened it and at once were wrapped in clouds of loud talk, cigarette smoke, and coffee smells. People were dancing or arguing in knots all over the greasy black floor. Gradually the crowd, with their coffee cups, drifted toward the podium, and when everyone had settled in their chairs, someone got up. The talk was on.

This club, eventually called the Club or the Artists' Club, began as a substitute for more casual meetings all over the Village and in the Waldorf Cafeteria on Sixth Avenue and Eighth Street, where, while coffee slopped over, butts collected in saucers, and tired busboys shot us dirty looks, questions about art and life were tackled earnestly far into the night. The Club, a long, dark den of a loft, with blind windows fore and aft, was in the end more comfortable than this, and a bit more exclusive. Once a week, Fridays or Saturdays, it became a home for us all.

I went there, reluctantly, for the first time in late 1949. Jacob was a baby, and like any nursing mother, even a painter, I really wanted to have nothing to do with anything except the baby. But I had heard

about the Club, and I forced myself to go there and be with other artists again.

I found the big dark place relatively empty. Near a fireplace, three ill-matched people were trying to build a fire, cracking open orange crates salvaged from nearby supermarkets, stacking them and lighting them. Each had their own method. They argued. One was Mercedes Matter, one Landes Lewitin, one Jack Tworkov. Mercedes was haughty and infuriatingly chic, Lewitin sarcastic, Tworkov kind and benign.

Mercedes, tall, slender, and dark, made interesting pronouncements on art with a languid nasal drawl. She had no use for other women, nor did they like her, but her poise inevitably attracted men. That her father was already a painter—the semi-Cubist Arthur B. Carles—was her pride. Mercedes painted, and she founded the Studio School on Eighth Street with her friend Charles Cajori. United in their passion for Cézanne, they later broke in generations of young painters to their creed. Dorothy Pearlstein had us in stitches imitating the way she imagined they worked—bent over an invisible pad or canvas, her hand would make tender little touches, on and off, off and on, braking, hesitating, then going on and on in one staccato rhythm. This was the building of the picture plane according to the gospel of Saint Cézanne, the incessant breakup of reality into a softly brushed mosaic of little facets outlined with a willfully broken line.

That night, Lewitin regarded Mercedes with a baleful eye. Born in Egypt, he was older than most of the painters and he was not an Abstract Expressionist. When Mercedes ruined his careful stacking of the firewood, he hissed, "I wish twins on you," a Near Eastern curse. Sometimes, when people disagreed with him in an argument, he would stare uncomprehending. "Sorry," he would say, "I switched off my hearing aid." He had no hearing aid. He was erudite, spoke several languages, and was much listened to by the other painters. This crotchety man with the biting wit painted little beasties in pastel

colors. Like lizard children, they were both gay and sinister. They had something of the oblique serendipity of the later sculptures of Sidney Geist, which were similarly quirky.

Jack Tworkov was soft and worldly, a small, smiling man with a round head and a slight Polish accent that was endearing, but you never knew what he really thought. Not as aggressive as Lewitin, he was as erudite, something he did well to hide at the Club. Seemingly even-tempered and agreeable, you understood only after you knew him for a long time that he was much troubled by ambition and self-doubt and was more complex a personality than most. That almost everyone in his family was an artist did not help.

"Imagine," Jack once mused when looking at some of Rudy's New York photographs—jagged black edges of the roofs of loft buildings cutting into the sky over Manhattan streets. "Imagine a great catastrophe. And all this mowed down. From one minute to the next—lying down all their length, not casting a shadow anymore. Suddenly New York City a desert, just some broken stones, old rust and glass. And grass growing high in the streets. And tourists wandering around in all that emptiness—where was the Flatiron, the Empire State—looking for past grandeur. Imagine good old New York someday just like Egypt."

For Tworkov, a long stint in the back of Bill's studio on the Bowery was a mixed blessing. The presence of the mighty neighbor radiated into his space. For a while Bill's friendship and influence were overwhelming. It was there that Jack gave up smoking, he once told me. He often got so excited in the thrall of his first large, loose, wild paintings that "I would put my brush in my mouth and the burning cigarette to the canvas." This naturally contemplative man did not come to Action Painting easily.

After he had finished a painting that—despite the foam of color on darker, moody ground—could still disconcertingly be read as a fruit

tree in bloom, we kids from the Pyramid Group asked him to come and talk to us in our exhibition loft on Eighth Street. Unlike the other members of the Club, he was not condescending to us young ones, who were still hardly above student status. When he came, he made no authoritative statements and offered no cut-and-dried opinions but was hesitant and ambiguous, a kindness that we newly hatched painters, who were looking for sharp definitions we could follow or reject, did not appreciate.

The Tworkovs had a small but comfortable apartment on East Twenty-Third Street. No funky loft-style life for Wally, who was more or less an artist's wife. In those years, when everyone worried that they could not make a living, Jack, who was one of the few artists who also had children, worried even more. Yet the Tworkovs managed to give cocktail parties, which were always exciting and civilized, with a celebrity or two thrown in as a surprise. Not only did Wally hang up a fresh painting by Jack, but also recently finished works by others that they borrowed for the occasion or even bought. They supported up-and-coming names, but also less sensational art. When they visited me in Rome later, they bought a painting right off the wall. "You are a female Soutine," Jack said of the still life before a view of Siena.

At one of their early parties on Twenty-Third Street, a constellation of four canvases caused a mild sensation. All of them perfectly bare, they were hung so that the interstices of the darker wall between them formed a cross between the untouched linen. We all peered bewildered at the quatrefoil, each element the shape of a standard typewriter sheet. The photographer Henri Cartier-Bresson, one of the guests, French and serious, with his faithful Leica dangling as ever on his chest, studied the canvases as well. Then he scooped up his trusty instrument and began to snap furiously, recording both the strange art on the walls and the curious American art people. This conundrum of gessoed woven canvases, completely innocent of any brush, saying nothing at all, presaged John Cage's concerts composed of silence. The refusal to make signs or sounds was a paradoxical intention, exhorting us to be

good and pure. The four identical little canvases were staring black and white. The cross formed by the spaces on the wall behind them were an emblem, like one of the first American flags by Jasper Johns, which was also hung by the Tworkovs. It was the emblem of a new, still-unnamed movement.

This unusual work was by Robert Rauschenberg. After these empty canvases, he showed a full one at the Stable Gallery. It was full of earth, and the canvas had to be watered every day so that grass would sprout.

After that, in Rauschenberg's solo show at the Betty Parsons Gallery on Fifty-Seventh Street, the best work was a square of gold foil held by a pin within a frame, slowly stirred by currents of air.

Rauschenberg was little known when he left those canvases bare, but Cartier-Bresson was already the photographer's photographer.

In 1962 Jack and I were tourists together in Rome. Jack took me to the Etruscan Museum in Villa Giulia, where I had never been, though I was already living in Rome. We stood in front of a glass case full of rows and rows of terra-cotta votive objects.

"What do these remind you of?" Jack mused, pointing to a row of little triangular packages, like pockets with slits.

"Pussies?" I said stupidly. "Aren't they fertility symbols?"

"Yes, of course," said Jack, "but what else?" I didn't know. "Don't they look exactly like hamantaschen?" They did. They looked exactly like the little pastries baked in Jewish households the world over on the Purim holiday.

"You see, they aren't baked to celebrate clumsy old Haman"—Jack smiled—"but to celebrate Esther, the girl who outsmarted him, the Great Mother."

He made other illuminating remarks about Greek and Roman sculpture in other museums, and he took me to the first opening at the new Marlborough Gallery in Rome and to the right restaurant, which I didn't know. And after a delicious meal, there he stood in Via di Ripetta, a small gentleman with a stubble of gray on his round

head, with a tweed jacket, a vest, and a furled umbrella, speaking with that soft, slightly Polish-inflected English, the perfect traveler, knowing where it was at in all the capitals of Europe.

Always knowingly smiling, he did not have the pose of a master, but unassumingly made you feel he was one. All his large painting family came to his retrospective at the Guggenheim, where he received everyone with a small, slightly pinched smile among the grand array of his big, dark compositions. He had never been comfortable with Abstract Expressionism, but these muted grids in smoky grays or earth colors, these smooth surfaces, were not as quiet and careful as they seemed—knowledge as well as self-doubt smoldering underneath, the old, terrible search for balance.

Mercedes Matter, Landes Lewitin, and Jack Tworkov building a fire was my first impression of the Artists' Club. And the smell of coffee. It was said that Philip Pavia paid for the coffee. It was also said that he paid the rent. Philip was a blunt Italian American. His father was one of those stonemasons who left their anonymous mark all over lower Manhattan. With loving care they sculpted friezes on the high cornices of skyscrapers, where no one ever saw them again, and ornamented the keystone arches and stoops of brownstone tenements. Philip always insisted that his family, in a southern Italian village, spoke French, that they were an enclave of French Provençal people brought there in the trail of some obscure invasion. There are indeed Greek-speaking communities and Armenian-speaking communities in Calabria or Sicily, but I have never heard of a French-speaking one. At any rate, the humble stonemason in New York somehow managed to send his son to study art and art history abroad. That Philip had been to Paris and Milan even before World War II was revealed later, in the 1960s, when foreign studies were no longer frowned upon at the Club.

One day in the 1940s I met Bill and Aristodimos Kaldis, the big, towering, word-spouting Greek, at the corner of Fourteenth Street

and Fifth Avenue. "Let's go to Philip's studio," they said. It was an old-fashioned place, not like a loft, but rather like a proper artist's studio in Paris. It was very high and had north-facing skylights curtained by gathered white cloth attached to little metal rings running on rods so they could slide open and shut. The even light fell on a gathering of huge stone busts that had mute round heads and long noses. In their stern, monumental quietness they were as impressive as prehistoric gods. Philip himself had chunky features. He had a great bulbous nose in a mountainous, craftily impassive face, but his little black liquid eyes followed your every move. His voice could hardly be heard. He rasped, seeing us studying his sculptures, "You like them?"

Philip was also the editor and publisher of the Club magazine. It was simply called *It Is*. It was like Philip, like the members of the Club, like nothing before or since. It either said a lot or little—a magazine for and by people who understood only each other, who, imaginative and original in their art, were not schooled in the spoken word. All their utterances, stutters, hesitations, clumsy circumlocutions were printed exactly as they came, page upon page, unedited and rough, exactly as they spoke. *It Is* read like a transcript of everyday talk and shoptalk, of evenings at the Club—the voice of people who had read little and had not been to college but had pulled themselves through the school of hard knocks of post–World War II America. Without much literary allusion or sophisticated turns of phrase, they had forceful insight based on work experience. Tom Hess, the executive editor of *ARTnews*, loved *It Is* and printed long, inexorable passages from it next to the super-sophisticated phrasing of his favorite poets. He held Philip and his work in high esteem. *It Is*, the very name of the magazine, told a lot, sounding biblical in its firmness, and could mean either simplicity or wisdom. This was like Philip the man.

To what extent he supported the Club and *It Is* magazine was never exactly known, but he always seemed to have mysterious means aside from his many teaching jobs. In addition to a secret income, he

seemed to have connections everywhere, especially in Italy. In Pietrasanta, near Carrara, where I met him again in the 1980s, he seemed to have links with the Catholic church, having contrived to find accommodation in a convent for himself and his family while waiting for an old woman to be evicted from an apartment he had bought in the center of town.

Every day at noon, after a morning at work in the studio, Philip lumbered into the town square. There he stood, leaning on his silver-handled cane, black cap like a Sicilian *coppola* on his head, surveying the scene with hooded eyes—like any southern squire assessing his realm. Yet this was of course no southern Mafia-ridden village, but a tidy burg of the Tuscan north, where the marble craftsmen took the uncle from America with a grain of salt, mildly kidding him in the bar or calling after him when he limped off to the newsstand to buy his daily *Herald Tribune* from Paris. Mornings and afternoons he rode by on his moped on his way to and from his studio, wearing tweeds and high-laced leather boots even on the hottest days. The sea at Pietrasanta is only a mile away, and sooner or later all the sculptors take a dip in it, or at least sunbathe. Not so Philip. "I hate the sea," he said.

In the evening, under the bright Tuscan moon, he sat at the round table in the café, acting the guru, surrounded by openmouthed admirers, young sculptors from Germany and the rest of Europe. While the huddle of empty beer glasses grew bigger and bigger, while the ashtrays spilled over and the iron voice of the cathedral bells tolled the hours, Philip talked and talked, spreading his wisdom. The rasping whisper went on and on—there was something wrong with his voice—with the savvy and broad accent of a Bronx cabdriver. He spoke almost inaudibly out of the side of his mouth, as if giving out secret information. He was jovial, he grinned his crooked half smile in a face as chunky-featured as Gertrude Stein's. Hunched and cunning, he dealt in innuendo, bluntness, irrefutable dark statements, brooking

no contradiction—at any rate, his hearing aid was always turned off. We sat hating and loving it.

Philip's loyalties ran deep. He always stuck with all his friends, most of all Bill. This came home to me vividly in Pietrasanta. Here on this marble coast, where a welter of uninspired statuary threatened to glut your appetite for art forever, I came upon a group of little sculptures in Philip's apartment that left me breathless.

"Oh—this is alive. Who did all this?" I asked.

"Mostly Bill," said Philip. He had taken these little winged things, agitated like Bernini, straight from Bill's studio in East Hampton and painstakingly carried them to Pietrasanta to put them into the hands of just the right skillful artisan who would understand them and carefully enlarge and cast them. I had seen some large bronzes of Bill's in galleries and thought that those ungainly, potato-like lumps of striding figures were some ghastly mistake. Philip explained to me that those clumps of metal had been concocted by Xavier Fourcade, Bill's dealer, who had avidly snatched some of Bill's maquettes and had them enlarged and cast in some run-of-the-mill American foundry. Here in Italy, on a chest of drawers, stood little bodies, striving forward, fluttering like winged victories, as fresh as if Bill's shaping fingers were still hovering around them. This was true de Kooning, the painter with the surest stroke taking his measure in another medium. Next to these sweeps of quivering pink terracotta stood two glazed animals—a purple elephant and a yellow lion. I laughed out loud, they were so cunning and direct. "And who did these?" I cried.

"Lisa," said Philip. "I brought them from Nice last week."

Philip had gone there to try to take care of Lisa, Bill's daughter, and also to invite her to come and visit him and his family in Pietrasanta. She never did. I don't know if she was ever into art. But the hot innocence and blood knowledge of this thirty-year-old making solid, speaking animals with the whimsy of a child, as well as Bill's little female figures sweeping along on his immense experience, made you

forget the mindless elaborate fabrications all around you on this coast. This was real live sculpture that cut right into the basic idea of shaping.

"Great stuff, eh?" said Philip. "Wait till you see Bill's stuff cast, wait till we get a show for Lisa."

What Philip himself did on the marble coast was viewed with suspicion by the older sculptors and baffled the conventional abstractionists, but the young believed in it. Accumulation art looked too easy; it seemed to be without plan or willfully haphazard. After those early monoliths of Philip's that I had seen in the 1940s, which looked as imperturbable as Easter Island effigies, over the years his work had become a loose abstract composition of elements. Still as enigmatic as the artist himself, it was either blunt or deep. The true son of his stonemason father, Philip always had a predilection and respect for the raw stone itself. To show up its true body, he altered it little. To him this coast was a gold mine. From Carrara to Massa, from Seravezza to Pietrasanta, in the industrial marble yards and in the mountain quarries, he could select stone to his heart's content, any size, shape, or color that struck his fancy. Pieces of granite, lapis, alabaster, and all types of marble from near and far, where enticing veins or rough grain showed plainly or with softly shined sides. His rough or polished wedges, slabs or upright blocks stood erect in great huddles. In his studio were also moody ziggurats, or strange fortresses, of dense forms in clay, waiting to be cast in bronze.

One afternoon I watched Philip from a neighboring sculptor's studio. I saw him sitting in his yard under the fig tree. Before him was a wooden platform on which stood a group of disparate stones: white, black, deep green, reddish, blue, rectangular or squarish. They were off-balance but leaning together.

He sat like a bird of prey, watching, unblinking. Then a hand darted out, made a split-second shift, and withdrew. He was still again. He watched, hunched, pondered, then another lunge and change. After a while he stood up, lumbered around heavily, stretched, viewed everything from another angle. Sitting down again, he squinted, he stared.

The sun went by, the shadows of the fig leaves trembled, the sound of the hammer pierced the air. The stones were moved again and again. Slightly or dramatically, void was tuned against body, tension allowed to run free or cut short abruptly. The old sculptor calibrated, thought, was tense all afternoon. In the evening, there it stood, a constellation weighty and poised, a single movement in stone.

JOHN CAGE AND MERCE CUNNINGHAM

In 1945, after my first night with Rudy, he took me downtown on a quiet Sunday morning to have a look at his beloved Manhattan, its line of towers, from up close. I was wearing a little red dress with flowers and felt very cool and gay. As we were walking and talking and skipping in the deserted streets by Battery Park, I let my hand trail along the cast-iron fence. I had my house key in my hand, and it made a clattery irregular, metallic noise against the staves.

"You know," said Rudy, "I have a friend who makes music like that. He sticks things into the piano." This was the first time I heard about John Cage.

At the Artists' Club they bothered very little about the other arts. They let poets and critics talk to them sometimes, but did not have much use for music. At most it was something classical on records or the radio. You painted your pictures to Bach, Vivaldi, Brahms—at most Stravinsky. They liked the American pop music they all grew up with, but they kept it a secret.

But John Cage often came to the Club. The artists were vaguely puzzled by his attention to them. This dry Protestant Californian, with his almost manic grin and bright, penetrating eyes, was quite different from the warmer, moody, down-to-earth East Coast painters, with

their European, Jewish, or Italian roots. And because of his Club atten-
dance, they dutifully went to his concerts, having but an inkling of his
iconoclasm, which was so different from theirs. Though it is a fact that
at the earliest Cage concerts more painters and sculptors than other
musicians were present, it was loyalty and the Club spirit, rather than
understanding, that took them there.

So it was no surprise that he was allowed to give a talk at the Club.
Trying to introduce the painters to his way of thinking in making
music, he told them a story: "Once Merce and I were driving through
Vermont. We stopped at a roadhouse and went to swim in its pool.
Teenagers splashed and yelled around us, there was the wind in the
trees, cars whooshed by on the road. From inside the roadhouse came
some dance music from this big brown lit-up thing, this"—he hesi-
tated and looked around foolishly—"this . . ."

"Oh, come on, John," said the pianist Arthur Gold from the audience,
calling his elitist bluff. "You know damn well you mean the jukebox."
John smiled and good-naturedly went on in his high baby drawl.

"So here we were, in the dark, wet up to our necks, our heads in
the air hearing everything around us—snatches of pop song from
the Wurlitzer, the bells of the pinball machine, the kids' laughs, cars,
wind, water—all at once and at the same time. We were inside it all.
We were inside this mix. It was a piece of music."

The first time I saw John was at a birthday party for Merce
Cunningham, full of composers, at Merce's Lower Manhattan loft.
Rudy and Edwin had taken me to many parties in the music world,
and I had learned already that it was a world of men. At Merce's
party there were only men. Over all these brittle, brightly amusing
people, with their witty comebacks and sharp banter, there hung
a mystery that was new to me. The strangeness was alluring, but
there was also something cold and cliquish about it, so I felt more
timid than usual.

Then a man in a pale linen suit, who was lounging next to a zinc

washtub full of melting ice, smiled a twinkly smile at me. This was the charming, restless John Becker, who made me feel at ease. I cozily thought he was the only non-homosexual there and, despite his elegant suit, as poor as we were. Later I found out I was wrong on both counts. He proceeded to tell me wicked little tales and insights about the people around us, making me laugh despite the eerie thin-air world of so many men drinking and touching everywhere.

Near the fireplace stood two men, one being congratulated and receiving presents. Over him hung a box of pinned butterflies. This was Merce Cunningham, looking like a marvelous moth himself. I had seen him take extraordinarily light flying leaps over fences to Copland's *Appalachian Spring* when he was still dancing with Martha Graham. Here he was all furry and gangly, with long, loose limbs, like a faun or a stalking insect. His slanty eyes—under feathery eyebrows, like feelers, in a flat, high-cheekboned, quadrangular face that was slightly tilted sideways—looked at you as quizzically as a praying mantis. He was very friendly but still remote. The man next to him was all there, a foil to something aloof and secret in Merce, and to his seeming sweetness. Not long afterward, Merce and John came to the opening of my first show. Each brought me a daffodil. The two blond, upright young men coming in one after the other, each bearing a nodding flower, looked like nothing so much as a Pre-Raphaelite frieze.

The first concerts Rudy and Edwin took me to in those days, most of them in Little Carnegie Hall, with very early pieces by John Cage, Paul Bowles, Alexei Haieff, Darius Milhaud, and Vittorio Rieti, were electrifying. There was such an intense glamour to the just-hatched music that one felt acutely part of the event. The audience was made to feel special. Once, it shot through me like a high-voltage charge: this is it, we're on top of our time. I went home and painted a still life in blue, black, and yellow enamel house paints, one of my best, it was so serenely balanced. The piercingly fresh

music had carried me. (See *After a John Cage Concert*, figure 5 in the color insert.)

Today, John's "prepared piano" pieces sound mild and tinkly. Then, these eerie bits of sound would not fall into place, and something harsh, cutting, and abrasive hung about them.

John had been the first to bring to New York the new European composers he had met at the Darmstadt festivals in Germany. We heard Karlheinz Stockhausen and Pierre Boulez for the first time at the McMillin Theater near Columbia University. We were used to spare John, but somehow their dry, halting complexities left us cold.

The connection between the Club and John came through Bill. John had discovered Bill's great force, probably through Xenia Cage, his ex-wife, who had a great crush on Bill. She was an artist from Alaska with a Russian background—some even said Eskimo. Xenia had painstakingly constructed Duchamp's traveling valises: little one-man shows, all small copies of his previous work, packed and tidily organized in tiny boxes.

John gave intimate little concerts of his latest music for select groups of friends and sponsors in his walk-up apartment in the area between the Manhattan Bridge and Chinatown. The three tenement rooms on the fourth floor, once crowded with immigrant families, their children, their feather beds, and their old-world possessions, had been stripped down to essentials by the sober Californian. All was white and bare. The piano, the piano stool, and somewhere a bed, were the only pieces of furniture. The floors were covered with rough coconut-fiber matting, with extra runners of this fabric placed near the walls for guests to sit on. The bare windows, looking out over a panorama of tall buildings, bridges, and waterways, were its most splendid ornament.

Just as the members of the Club knew little about new music, John was not deeply into new painting, so in this spare place there was little visual art. But when you looked up, little glittering structures dangled

from long stretched wires near the ceiling. Tiny, airy sculptures made by Richard Lippold—each one different, each golden, each made of little crisscrossing staves of brass. Like stars or snow crystals, they shimmered with the music, trembling in the updraft of warm air, reminding you of Christmas. What John played under them came in bursts and clunks, full of mysterious halts, and though it was rough and metallic, it was glittery too.

These were his first "prepared piano" pieces, something unheard of at the time. John had taken a venerable traditional instrument, the grand piano—touched on the outside by skilled hands for centuries to evoke melodious runs of sound—and stuffed it on the inside. In the guts of its fat black belly he had stuck washers, nuts and bolts and nails, rubber rings, and string at strategic intervals. The sounds he teased from the old piano's innards were tinny or dumb; they skipped, limped, or stood still; thrilled, twanged, or bothered your ear. It was bits of silt, sand, sludge, crumbs curdled out of the air. You didn't know what you were at; you weren't supposed to know where you were at. Only later, in memory, would it fall into a logic of its own.

The specially selected audience was always polite and attentive. There were, of course, Bill and Elaine and Rudy and myself. There was Richard Lippold and his wife, Louise Greuel, a dancer who always wore long white dresses. Both were blond and somehow slightly out of it. Then there were people like deep-voiced Betty Parsons, with that confident set of her jaw and her little black dress and pearls, and other doers and makers from uptown who were potentially useful to John's cause. There was the painter and collagist Susan Weil, a dark, waiflike figure in shocking pink stockings and black Mary Jane shoes. When she and Robert Rauschenberg, whom she had met at Black Mountain College, were going to be married, they had sent out engraved announcements, something unheard of in our bohemian circles. At that time Rauschenberg was an obscure student, and at John's he was quietly taking it all in, for some reason always scratching his back.

Before Susan and he broke up, they had a son who became a

photographer when still quite young. Rudy, who rarely praised other photographers, thought the kid was exceptionally good. "Imagine," he said, "maybe someday they'll say the great Christopher Rauschenberg had a father who was also an artist, someone called Robert."

John, like most artists, and some other people who don't have to think up a meal for their family every day, was an excellent cook. He gave exquisitely simple little dinners. One of his standard dishes then was wild Louisiana rice with shellfish or chicken livers, always with very good wine. After the music, we sat on the floor, pleasantly talking and eating.

Helen DeMott, my friend from the Art Students League who always used to call John "the prepared Cage," dropped in on him one afternoon. She rang his bell, and after a long time he opened the door with a beatific smile. "Oh, do come in," he said. "I am so glad you came. I just finished a piece. It took me all day to compose. Would you like to hear it?"

She settled down on one of the mats on the floor, as listeners habitually did, and leaned against the wall. John sat on his piano stool, straightened his back, and faced forward. For a long time he did nothing. He breathed softly. Then he lifted his right hand high and with the greatest precision let one finger drop on one key. There was one note, pure and clean. It lingered on and on. After the last echo had faded and all was silent, John turned. With a radiant, satisfied smile, he bowed. Helen clapped her hands.

John, who had seen Rudy's photographs and films celebrating downtown New York, knew that an invitation to take pictures from his windows high over Manhattan would be most welcome. He gave Rudy keys so that he could sometimes come and do that. Rudy had probably gotten to know John through Edwin, and then they became good friends one summer at Black Mountain College. John would come over to our loft when Rudy showed films he had just finished. Rudy's films were "homemade"—that is, entirely shot and edited by himself with the most basic equipment. They were built on the composition of a visual pattern—after all, he was a painter—so that there

were long, still shots of elements he had discovered in the city and wanted to show us: a single fat hydrant, like a penis with its little chain; the front of a drugstore with its various ads; a lonely turning barber pole; the fine-grained slab of granite cladding a bank.

After John saw *How Wide Is Sixth Avenue* (1945), he said to Rudy, "I think I would like to write the music for your next movie. Let me know when it's finished." Rudy was very pleased. Another movie, *Under the Brooklyn Bridge* (1953), featured a lovely sequence of little boys jumping into the East River from rotting pilings. They must have been Italian or Puerto Rican, at any rate Catholics, because each one made the sign of the cross before it was his turn to dive. They were naked and outlined clearly, and when they jumped, holding their noses, their little penises swung out like the clappers of church bells in the breeze. It was a touching moment. And the great bridge and all its approaches and traffic, the many-faceted steel and stone, made a glittering background for the bemused humans. Like most of Rudy's films, it was a gentle, slightly melancholy observation of ordinary people caught moving, from close up and from afar, against the climate of New York.

But after John saw it, he shook his head. "It's too socially conscious," he said, which puzzled us. To this day I don't quite know what John meant. But "social consciousness," like today's "political correctness," was frowned upon in our newly aesthetic circles. As if John himself were not subversive. But he was shrewd. He kept his pure, far-out inventions palatable within the world of future followers and sponsors.

Rudy told me that at Black Mountain College, John had played mostly Erik Satie to his students—he adored Satie's delicate distilled wit—and sometimes the spare intellectual structures of Anton Webern. During the evenings in our loft he talked about silence. We knew that he, along with quite a few other downtown people, was taking courses at Columbia with Dr. D. T. Suzuki to learn about Zen Buddhism.

John also talked a great deal about the law of chance. I had heard about the concept from Jean Arp some years before, when we visited him in suburban Meudon in 1947. As early as the 1920s, he and his

wife, Sophie Taeuber-Arp, had thrown bits of string and shreds of paper onto a page any which way and then glued them down in the places where they fell. How could it be a "law"? I secretly thought. Later I saw that, though Action Painting was also improvisation—the painters holding up their innards, the flesh and the heartbeat of color—they still manipulated it, and they knew it. They did not call it "the controlled accident" for nothing. Later still, I wondered how far the musicians and dancers around John truly let themselves be governed by what happened in the previous moment—could not this attitude itself turn into a fixed style?

On one of those evenings with Bill and Elaine and us, John said that he had thought up a great idea for a concert. He would have twelve musicians dress in their regular classical concert suits—black tie, tails, and all, the way they did for Schubert and Brahms—and have them all come out on a stage on which would stand a row of little stools with little radio sets on each of them. The musicians would bow and sit down, waiting for the conductor to raise his baton. When the baton came down, they would switch on the radios and turn and fiddle with the knobs, tuning in to any program, any talking voice, jazz, or symphony—anything they caught—but only as long or short as the score demanded. "The written piece will be based on time alone," he said.

We all laughed. "Come on, John," we said. "You can't do such a thing." But he could, and he did. Except that the first time *Imaginary Landscape No. 4* was performed, it was placed last on a long program, and in those days most stations went off the air after midnight. So instead of cacophony interrupted by crashing silences, as intended, there were feeble cheeps and scratches of static and some shreds of overseas pop music. In a way it was shocking, but because there was so little to scoop from, it was a bit of an anticlimax.

To new music fans now, it might seem that the avant-garde music scene of the 1950s was one continuous high, and that I must have felt exceptionally privileged to have been there at the start. But the harsh

and demanding downtown experimentation could sometimes grow too much for me.

"Please," I said to Rudy, "before you take me to sit through another outlandish concert, I want a reward." So a few nights after a Cage concert we went uptown to the Met, bathing in the full glamour of eighteenth-century Mozart's *Marriage of Figaro*, perhaps understanding it all the better for our previous downtown discipline.

When John came to our parties or movie premieres, he showed interest in our own or our friends' paintings only if they were uncompromisingly abstract. But one night something arrested him. He stared hard at the little wreaths of Maine mushrooms I had hung up to dry. "What are those?" he asked with an innocent smile, affecting the air of a seriously inquisitive child.

I explained they were chanterelles, that these little egg-yolk yellow things in the shape of turned-up umbrellas in the wind were the only mushrooms without a poisonous counterpart. When still fresh, they had a juicy, semen-like smell, and they could be cooked with parsley, butter, and garlic to make a delicious vegetable. I told him that Rudy and I had gathered them on the Porters' island, Great Spruce Head, in Maine. I had threaded them with a needle in Maine, laid them out on boards to dry in sea wind and sun, and then taken them home to Chelsea to dry and shrivel some more. Eventually they turned crisp, and I put them up in jars. Later they could be soaked in water or wine for a sauce or crumbled into a fine powder to make a spicy condiment. Soon after, I heard that John had gone into mushrooms himself—that he gave lectures on them, led guided tours into the woods to gather them. He said he had given up music for mushrooms. He said mushrooms were music. Had I started all this?

John and Merce served in a rarefied air, at the shrine of purity. Never mind the pleasure of sound—it was the fresh ear, the intelligence, the idea that counted. Don't just sit there and let wicked melody, shopworn sentiment, fake opulence, music played routinely

on the same centuries-old instruments wash over you again and
again and lazily accept it. Work!

Just as Duchamp had taken the shape of the base, hot-piss-
receiving urinal and held it up as art, so John had pulled out the raw
noise we live with and rubbed our noses in it. Few have been so un-
wavering and ambitious (ambitious for himself and for his cause) or
so shrewd. Only when he had shocked us out of our dirty habits, when
the prophet had found apostles—perhaps too many for comfort—
when his relentless approach itself had become a style, did he let go.
His later works were finally lyrical.

I saw John in Rome again a few years later at a party given by the Ital-
ian composer Giacinto Scelsi—who wrote the oddest and most archaic
music of anyone—on his penthouse terrace across from the Palatine.
John wore a beard, which gave him a cobwebby and remote look. He
said he did not drink, that he was on a macrobiotic diet. There was
something absent and mild about him. We were gazing out over the
flickering torches on the terrace railing, looking at the ghostly ruins
where the emperors had enjoyed so much luxury and excess, and John
told us about his austere new fare, discussing the merits of the differ-
ent health food stores he had discovered already in modern Rome.

In 1983 there was a week of dance performances in Rome at the
Teatro Olimpico by Merce and his group, with music by John and his
young avant-garde friends. Curious, I went to the concert. Of course
Merce could no longer be as nimble; he looked like a gnarled piece of
furniture and was a tad guarded, but his marvelously knobby dancer's
feet were as sure as ever. And it did not alter his sweetness and his grace.

Merce's dancers mercilessly pointed up the everyday. They were
purposely gawky, made brief lunges and arrests, were stilted, made
little cripple movements, indulged in long halts and nothings. Every-
thing was staccato. Common gestures, like cutting beans, opening an
umbrella, putting on gloves, masturbating, were served up raw. They

never touched each other, each a clean and thinking person, asexual, floating in his or her own loneliness.

In Merce's dances, as in John's music, the found, the unsorted, and the folded hands of silence were displayed uncompromisingly to make you sit up, to make you be good and get your act of truth together. But the young dancers executing Merce's ideas at the Teatro Olimpico were too smooth, too clever; their dancing involved complex patterns as studied as traditional ballet. It was almost classical. Seeing them so brittle and cerebral, so aware that they were doing the right thing—those blond boys and girls, so chaste and interchangeable—made it unnerving and sad.

But then there was Merce, solo, like a furry old faun or stag weaving his midnight dance, a leafy oak soughing in the wind, his strange, articulate body poignantly animated, slashing bright movement into the weather. It hung there, long after it was done. It was heartrending, youth and age as one.

Later, backstage, I saw slant-eyed Merce up close, his odd features smoothed over high cheekbones. He welcomed me at once with a warm smile. John was more distant, sometimes having trouble placing old friends. His eyes were as penetrating as ever, but his smile was less fiercely artless, sunnier. After all these years of uphill fight, he was now more relaxed. Seeing these two old friends together, at ease and amiable among their admirers, it struck me that perhaps, after all, it had always been different from the way it appeared. Perhaps the hidden secret was that accommodating, gentle Merce had been the steely one, the driving force, and John the contemplative one behind him, musing and thinking, intent only on his inventions. But all this was idle speculation. As with all old friends, old partners, old lovers who have worked and lived together for so long, by now their roles were inextricably intertwined and interchangeable. They looked good together.

I told them what I liked about the evening. When I told John I liked the dog voices among the sounds, he pointed to the young composer Takehisa Kosugi, who bowed and shot me an impish glance.

"They reminded me of Alvin," I said. I was thinking of Alvin Curran's first record, the *Canti e Vedute del Giardino Magnetico*, on which our dog's voice and the voices of the neighbors' dogs had been recorded barking all through one hot moonlit summer night on a hill overlooking the Ligurian Sea.

John beamed. "Oh, do you know Alvin Curran?"

I should say I did, having lived with the man for nigh on twenty years. I nodded.

John smiled some more. "Oh, he's the best," he said. "You must tell him that." And then he added in his old languid drawl, "But I guess he knows that already."

John Cage, Merce Cunningham, and Robert Rauschenberg (left to right).
Photograph by Douglas H. Jeffrey, 1964

MUSICA ELETTRONICA VIVA (MEV)

In the 1960s I had a show called *Watercolors and Watercolor Music* at St. Paul's Within the Walls, the Episcopal Church in Rome. Alvin Curran had composed his first tape for our combined effort. While

the show was on, Alvin, Frederic Rzewski, Allan Bryant, Richard Teitelbaum, John Phetteplace, Ivan Vandor, Carol Plantamura, and others performed their new compositions.

After various concerts of this kind, the young Americans decided to form a group, Musica Elettronica Viva (MEV), and they had their first sessions in the crypt of the church. Soon the rector, Wilbur Woodhams, gave them permission to play upstairs in the Pre-Raphaelite nave. And so

Announcement for show of Alvin Curran and Edith Schloss at St Paul's Within the Walls, the American Episcopal Church in Rome, by Edith Schloss, 1966

it happened that under the floating, lily-bearing angels of Burne-Jones, the most outlandish events occurred. In one concert the composer Allan Bryant stood on the pulpit. But instead of a sermon there issued forth the most astonishing hum—a wildly archaic sound—as he swung an Australian bullroarer full force over the heads of the audience. Then, for Alvin's piece called *Slide Lecture*, we rigged up one of our bedsheets in

front of the altar, projecting on it a strange assortment of paintings and photos, among them erotic fragments.

Scruffy and full of drive, MEV began to play in Italy, then anywhere, any place, all over Europe and the United States. Traveling endlessly from gigs in factories and prisons, parks and public squares, they also recruited their wives and girlfriends to play. So once, in a pinch, Nicole Rzewski, Barbara Bryant, and I found ourselves performing with Frederic and Alvin at the Teatro Olimpico under the auspices of the Accademia Filarmonica Romana. I played on other stages in Italy, then at SUNY Albany, where we also painted and danced and hung from the rafters, and finally my moment came at the Brooklyn Academy of Music, when I had to do a solo piece specially written for MEV by Morton Feldman. I played the strings *inside* the "unprepared" piano, twanging the chords any way I wished, but strictly according to the periods of time prescribed in the score.

Cage was the respected, puzzling Californian, but Morty was one of us. Cage was tied to the earlier Club, but Morty was a New Yorker among New Yorkers. Morty's music was Abstract Expressionist only in its looseness and its pauses. Some said it was oriental, some said it was like watercolor in its severe simplicity. Yes, it was something distilled, splinters of dawn and dusk, gritty bits of the city, taut liquid drops and shining.

Morty had the bluntness and wit, and above all the down-to-earth voice of the city. Once, at a rehearsal of his music in Italy when the famous and immensely suave pianist Bruno Canino made a few too many fumbles, Morty took the cigar out of his mouth. "Boy," he growled, "if you make that mistake once again, I'll *moider* you." After that, Canino was perfect.

When Elaine was in Germany at the Städel Museum in Frankfurt to receive a prize for Bill, she heard someone behind her exclaim, "Who did this kind of shit?"

"Morty!" she cried, turning and hugging her fat friend. "It had to be you!"

Morton Feldman at the Cedar Bar (on the left is the painter James Brooks).
Photograph by John Cohen, circa 1959

And as they both gazed at a painting by Georg Baselitz, Morty squinted. "I mean, all that upside-down stuff. It's a gimmick, that's why I said shit." And when the two New York pals wandered on into

the Max Beckmann collection, he was again not impressed. "I mean, take a gander at this: a broken leg or two here, a bandaged arm there, and a cross-eyed clown can go a long way."

When I first met Alvin Curran in Rome, where he was fresh from a Ford Foundation grant in Berlin, he was ranting and raving against Baroque music. At Yale music school there had hardly been anything else. Then he had studied with Elliott Carter, which was illuminating but difficult. In Berlin, like many of his generation and other young composers who knew little about contemporary art, he saw a show of Robert Rauschenberg's *Combines* (the only work of his I really respected) and a plethora of collages. After his first Stravinsky and Carter influences, the impressionable young composer was carried away, so he came under Cage's indirect influence, transmitted via Rauschenberg's collaging, and his music opened up into the bits and pieces he had already obscurely longed for. His scores also became interspersed and ornamented with wild little scratch bursts of pen drawings in the spaces where someone was to improvise at will. Since Alvin always had to earn his living as a jazz pianist, improvising for him was nothing special.

To me, it seems that new music is always a step behind the new in art, so MEV's long, crashing improvisations, made with all kinds of unheard-of instruments—from old gas drums and band saws found in Roman alleys to glass plates and a vibrator bought in an Antwerp porn shop—were still quite Expressionist. Also they were far from the marvelously witty scramble and elegant logic based on the folk art of the jam session. And because of their traditional college background, despite themselves, those composers still heard what they were fighting against, and at odd moments some of it came up like crumbs on a bowl of soup. But at their best, the long, thick texture of their dirges— sound overlapping and boiling and going under, keening and rising, and sustained in long, intense, even serene stretches—could be deeply stirring.

While the musicians of MEV worshipped John Cage, they knew lit-

tle about the East or the minimal, but somehow they had absorbed his idea of pauses. Unlike Cage, they were already hip to the fact that, like poetry, writing music brought no money, but performing it—like jazz

MEV (left to right): Alvin Curran, Caspar, Edith Schloss, Richard Teitelbaum, Barbara Mayfield, Nicole and Frederic Rzewski, Piazza Navona, Rome. Photograph by Clyde Steiner, 1970

musicians—did. Most of all, in the thick of the spirit of the revolutionary 1960s, they understood music as political action and attack. What saved them was their intelligence, their rough, young seriousness and passion, and the way they dug into anything, played any old place, any old way, gloriously grubby and full of life.

After I started living with Alvin, I traveled with MEV and even performed with them, which was how I met John again, at a modern music festival in Palermo in 1968. Baron Francesco Agnello, the great Sicilian patron of modern music, had organized an avant-garde event for that winter-bleak, Mafia-haunted city, with its black-eyed, half-clad children hovering under palm trees and derelict palaces, its

pharmacies and herb tea stalls at every corner, where the difference between rich and poor was more cruelly blatant than anywhere else in Italy.

MEV was the only hippie element in a festival of otherwise conventional new music. But after a week of tedious and convoluted pieces by new Italians, while MEV climbed all over the rafters of the Teatro Politeama and created other mischief, when it became MEV's turn to perform, having exhausted themselves in pranks and continuous highs, they played little that was memorable.

But then there was John Cage. On New Year's Eve, his *Winter Music* was to be performed at the nearby Teatro Biondo, and he had asked Alvin, Frederic Rzewski, Richard Teitelbaum, and the English composer Cornelius Cardew to take part. The audience, Palermo high society wearing proper evening clothes, filed in. They sat respectfully while the regular instruments began to play some rather irregular music, but when hirsute foreign young men in ragged jeans began to climb over them to open the high windows of the hall one by one and let in the cold air, it was too much.

"*Scemi, cretini!*" they shouted furiously. "*Fermate quei hippie contestatori!* Jerks, idiots. Stop those hippie protesters," they yelled, indignant at what they thought was a political interruption of a very expensive concert. Only after gestures and pacifying smiles by John did it dawn on them that this had been planned and they had mistaken collaboration for sabotage. Shivering and meek, they settled again in their red plush seats. It streamed over them—the cold winter night, the car horns and first gunshots hailing in the New Year, the ships' sirens from the old harbor outside, and inside the *plinkety plunk, ping, ping, ping, plunkety, plunk* of the strings—everything mingling, making a live fabric of sound just as John had intended. It was so vibrant, the audience felt it at last and stood clapping for a long time with southern enthusiasm.

Afterward, backstage, I saw John again up close. Frederic Rzewski, always eager for music people to get to know each other, attempted to

introduce me to John. John stopped him. As always, wearing his old singleness-of-purpose smile, he languidly drawled, "Edith and I are old friends."

Lots of pieces later—*Litany for the Whale, Thirty Pieces for Five Orchestras*, slam-bang vast radio station events, some of the old squeaky dirges, some like Gregorian chants, some like improvised jazz, some even melodious—when John did not have to try so hard any longer, he could afford to dive straight into straight music. Or was it just me who once heard the pieces as necklaces and quilts of sound? When we met up again in New York, I heard them as sheer music. This was in the spring of 1991 at the Bang on a Can Marathon, a concert of young composers at the La MaMa Theatre on the Lower East Side.

John's eyes were as bright as ever, but not so searching, the smile still really nice. His throat was as crumpled as his gray work shirt that opened to it, which was disarming. There was no trace of coyness and that unforgiving dry charge anymore—it was long since he had had to go against the grain, all was easy.

He was on a high bench in the back of the wood-beamed, rather rustic theater, dwelling in a hush of respectful silence and admiration. He sat looking forward, calm and benign. The pieces unfolded. They were long, they were complicated. If there were silences, they felt suffered and stilted. If there was a stormy gesture, it was premeditated. The electronics were too loud, the drumming too long and heavy. There was little raking through to clarity. Anything wild was not wild, it was style.

Was that John's legacy? The audience believed it was. They, the composers, the performers, the artists, either just over thirty or into their fifties, seemed a family. They wore grungy work clothes, very odd or very ordinary hairdos, and the audience was in chic international black. They all wore smug little smiles, which said they knew where it was at.

John had always been tolerant. He had always encouraged younger musicians. His presence here proved it. But wondering how far this

went, I went up to him after the concert. I looked into his rugged, complicated face, now more rugged and complicated.

"John," I asked, smiling, "how did you like the music?"

He smiled back. He looked me straight in the eye. And then wicked old John drawled, "Folk art, don't you think?" And grinned gleefully. Both of us, misted by all those years, for a moment glanced at each other in companionable merriment; then a crowd of young people, wanting to hear every word he had to say, blocked him from my view.

After John Cage died, in 1992, I was in Pietrasanta. On a fine summer morning, idling away some time before a dentist's appointment, I walked into the old cathedral. It was empty. Minor medieval and Renaissance artifacts rose mellow white in the soft gloom, and the sweetish smell of stale incense hung over it all. A swath of sunlight full of old dust motes shed on a rack of lighted candles for the dead. The alms box underneath waited for contributions. Not a Catholic myself, but enjoying ritual, I often lit candles in Italian churches. (Nowadays few offer wax ones; most are electric, and as Helen DeMott always said, God does not like to listen to switched-on candles.) Without thinking, I was holding the wick of a fresh candle to a burning one, sticking the newly lighted one back on its spike on the rack. Who did I light it for, I wonder. For John, of course. Protestant, Zen Buddhist, Taoist, or whatever, I think he would like it.

I stand looking into the little yellow heart of flame. I hear things. In the back of the cathedral the cleaning woman and the sacristan have words. She bashes around her pails. He slams a door. Then a pigeon under the eaves unfolds its wings with a metallic whirr, saying *courrou, courrou, courrou.* Outside, a Vespa takes off across the piazza with a roar; someone skips by, singing "Unforgettable." A block away, a train clatters through the station on its way to Leghorn or Paris. And from the plain, a mile away, comes the whoosh and drone of cars and trucks traveling on the Aurelian Way. Behind everything is the snore and snuffle of the mills, eternally sawing marble. What a nice concert. Thank you, John Cage. But for your teaching, I might never have heard it.

FRANK O'HARA

Frank O'Hara, a new American poet, was one of the most assiduous visitors to the Club. This young man, with his nose out of joint, wiry body, and blue eyes, took on the Club as if it were a baseball team, with rapid talk and smart comebacks. The painters were intrigued by his liveliness and the generosity of spirit with which he would tackle any question. He had never been to Europe, but he wrote the introduction to Edwin and Rudy's *Mediterranean Cities*. He had never studied the Renaissance, but he lectured on it freely at the Club.

"Now, take the portraits of Parmigianino," he drawled nasally, lingering over each syllable of the minor master's name. "Take Parmigianino . . ." he tenderly repeated.

Afterward I buttonholed the dapper Frank. "What's with Parmigianino? Didn't you mention him only so you could pronounce that lovely Italian word?"

He grinned ruefully. "Well, natch," he said.

Then there was his dancing. Everyone milled around the Club any old way, but not Frank. A superb dancer, he made you feel like one too when you moved with him. I am usually a very clumsy dancer, but when Frank pulled me to him tight and hard, it felt elegant and sexy, as if I'd never danced before. Once, as we were gliding cheek to cheek, he breathed, "Ah, dancing with you like this, it's like a night with Lotte Lenya."

Dazzled, I stammered, "When did you meet her?"

"Never," said Frank.

His extravagant praise of Jane Freilicher, whose paintings were in the wake of Fairfield Porter's, was hard to take. If Elaine was the queen of the painters, Jane was the queen of the poets. It wasn't so much natural jealousy that irked me most, but all that New York chic. Sometimes Frank's poems were too New York chic, too inbred and exclusive, intelligible only to his "in" friends.

He wrote one of his best poems for the marriage of Joe Hazan to

Jane Freilicher. It was about a downtown walk, visiting the sights all three had in common, in the end trying to reach for the neon ring flickering over the door of the Cedar Bar. Occasional poetry is always more tasty, and Frank's, full of oddments and candle ends, was his best. Then he cherished and touched sharp bits of city life as they came, making the stale and dreary turn quicksilver for a second: fire escapes and bathroom shelves, supermarket cans and the green down under an armpit and a window full of roses. Like Jimmy Schuyler, he freely espoused the touchable and smellable right under his nose, the grit and weather of Americana long before Pop Art found it.

Frank and Jimmy Schuyler were penniless poets. To make ends meet, they worked at the desk of the Museum of Modern Art selling tickets and postcards, but their miserable job was not without interest. Of course they liked to say hello and chat with their painter friends before and after their visits, but mostly they were intrigued by the teenagers and their unexpected tastes. They noticed that Pavel Tchelitchew's *Hide-and-Seek*—an oil of half-transparent children playing around a huge oak, their veins showing in their tender skulls—and *Christina's World* by Andrew Wyeth were by far the most postcards sold.

Christina's World is of a huge dun-colored pasture sloping up to a weathered Maine barn on its crest, a teenage girl lying in the tall grass in the foreground, reaching up. I realized only years later that this girl was disabled. The model for the barn, the real one, stood next to my friend Lois Dodd's place in Cushing, Maine, and she told me that year in and year out, people came on pilgrimages to see it.

Both *Hide-and-Seek* and *Christina's World* were haunted by a surreal, slightly sinister look. Too figurative and explicit for the sophisticated museum visitor or the painters from the Club who paid no attention to them, these two oils were by far the most popular with ordinary people. It gave the poets food for thought.

For the poets, another way of making a precarious living was art criticism. It may have been Fairfield Porter who thought of this first. He took John Ashbery to see Tom Hess at *ARTnews*, although Tom

did not hire him at first. Later John Ashbery, wild Frank, dear Jimmy, and Kenneth Koch were all taken on. It changed the magazine.

Frank, much more interested in pushing words around than in feeling out paint, had more fun than anybody. Sometimes he was so outrageous he could be downright annoying; at other times he was acutely brainy or hilarious. Relentlessly cheerful, he knew an enormous number of people, and he had the knack to turn the banal into the lyrical and to make everyone feel that they were his own special friend. At times I felt that his friendliness to me was really not so friendly—I was female, and he moved in the classy, thin air of his clique, full of private passwords alluding to pop songs and brand names, to Americana games and rules I couldn't relate to. But like everyone else, I could not resist his beckoning, jolly niceness. Like everyone else, I wanted someday to confess everything to him.

After I left New York, in 1962, I had a difficult time in Italy, with many ups and downs. In the back of my mind there was always the thought: someday I'll go back to New York, lean my head on Frank's shoulder, and tell him all. Then we'll have a good laugh. It was not to be. One day in 1966 a postcard arrived, with a Delacroix watercolor on one side and a scribble on the other. It was from Trumbull Higgins in Long Island, the husband of the poet Barbara Guest: "Today we are burying Frank." It took me a long time to understand this.

I see Frank as in Larry Rivers's picture. A small, boyish man with a broken nose, terribly pink and bare all over, standing defiantly in battered boots, so tough and so fragile. (See *O'Hara Nude with Boots*, by Larry Rivers, figure 6 in the color insert.)

JOHN ASHBERY AND JIMMY SCHUYLER

John Ashbery was Frank's great pal. One day Rudy said, "Let's go down to the Cherry Lane Theatre tonight."

"Oh, no." I sighed, remembering the *Blithe Spirit*–type plays with mediocre old actors and the semi-avant-garde performances that were usually put on by the little theater in the Village.

"This is different." Rudy smiled. "Edwin says there's some fantastic rehearsing going on down there, a wild woman has got ahold of John and Frank and has them standing on their heads."

When we got to the theater that night in 1952, we saw she really had. At the right side of the stage were Frank and John on their hands, looking wild-eyed into the audience from between their legs. Then they jumped up, their hair standing in tufts, and wielding two mops, they crazily recited disconnected sentences while Judith Malina coaxed them, pushed them, screamed at them. She was directing them and other brilliant amateurs in Picasso's *Desire Caught by the Tail*. Wild and ornery, Judith was at the beginning of her powerful career, but already as astute as ever. She had caught John and Frank's act—they were like Tweedledee and Tweedledum—and had used this for her own purposes. Each was straight man for the other's jokes, each egged the other on, each affected a thin, high, nasal drawl. John was taller than Frank and looked down his nose. He had a Punch and Judy profile, a turned-down mouth between beaky nose and beaky chin, which gave him a haughty air. Probably this disdain was a bit of shyness—which, in Frank's case, by contrast, was totally masked by flamboyance and outgoing passion. It was a hedge, a feint to hide his privacy.

When John Ashbery was with Jimmy Schuyler, it was as if they had a secret. Jimmy's obliqueness, covering old hurts and an unacknowledged past, was thick and strange, and he was even more guarded than usual. He said so little you felt embarrassed in his company. Once in a while he let out a sentence that was so sweetly pungent and bright, it cleared the air like lightning. But it all really came out in his beautiful written words. (See *Jimmy and John*, by Fairfield Porter, figure 7 in the color insert.)

Jimmy, even more than John, Frank, Jane Freilicher, and Kenneth
Koch, had an obsession with American brand names. Maybe this
was something stuck in his childhood memories, that moment after
the privations of the Depression, when plentiful junk food suddenly
meant safety and new comfort. Alluding to brand names or popular
songs did not go well at the Club, most of the artists being children of
immigrants or immigrants themselves, all of them aspiring to high
culture. They did not realize that this pride, this imagery based on or-
dinary foods and household products, was the harbinger of Pop Art.
Which was just as well, because later they hated Pop Art. Even the
old Club artist Philip Pavia would sit up as though stung by a bee
when he heard the term. A generation later, other poets, mostly Clark
Coolidge, used American food words and labels like their bread and
butter—well, peanut butter—with a vengeance.

It might seem odd that John's words, with traces of the folksy and
the everyday, should have been chosen by Elliott Carter to go with his
music. But if you look at them both, Ashbery and Carter have a sim-
ilar attitude au fond, an American respect for civilized sincerity and
the European past.

In Paris in the early 1950s, where we spent some time with John,
he was more open and natural. He lived with Pierre Martory, a stocky
young bullet-headed Frenchman, and wrote art reviews for the *Paris
Herald Tribune*. It was still the time of Existentialism, and Pierre wore
black, like the Existentialists, but was always to the point, bright,
and cheerful. I needled him about the relentless theories that were
still in the air. I only vaguely understood the bleak philosophies of
Kierkegaard, Karl Jaspers, and so on, but somehow felt they were reek-
ing of brimstone, biblical exhortation, and austere Nordic puritanism.

But Pierre's basic bleak views did not stop him from liking good
food. Both he and John smoked cigars and went to good restaurants.
They took us to special ones, once to a Belle Epoque establishment
resplendent with curvilinear brass accoutrements, opalescent lamps,
and glass partitions.

John smiled at the food pleasantly and sometimes made mild jokes with Pierre. He said nothing about the Paris shows he had seen, unless really prodded, and even then talked about them only in a muffled, oblique way. You could never pin him down. His writing was dry and factual and at times witty, but you could never tell if he liked or didn't like an artist. John never really declared himself like the rowdy rest of us.

In Paris he got the idea to write about Jean Hélion, the most controversial painter of the moment. When Rudy and I were in Paris in 1947, it had been quite easy to visit painters in their studios. Now, in the 1950s, things had changed. But being friends with a critic on the *Paris Herald Tribune* certainly helped.

So when John decided to write about the suddenly notorious Hélion, we asked to go along this time, and John did not mind. Nor could he say no to Harry Mathews and his wife. Mathews was about to publish a poetry magazine, *Locus Solus*, which would include some poems by John, Raymond Roussel, and himself.

Hélion welcomed us gravely. He had had a difficult time as a prisoner of war in Germany, and now he was in trouble with the Paris art world. He had been known for his bright abstractions in primary colors, half-rounded shapes or slices and wedges, and little commalike touches nudging one another in precarious but interesting balance. But he had recently turned to the figurative. He told us that in the Paris art world this simply was not done. The abstract painters treated him like a traitor. They crossed to the other side of the street when they saw him coming and refused to greet him.

His apartment, like most Paris apartments then, was damp and dark and chilly and smelled of onions, celery, and cooking gas. Oddly, on some walls were little half-primitive paintings crowded with curious gingerbread people, and tumbles of quilted vests, gypsy skirts, and scarves were thrown here and there over the chairs, a sort of melancholy disorder, surely not caused by the austere and neat Hélion. Something unspoken and sad hung over the musty apartment, and only

later did we find out that these were traces of his unlucky wife, Pegeen, Peggy Guggenheim's daughter, who later died by suicide.

The grayish kitchen was the studio. On its big table was a display: a big pumpkin sliced open to its innermost orangeness, onions trailing green shoots, apples, mouse-brown jugs, common enamel utensils, and, over the edge, a green umbrella and a wrinkled raincoat. All this was in the process of being soberly rendered on the canvas on the easel. Hélion was giving the "real" shapes the same care he had given those of his abstractions. But the color was different. Instead of the flaglike brightness of his former blues, reds and whites, and lacquer blacks, there was now much green, beige, and some orange. Everything was muted, scraped down to a smooth, dry soberness. It was decent, highly skilled still-life painting. That it wasn't abstract didn't bother me, but I minded that the splendidly composed decoration was as cold as the marble top of the kitchen table it was presented on. The cheery abstractions, with all their small mistakes, had been more human.

John seemed to find everything reasonable and to like the new noncommittal stance. The rest of us were slightly put off. As we went down the steep, winding stairs, we all animatedly discussed the work we had just seen. John only smiled amiably. Mrs. Mathews was the most excited of us all. This had been her first-ever studio visit, the first famous painter she had seen up close.

Mrs. Mathews had been a cover girl for top American magazines. I admired her ease, her slinky walk and poise, always wearing the right clothes on the beach, at cocktail parties, even when shopping in the Village, or as a distracted mother in the parlor. She was blond and beautiful, but always a little wistful. She said she had had a sad and difficult childhood, her father molesting her in the bathtub. Her father was a French aristocrat and her mother an American heiress. She had been brought up in Paris and New York. She did snippety-frippety little collages that I couldn't quite believe in. Her husband, Harry, had tiny ears and wished to be taken seriously as a poet and publisher.

Later in Paris, we went to select restaurants with the Mathewses a

few times, until we discovered that, after they lustfully tasted course after course of rich French food while we timidly tried a little, they expected us to pay exactly half of the exorbitant bill. Their Lost Generation stance amused us to a point. Leisurely and infuriatingly elegant, traveling, drinking, and eating a lot and always on the edge of being "creative," the two tall beige Mathewses appeared like a latter-day Fitzgerald couple.

After she and Harry divorced, she met and began to live with one of the most amusing artists around—Jean Tinguely. He was Swiss and had done his military service together with Rudy's brother Lukas. His new companion was the first to wear pantsuits at the Paris Opera, in white silk, of course. In front of audiences, the two of them began to shoot bullets at little paint-filled rubber balloons that were fastened to canvases, so that streaks and tears of paint spilling down could make pictures all by themselves. This was at a time when the aleatory was just beginning to be exalted by John Cage and was still practically a secret to the world at large. Later she worked on big, puppety sculptures in shiny color, and I still don't know whether I like them or not, they are so brash. Today, when Hélion's name is hardly on anyone's lips, the ex–Mrs. Mathews is notorious the world over for her big park full of hilarious monsters. She is none other than Niki de Saint Phalle.

Years later, after I had settled in Italy, I met John Ashbery again at the Spoleto Festival. He had come as an art critic. I hardly dared to approach him, he was so well-known. But we soon found ourselves having our caffe latte on a platform in front of the same little café every morning. We sat like old pals, making comments as we watched the music people going to and fro on their way to rehearsals and concerts. John's were quick and witty and sometimes so drily to the point they made me shake with giggles.

After the *Paris Trib* and *ARTnews*, he wrote art reviews for *New York* magazine. He came to all my shows dutifully, looked at all the

pictures kindly and carefully, and often stayed quite some time, but he never wrote a word. Once, at the Ingber Gallery, I complained to him that a critic had written that my painting was "semiabstract." "I don't want to be semi," I said. John looked at me slyly. "Isn't all life semi?" he wondered wisely. And we cracked up.

KENNETH KOCH, ALLEN GINSBERG, AND DENISE LEVERTOV

Did Kenneth Koch too stalk around the Club? Like all the other poets, he had a way of drawling his fancy words and looking down his nose, though he usually grinned gleefully from behind his glinting Harold Lloyd–type glasses, scattering American colloquialisms as if they were set in quotes.

One summer in Rockport, Massachusetts, he was young and carefree, as we all were, crowding around George Morrison's and Al Kresch's avant-garde art school in a loft over the harbor. I was taking a breather from living with Rudy so intensely, or he was taking a breather from me.

After living together for a year, Rudy, always attracted by the South, had followed an invitation from John Cage to visit him while he was teaching at Black Mountain College. I had headed north, to the Porters' island in Maine. On my way, I spent some time with my pals from the Art Students League and the Jane Street Gallery, one of New York's first cooperative painters' groups, and with some poets in the old fishing port on Cape Ann, all of us on quite a different keel from the usual summer inhabitants of that sleepy village, with its white clapboard houses and steepled thin churches. There, on any bright morning, sitting on stools on sun-dappled lawns under the elms, ladies and older men in straw hats and blue smocks tenderly devoted themselves to painting motif number one: the New England village. Or, on their flimsy easels, they painted motif number two: the New

England harbor, with its jogging dinghies reflected in the water and the multicolored lobster buoys in bright contrast to the weather-grayed boat shacks where the buoys were strung. Everything was rendered in timid greens, bits of yellow, and a few more daring reds and blues, Post-Impressionist daubs that were a far cry from the sharp shapes and spurts of rough paint the rest of us practiced and concocted in the same town.

In this lovely blue summer, aside from the swimming, there were a lot of reckless parties. After one, I found myself in George Morrison's bed. This old pal of mine from the Art Students League, the Chippewa from Minnesota, was a terrific swimmer. We got up to splash in the middle of the night in the moonlit harbor—to discover by the light of dawn that we had been swimming in puddles of shimmering machine oil and splinters of wooden flotsam. George's bulk and buoyancy gave me enough confidence to swim out with him into the open sea beyond the lighthouse, my longest swim ever. But sea swimming was out after we discovered the abandoned quarry in the woods.

This was where Kenneth Koch hung out, writing. It was a huge amphitheater of granite shelves descending to a big, square natural pool, an enormous black hole filled with deliciously soft and pure rainwater and water from deep upwelling underground springs. We dived into the all-enfolding cool wet again and again and then basked in the sun on those coarse, square-hewn steps going up to the edge of the leafy green woods. We were diving and lounging like the picturesque groups on a Bazille canvas. And Kenneth, prince here, stalked up and down the steps on his knobby, stork-like legs, lording it over us. Spectacles glinting, grinning, and declaiming, he scattered amusing sentences and bits of lilting poetry until all the females had a crush on him, especially one in particular, Robin, a folksinger. Stretching out on the stone in a fine reclining pose, she always gazed up at the poet adoringly. He wrote a poem to her. When I told him I liked it, he responded haughtily, "It's in the manner of Swinburne," expecting me not to understand.

I was always impressed by his deft use of heartland American expressions, and I have always admired that cutting epithet he used in the text he made for one of Rudy's documentary-comedy films: *pissant*. For a long time I believed like the rest of us that he was a genuine Midwestern boy. Then I was surprised to learn that his parents were Jewish immigrants from Europe, like me, and I realized that this accounted for a certain stiltedness, the feeling that everything was in quotes after all. His wit and his manipulation of words, as if they were delectable toys, were intriguing, but later, especially in his plays, his humor seemed recherché and self-conscious. But he did achieve something marvelous with children. As a teacher in slum schools, part of the New York City Poets in the Schools program, he was able to touch a clear hidden spring of innocence in which the children bubbled up with sparkling bits of insight and unsullied underground wisdom.

There was another poet in Rockport that year. He spent all summer sitting on a lawn in front of the white house rented by Helen Parker, a tough, cheerful redheaded journalist who had been John Dos Passos's secretary. She had two wild Irish sons who played baseball on the lawn all the time, dressed only in their nightshirts.

The young poet, who was Helen's boyfriend—black curly hair, his shirttail trailing over his jeans—was usually sitting morosely on a folding chair, watching the boys or staring down at the grass, smoking pensively. I did not know then that what he was smoking were joints. Besides sitting mute on the lawn, he spent the rest of his time in the attic writing poetry.

Much later, I heard this once-sullen boy shouting his poetry at a reading at NYU. His voice was loud and harsh, and he amazed us with his shocking language and great pounding rhythm. The black-curled youth was Allen Ginsberg, declaiming *Howl*.

Denise Levertov was reading with him that night. She was considered one of the Beats, though she was not like them in spirit, only of

the same generation. Always breathless when she rushed into a room, into a conversation, a situation, she was as enchanted as a child coming upon everything as if for the first time.

Her luck was that she'd never had conventional schooling. Her father, a Jew, had come from Poland and had become an Episcopalian bishop in England. Her mother, a schoolteacher from Wales, taught her at home. Later she studied ballet in London. There, after the end of World War II, she met Mitch Goodman, an American G.I., and went to live with him in a Genoese fishing village, where he finished his first novel, *The End of It*, before moving to Chelsea in New York.

Denise looked at everything with a clear young eye: America, the live world around her, her own intimacies. She took them in her hand and turned them over and made them into a few liquid, bracing sentences. She let her men, big and little, have a bit too much of their own rights—after all, she followed the extra-permissive British style and was unusually generous. Though she took them and the household in her stride, it was writing that was her true nature. Later she became involved in the issues of her time: feminism and the anti–Vietnam War movement. Someone once wrote that her later, explicitly political writing was less political than her early poetry, her true political voice. Denise, you were always so fresh and breathless, I hope you stayed that way.

CRITICS AND ARTISTS

POET-CRITICS, ARTIST-CRITICS

Jimmy Schuyler was the most perceptive of the poet-critics. To me he was also the most lyrical of the poets. His sweet intuition, his poignant look at the everyday and at nature, and his plain, even voice were ravishing.

This quiet and beautiful poet came to Provincetown with Edwin one summer. They rented a shack near ours, not far from the gentle hollow in which stood the pump that supplied us with our three daily buckets of water. After their shopping sprees in town, Jimmy gleefully recited the various brand names of the food that they had bought. This love for Americana and popular art, which always appeared in his poems, was still unusual then. He wore L. L. Bean sneakers, busied himself quietly, but said little. His face was friendly but closed. Near their shack, Jacob found little seed balls in the sand; they had sprung open in a fringe of triangular shapes on which they stood. Jimmy liked it when Jacob called them "little secrets on tiptoe." He liked it less when I had to drown a baby rabbit, badly mauled by our cat, in the pump pail.

One late afternoon when the dog roses were blooming, I got to the pump while Jimmy was drawing water. Different kinds of lacy tracks—of snakes, gulls, or rabbits—had converged on the water hole.

Little yellow-green finches alighted on our pails and giggled madly. To the west, the red sun was setting; to the east, the white moon was rising—the two lights mixing in unearthly airs—an eerie moment between days. The dunes became a pale yellow, the roses a floating pink, and we watched everything slowly sinking into smoky purple.

The poets were marginal at the Club. With their airy, knowing ways, they were tolerated because they gave it a sort of cultural veneer. As poet-critics, however, they were grudgingly welcomed because they could be useful. Their praise, most often beside the point, was itchingly accepted.

The artist-critics were another matter. They had an equivocal position, an uncomfortable distance, and an unspoken suspicion and dislike hovered between them and the rest of the Club. It must be admitted that there is one thing in their favor: who but another artist, writing reasonably well, is at all tuned in to a fellow artist or can guess what she or he is about? The artist-critic can slide under the skin, under the technique, the outlook, the pain or joy, because they have similar struggles. The drawback is that they may fall into unconscious preferences, may be particularly drawn to work close to their own quest. But that is minor in comparison with the special understanding born of fellowship. An able artist-writer puts a probe into another's well of creativity, pulls it out, and regards its sparkle or dullness from all angles. Elaborating on the sparkle or shining up the dullness a bit, he or she then brings out the artist's own special thing, the main root and intention, cutting it open, with wisdom, for all to see. Best of all, an artist-critic is more intimate, can project into the artist's aims and wishes with a special insight and thus even nudge the artist in the right direction, though this is rare.

Virginia Woolf once wrote that she was always hopelessly waiting for the ideal review, the one for her, the one in which she was taught sharply what she was about, that saw her work from the outside and gave a great big push for her to get better. When I was having my first solo show, I eagerly ran to the scrap sheets of the reviews tacked up in

the *ARTnews* office. Jimmy had written a review about my paintings. He wrote nicely about gleaming pots and jugs, sprigs of wildflowers, the sea, all that was there to see on the surface. But he didn't write about what was in them. It was not enough. He didn't show me the way to go on—that nearly impossible thing you hope for time and again. I was disappointed. Later, when I read the review more calmly, it was really quite nice. But it wasn't the praise and insight into what I did that I had expected and still expect. They never understand you, never.

The run-of-the-mill artist-critic's review is good writing, good praise, nicely aired views. At worst, it gives lame approval or is spiked with irritated little smarts. But most often it is comfortably sympathetic and knowledgeable. There is a hitch: power. Ordinary artists hardly ever get to have a say. The artist-critic, sitting on both sides of the fence, can say anything in print, air opinions, judge fellow artists in public. And that is a dirty business.

In Europe, artist-critics are considered weird and a nuisance, although in the 1920s there were such sober and intelligent art writers as the Metaphysical painter Carlo Carrà. This is because, by tradition, the role of the critic is strictly defined. The camps between art and criticism are severely divided; there can be no fence-sitting. The critic is a political—even a party-political—creature, and the artist must be his passive tool.

In America, a review, even at its most interesting and entertaining, has hardly any influence on market value. In Europe it most certainly does; there, the critic, not the gallery, is the mediator between the artist's work and the public. The artist is practically in his thrall—the critic may very well decide how and what the artists create and where they show. The critics propose ideas and create trends deliberately. They have a direct influence on the artist, the exhibition, and market activity. In Europe the critic is an intellectual as well as an entrepreneur. In America, when artists meet and want to sniff out one another's style, they ask politely, "What gallery are you with?" But in Europe people quite seriously ask, "What critic is behind you?"

Art writing for the artist who also loves words, who looks at art and loves it, is one of the most quixotic of activities. For it takes much longer to put what you have seen into a few pithy sentences than to paint what you want to paint, to paint your whole painterly experience in one grand, happy rush on canvas. For people like me, painting, despite heartrending struggle, is a letting go. Art writing takes away from your painting time and is miserably paid to boot. In the end, painting done in all its fullness fetches a far greater price.

Art writing is like embroidery, knitting, or another painstaking craft. Pushing words around gives you the satisfaction of a craft well done. You get your wits together to write as intelligently and amusingly as you are able to. Its greatest reward is this: while your art may languish away in the studio, your art writing bursts into the daylight and functions in public. Immediately in print, it serves people, neatly fits into everyday activity. At its best it is a signpost to the viewer, to show her or him how to appreciate things anew, to stir up fresh perception.

At the Club, there were the artist-writers: Hubert Crehan, Lawrence Campbell, Sidney Tillim, Manny Farber, Rackstraw Downes, Louis Finkelstein, myself, and others. There was also Maurice Grosser. But there was never anyone as fair and acute as Fairfield Porter. His abrupt and unexpected revelations, his fearless pronouncements, were brilliant. Because of the cool air of his private thinking and his unusual erudition, he unerringly got to the core of the work of art presented and put its meaning into a few pungent sentences.

But in the end, after the poet-critics and the artist-critics, the regular critics, feared or liked with reservations, counted most at the Club. They were always regarded with suspicion but undiluted respect. David Sylvester came from London and preached about Alberto Burri and Alberto Giacometti, but few bothered to argue with him. It was the local critics who were attacked vociferously, no holds barred. They were after all the ones you had to deal with. There was Irving Sandler, who was rather liked because he tended to be flattering. But Clement Greenberg

stood out. His was close to the kind of highly influential art writing practiced in Europe. With coldly opinionated and sometimes arbitrary propositions, he tried not only to interpret but to categorize and mold existing trends. His intellectualism and his way of tempting submission irritated the artists. Bill simply called him "Clemberg."

HAROLD ROSENBERG

It was different with Harold Rosenberg. He was the kingpin of the critics at the Club. He had more understanding and sympathy for what the artists were up to than most. He was their champion. That his thinking was colored by Marxist logic, just after the artists had freed themselves from the pieties of social consciousness, was not held against him. His writing was to the point, alive, and shot with analytical insight, even if, as an intellectual, he wrote on top of the art, not from inside it. He had the sharp, quick wit of a *New Yorker* writer as well as the slyness and diffidence. His knack of inventing catchphrases surprised the artists themselves. Who but Harold could have coined such a tauntingly expressive term as "Action Painting"? (See *Harold Rosenberg #3*, by Elaine de Kooning, figure 8 in the color insert.)

A tall, lumbering man with a slight awkwardness, he looked down with probing dark eyes and a little good-natured snort under his mustache. He was slow moving, weighing his words, and generally reticent. His wife, Natalie Tabak, a writer, had a big air about her too and—with jagged features and a wild black mane, in black caftans and swinging beads—was more flamboyant than he was. At their lively parties in their first-floor apartment near St. Mark's Place, there reigned the high, thin air of intellectualism and a fervid faith in abstraction. It intimidated me—then a figurative painter in the footsteps of the intrepid Fairfield Porter—to such an extent that when asked what I did, I would demurely reply, "I use the typewriter," meaning

I was writing. But of course that led people to think I was a secretary. Nevertheless, feeling like a sort of under-the-bed painter among them, I left it at that.

After you climbed up the stoop of their brownstone, you immediately found yourself in rooms chock-full of small paintings. These were works by people the Rosenbergs knew well, some given as gifts, many bought. Each painting had a special meaning for Harold, either because he liked the painter or because it intrigued him, or both. It was an extraordinarily idiosyncratic selection. Meaner collectors are motivated by speculation, by dumb guesses as to whether "their" artist will be successful; they collect work and treat it like trophies. To them collecting means investment and a status symbol. Rosenberg simply loved what he had. "You hang up the work because you like it," he said. "If she or he makes it, all the better. If not, you still have the work you love." And it's true that history proves that disregard for immediate value and an instinct for quality have led to the most brilliant collections.

After I settled in Italy in the 1960s, I once ran into the Rosenbergs. I was rounding a windy corner of Piazza Venezia in Rome, and there they stood, like two ships' figureheads, becalmed in a choppy flood of hurrying Romans. He was bundled up in a Burberry, she in a great black cape, a large canvas bag slung over her shoulder. Big, chunky silhouettes from abroad, they stood at a loss in the busy thoroughfare. I said hello to the hesitant, usually savvy New Yorkers.

"Hmm," said Harold, nonchalantly clearing his throat. "We were just on our way to the Forum."

"I understand it's full of good herbs for condiments there," said Natalie. They had no idea they were so near.

"Just follow me," I told them, walking them by Mussolini's balcony on Palazzo Venezia into the marvelous wilderness of old stone and sprouting greenery. Natalie was interested in the little olive tree by the ancient Senate, but Harold looked up musingly at the bricks of the ancient place of law. Natalie picked the sprigs of *rughetta* and filled her bag with *erba rossa* and wild fennel on the Palatine. They eyed ev-

erything with a strange naturalness, as if they had been there before, their voluminous clothing fluttering like togas.

As we were winding our way down from the Palatine, I stopped them.

"We are now near the Arch of Titus, but we can't go there," I warned.

"And why not?" drawled Harold.

"It's famous for depicting the destruction of the temple in Jerusalem and the Romans' final victory over the Jews," I explained, "and us being Jews, we can't go under it. It's the worst of luck."

"Says who?" Harold snorted through his mustache, drawing himself up. "My father never told me anything about this, and what my father didn't tell me isn't true."

And striding forward briskly, he was already under the arch. We had no choice but to follow him, and we too gazed up at this most graceful of arches, with its frieze of our forebears in chains and the Roman legionnaires carrying the treasure chest and the great menorah out of the temple forever. Harold studied it all, as he had studied the antiquities earlier, musing in a genial, good-natured tone, throwing his lines away. With his mind steeped in old Marxist logic, he managed to tumble some of my ideas about Roman history upside down. And here, among the ancient stones and grasses sighing in the wind, Natalie—with her fluttering stole and raven locks and her bunches of weeds and simples clutched to her bosom—looked like a sibyl. Harold, the critic from New York, stood stern and jovial, the prophet from a new world.

TOM HESS AND *ARTNEWS*

Rosenberg's writing was sober, logical, to the point, and analytical. He had a keen wit which invented some of those most felicitous art slogans that stuck with us forever. On the other hand, Tom Hess's writing was baroque, would-be hip, trying to be terribly bright and with-it. He

was intellectually savvy and academically trained, and his sentences tended to become ambiguous. But under all his convolutions, he carried his heart on his sleeve and sweetly and passionately spoke up for the artists he loved. And he had one thing over Rosenberg: power. He was not simply a contributor, but coeditor of *ARTnews*, the only decent art magazine around. Tom had no boss. He could write as he pleased. This showed, of course, and his flamboyancy often unraveled itself in all directions.

Yet it was not his writing that counted, but his choices. The artists he caught, and also some of the critics he employed, were the true movers of the 1940s and the 1950s and the spearhead of all that was to come.

Tom had a high oval forehead, a crew cut, a fleshy nose, sensual lips, and a bright, questioning look. He looked down at you with a quizzical, not always friendly smile. His speech had the twang of Yale, a potato-in-the-mouth, upper-class, almost English drawl. He came on tough and savvy, brown eyes aglitter, but there was a certain shyness,

Tom Hess (Thomas B. Hess) at the Artists' Club. On the left is Hubert Crehan, and on the right is Harry Holtzman. Photograph by John Cohen, 1960

a rough, puppy kindness lurking underneath. He dressed in tweedy English suits with vests, and he wore oxfords, brown brogues shined to a beautiful gloss, something never seen in our circles. Striding into his office, he moved with quick, decisive steps.

Because he first and always championed de Kooning, nasty tongues had it that this was because he was in love with Elaine. Tom, usually so skeptical when listening to others, took in her talk with an attentive, adoring air, spellbound in the presence of the vivacious queen of the lofts, as were most men at that time. But Bill de Kooning was the apple of Tom's eye. He was first of all in love with Bill's absolute sunstruck power. And being the first in an official position to sponsor him, he stuck to his belief, writing about him and cherishing him to the end.

One day we were driving through the woods, the sunlit Hudson River blinking through the spaces between tree trunks and green leafy branches—Rudy and I in our cumbersome old Chrysler with Tom Hess. We were heading upstate, on our way to collaborate with Tom on one of the features in the magazine's "Paints a Picture" series, his favorite baby. In each article, a chosen painter or sculptor was photographed in his own studio during various stages of a work in progress, and the final result was revealed in a full-page color reproduction. Rudy took the pictures, and the accompanying texts were mostly by Tom, or Fairfield Porter, Frank O'Hara, Elaine, and others.

When we arrived at a cottage in the woods, the Russian painter Nicholas Vasilieff and his big, busty blond wife gave us a hearty welcome, obviously thrilled to have a whole *ARTnews* crew descend on them. Inside the cozy, woodsy, flowered-fabric house they had artlessly displayed recent issues of the magazine all over the coffee tables.

Mrs. Vasilieff, large and comfortable, made large, comfortable remarks. Vasilieff conceded little about his work but talked about the daily life they had left behind in Russia and about Renaissance masters.

They both had that cumbersome, rich Russian accent and manner that conjures the literature of their past, not their political present.

The house was almost too cozy and stuffy against the cool, glittering fall light of upstate New York coming through the open door. The living room was full of weighty brown furniture with chintzy covers and brass kerosene lamps, a samovar, white china, and fruit on compotes. These were Vasilieff's models: fruit cut to the flesh or smoothly whole against gleaming jugs and pitchers. The gold-orange half-moon of a sliced pumpkin, bulging out with all its seeds against the dark purple sheen of an eggplant and the satin green of an apple, came out at you from a warm dark mahogany. The fresh, transient fruit was as glowing and absolute as the segments forming an icon. All the objects and fruit in lush, buttery strokes were leaning, swaying, not embattled with space, but going away with time.

While Rudy with his camera prowled around the canvases and the working painter and Tom wrote notes, I held up the lights, an easy job and a good excuse for observant participation. Thus one of the first in the "Paints a Picture" series was born.

Fairfield had told Tom about Vasilieff, just as he had discovered Leon Hartl, another displaced person who painted still lifes in America. While Vasilieff's stroke was wide and juicy, Hartl built fragrant arrangements of smoky, silvery flowers and fruit with fluffy bits of paint. These little touches, adding up to a late Impressionist surface, were tufty and tautly bittersweet. There were also shimmery views in muted pinks and greens of girls at play, homages to his late wife. Hartl had been a dyer in his native France.

Vasilieff and Hartl, and later Albert York, were Fairfield's own discoveries. All had a secret, modest touch—all, like Giorgio Morandi, grouped commonplace things like saints. None of them fell into any current style; they could even be considered old-fashioned. All had a mild poetry and sweet innocence of outlook that were enviable. And each had a small but very devoted audience.

Fairfield wrote about Hartl, but when it came to Fairfield himself

as a painter, it was naturally Frank O'Hara who was commissioned to write "Porter Paints a Picture" in 1955. For the Porter family, for Frank, and for us the job was a picnic. All old friends already, we enjoyed moving around the Porters' parlor, with its lovely furniture and nooks that delighted the eye. For the occasion, Fairfield chose to paint a portrait of his daughter Katie. There she sat, blond, small, fragile, with shadowy eyes, a little girl huddled up in a flowery wingback armchair, wrapped up in her own thoughts and musings.

Anne, Katie, and Fairfield Porter in Southampton. Photograph by
Rudy Burckhardt, 1955

This series of Tom's was supposed to illuminate an artist's work procedure. The stages from empty canvas to full one were to be shown in photographs, along with tools, studio, and/or home. Yet to try to scrutinize an artist at work poses a conundrum: first of all, painting is a private, solitary business. Second, when artists today are not brought up to rely on steady craftsmanship, as they were in the Renaissance and before, even with the most carefully planned work, you never know how it will come out. You usually work alone and in silence and think and hum and correct and go on and go back and add and scratch

away, boil an egg in between, wash the salad. The presence of even the most sympathetic observers will inhibit you, hinder your natural drive. Even when alone, with a clear idea to start with, you can hardly ever predict what will eventually spin out of you, what will happen for the good or the bad. And if someone looks over your shoulder while you tenderly or roughly scoop from your imagination and your knowledge, working with your tools, you become public, you become self-conscious and, at worst, stiff and mechanical. So, if it is observed by an outsider, a work that may have been started in all confidence rarely becomes as good as one of the artist's best.

We resorted to a trick. In most cases, the series was a bit faked. The painters, not happy with an end result done under pressure, developed a backward sequence: they chose a finished work they considered most representative, along with a good early sketch for it, and then, trying to remember as best they could, re-created the stages in between. This procedure, even if not exactly real, could still give a fine idea of an artist's work in progress. Nevertheless, some artists nonchalantly let Rudy photograph from the empty canvas to the full one. And someone as forthright as Fairfield would not resort to this tricky business either, so he let Rudy follow him all along, which may account for the fact that the picture of pensive little Katie is one of his most awkward.

But much more than the "Paints a Picture" series, it was Tom's new concept of art criticism that made *ARTnews* such a lively magazine. He invented "parallel poetry," which was about sheer, clear visual experience—you experienced a work of art and had a feeling about it, and with your words you conveyed a similar feeling. There was no literal description, no clunky analysis. The art was an experience, the words were an experience. The good words that came out would entice others to go and see for themselves. Of course this was a natural job for poets.

Not since the French in the nineteenth century had poets or painters written about art. Tom upset the custom of printing the essays of academically trained art historians by hiring poets and unspecialized

people. He had little use for people with university degrees and fancy jobs who looked down their noses at the new, or proceeded to talk about it in impenetrable jargon and dry lingo. Jimmy Schuyler, Frank O'Hara, John Ashbery, sometimes Kenneth Koch, Fairfield Porter, who all wrote poetry; Larry Campbell, myself, and so on, some of us having worked in factories and restaurants and as errand boys and waitresses, many of us with little schooling or special degrees—we all were hired by Tom for our ability, not for our credentials. And throughout, he took the risk of championing Bill and his stalwart camp of followers and friends at the Club. He ruled *ARTnews* with an iron will and a wise hand, modifying all articles to suit his own ends, as I later found out to my chagrin.

Tom, usually so rambunctious, sardonic, and argumentative when with Elaine and the rest of us, was quite another person at home. He deferred to his wife, and in her presence was attentive but politely reserved. It was obvious that there was a devoted understanding between them. Like Tom, she was a mover. She had been active in the Adlai Stevenson campaign, and with a civic group had defeated a plan for a highway that would have cut right through Washington Square Park. She was also an important member of other committees fighting political malfeasance and urban injustice, and with her inheritance she contributed to various worthy causes.

One evening the Hesses welcomed us for dinner at their duplex on Sutton Place. We were surprised by how spare it seemed, as honed down and understated as their clothes. It was all bare wood, polished glass and metal, and great empty spaces, with a few fine rugs scattered over the gleaming parquet. But it was the art that astonished us most, for the works on the walls were exceedingly small for sponsors of artists who worked so big. There was a small diamond-clear de Kooning, a Kline, Elaine of course, probably a Guston or a Pollock, a chalk-white box by Joseph Cornell, a greenish Louis Eilshemius of jumping

nymphs, a pinkish dabbed Arnold Friedman of Brooklyn rooftops, and an honest-to-goodness Picasso. The black-and-whites were just as small and choice: etchings by Rembrandt and Goya. On the furniture were small terra-cottas by Reuben Nakian, a rare sculptor whose little statues of Greek gods, marked with vivid cuts and curls and fresh fingerprints, were quick-thrown and immediate, of a fresh, open quirkiness.

A maid took us upstairs so we could dispose of our coats and wash. We saw the master bed already turned down for the night, with slippers and robes tidily ready. Order also reigned in the children's rooms, which had cribs furnished with microphones so that, if in trouble, the kids could reach their parents at once. For months afterward, when we crawled into our unmade bed in our grungy loft, Rudy and I joked about beds turned down by maids and about closely watched children, when we left our Jacob guarded only by the dog.

Downstairs, at the dinner table, everything was as controlled as upstairs, even the conversation. The guests were Curt Valentin, Ileana Castelli, Michael Sonnabend, and others. It intrigued me to see Valentin, the little, chubby gentleman of a dealer, up close. He knew what was what about European, especially German, art and had been among the first to introduce it to New York in his Buchholz Gallery.

Now I was sitting at the same dinner table as the mighty dealer. Next to him was Ileana Castelli, a plump lady I had never seen before. She had come in late with her attentive companion. The Hesses seemed happy to have her, for, as it transpired, she hardly ever dined out because she was sickly. She was bosomy and languid and wore dowdy silky browns. She did not say much, but once in a while, like a fluffy bird on a twig, she would open a black eye wide, as if sighting a worm, and make one sharp remark. Of course we knew her husband, Leo Castelli, from the Club, where the affable and dapper man, sleekly dressed, took in all the activity with a friendly air, no one knew why. Nor did we know that the man who was to become one of the most formidable dealers of our era had a wife. The Hesses treated her with respect—probably, as we would later find out, because she was a shrewd heiress.

Her companion that evening was Michael Sonnabend, a man with merry, twinkling eyes under a curly head of graying hair, who blithely talked about Dante as if he had met him on the street yesterday—yes, Dante Alighieri. While almost everyone present was interested in art, he was interested in language. He possessed a vast fund of esoteric knowledge about words, true dinner party gold. It appeared that he was a houseguest at the Castellis'. When asked what he did, he replied, "Reading," and at the drop of a hat would quote with verve from *The Divine Comedy*. That a full-grown man could regard reading and studying Dante as a full-time job, and that he could be a houseguest forever, puzzled me.

Later, when he was finally married to Ileana and I met them in Rome in 1962, he was as clever with words as ever and gaily compared Roman street names with New York ones. He smiled impishly when he declared that the chic Via Condotti was nothing but Canal Street, and that Passeggiata di Ripetta, where they were staying, was actually Riverside Drive. Michael Sonnabend enjoyed being boyish and twinkly and knowledgeable, but when he was older and had become openly shrewd and a dealer, this coming on cute under grizzled hair was less convincing. But at the Hesses' that evening, next to his heavy-lidded lady, the sunny Michael was a fine foil for the urbane Curt Valentin, the refined European so firm in his long-ago acquired opinions.

As I sat, out of the conversation, staring at my chilly glass of wine, I was suddenly startled by an explosion of sound: a whole litter of little dachshunds, yapping and yelping, came hurtling down the stairs, crumpling rugs in their wake and sliding over the parquet. The scrabbly brown warm things, the jolly pack tearing into the rarefied uptown atmosphere, made my evening.

I got to know Tom well not only because of the "Paints a Picture" series but because he often called and made me write down directions for Rudy to go and photograph de Kooning paintings he had hunted

up for his book in progress. I had a Vespa—acquired with the sum the German government had given me to make up for the fact that their politics had aborted my college education—and Rudy borrowed it to transport himself and his cumbersome equipment the width and length of Manhattan. Uptown, sometimes on Park Avenue, he, the scion of one of the most noble Swiss families, was often asked to use the service entrance.

One day in 1954 something very daring had occurred to me. I would use my acquaintance with Tom. Our Jacob was being enrolled in the Hudson Guild nursery school, but I was told it was only for the children of working mothers, and as a painter, I was not a working mother. Then I had an inspiration. I put on my best dress, the one with stripes that my mother had made me, and without telling anyone, I quietly took the subway uptown.

When I ran into Lotte Lenya right outside the *ARTnews* office on Madison Avenue, I knew it was good luck. I had first met her when Stravinsky was conducting *Symphonie de Psaumes*, wearing a towel around his neck in an NBC studio near Broadway. Looking like any ordinary Viennese woman, Lenya had hugged Rudy, whom she knew from Edwin's loft. Then I met her again at an interior decorator's party in an apartment on Third Avenue that was full of red plush, baroque armchairs, and a four-poster bed on which everyone was lolling. Her husband, George Davis, who later died tragically, was in the crowd. Lotte, this marvelous star, who with her tough and haunting voice conjured up the somber aura of the Weimar years, had been standing in the kitchen, rolling out dough for a strudel, like any hausfrau.

"I'm not comfortable here," I'd confided in her. "It's an odd party, only the two of us are women."

"Not comfortable here?" She laughed. "Why, *Eichkätzerl*, who's comfortable here? Aren't we all out of it? That's why we have to drink so much."

Now, in the middle of Madison Avenue, I dared to confess my secret to her. Smiling, she looked me straight in the eye. "Just ask for it,

there's no harm in it. If you want it enough, you'll get the job." Then she called me *Eichkätzerl*, or squirrel, once more.

When I boldly stepped into the *ARTnews* office and asked for the editor, I was soon admitted to his office. Tom gave me an absent-minded smile while looking up from his papers. "Yes?" For a second I was dumb. Then I swallowed. Then I said it straight: "Tom, could I be an art critic for you?" For a moment he looked at me quizzically over his glasses. "Hmm," he mused. He could have asked me all kinds of questions, what I knew, what I had studied, and so on. But he didn't. He shoved up his glasses and simply said, "Why not?" After a while he added, noting my foolish smile, "Tell you what: you write for us for a month. If you are good, you stay. If you are not, you go."

I stayed. An editorial associate for *ARTnews*, I began a happily active life as a working mother. Rudy didn't seem to mind. Jacob was not pleased and whined every time he saw me putting a pencil behind my ear. He knew it meant that I would sit down behind the typewriter and for a while be too absorbed to think about him. Nor was Fairfield pleased. He had just recommended John Ashbery to *ARTnews*, and strangely enough, Tom had rejected him, though of course later he became one of the magazine's most brilliant contributors.

It was marvelous. Here I was, without connections, without much art historical background, without a clique pushing me, and, having been forced out of school at the age of sixteen, suddenly on the staff of the prestigious *ARTnews*.

Naturally, as a painter, I had always gone to shows, looking and looking, at the same time blithely discussing the work with the friends and colleagues who were with me. Now I went to shows looking and looking but spoke only to my notepad. I liked jotting down my immediate reactions—they were usually the best. This became a habit.

From the point of view of earnings, it is laughable—it wasn't much then and isn't now. Art writing, like all intellectual activity, simply is not well paid. After *ARTnews* I worked for the *International Herald Tribune* of Paris and for *Wanted in Rome* of Rome and for many other

publications. From then on, I always looked at art in two ways: one for myself and one for the reader.

I looked at it first for what it could give me, what I could get out of it for my own work. I looked at it second as a general phenomenon, a wonderful manifestation of the human spirit. I felt like Little Red Riding Hood going out into the woods with a basket, hunting for mushrooms. Under every tree a different batch was sprouting, with different leaves, colors, spores. Man's art activity has always grown and spread and faltered and been destroyed in an immensely rich and kaleidoscopic variety; there is no end to it. Every show teaches you something new. Every subject is always a discovery and a mystery. You learn from it—from the Bronze Age menhirs of La Spezia, to Mesopotamian art, to Lysippos, Tintoretto, Caravaggio, David, Courbet, not to speak of late-nineteenth-century Italian art, whatever you come across—and then you show and tell. When Italians ask me, as they often do, what art period I specialize in, I always reply, "I write about things from the Stone Age on to last Tuesday's art."

Besides teaching me ever more about art and the stimulus of having to make sense of it with intelligent phrases, reviewing has also given me a sense of proportion about myself as an artist. I have come across too many artists sitting alone in their studios, fancying themselves unique—many even writing weighty statements about themselves, not realizing they are much like everyone else's statements. As an artist, you follow your quest the best you can, taking notice that the person next to you does it too, and get on with the job.

I slipped into the rhythm of Tom's idea of "parallel poetry." Tom was a brilliant editor. Right in the beginning he told me, "You can knock the famous. You can knock the dead. But the little ones you leave alone." And he added, "Don't knock Picasso." But he wanted most what every editor wants. "Keep it short. Tell it the way you would to a person sitting next to you at dinner."

"You are a tailor, Tom," I told him. He would tailor reviews to his liking. If I wrote something bad about someone he liked, he would

alter everything so it appeared that I had written something good. If I wrote something nice about someone he disapproved of, it might disappear, but it was all done in a seamless way. Editors just love to edit. The public has no idea about what they are empowered to do, how they have whittled away, have banalized good runs of words, and worst of all have invented sensational titles that have little to do with the words under them. What the good editor does is to see and eliminate the superfluous. Most often Tom did just that. He expected clipped, gutsy reviews, and he got them. It was superb training.

It could be a tedious business. Because magazines work several months ahead of the publishing date, very often I had to review elements of a show, not the whole exhibition well installed. I would have to look at paintings stacked in closets, arranged on a shelf over the bathtub, in the bathroom over a dripping faucet, and, worst of all, helter-skelter in an artist's studio. This was uncomfortable and counterproductive. The artist was naturally always anxious, so you got somehow involved in his family life, his ambitions, his private miseries. After the personal contact, you felt obliged to be kind, not neutral.

ARTnews made it a rule to cover all shows current in New York as a matter of historical record. In case of dislike, a mere mention would do, but there had to be at least one line. And, blissfully, it did not depend on the advertising. Even if someone thought that taking out a full-page ad would buy a long review, it was still entirely up to the individual reviewer's integrity to cut it short if he or she thought they deserved it.

The galleries simply never understood that you had to review ahead of time and you had to follow the order of the list Tom gave you each month. Soon after word got around that I was reviewing for *ARTnews*, I was overwhelmed with announcements and invitations stuffing our mailbox. Once I went down to Carmine Street to invite Elaine in person to an opening of the Pyramid Group, to which I belonged. She had just gotten up. She came down with me for a coffee and opened her mailbox, which was choked with announcements that tumbled out

when she opened it. Grinning, Elaine—*ARTnews* reviewer—picked up the whole batch and, in slow motion, proceeded to tear each one down the middle into long scrolls. The important shreds curled and slowly drifted down to the pavement. I watched, stunned, ever after envying her elegant sense of destruction.

Sometimes the problem of being an artist first and also an art writer boiled to the surface. Galleries would tell the art writer E.B. (this was the only place I used my married name, Edith Burckhardt), "You know how it is; there are no artists around, we have no show this month." But then, when the *artist* E.S. showed up on their doorstep with her goodies under her arm, they practically shut the door in her face. "You know how it is. We are all booked up."

Like everyone else, I was always late for the deadline, and once I rushed into *ARTnews* without having finished or even corrected some of my little bits of reviews. I found all desks occupied, but Tom's office empty. So I sat down behind his desk in his swivel chair and began to work. Suddenly I heard him behind me. Caught, I looked up, embarrassed. "Ha, so you're sitting in my place." He grinned broadly. "So how does it feel?" Suddenly I found myself spinning recklessly in his swivel chair, around and around. Exhilarated, I cried, "It feels like power." I swung once more. "Power!"

LEO CASTELLI

We never dressed up for the Club. The painters wore open shirts, sweaters, Hush Puppies, lumberjack boots, and we "girls" wore peasant blouses, cinch belts, ballerina skirts, and Capezio slippers. We were comfortable. The words that flew over our heads—to and from the assorted speakers on the podium down to the audience and back—were by no means comfortable. A smooth, small man, urbane and wily,

wearing a tie, a vest, and a fitted suit always sat on one of the folding chairs in the first rows. He was relentlessly elegant and relentlessly attentive. He was couth. He never said a word.

The dapper little man listened and listened. We kidded him, and

Leo Castelli at an opening. Photograph by John Cohen, 1959

he took it with good humor. Some said he ran a T-shirt factory in Queens and that the bright shirts actually had slogans and pictures printed on them. This seemed funny to us at the time. (We didn't dream of the Niagara Falls of print on people's chests today.) What was even funnier, they said the little man wanted to open a gallery.

"Hey Leo!" Some of us slapped him on the back. "Get going. You were always watching. Now do something before it's too late!" We need not have worried, as it was just the right moment. The European gentleman smiled smoothly, never saying a thing, poised like a black-eyed cricket in the grass. And then one day the cricket jumped.

Suddenly there was the Leo Castelli Gallery. Every Saturday afternoon we flocked uptown to look at this new item on our list. The gallery was in an old town house on the Upper East Side, completely modernized, with the walls torn out, very airy. Leo had done his homework. Not only guessing and defining the new trend, he had devised how to frame it and had sniffed out our secret: loft white. The cleanliness of loft white set off all his finds.

Whether we liked it or not, what he showed was always a gas— some of it alluring and subtle, some of it startling and crude or off-putting. It was never a bore. When we visited the new shows, he treated each of us scruffy ones from the Club with attention. We had always smiled a bit at his old-world politeness. "Leo's okay," we still murmured condescendingly about this new man in power uptown. But we would fall flat on our faces if we sniffed the faintest scent of a chance of being elected to his stable. And he kept his hand in. He still came to the Club; he still came to our lowly parties in Chelsea and other parts of downtown.

One of Rudy's first really rewarding jobs was working for Leo, who accepted him as a friend from the Club but most of all appreciated Rudy's artist's eye and sensitivity and his devotion to accurate printing. "Leo is a true gentleman," Rudy said. And he was also prompt in his payments. Rudy was amused at Leo's unremitting tidiness. "What a fusspot," Rudy said, smiling. "He picks up after me. He picks up every

little bit of extra litter, every cigarette butt, every bit of fluff." And he grinned when he told me that Leo, in person, had fitted specially made white sheaths, like stockings, over the bright red fire extinguishers required by law in the gallery. "With Leo, everything has to be white and neat." Most of all, Rudy enjoyed seeing the work being unwrapped and set up, the surprises, and coming home, he described and discussed the new and the odd. He was always curious, always ready—different from me, the new critic, who was far less generous.

But even Rudy, ever amused by every new artist dug up by the unfailingly intuitive Leo, had to balk one day. He came home quite annoyed. With a thump he put down his heavy equipment, which was already making him round-shouldered, the trademark of the hardworking photographer.

"I've had it," he cried. "The lunk Leo has picked up! The *cafone!*" We had traveled in Italy and used Italian cusswords in Chelsea quite a lot. "This pretentious crud Leo has picked up this time is too much. Like all these so-called *signori* in the south, he thinks that people who work for him are the lowest and must be treated like shit. So I'm only the hired hand." He was furious. "And the worst of it is, his stuff doesn't even look like art. This crude character's gimmick is to take warped wooden stretchers and bandage them with torn old canvas. He doesn't *paint* on stretched canvas; he *rips* stretched canvas. He thinks that's cute. I think it's subversive." Rudy wasn't going to be ordered around or expend his skill on work he didn't respect. He refused to take further photographs of it.

That *cafone*, Salvatore Scarpitta, though rude and rough, was cunning, and he made contraptions that looked like weathered sleds. Later still, he invented toylike miniature racing cars, some sort of pop objects in bright colors that you could stand up in your living room or sport on your walls if you were rich. But in Scarpitta's bleak, funky, wrapped stretchers in that 1959 show—those weird bundles Rudy had taken exception to—Leo, clairvoyant as ever, had made a discovery: they were the seeds of Arte Povera and of Assemblage Art, the kind of

garbage art that led to Robert Rauschenberg's *Combines*. It was a tide that was flowing, and I was part of it.

It was defined by the scholar and curator William Seitz, who put together *The Art of Assemblage* exhibition at the Museum of Modern Art in the fall of 1961. I had a little weathered box in it. Out of nowhere, not even knowing about Joseph Cornell, whom I later became good friends with through Rudy, I had filled little worn boxes with precious flotsam. But I hadn't foraged in the gutters of Manhattan like the rest of the scavengers, but in the country. I had gleaned dry and feathered and desiccated goodies from the beaches, the woods, and the abandoned mariners' houses in Maine.

Leo's knack for presaging trends didn't always click. Angelo Savelli, an Italian painter who had followed his American wife to New York, showed Leo his canvases. He had become a devoted abstractionist right after World War II, in the wake of the liberation, in the rebellious drive of Italian painters fiercely rejecting all left-wing "for the people" figuration. Leo as usual considered Savelli's work, so tasteful and tidy, with musing studiousness. He was particularly attracted by some canvases, which were all in white. Subtle, smooth expanses of snowy paint strokes laid across snowy paint strokes: a shimmering fabric without color.

"Marvelous," Leo exclaimed. "I tell you what. Paint me a whole series of these and you'll have a show." Angelo was flabbergasted and appalled, as any sane painter would be.

"That Leo," he said to me years later as we were hanging from the straps of a bus snaking its way along the Passeggiata di Ripetta in Rome. "I didn't like it at all. But then I thought of our Italian tradition of painters as craftsmen who had to work to order for princes and popes. So I knuckled under. I painted and painted for months. In fluffy white, in tight white, in feathery white, in steely white, lots of precious, tidy canvases in all sizes. *Bellissimo! Favoloso!* A beautiful whole show all in marvelous white." He laughed bitterly and turned to face me. "And then—you know what?"

"What?" I said dutifully.

He laughed some more. "It was a flop. Leo didn't sell a thing. After all that effort, nothing. And then he dropped me."

The pitiless dealer had been on the dot, but his timing had been wrong. Only a short while later, monochromes were in—Steve Durkee, Robert Ryman, the Italian Mario Schifano, to some extent even Agnes Martin. Painters are still painting monochromes, even now. In delectable buttery cream, in velvety gray, in sunny yellow, in tomato red, in unforgiving black, and in white, white, and white. And the wonder is, all are different. Savelli strangely stuck to white. For years I received his invitations to shows in Milan, Turin, and Rome, all lovely reproductions of abstractions in the most varied forms of lovely silvery white.

Leo was astute and diplomatic, and his underground machinations were fabulous. How did he manage to get a work by a completely unknown artist on the cover of prestigious *ARTnews* before he'd had his first solo show ever? This had never happened before.

Jasper Johns, the artist Leo had chosen (some still say for his *echt* American name), had studied briefly at the University of North Carolina. The work on the *ARTnews* cover had been manipulated with an encaustic procedure that the young man had invented. It was made of big, wide yellow and blue rings on red, on smudged newsprint, set in a wooden box. Along the upper rim of the box were four lower halves of male faces, all alike and mysteriously enigmatic, sphinxlike, the whole thing hermetic but bright, attracting you and at the same time bewildering you. Was it late Dada, I wondered? But of course *Target* was one of the first examples of the yet unknown and unnamed Pop Art. This cover of *ARTnews* heralded a new era.

Leo found Johns in a drafty old loft on Pearl Street, rarely heated, under time-blackened splintery ceiling beams. First rented by Stephen Durkee, now by Robert Rauschenberg, at times shared with Cy Twombly, this loft, like all our lofts, had been a family brownstone

with a stoop, its walls torn out for greater space to serve an industrial enterprise. This one had been a factory that made American flags. The heavier bits of machinery and some bales of half-moldering cloth, still merrily sporting the red, white, and blue Stars and Stripes, had been left behind, scattered among the living and art-making amenities of the raw young artists who came from the South and the Midwest to challenge the art world of New York.

Soon after, in a group show at the Stable Gallery, around the corner from the Art Students League, Robert Rauschenberg hung a wooden frame filled with garden earth that was held up by a hidden wire net. He came to the gallery every day with a watering can to moisten the dirt, in which seeds were sleeping. Little by little, thin yellow-green sprouts appeared, growing bigger and bigger throughout the show until sprigs and tendrils and ferns hung down in hairy green falls of surprising beauty. Maurice Grosser, the critic for *The Nation* who was also a figurative painter, declared the work an outrage. This bit of earth and grass undermined the understanding of art. It was subversive.

There was nothing good and pure, however, about Rauschenberg's next appearance, which was at Castelli's, and the works were loud and ungainly, soiled and unforgiving. The best was the quilt. Grungy and worn, it must have come from some forlorn rural American back-water. Its sewn-together patches were unthreading and fading, an empty pillowcase hung over it sloppily, the poor old things all tacked to an upright board on the wall. The painter had taken his brushes to it, loaded them with paint, and lashed it. Spurts of nasty fresh oil paint dripped all over. The cozy cover—under which mothers had nursed their piss-smelling babies, couples had coupled, grandfathers had snotted and snored and died—this whole bit of embroidered melodrama, nostalgic and forlorn, a package of other peoples' pasts, had been desecrated. And at the same time it had quickened to new life and turned into a piece of art. It gave me the shivers as much as Meret Oppenheim's furry teacup had decades earlier.

Rudy photographed the quilt in all its funky glory. "I enjoyed

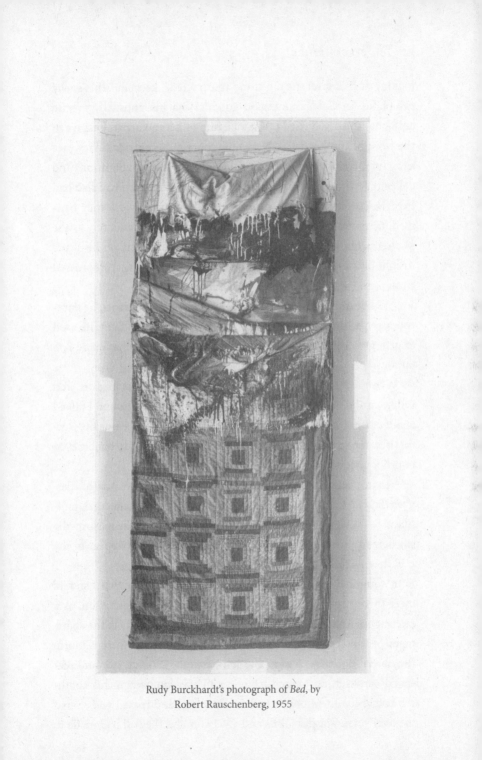

Rudy Burckhardt's photograph of *Bed*, by
Robert Rauschenberg, 1955

looking at that fantastic old thing resurrected," he said. "That's why my photo for Leo came out so good." With his unusually precise craftsmanship, Rudy had taken a picture of it as an artist sensitive to the work of another artist. But to his chagrin, his extraordinary care as a commercial photographer backfired. Too many publications and collectors clamored for his image of the quilt. Since he had had bad experience with sloppy assistants indifferent to the work they handled, he preferred to do the prints all on his own. His success as the photographer of other artists' work was based not only on his acute insight but also on his painstakingly accurate printing. Leo ordered sheaves and sheaves of copies of the quilt.

"It's become a chore," Rudy groaned, spending hours in the darkroom processing this print. Later, usually modest to a fault, he used to grin gleefully and say, "I guess it's my fault. It's me that made Bob famous."

When Robert Rauschenberg began, he was a serious jokester, and I didn't mind. Joseph Cornell, however, did: whenever he and I talked about current shows on the phone and the work of Bob came up, Cornell became speechless with distaste. He began to stutter, unable even to pronounce his name.

"That . . . that . . ." he muttered, as if foaming at the mouth. Alas, over the years, Rauschenberg lost himself in jittery, intellectual, multifaceted juxtapositions, flat collage work mixed with the mass media silk-screen process, which grew to have an enormous appeal to the middlebrow masses.

I would have been surprised if anyone had told me that I should meet that once jittery kid from the South, new in Manhattan, as a celebrity in Rome decades later. It was at a cocktail party at the apartment of the avant-garde dealer Fabio Sargentini on Corso Vittorio Emanuele. Bob, now plump and jolly, an international star and seasoned carouser, no longer itchy, was in the company of his southern friends, with whom he had once roomed and roared and shared the lean years—Jasper Johns and Cy Twombly. They all had made it,

all had hit the big time, though I secretly believed that of the three, only Cy had not lost his wonder. Bob, glass in hand, had his arm around Cy. Next to them stood Jasper. All three looked middle-aged, comfortable, rosy, and round.

FRANK'S "CREAM-COLORED SCREAMS"

One day, bathroom-beige canvases appeared on the walls at Leo Castelli's gallery. They were alive with pink slits and pencil and pastel scribbles, signifying cocks and balls and wounds, and tufts of color, little turbulent nomads traveling sideways. It was hellish writing and paint about heathen events, body functions, love and slaughter, and laughter. Naughtiness and childishness were cunningly scrambled with piquant sophistication and early wisdom.

At the opening, few knew what to say. But the critics in the daily papers wailed the next day: "What is this sticky tricky stuff, that you can see anyhow on public urinal walls? What is this scribbly latrine rubbish doing on fancy canvas, hung on fancy gallery walls? Is this art?"

Tom Hess sent Frank O'Hara to review the show. He adored it. Cy Twombly's gashes and exclamatory lines—like dirty, funny lavatory marks in pale, elegant rushes and furies—bewitched him. He wrote a brief, sparkling paean to them, as brief and sparkling as his Manhattan poems, raving about Cy's paintings in his most exultant prose: "A bird seems to have passed through the impasto with cream-colored screams and bitter claw marks."

Then all hell broke loose at *ARTnews*. The phones never ceased ringing. Enraged subscribers demanded the meaning of this praise of garbage, demanded something reasonable, an apology, a cancellation. *ARTnews* was then the most noble and one of the most prestigious magazines on art in the U.S. Its president, Dr. Alfred Frankfurter, had addressed his publication to benevolent old art lovers, collectors of

conventional art, and illuminated art historians. But Tom Hess had livened up the works by sponsoring the wild new downtown painters and getting the wild new poets and unschooled people like me to write about them. We, who were officially called editorial associates, were taken on by Tom to write in a different way from the schooled historians on the staff, who hated us as interlopers.

And now Frank O'Hara had written his most superb piece of "parallel poetry" about Twombly. The readers protested to Dr. Frankfurter; they protested to Tom. What kind of language was that? What kind of painting was that? It was all too smart-alecky, all too much. So Tom called an editorial conference. There had never been an editorial conference. That momentous gray, gloomy New York afternoon suddenly found all hands in a gray, gloomy office with some of us gathered around Tom, the others whispering around Dr. Frankfurter. In that room full of electricity the question on the agenda was: Were there or were there not such things as "cream-colored screams"?

Some of us tried to be reasonable—or at least to appear reasonable. Some of us were irritated, some half amused. Heated and silly arguments raged for or against the supposedly outrageous pictures or the outrageous review. The opposing parties neatly jelled. The staff of *ARTnews* was split down the middle. On the side against the "screams" were Dr. Frankfurter and his minions. On Tom's side stood Frank, Fairfield, Larry Campbell, and myself. On one side the stuffy stick-in-the-muds, on the other the hip and the with-its. We carried the day—there was to be no printed apology in the next issue. Frank's rave stood. Cy's paintings at Castelli were indeed cream-colored screams. Light-headed, the five of us breezed out of the office, high on our acumen, befuddled by our cleverness as astute critics, our own exulting bracing free view, our being in the right place at the right moment.

We were not only riding high on our victory, we were thrilled to be buoyed in the wake of a rising star. At that moment Cy was all that mattered, and this was us, and this was New York, and this was where it was at.

To tell the truth, secretly I didn't yet know what to make of Cy. I was still faithful to Bill and the boys, although I didn't exactly paint like them, but rather followed Fairfield. I didn't get Cy's glitter and flying ease. Only years later, in Rome, did it hit me—the crumbs and clots of delicious paint, the rosy puddles and whooshes and rains and ruins of line, the ominous and flickering deep glamour. The lightning took me into another land. It bewitched me, and I have been bewitched ever since in a land of heathen freedom.

JOSEPH CORNELL: A TRIP TO UTOPIA PARKWAY

One day a small ticket, not a regular gallery announcement, inviting me to *Night Voyage*, took me to the Egan Gallery, on whose walls were small black boxes covered with glass, private, enticing.

Stepping up close to each, I saw, against chalky white or midnight blue, an array of things: dice, clay pipes, a tinsel hoop, portraits of royal children, hotel labels, wineglasses, mariners' charts, engravings of constellations, a quivering compass, and sifting amber sand.

I lost all sense of time. Each defined little space—a stage, a shrine, inhabited by a few sparse forms—touched off unremembered memories, drew me into unheard-of distances. It was like a feeling I had as a small child when, in a Christmas play, someone brought a black round tin box to a sorcerer on the stage. He opened it, and, probably by some trick of stage lighting, the emptiness inside was suddenly transformed, and a strange, sunny glow, an undefinable magic, spilled from it. Time and light stood still. Looking at Joseph Cornell's boxes was like that.

"I thought that everything can be used in a lifetime . . . I came on a shop window full of boxes of different kinds. Halfway home on the train . . . I thought of the compasses and boxes, and it occurred to me to put them together," Cornell once wrote. Was it as simple as that?

One day in the early 1950s Rudy and I took the train to Flushing, Queens. The elevated clattered past rows of clapboard houses, backyards full of scraggly trees. Leaving the subway station, we walked through deserted Sunday streets lined with other wooden houses.

Cornell stood in front of one of them, welcoming us quietly, not too cordially. He spoke in a dry, matter-of-fact, nasal New Yorkese. He wore a dark cotton turtleneck sweater. The fluff of graying hair over his pale high forehead, his deep-set, shaded eyes, the slight stoop made him look like a tall bird. There was about him something cautious, purposely vague, a grouchy suspiciousness, like that of a night animal reluctant to be with others in daylight. Later, when we got to know him better, he was less grudging, suddenly making jokes and wry comments, and though he never said much more than necessary in one's presence, he could talk on the telephone amusingly and pungently for hours.

He took us first to the garage, his workshop. Outside was a quince tree. Inside were tools, lumber, and shelves containing collections of objects and boxes with their faces to the wall. He turned one around here and there, too quickly for us to see properly. Not all were finished. The completed, minutely crafted ones were at the Stable Gallery. He sighed, saying, "She lets them all go." "Letting go" meant selling them, and this seemed strange to us, artists who liked to find collectors. He did not seem to like parting with his work. His boxes, early appreciated by the Surrealists and by Peggy Guggenheim, had been coveted by a small in-group of ardent collectors since the 1930s.

When it turned out that we had not had lunch, he quickly took us up a few steps to the kitchen at the back of the house. Working deftly, reaching for spatula, pan, and ingredients without looking, knowing exactly where everything was, like a cook in a ship's galley, he scrambled some eggs and fixed us a simple meal.

There were decals of Disney animals on the tiles over the sink and on the Windsor chairs. The furniture was ordinary, like that in most American suburban houses. The parlor, which we saw later, was also

unremarkable. Cornell's brother, Robert, crippled by polio, was watching TV, and his mother, a plump lady with short white curly hair wearing a short, flowered dress, greeted us. She was fussing over a piece of lace she held in her hand, saying she could not match it but hoped to find something suitable in the attic. Cornell told us that she sometimes made delicious jelly from the quinces on the tree by the garage. The room was neither old-fashioned nor modern, just lived-in. There were several glass cabinets filled with knickknacks, and pictures of ancestors and sailing vessels on the walls. At the time, I was puzzled by the neat, normal decor, not used to it in the houses of artists. Later in Italy, in Giorgio Morandi's house in Grizzana, I saw a similar setup. Perhaps ordinary daily life, outward order, worked best to bring inner yearning and fantasy into play. Then Cornell took us into his own small room at the top of the stairs. It looked out over the half-bare trees and bleak backyards of Queens. It was full of shelves, and there was a desk. On these and in drawers were folders and folders, his "dossiers," as he called them. He opened some of them for us. Prints, maps, photos, bills, letters, newspaper clippings—all ordered according to subject: heavenly bodies, Renaissance children, birds, exotic plants, nineteenth-century opera, singers, Paris streets and hotels, stamps—a mass of bits of paper and mementos, all known by heart. There were also hatboxes and shoeboxes that I later saw in the inner sanctum of the Smithsonian Institution in Washington.

When we asked him if he had ever been or wanted to go abroad, we realized it was a superfluous question. Had he ever gone to the places or met the people he dreamed about, it would not have been the same. His sense of them was far more acute than that of the traveler who had been there. In that little upstairs room, the past, the present, and distant foreign parts were at his fingertips. There he reigned, alone in a Hotel de l'Univers all his own.

He showed us a film of neglected gardens at dusk, traceries of fireflies over them, that Stan Brakhage had filmed under his direction. One of the reasons for our visit that Sunday was that Cornell wanted

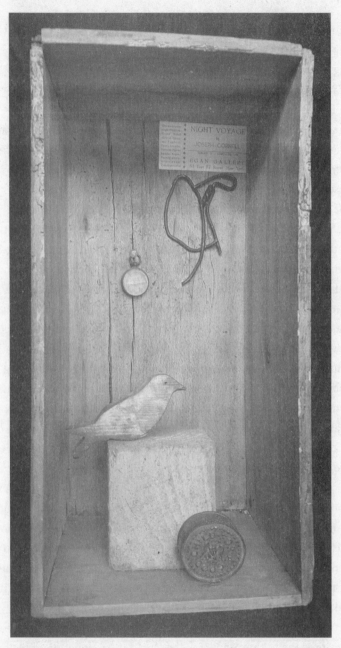

Night Voyage, Edith's box, featuring the yellow wooden bird Joseph Cornell
gave her and the card for his show. Photograph by Silvia Stucky, 2014

Rudy to collaborate with him on another film. They talked about it for a while. Eventually Cornell walked us to the subway, past empty lots choked with weeds just like those in Brakhage's film. Before he left us, he slipped into my hand a small yellow wooden bird he had made. I kept it forever.

The first time he came to our loft in Chelsea, I proudly showed him a box of mine. I had been making collages for quite some time, as well as painting. Somehow a box seemed to be the consequence of a flat collage, a collage in the round so to speak. I knew nothing of Cornell's boxes when I did this first little set of things circumscribed by four walls. (I called it *Viva Roncalli* because the objects in it had been collected in Rome and it was finished the day Cardinal Roncalli was elected Pope John XXIII.)

Our friend Lucia Vernarelli, who also did collages, had come over that day. We all said little, talked softly, and were polite, in awe of the famous man. But when he and Rudy tested some film equipment and Joseph put the wrong plug into the wall and got a shock, he cussed loudly.

"Fuck!" he cried. It broke the spell: he was suddenly a New Yorker like the rest of us.

From that time on, we saw each other often. Alongside Rudy's own films at private showings, Cornell allowed him to show movies like *Rose Hobart*, a collage film he had snipped together from an old Hollywood movie—a style practiced by younger filmmakers later, who perhaps didn't even know of Cornell's experiments. It was in blue tints, marvelous juxtapositions of silky platinum blondes and men wearing pith helmets, with erupting volcanoes, jungles, and elephants; or of ladies in high wigs and panniered skirts and their cavaliers, lingering on avenues of autumnal parks, over which the leaves drifted down one by one.

These films, presented in small theaters and lofts in the Village, were of course shown in the evening. When Rudy first called to ask Cornell to come along, he said hesitantly, with wonder in his voice, "What, a night in Manhattan?" But he never came. Later we understood that because

there was no one else to take care of his brother, he could never come to the city in the evening. For the film collaboration with Rudy he came to town every Saturday afternoon, and each time, he brought a young girl loaded with shopping bags to our loft. The film was to be about a young person perceiving New York with a completely fresh eye. He brought a stream of out-of-town girls, one after another, for the part. Not one was *the* one. But tall or small, blond or dark, pretty but never beautiful, the secretaries, models, receptionists, editorial assistants in their first jobs had one thing in common: an unprejudiced freshness, an innocence. He was precise only about this wonder of theirs—arriving for the first time in the great city—but not about the action. And so, after many takes of these small-town girls wandering wide-eyed, no proper movie came of it. What interested him had been the unspoiled bloom that made these girls unattainable.

There was a story about him, how he had prepared one of his first exhibitions at the Julien Levy Gallery around the subject of a young French ballerina. This ballerina was in New York at the time, and she was invited to come to the gallery. Cornell was busy in the gallery for hours, but just before she was expected, he locked himself in the bathroom. Later, he emerged, ill, excused himself, and went home. He never met her—he had wanted the imagined dancer, not the real one.

After the first attempt at making a film with Rudy, Cornell sent "scripts"—beautiful essays about a bird of paradise flying into a shop full of crystal chandeliers or about a statue coming to life in a snowstorm in Union Square. He knew each monument in that square and in other parks. He wrote of the fleeting meeting of eyes between strangers in the subway who would never meet again yet would remember the moment forever. All this was as cleanly and elegantly written as the text on his *Taglioni* box, where he describes an event symbolized by the contents of the box: the ballerina's dance on a pelt in the snow to ransom herself and her jewels from robbers. Yet these so-called scripts, concise and poetic, could not be elaborated into a

long series of images, a film, but were best translated into the small, wondrous worlds of the boxes.

Cornell wrote notes and Christmas cards to Jacob and gave him an old American toy he had bought at the Armory Antique Fair. He often called, especially late at night, to talk to Rudy about projects, and he was particularly excited when there was a snowstorm and disappointed if Rudy could not go and film it with him then and there. Sometimes he talked to me for a long time on the phone, especially when it snowed. Though one never saw him at art openings, he knew about everything that was going on. He respected de Kooning and Kline. Although he came from Surrealism and his style changed little—except for different selections of objects—over the years, at the height of Abstract Expressionism his formerly austere background whites were splashed with pearly strings of midnight blue.

He was not eager to have people write about him, but once he said, "Marianne Moore would do me justice," which is not surprising, since his way of cherishing objects, recognizing their intrinsic meaning, and gathering them together in new, shining contexts was much like her poems. And he shared her passion for hiding strong feelings behind matter-of-fact delivery. In general, he did not care much about contemporary art, becoming more than impatient every time Rauschenberg was mentioned. He must have looked at some of my own boxes in exhibitions, for one day, talking about assemblages, he surprised and pleased me by treating me like a fellow box maker.

One night he told me how his father used to take him to Manhattan when he was little, to Union Square and Twenty-Third Street in the snow, and how they went from store to dazzling store and he enjoyed the emporiums full of toys, with their iron columns and Christmas glitter. But after these talks on the phone, if we happened to meet face-to-face in one of the Eighth Street bookstores, he was different. He stood, gaunt and frail, hunched up in a dark, bulky coat, peering down on the books like a stork, saying a few words querulously. Eventually,

he became less elusive and would look up with a glint of amusement and friendliness in his eye.

One of his last exhibitions, at Cooper Union in 1972, was for children only. No grown-ups were allowed unless accompanied by a child. The little boy growing up in Nyack and Flushing had lived for his visits to downtown Manhattan, its penny arcades, peep shows, emporiums, and Christmas storms. Haunted by the curiosity of his navigator ancestors for new countries and odd artifacts, he was born too late for the Grand Tour, or to become a Jamesian traveler.

In an upstairs room in his house on Utopia Parkway he kept vigil through the winter nights, imagining Renaissance voyages, hotel rooms in Paris, and ballerinas dancing under the open sky. He wrote on the back of the boxes he made that they could be opened to be repaired only by him. Now they are closed forever. All his belongings and longings are in there, small worlds to lift us out of our own, lighted by sailors' stars and yellow explorers' suns.

LARRY RIVERS

Because Bob Bass, Nell Blaine's husband, was a jazz musician, a lot of jazz musicians hung around Nellie's loft on Twenty-First Street. They played "Salt Peanuts" over and over again, taking the needle off the record and putting it back on the same special passage. Some of the musicians also brought their paintings for Nellie to judge. One, called Otto, showed us a little landscape, with green skies and dinosaurs crawling around among indiscriminate spiky objects in the foreground.

"What are those?" asked Nellie, pointing to a tangle.

"Oh, that." Otto coughed modestly. "Oh, that there is natural derbis."

For years after we talked about "natural derbis"—in our pictures and out of them.

FIGURE 1.
Back from Matisse, by Edith Schloss, 1969
(© 1969 The Estate of Edith Schloss Burckhardt. Photograph by Jacob Burckhardt)

FIGURE 2.
Rudy Burckhardt,
by Willem de Kooning, 1937
(© 1937 The Willem de Kooning
Foundation / Artists Rights
Society [ARS], New York)

FIGURE 3.
Edwin Denby,
by Alex Katz, 1961
(© 1961 Alex Katz /
Licensed by VAGA at
Artists Rights Society
[ARS], New York. Oil on
masonite, 36 x 24 in.
[91.4 x 61 cm]. Colby
College Museum of Art.
Gift of Yvonne Jacquette
Burckhardt, 2014.063)

FIGURE 4.
Portrait of Edith Schloss in the Porters' Southampton Parlor, by Fairfield Porter, 1953
(© 1953 The Estate of Fairfield Porter / Artists Rights Society [ARS], New York. Photograph by Jacob Burckhardt)

FIGURE 5.
After a John Cage Concert, by Edith Schloss, date unknown
(© 2021 The Estate of Edith Schloss Burckhardt. Photograph by Jacob Burckhardt)

FIGURE 6.
O'Hara Nude with Boots,
by Larry Rivers, 1954
(© 1954 Estate of Larry Rivers /
Licensed by VAGA at Artists
Rights Society [ARS], New York.
Photograph by Gary Mamay
© 2009)

FIGURE 7.
Jimmy and John (James
Schuyler and John Ashbery),
by Fairfield Porter, 1958
(© 1958 The Estate of Fairfield
Porter / Artists Rights Society
[ARS], New York)

FIGURE 8.
Harold Rosenberg #3, by Elaine de Kooning, 1956
(© 1958 The National Portrait Gallery, Smithsonian Institution, Washington, D.C.)

FIGURE 9.
Larry Rivers,
by Fairfield Porter,
circa 1951 (© 1951
The Estate of Fairfield
Porter / Artists Rights
Society [ARS], New York.
Oil on canvas, 40 inches
x 30 inches [101.6 cm x
72.6 cm]. Colby College
Museum of Art, Water-
ville, Maine. Museum
purchase from the Jere
Abbott Acquisitions
Fund, Accession
Number 1994.003)

FIGURE 10.
Barbours Shore,
Deer Isle, Maine,
by Edith Schloss
(© 1958 The Estate of
Edith Schloss Burckhardt.
Photograph by Jacob
Burckhardt)

FIGURE 11.
On the Ledge, by Edith Schloss, 1976
(© 1976 The Estate of Edith Schloss Burckhardt. Photograph by Jacob Burckhardt)

FIGURE 12.
Rignalla, by Edith Schloss, 1967
(© 1967 The Estate of Edith Schloss Burckhardt. Photograph by Jacob Burckhardt)

FIGURE 13.

Third Leda, by Edith Schloss, painted in Edith's last summer in Pietrasanta, 2011

(© 2011 The Estate of Edith Schloss Burckhardt. Photograph by Jacob Burckhardt)

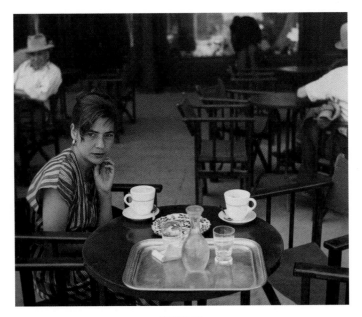

FIGURE 14.

Edith in Ravenna, photograph by Rudy Burckhardt, 1947

(© 1947 The Estate of Rudy Burckhardt / Artists Rights Society [ARS], New York)

Another musician, an intense, fast-talking saxophone player, took hold of Nell's brushes one day and messed around with them on her palette. Then he began to paint patterns on her husband's drums. Far from being annoyed, she liked it. "You should go and study with Hofmann," she told him. He did.

This was Larry Rivers. With sharp features, he looked at you with black eyes, sizing you up and rapping with a wide Bronx accent. Openly a street rat, he was out for himself, but brash, wise, funny. His first paintings were not abstract, like those of the other Hofmann students. They were almost sentimental, of nudes, tightly and a little awkwardly brushed in purple-gray fabrics like Bonnard's or Vuillard's. But the poses, unlike Bonnard's, were unheard of. A girl sat cozily in an armchair, her legs wide apart—her patch of black pubic hair showing a pink lick of pussy. Much later, a couple—yuppie Long Island socialites—commissioned their double portrait, also in nice Impressionist brushing, in conventional light and pose. Both were nude, and the composition implied that they had just had sex.

Larry had his first solo show of pleasingly painted nudes with unforeseen naughty details at the Jane Street Gallery cooperative, which was run by Nell. He went on studying at the Hofmann school and continued to play his saxophone in clubs at night. The jazz musicians were saying he was probably a good painter and not such a hot musician, and the painters put it the other way around.

He began using hard drugs early on and volunteered to cure his habit in a rehab center in Lexington, Kentucky. The day he came back, he went straight to Nell. I can still see him standing on the sidewalk on Twenty-First Street, a nifty figure in a zoot suit and cap, carrying a furled umbrella and a neat little suitcase—a young man just back from hell. My, was he snazzy. Looking you over as busily as ever, he was about to move into the "Penn Zone," a rooming house for derelicts across the street from us, in order to be close to Nell and her friends.

One of the musicians around Nell and Bob was Jack Freilicher. His wife, Jane, was also a Hofmann student. Once, everyone in the Jane

Street group, with myself as a hanger-on, went to their house near the beach in Coney Island. Sitting on the sand under the boardwalk, the late-fall visitors stomping along over our heads, we munched hot dogs and sang Glenn Miller and early Sinatra. I, as a European, was still surprised that sophisticated painters would so heartily embrace pop culture. We turned on in the Freilichers' bathroom, which was green with hanging philodendrons. Jane's paintings were also green, and not abstract, full of home still lifes.

In the late 1940s a group from the Jane Street Gallery hired a bus to go on a pilgrimage to a Matisse show in Philadelphia. At one point, looking back in the bus, I was surprised to see Jane Freilicher and Larry sitting close together on the back seat, holding hands. Placid Jane and rough Larry?

Jane left her husband for him. It seemed as if Larry's affair with Jane was one of his sweetest and most touching. But it did not work. Larry was terribly lost. Fairfield found him in his loft, just sitting there, hands hanging down, staring at a washing line strung all over, on which hung all of Jane's panties. He tried suicide too. Afterward Fairfield took him to his house in Southampton to recover and painted his portrait, one of his most vivid ever. Here a frenzied young man, eyes wild and shining, both wrists bandaged white, holds on to the edge of his chair, as taut as a bow, ready to spring up and yell at the world. (See *Larry Rivers*, by Fairfield Porter, figure 9 in the color insert.)

In the end, Larry settled in Southampton, buying an old frame house, suddenly bringing a large family from nowhere: a wife, her child and her mother, and a child between them—Augusta née Burger; her son, Joseph; her mother, Berdie Burger; and their son, Stevie Rivers. Larry's mother-in-law, a pink-fleshed, comfortable middle-aged matron, became his favorite model. Patiently sitting on couches, she submitted her sagging body to his scrutiny. It was never clear whether these nudes of a good-natured, faded housewife were done as a close-up of the human condition or, less charitably, for their shock value. Also, Larry had eventually come to brushwork that was light and fluid, with

fudged, unfinished-looking passages, much like in Jules Pascin's bittersweet whorehouse scenes in Paris. Yet the more pleasing and facile his technique, the more his subject matter, on the contrary, was not.

Fairfield, his neighbor, entertained the new poets from New York. Among them was Frank O'Hara, wonderfully quick, friendly, interested in everyone and everything from jazz to brand names, obscure old novels to new Abstract Expressionism. There was no one who did not think him charming and disarming. Larry later said, "He had a crush on me." But then WASP men always had a crush on wild Larry from the Bronx. Until then, he might never have had a homosexual affair, but we all could see that this one was breathtaking and sweet. In the midst of his daily life with his family, Larry carried on with Frank.

He had Frank posing. I saw the portrait, leaning there in the dark basement that was his studio. There was Frank, with a lick of triangular hair, like that of a little demon, over his forehead, his wide-awake blue eyes, his flaring nostrils and open wet lips. Fey, delicate Frank, so poised and vulnerable, his boy's body coming out bare and pink and aroused, covered only by the broken brown leather army boots on his feet. So alive, so terribly heartrending, this picture was done completely with the insight of intimacy. Nothing Larry ever did after that was so outrageously moving. (See *O'Hara Nude with Boots*, by Larry Rivers, figure 6 in the color insert.)

His family seemed to live through all these early Southampton days unperturbed, especially Berdie, always sitting placidly, as if posing nude was the same for young and old. After that came Larry's paintings based on historical events. *Washington Crossing the Delaware* was the first and most notorious. Taking this holy old American history icon and turning it into something impudently modern earned him national attention, but it was Berdie's fading flesh, pink and bare Frank in boots, and the naked Long Island high-society newlyweds that brought him notoriety in New York.

Larry was always surrounded by male admirers—Rudy, Edwin, Fairfield, all with well-protected backgrounds, from upper-class Protestant

families. Feeling themselves too civilized, faded and mild, they adored the Bronx street urchin and jazzman, a live wire without tact, immediate and bright. It was not so much his painting, but a fascination with Larry's drive and chutzpah, his unflagging vitality. They were taken in by this while some of us stood on the sidelines with a bit of a critical grin. Fairfield was particularly intrigued, saying he admired the way Larry could control his own health. "How?" we asked.

"He can choose when to be sick or not."

He said he meant that Larry had the guts to dive into the drug world whenever he wanted to check out from daily life and come back whenever he felt like it.

It was Nell, by helping him exhibit at the Jane Street Gallery, who boosted him first. Then it was Rudy and Edwin, and eventually Fairfield introduced him to his own dealer, Johnny Myers at the Tibor de Nagy Gallery, who for many years was Larry's dealer. But when Larry made appearances later at the Club, he was tolerated only as a young whippersnapper and protégé of outsiders. It did not help that at one time the images in his paintings were hailed by some lesser critics as close to de Kooning's.

Rudy and Edwin had a way of selecting an artist and making him their cause. They adored Bill. Nothing he did was wrong. When Bill had made it, they focused on Larry. Jane Freilicher was the only woman artist they ever admired, but not until the poets had made her their grande dame. After Larry had arrived, they took up Alex Katz. Standing up for Bill was more than justified by his grand stature as an artist and his incandescent character. But we three "Chelsea girls"—Lucia Vernarelli, Helen DeMott, and myself—thought that Edwin and Rudy's sponsoring was on a diminishing scale, and we whispered wickedly, "After Bill, after Larry Rivers, after Alex, what next? Felix Pasilis?" This was a rough, mute Greek, doing rough, mute Expressionist work.

Larry stars in one of Rudy's films, *A Day in the Life of a Cleaning Woman*, with the script by Anne Porter. Anne, in real life so extraor-

dinary, wanted here to be an ordinary woman. She plays Mrs. Rocker, who "earns her living the hard way" and works as a cleaning woman in the mansion of a Russian countess, "Her Exigency, Nathalie de Caviar," played by me. Larry appears as a bum, the Fuller Brush man, who, with a diabolical grin, sells a magic dishmop to Mrs. Rocker. When she begins to work with it, everything she touches immediately becomes clean and neat. But when the lazy countess wrenches it away from her, the magic turns against her, making everything filthier and messier. Then, as if struck by lightning, both women realize that the bum is the countess's long-lost brother, and everything ends happily. Mrs. Rocker is served breakfast in bed by the corseted countess, and her magic mop is restored. Meanwhile, down in the salon, her boyfriend, Elmer Turnip, acted by Fairfield, plays a board game with the bum-turned-count. They sit on a sofa, the farmer in dungarees with frayed knees, the count in a once-white twill suit and old riding boots. This is Fairfield in real life, the knowledgeable New Englander happily pretending to be the dumb farmer, scratching his head and trying to understand the Russian's last move.

Years later, after Fairfield's death, in 1975, when he was sixty-eight, there was a memorial panel at the Parrish Museum in Southampton, which owns a great deal of his paintings, given to them by Anne. Fairfield's friends gathered from all over, and everyone had their say. Painters and poets talked about their love for Fairfield and his work and of their companionship with him in various ways. Our sadness was relieved by the showing of *A Day in the Life of a Cleaning Woman*. Once more we saw Fairfield, playing the simple farmer, innocently demolishing Larry, the make-believe aristocrat, by facing the audience and breaking into his most beautiful open grin.

Larry arrived late, in a foul mood and unprepared. "So you've all been talking," he declared grouchily, "but was he really all that good?" Maybe Larry just didn't want to be corny. But we sat dumbfounded. Larry, man! This was your sponsor, your friend.

Even if Larry's technique was salted with clinically uninhibited

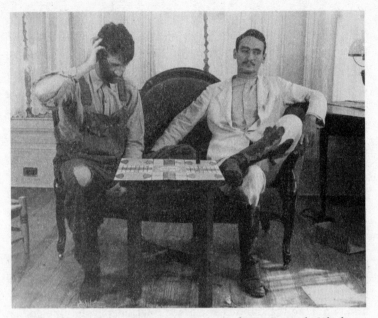

Fairfield Porter (left) and Larry Rivers in a scene from *A Day in the Life of a Cleaning Woman*. Photograph by Rudy Burckhardt, 1953

observation of things that were taboo until then, it was always more bland than daring. Nevertheless, he used the tricks of modern mannerism. Fragmentation, people quoted in bits and pieces, or arrows pointing and stenciled lettering wickedly spelling out the obvious; tongue-in-cheek citations of revered historical events, famous set-piece group shots of political leaders, old and new masters, and the holy graphics of French and American money enlarged and held up like flags. But over all this was tufty, fudged brushing, in pastelish colors close to illustration.

He was still on the same riff when I saw his paintings again, decades later, in Rome in late 1992. Now some elements had been cut out and mounted on styrofoam so that the whole worked like a bas-relief. They

were reliefs like those of his gallery mate Red Grooms, but not as folksy. Larry was as eclectic as ever, but there was also a milder, misted quality in these coastal summer scenes of birds and people in garden chairs. A self-portrait in WASP sportswear wanted to be straight and merciless, not only because of the predominance of scrubbed-over grayish whites. And I admit that an inquiry as lively as ever was still there too. But the main picture was of a kid, naked, with his bare back to us, kneeling in front of an armchair in an otherwise ordinary interior, a roll of toilet paper next to him. It's called *Memory*, its sweetish, light colors lashing or caressing nudity. Some peculiar erotic ritual, something piquant, something unmentionable is going on here in a scene that's otherwise humdrum, even gauche and cozy. Larry, man, you've done it again.

He stood in the back of the gallery. He had already wowed the usually blasé Romans, giving people the once-over, ready to go, with hip talk and sharp repartee. I looked at him. What made Larry run? With his rapacious ambition and burning appetite, where did he really go? True, he had a résumé a mile long, chock-full of fancy museum shows, awards, commissions, fine teaching jobs, exciting events. But did he ever go as far as doing anything as clamorous as Warhol? Did he ever commit himself to something soul-shaking? Despite all his drive, his fluffy, sometimes naughty paintings are only a chunk of New York art history.

That night in Rome he had no lean, elegant young thing by his side, no male followers, hard of hearing, his hair graying. But as always he came on loud, sharp, all there. His beaky bird-of-prey face and glittery eyes sized you up straight and even. All right, you've lived, man— you know how to live. Here's to you, old stinko.

PART II

ITALY

ITALY WITH THE FAMILY, 1950–1951

ISCHIA

In 1949, around the time Jacob was born, Edwin was in Europe on a Guggenheim Fellowship. He had to have an operation while in Paris, and to recover from it he went to stay on the island of Ischia in the Bay of Naples, in a villa rented by the pianists Arthur Gold and Robert Fizdale.

When the pianists left, Edwin wanted us to join him in Italy. Since Rudy was eligible to study on the G.I. Bill, he decided to study painting in Italy. He had studied with Amédée Ozenfant in New York, and he chose the Naples Academy. We soon found out that G.I. Bill students were on the lowest rung of the totem pole of Americans in Europe. Fulbright scholars were but a little higher; then came the American Academy in Rome fellows, and of course Guggenheim grant fellows were the elite. Even if the prices in Italy were still low in the years just after the war, we knew that, unlike expatriates in novels, we would have to live very modestly. So we chose southern Italy, not only because it was so picturesquely rural, but because, being less developed, prices would be low. Little did I dream how undeveloped.

In the fall of 1950, Rudy, Jacob, and I took berths on the luxury liner *Vulcania* and sailed to Naples to join Edwin. But it was only first class that was luxury class—mahogany lined and with red velvet.

Tourist class, where we were, was steerage. We read and relaxed on our bunks; we had no lounges. In New York they looked down on my breast-feeding Jacob as unseemly, but on the *Vulcania*, the waiters, who saw me hurry along the length of the ship to the kitchen to warm Jacob's bottle, when he was only eleven months old, thought that bottle-feeding so early was unfeeling.

After Gibraltar and the lion-yellow coast of Africa, our first landfall was Palermo. Since we had a few hours there, we rented a carriage to go sightseeing with a Quaker family from Philadelphia, the mother a light-skinned black woman. When the others were inside the cathedral, our very dark coachman said to me, "What makes you all drive around with a *negretta*?" Probably it was more provincial ignorance than straight-on racism, but this first encounter with southern Italy gave me a jolt.

The mosaics in most of the churches were too complex and grandly glittering to be taken in by tired voyagers, but the white cloisters with their palms and lemon trees and the sparkling of the Palatine Knights and the symmetry of their mosaic of leopards and peacocks in the little chapel lit up everything for us.

Opening the porthole of our cabin at dawn the next day, I saw a bustling harbor full of boats and cranes, the dusty city of Naples climbing up hills, but not the famed blue sky, not Vesuvius with its plume of smoke that my father had told me about. All I knew of Italy was ordered and graceful Tuscany, where I had been as a teenager. Here, at first, the mess of Naples was bewildering. From the terrace of our pensione on the Vomero, Naples looked better, but the great volcano had no smoke when it appeared out of the haze.

Jacob had a lot of space for crawling on the terrace, and we celebrated his first birthday up there. From this height I got little feeling for the teeming city below, which I acquired with a vengeance years later. But I learned right away how Neapolitans have always been forced to live by their wits and how the rich distrust the poor so much in the south. When the maid came back from the market, every item in her shopping bag was carefully checked and weighed by

the *padrona* so she could not cheat on the prices. The chicken cages on the roof were tightly padlocked so the little urchin who worked as a waiter could not go inside. Still, I saw him sucking an egg in a dark corner once in a while, and Jacob's silver spoon from Switzerland disappeared, probably conjured away by the wide-eyed, good-humored *scugnizzo* (ragamuffin).

Rudy enrolled at the Naples Academy, where his professor, believing he was a primitive, sent him to the San Martino museum to copy a vast panorama painting of Naples done by an anonymous painter in the eighteenth century. Rudy worked dutifully on this throughout our stay on the bay.

Meanwhile Edwin had arrived, and he and Rudy went off to survey all possible sites for us to settle. I stayed behind, Jacob on my arm, spending hours among the nannies and white-clad little children in the Florida Park or among the prim, chic little student girls flopping along in their new sandals in the Caracciolo Park, both places full of slender and curving palms. But most of the time I spent gazing through the streaked panes of the tanks in the aquarium, watching the mysterious underwater denizens of the bay swimming by.

Rudy and Edwin had journeyed as far as Taormina and Positano and then to Capri and found them either wanting or too full of déjà vu expatriates. Finally Rudy came back one day and said, "We found it. We found a house where you look down on the sea and you see all kinds of blues changing and changing, wonderful blues. It's on the island of Ischia."

So on an overcast day, Jacob, Edwin, Rudy, and I set off with all our luggage on the boat heading across the Bay of Naples to Ischia. Again there was no Vesuvius, only haze, and no blues. We were the only travelers with modern suitcases; the other passengers had cardboard boxes, packages, fowl, and old trunks. A group of men huddled in the stern. Coming close, I saw that they were in chains. When the boat stopped in Procida, they were marched off to the fortress there, a notorious prison.

"It's the Romans who started it," Edwin said. "They brought their prisoners here. And when they let the naughty imperial ladies loose, they swam and dived and fished with the fishermen and got suntans. Back in Rome, they were the first to make suntans fashionable."

In the harbor of Ischia, one of the many coachmen competing for trade got us to climb up the iron step of his vehicle. It smelled of mouse turds and straw, the horse was skinny, and the blanket he threw over our knees was green-black and hairy. We trotted past the only noteworthy building on the island, the castle in which Michelangelo is said to have lived with Vittoria Colonna, and then we were off to the wilds. After the umbrella pines of the *pineta* came canebrakes, some vineyards and orchards, and then stands of trees, rows of tall trees. I thought they were probably poplar, but to be sure I asked the driver what they were. "*Legname*," he said laconically.

"*Legname*. Firewood?" Were all Ischians going to be like that?

Now the road was just some ruts through rough fields lined with blackened cornstalks with rustling leaves. Rooks flew up, and sometimes a peasant woman in a black kerchief, pruning knife in hand, let out a guttural cry. We were jolting around in the carriage, Jacob crying on my lap, no sun, no sea, no houses.

I felt I had left civilization. Edwin sensed this and began murmuring something about Americans being pioneers: "They are used to facing the unknown, to going forth into wild places; they are used to being frugal and making do with few things," he pontificated. At that moment I felt neither particularly American nor up to being frugal.

In New York, when Jacob was little and I was nursing him and he was always crying and I was always tired, Rudy hugged me once for comfort. "You'll see. Someday this kid will blow smoke rings like his daddy." It made me laugh. I laughed even more when he said, "You'll see. As soon as we can, we'll go to Italy. And we'll rent a nice big white house by the sea." I imagined a comfortable villa on the beach, sun and fruit trees and cypress and lots of painting to do. But Il Palazzo del Capitano was nothing like that.

Edith and Jacob in Italy. Photograph by Rudy Burckhardt, 1951

It was a row of rooms on the edge of a cliff, the vault of the dome roof painted sky blue. It was the only building in the tiny village not consisting of just one room for the whole family. The rooms were lined up along a long, narrow terrace with a railing, their backs toward an alley that led to a steep path down to the sea, their fronts with a French window each, facing the vast bay. Near the street entrance to the terrace was a well and a kitchen with little holes for burning charcoal.

The rainwater coming from the dome roof was channeled into a cistern, and this was our only water. Angiolina, the little maid, pulled it up in a bucket, winding a rope over a wheel. A little urchin brought

drinking water from a far spring in a big bottle that he balanced on a rag on his head. When Angiolina saw rain clouds appearing on the horizon, she ran up to the roof with her broom to sweep it free of cat and gull droppings so our water would be clean. When there was a *tramontana* (a north wind), the swinging bucket made a rhythmic noise through the night. There was a tile stove for wood burning in the room where we ate. The other three rooms, all bedrooms, received some winter sunshine at noon. So each night we had to climb into icy beds.

This house was called Il Palazzo del Capitano because it belonged to an old, gnarled man who had been to sea. He had also been to America and had learned to say only "boss" and "job" and the usual cusswords there. Sometimes at noon he came to our kitchen to make huge sandwiches, filled with tomatoes and onions and oil, for the hired help in his vineyards below. He always wore his captain's cap and pajamas, just like the husband of the midwife who lived with her twins at the end of our terrace. Pajamas and slippers were the mark of a gentleman at leisure.

The village had a church and one store, but no café. There were no dairy products or fresh vegetables or fruit, oil or fish or fowl or meat in the store. In those early years after World War II, there were no serious tourists. For centuries the people had been used to growing and providing everything for themselves. On the shelves were sacks of grains, chickpeas, dry pasta, flour, salt, sugar. Small wooden cages to lure birds for the hunt, and bunches of wooden *zoccoli* (clogs) hung from the ceiling. There were acid-colored sour balls in jars for the kids. Over all this hung the smell of artificial fertilizer. A far cry from the funky but well-stocked A&P supermarket on Eighth Avenue in Chelsea.

A goatherd with cheeses in his backpack came to our terrace with his flock most days and squeezed milk straight from the goat's udder into an enamel pot that Angiolina held underneath. In the evening we could hear the fishermen's feet pound down the beach path behind our house and then see their lure lamps light up the sea, like another

firmament, all through the night. In the morning their wives came with baskets and brass scales to offer us some of the still-wiggling, glistening catch. Aside from the pink and blue fish, there were white cuttlefish, and brownish-black squid and octopus, which stayed tough even after long cooking. Once a week an old ox was towed in on a raft all the way from Naples, to stand in the middle of the village square, where people pointed to the parts of the live animal that they wanted to eat. The ordered parts were distributed after the butchering on Friday. I ordered liver this way—just once.

One day we found Angiolina in the dining room palavering with an old woman who was holding a chicken by its legs. While the upside-down bird squawked and dropped turds, the two women were bargaining loudly. Our own good Angiolina bargained for everything—the wood for the stove, charcoal for her kitchen holes, soap and shoelaces from itinerant peddlers. After she got the hen for the right price, she put it into a cage outside the kitchen.

She began to feed it carefully. I sometimes took it out for Jacob, and it became a pet for all of us as it ran around on the terrace. One day Angiolina declared, "Tonight you will have chicken dinner." Knowing she was as good as her word, we took off on a long-planned trip to the other end of the island. In Forio, because of its thermal springs visited since classical times by arthritis sufferers, everything was more civilized and very different from our own godforsaken village of Testaccio. There was even an Anglo-Saxon colony here, its most famous member the composer William Walton. We went to W. H. Auden's house, which he shared with Chester Kallman. The poet was away, but Chester lived with a local boy, a sailor. Their attachment was so evident and sweet it was touching. There was only one bus a day, so we went back to Testaccio in the early evening and lay down to rest.

"*Mangiare! Mangiare!*" It was Angiolina knocking on our doors. When we were all seated around the dining room table, she brought in a tureen of soup. We drank it. But then she came in with a steaming

platter. In the middle of it lay our chicken legs up, gray. To please Angiolina, each of us managed to swallow a bite or two.

When I told Anne Porter about life in southern Italy, she said, "It must have been basic." It was difficult to get food, difficult to get warm. Sweet, red-cheeked Angiolina's ideas were those of peasants through the ages, and I didn't dare leave Jacob with her. Either the volcanic soil or the well water didn't agree with him, and he was always sick. Nor was there a decent doctor.

I had cystitis. I had crabs. We all had them, but Edwin poohpoohed this, saying, "In Berlin in the 1930s we combed them out of our eyebrows."

Few other foreigners came to our end of the island. Once, Bud Wirtschafter, a painter from New York, and his Brita from Sweden arrived on their Harley-Davidson and stayed a few weeks. Bread and Butter, we called them. Esta from Hoboken paid a visit. And my own friends, Helen DeMott, Lucia Vernarelli, and her husband, Ernst Hacker, who had a Fulbright fellowship, came over. We took long walks, but we weren't as cheerful as we were in Chelsea.

Because I couldn't paint, I was bored. Edwin and Rudy were murmuring in the dining room all day. They at least went to Naples once a week, where Rudy went to the Academy or explored the red-light district. On the island I was half mother, half companion to Edwin's companion. The house was not even by the sea, but far over it.

The steep, rocky path down to the beach was not easy to manage with a baby on your arm. Once you got past its slippery, rain-soaked passages, you could walk along the beach under a cliff. You came to a little trattoria in a cave, with an arbor made of corn leaves in front of it, where a young peasant served spaghetti and wine. Farther on, the cliff was split by the narrowest of riverbeds; and cell-like bathing rooms, each with a wooden tub, were carved into the high rock walls. Women came down from the hot springs farther up with towels on their arms and pails of hot, steaming water on their heads. If you wished, they would pour the water over your head while you sat in a

tub and after a soak would rub you dry. But we never used these primitive beneficial baths. Nor did we go swimming. In the late fall and early winter, the sea, even in the south, was by no means warm. But we sunned on the beach.

There has always been volcanic activity in the Bay of Naples. Bits of pumice stone floated on the clear gray-blue wavelets, while in the black, glinting sand there were fissures out of which came tongues of steam from lava active far beneath—the fumaroles, which sometimes made us homesick for the manholes of Manhattan.

Edwin often came down to the trattoria on the beach to exchange a few words with the young man and to eat his pasta. Afterward you would find him in his bathing trunks, resting under the overhang of the cliff, book in hand, gazing out to sea. His back was to the rock, his sinewy dancer's legs ending in articulated knobby feet stretched out before him. Yellow wasps played around his toes. The three women in their black shifts and bare feet, steaming pails on their heads, swayed by like wordless sibyls.

The blue-eyed poet was in his element next to the subterranean fires, his nervy, complicated body bare to the sea wind. He looked as if he had come straight from ancient Greece.

Who will ever forget the smell of a southern house in winter—the damp of mildewing whitewash, the soot of cold charcoal, the faint bitterness of lemons, and the salty air of the sea wind blowing through it all?

But winter is best spent in a truly cold country, where they are equipped for it and know how to deal with it seriously, so when Rudy and I decided to spend Christmas with his mother in Switzerland, I said I would not come back to Ischia. While we were staying in a hotel in Naples on our way to Basel, Edwin came and rode up and down in the elevator with me, trying to convince me otherwise. In Switzerland I amused Rudy's mother by telling her that Edwin, breathing down my neck in Ischia, had been my real mother-in-law. With one two-week exception, we three never lived like a fake family again.

THE CASTELLI ROMANI

In Basel we enjoyed the famous Fasnacht—the carnival—in which I, together with Meret Oppenheim, won a prize for our costumes. And then, after Jacob was christened—Italians had always worried about his heathen state—we went back to Italy. Rudy had rented a garden apartment in a villa above Lake Albano, in a cluster of houses called Villini di Castel Gandolfo, not far from the pope's summer residence. Rudy now studied painting with Beppe Guzzi at an art academy in Rome.

It was April. I loved the garden, with its flowers gone wild and its Mediterranean herbs. Jacob was never happier. He was now one and a half years old, perhaps the most carefree age for any of us. In his little blue Swiss smock, with nothing on underneath, he padded all over, through nettles and grass, up and down steps, after cows with swishing tails, after lizards and butterflies. I painted the underwater sea life I had observed in the Naples Aquarium; the violets, fig trees, poppies, golden-eyed toads, and passionflowers in the garden; the swallows caught in the chimney; and the view of the lake and Monte Cavo, the mountain on which the temple of Jupiter had once stood.

Rudy swam in the lake before breakfast and brought back figs fresh with dew. We took sunbaths on the terrace and listened to the fishermen on the lake sing the "Internazionale" as if it were an aria from an opera. And at night we heard the nightingales fluting in the oak woods on the way to Marino Laziale. We had dinners in the *trattorie* of Albano or in that countryside commonly called the Castelli Romani, or we had lunch by the round marble table under the wisteria arbor, drinking the seemingly mild but fiendishly potent local wine.

Angiolina came from Ischia, we thought for good, but after she had fulfilled her lifetime wish of being blessed by the pope, she departed abruptly. Though the stove was smoky and the market in the piazza in Marino far away, housekeeping was infinitely easier than in Ischia even without her.

Of course Edwin was hovering on the horizon, staying in Rome. Once when he visited, we went to the center of Castel Gandolfo and the pope was on his balcony. Edwin was intrigued by his little ermine shoulder cape and his old-man gestures—the hesitant, elegant raising of his hands, repeated again and again as if to soothe us all. We were blessed by Pius XII along with the believers.

The next time Edwin came, he took us to lunch in Castel Gandolfo in one of the best *trattorie* overlooking the lake. He was accompanied by a young Italian, the son of a famous actor, Sergio Tofano, who was known all over Italy for his comic strip, one of the first—about a Signor Bonaventura who, together with his little dachshund, was forever hoping to win a million lire in the lottery. Gilberto, the son, told us that his parents, both actors, did not want their child to suffer the life on the stage they had been through and did not want him to become an actor, so they put him in a faraway boarding school. But in the tradition of Neapolitan actors, his father had been trained as both an acrobat and a juggler, and at the end of the little boy's weekend visits, just when he reached the downstairs door, the father folded himself into a ball upstairs and let himself roll down two flights of stairs as a cheerful farewell. Of course that did anything but discourage the boy, and when Edwin met him, he was already an acclaimed ballet dancer.

Another young Italian Edwin befriended was Giovanni Grottanelli de' Santi, of an old Sienese family. Edwin let him stay in our loft when he came to New York and we were in Maine. Later, when Rudy and I stayed in Siena at Giovanni's aunt's pensione, an old palace with painted Renaissance vaults, she wouldn't let us pay. A fine exchange: our funky loft for a palace.

In Castel Gandolfo, Edwin gave me Stendhal's *Pages d'Italie* for my birthday, along with a Berber cross hanging from a child's coral necklace that he had bought on the Ponte Vecchio in Florence, and he took me to choice sights in Rome. When we crossed the Piazza Farnese to see the Carracci murals in the Michelangelo palace that houses the French embassy, Edwin pointed to the splendid fountains on either

side, matching antique marble tubs topped by fleurs-de-lis. "Look," he smiled, "this is for the ambassador, that for his wife. His and hers." Every time I cross that square, I have the vision of *Madame* and *Monsieur* stepping out at dawn to take a bath, he to larboard, she to starboard.

When we went to the Museo Nazionale together, Edwin wondered about the authenticity of the Ludovisi *Birth of Venus*, as others did later. Then we looked at the Roman portrait busts lined up. Roman aristocrats, Roman politicians and merchants, their wives and daughters, sculpted with merciless realism, faced us sternly. Marked features, lined foreheads, bold noses, fleshy or thin lips, skin folds on chin or neck, shaven or bald skulls, rows and edifices of artificially stacked curls and ringlets—carved stubbornly and without fear of the truth. "Don't you think they look like Americans?" Edwin asked. It was true. Take away a bit of toga here, rippling cloth there, and imagine coat and tie or ball gown instead, you could easily have taken them for Midwestern millionaires, diplomats, politicians, or Mafia bosses and their families, decent and respectable or not at all.

I enjoyed Castel Gandolfo even when Edwin whisked Rudy off to Greece or Morocco. In Morocco, Rudy kept a diary in which he mentioned holding hands with Arab boys and visiting dancing girls and brothels. When he later naively offered his photographs, together with the diary, to *National Geographic* for an article, they did not like it. Neither did I.

It was in Sicily that we all lived together once more. With us was Frank Safford, who had dropped out of Harvard and run off to Vienna with Edwin. He had just lost his wife, Sylvia, his companion for many years, and badly needed a change. In Taormina, Edwin carried Jacob as we took walks to the still-desolate villages or to the far slopes and orchards under the black, snow-laced Mount Etna. Most of the time I stayed there and tried to paint the astonishing sea views while the men went to Syracuse and other Greek sites.

While we lived in different parts of Italy in later periods, Edwin, never far, wrote us postcards to tell what he had seen and what we

ought to see. One day in Florence we received a telegram: "Meet me noon Monday San Zeno." We had no idea what San Zeno was nor where it was. But after much inquiry and some traveling in our Citroën Deux Chevaux, we reached Verona on a Monday and found ourselves on a square in front of a Romanesque church. On its gable stood a saint with a sword in his head. The bronze gate was decorated with the most endearing reliefs but was tightly shut, the church and its completely empty square dipped in the blinding white light of noon. There was no one in sight. And then suddenly out of a shadow stepped Edwin.

He had started dealings with the Mardersteigs, who ran a small but prestigious publishing house, the Valdonega Press, near Verona. They were to publish his sonnets accompanied by Rudy's photographs. Edwin stayed in Verona while Rudy, Jacob, and I stayed in rooms in the town hall rented to us by the mayor of nearby Lake Garda. Edwin and Rudy were following the progress of the printing of *Mediterranean Cities*, which was published by Wittenborn in New York in 1956.

There had always had been strong friendships with women in Edwin's life. Among the women he admired, if not worshipped, was Olga Signorelli in Rome. To me, when I first met her, she was an "older woman." She was tall, with high Slavic cheekbones, steely gray hair, and a willowy 1920s body. I still see her in her rippling Fortuny gown, peering down to water the plants on her terrace. The husk of greenish-blue fluted silk clung to her body to make it look like a column. It left her arms bare, but its simple fluidity made the sinewy old flesh part of its elegance. She was a chain-smoker, the mark of modern emancipation of her generation. She had been friends with Eleonora Duse and had written a biography of her. She was friends with the leading intellectuals of the day, Benedetto Croce and Giovanni Comisso among them. Edwin lent me her Comisso books, vivid accounts of the life of young men in a still-pastoral Italy.

Olga had also been friends with the great Ferrarese painter Filippo De Pisis, a late Impressionist of the 1920s. Her walls were covered with his fresh, lyrical quicksilver views of the skies of Venice, his sparkling pungent still lifes, his busy, nervously brushed street scenes of Paris and London. When she asked me what I thought of them, obtuse and burdened with New York prejudices that I was, I responded, "Too much bare canvas." How much I came to love him later. How much did I, too, leave canvas bare.

Olga's apartment was on the top floor on Via Corsini, a dead-end cobbled street in Trastevere. It was next to the Palazzo Corsini and its gardens, nestling against the slopes of the Janiculum hill. These botanical gardens had gone to seed by then, and their palm trees hung their leaves over swampy fountains where young priests sat on old gray stone. At the entrance of Via Corsini a huge magnolia tree stands in the middle of the street, surrounded by a big black fence. At the end of the street was a *carabinieri* barracks, the unusual quiet of this backwater occasionally shattered by the earsplitting sound of motorbikes at the most unexpected moments.

Olga's cozy apartment, full to bursting with paintings, books, loved objects, and plants, had its special memories. We sat listening, trying hard to imagine it, when she told us about the terror and fear at the end of the Fascist regime, the horrendous events that had occurred at Regina Coeli, the Queen of Heaven prison, only two blocks away, and the debilitating and degrading scavenging for food in the long winters without heat or electricity. The darkness and hunger and fear of the Fascists, the war, and the first months after had left such lasting, cutting marks that she came back to them again and again. But she also conjured up a lively intellectual milieu in Italy, which we knew nothing about, from the 1920s until the 1950s. When Edwin told her that I was the only person he knew who had read all of Giovanni Verga, it didn't impress her. Verga, like Matilde Serao and Grazia Deledda, the earliest realists, were considered old-fashioned. Now it was the turn

of post-Hemingway writing—of Alberto Moravia, Cesare Pavese, Elio Vittorini, Giuseppe Berto, and Pier Paolo Pasolini—while Natalia Ginzburg and Elsa Morante had already begun to write down their bittersweet tales.

Born in Russia, Olga had married the Italian physician and patron of the arts Angelo Signorelli. They had three daughters: one became a well-known puppeteer; another, Vera, a poet, married the poet Edoardo Cacciatore. Vera and her husband lived as custodians in the Keats-Shelley House in Rome at the bottom of the Spanish Steps from 1932 onward. Once the Cacciatores retired in the 1970s I would sometimes see them pass by in the "English ghetto" near the Spanish Steps, arm in arm, fine profiles forward, familiar Roman silhouettes from a recent past.

When the Pierpont Morgan Library in New York organized an exhibition of Keats's manuscripts, Vera Cacciatore took most of them over from the Keats house she guarded. When she invited Edwin to the opening of the show, he took me along. In the lobby, attendants took our two raincoats and haughtily put them among the rows and rows of sleek minks of the sponsors, where they hung, poor and limp. When we got inside the hall, which was lined with some of the most precious volumes in Christendom, the cocktail party for the millionaires was in full swing. And Edwin just had to light a cigarette in full sight of the Gutenberg Bible. After this naughty act of defiance was stopped by an attendant, we were the only ones leaning down to read the words of the poet.

In the 1960s, when I was already living in Italy, we organized film showings of Rudy's movies—made with family and friends in Maine and New York—at the Artists and Students Center of St. Paul's Within the Walls in Rome. As always, Edwin had the starring roles, as the mad scientist in *Lurk* (1964), as the wicked capitalist in *Money* (1968), and so on. I invited Olga. She had seen Edwin dance, but had never seen him act in the movies. She came, tall, moving delicately in her old fur

coat. Afterward I took her to a taxi in the Via Nazionale. Getting in, she turned to me with a wide smile and said, *"Che ragazzo adorabile!"* Edwin was still the darling boy to her.

John Becker, Edwin's old friend from Harvard, a nice, attentive man, with his small hooked nose, mustache, wickedly inquisitive eyes, witty mouth, and tweedy Edwardian dress, told me that in Paris they always mistook him for Alice Toklas, Gertrude Stein's lifelong partner. In New York, John had a gallery in a Park Avenue penthouse, one of the first galleries of modern art in New York. He was the first ever to show a de Kooning painting. Well-off and gifted in too many directions, he was disarmingly ironic and kind, with a searching intelligence. Forever restless, he had flitted from art dealing and art collecting to writing and acting, from his native Chicago to his Sutton Place penthouse facing the East River in New York, later from palazzo to palazzo in Rome, from boys to women and back.

Eventually he settled with the Hollywood actress, painter, and puppeteer Virginia Campbell. In Rome, they concocted marvelous puppet plays, and Federico Fellini based a scene of *La Dolce Vita* on one of their parties. Once, when Rudy and I were traveling through Rome as tourists, we were invited to one of the Beckers' fabulous puppet-plays-cum-parties. I came with little Jacob. Rudy arrived on his own later. He came in breathless.

"Sorry I'm late," he said, "but on my way here I passed the Trevi Fountain. Something great was happening there, and I absolutely had to watch. It was all floodlit for a film. And this fat woman dived into it again and again. The man who was yelling at her and directing her was absolutely sure of what he was doing. She did everything he wanted devotedly, without objections—went into the cold water over and over again. He stood there bossing her and everyone else around, tough like a king, absolutely right. It was great to watch someone knowing

exactly what he was doing." Rudy had witnessed the almighty Fellini directing Anita Ekberg in *La Dolce Vita*.

It was all very *dolce vita* on John and Ginny Becker's terrace among the candles and good food and drink that hot evening at the Palazzo Caetani in Via delle Botteghe Oscure. Among the many expatriates were Jenny Cross, Robert Graves's daughter, and the New York critic and historian Milton Gendel, who was friends with the old Rome aristocrats. The talk seemed frivolous and frittery to us earnest, sophisticated New Yorkers. On the stairs going out, Rudy and I looked at each other and shuddered. "God, don't let us become expatriates!" we said. But look at me, all these years later, here I am.

The text of the elegant puppet plays, full of amusing puns and preposterous situations, at first seeming only fluffy, may have been John Becker's most acute and serious work. He also wrote pricelessly funny and unforgettable rhymes for a children's book, with Ginny's guileless, sunny illustrations, called *New Feathers for the Old Goose*.

John had a special way with children, cunningly wooing them, meeting them on their level. Once, in Paris, he invited Jacob to a restaurant at the Place de l'Étoile and bought him a dinner that was entirely pink: lobster bisque, salmon, strawberry ice cream. He was always in cahoots with Jacob and other children, winking and laughing, engaged in secret games. John and Ginny had a little girl of their own, Haidee, who was Jacob's age, whose life and doings had inspired *New Feathers for the Old Goose*. John, who liked Jacob a lot, fancied him for her, but fate took a different turn. When Jacob was in college and John already ill, staying in a New York hotel, he invited Jacob for cocktails. Grandly, he had him fetched in a Daimler.

VENICE BIENNALE, 1964 AND 1968

Though Leo Castelli paid little attention to women as artists—he had only structural, cool Lee Bontecou and the beautiful Marisol in his stable, no Joan Mitchell, Grace Hartigan, or sparkling Elaine—he sure had an eye for the ladies. Helen DeMott and I had recently traveled in Italy, and adoring all things Italian, we loved to throw Italian verbiage around, so we began calling Leo "*lo zio Leone*" (Uncle Leone), which spoiled his game a little, but he suffered it mildly, seemingly with good nature. Wise and steely underneath, he knew he had to get along with two such quirky little women painters as DeMott and me. It paid not to act rough like the rest of them in New York.

It looked like *lo zio Leone* would never do anything to raise a riot. But then he did. In 1964, Leo's discovery, Robert Rauschenberg, was the first American artist to win the grand prize at the Venice Biennale. Leo's other boys, Jim Dine and Jasper Johns, also showed, as did Morris Louis, Kenneth Noland, John Chamberlain, Claes Oldenburg, and Frank Stella.

Leo had been a particularly nimble dealer and smart operator on the New York scene, but now he topped everything, and it became splendidly evident that he was a brilliant navigator in the murky waters of international art politics as well.

In 1962 I had put an ocean between Rudy and myself, to escape our troubles. I had gone with Jacob via Basel to Rome for a brief spell, a few months of rest. I began to see Rome not just as a fantastical collage of layers and layers of history but as a present-day center of art. After World War II, painters, some of them actual partisans, had turned against figurative convention, socially conscious or otherwise, and steered into a new, bright, and clean abstraction. By now they were beginning to invent their own bastard versions of American Pop Art. But the scene was leisurely and spare, if not dismal, compared with New York, and very inbred and a closed shop indeed.

In the summer of 1964 I was bereft, as Jacob had gone to stay with Rudy in Maine for the summer. My friend Barbara Bryant and I decided to travel to the Venice Biennale to find out where it was at. Barbara drove my little Cinquecento Giardiniera, a Fiat 500 station wagon, bare foot on the pedal, blond hair streaking in the wind, all through the Po Plain. In Venice we found lodging in a tiny pensione where I had been before. Owned by a frail old spinster, it was situated over a billiard parlor, across the square from La Fenice opera house. The rooms were grungy but adequate. The signora made a point of repeating her tales about her good old family, who were exposed in innumerable framed pictures and knickknacks all over the worn furniture. She daily brought me ground meat for my dachshund from the Rialto market and kept us informed about the doings of the Biennale from the latest newspaper headlines.

One day, a couple of tidy and proper men, Belgian art dealers on the make, happened to watch Barbara on her hands and knees in the tunnel of a bizarre installation you were programmed to crawl through. They invited us for dinner at Al Colombo, the fanciest restaurant in Venice. They didn't know what to make of Barbara or me, but they were completely befuddled when, after thanking them, we escaped this stiffly conventional pair through the entrance to the poolroom, which led to our humble pensione upstairs, leaving them in speechless bafflement.

On another occasion, a couple, a plump heiress tottering on stiletto heels and her new chubby husband, invited us to their palace. They wanted us to admire their latest acquisitions. Their palace was on the Grand Canal, not far from Ca' d'Oro, the haunt of the Franchetti, Cy Twombly's in-laws. We followed them through a gloomy sequence of grand halls full of heavy furniture, marble floors, and very heavy oils of holy figures swirling in flamboyant drapes. The dining room walls were decorated with rows and rows of Sèvres plates, each daintily painted with a feathery view of a foreign city. Everything here was heavily traditional, but in the dreary baroque darkness, suddenly a little door was thrown open, and lo, as if in a fairy tale, there appeared a little world, shiny, new, and sparkling. A host of brand-new art huddled together in jolly communion.

There were repeats of finely polished identical metal cubes; there were neon-tube staffs humming in candy colors, arranged in geometric patterns; there were conundrums of glaring white plaster heads of Greek gods signifying an intellectual idea; and there were consumer goods in new contexts: faded or abused household discards and fragments resurrected from garbage cans. All stood elegantly arranged, bathed in the aura of new art. It was properly enigmatic and chic. Only the truly fashionable could be hip to it; it was either too deep or too shallow for the rest of us.

We left the lugubrious, ancient palace, spiced with its little ultramodern inset, a futile spell against a congealed past, and ran to our quite ordinary, everyday lunch spot—a hidden little counter where the gondoliers took their fishy snacks to talk shop and soccer. Here we were rid of the Biennale and complicated art and its antics. Here was sober, everyday Venice.

We usually met there at midday, but we would have breakfast in the café of La Fenice. Here, in its fragrant mid-morning bustle, with the hot July day rising outside, Leo Castelli buzzed in with the breeze, a slew of young American artists in tow. Crisp and cool in his pearl-gray summer suit, as dapper and polite as ever, he was about to give me, the

old pal from the Club, a cursory but still friendly smile, when his little black eyes lit on Barbara. With her straight fall of long blond hair, her faded blue babydoll dress doing nothing to hide her generous body, she looked so wisely fresh, so straight American, so timely. Around us,

Robert Rauschenberg's work on the Grand Canal in Venice.
Photograph by Ugo Mulas, 1964

Johns, Rauschenberg, and some journalists were boisterously involved with one another and their own glory in this exhilarating water city.

Bob's squeaky voice dominated the conversation. When he said brightly, "Don't you love Venice!" we shut up and were all attention. "They have the most fabulous Westerns here," he continued blithely. "I saw a great early John Wayne yesterday." His eyes were slitting wickedly. "You know what, I sit in the movies every afternoon. It's fun in Venice to sit in the dark, let the sun glare outside, and watch a cowboy movie." I was shocked, and I was supposed to be.

In the general bustle, Leo edged closer to Barbara. The madly important dealer, the man of the hour in Venice, was at his most amiable, his most charming. Then, firmly, smiling sweetly, Barbara gave him a graceful brush-off. Leo, as gracefully, understood. After drinking his coffee, he was out of the bar, Bob, Jasper, the other painters and hangers-on, hungry for new events, bustling after him. Barbara stretched and shook herself. "Good grief." She yawned. "And who was that?" She smiled, full of bored ignorance. "Now let's go to Harry's Bar and check out the real stars."

In the 1968 Venice Biennale, the impish, brave, and wise Piero Manzoni, who had died in 1963 in Milan at the age of twenty-nine, was being honored with a sparkling show all over the foyer and staircase of the already sparkling La Fenice opera house. We crashed the opening, which was chock-full of sparkling people. Manzoni's linen bedsheets, wrinkled horizontally in abstract patterns; his bluffs of surgical cotton stretched out to look like Coney Island spun sugar; his *rosette*, baked rose-shaped rolls slathered with dead-white house paint; his so-called Achromes—all stared nonchalantly and airily out of glass cases. And then there were the unopened, stringed, red-sealed postal packages; his little balloons filled with "artist's breath"; his little cans filled with "artist's shit." Amid the gold and glitter of

the curlicue rococo decorations, the mirrors, the Murano glass candelabra, the lavish appointments of the old opera house, they looked upsetting, whimsical, and also absolutely fitting. Over the froth and chatter, over the champagne flutes held high, Manzoni's Dada and/or Arte Povera objects, sealed or unsealed, held court.

But the spirit of the city was rent with timely protest. I even saw a protest against protest, watching the wild, willful, snake-haired Pino Pascali in the Giardini. In jeans, sandals, and leather *blouson noir* motorcycle jacket, he was ranting in the middle of a circle of comrades and reporters. Here was another magician of found things. His sticks and stones, his contraptions like cavemen's tools—dark, unkempt, hairy, and bumpy, standing rough and glowering like primeval monsters— menaced no one. Despite everything, they were good-natured beauties.

Gastone Novelli was another matter. I noticed him in one of the main halls of the Biennale, which was to honor his work. Though quite conventionally dressed compared with Pascali, he had a far more engaged past. As a young partisan, he had been caught and tortured by the Germans in the Regina Coeli prison in Rome. Now he was standing by a row of his works, immersed in discussion with his comrades. In his paintings, you could see the canvas, the white weave daubed with darts, slivers, jabs, arrows, and clots of vivid paint— jittery or calm linear work connecting them—lyrical exclamations with bitter, biting, cutting, and exhilarating script. Splinters and red jagged attacks suggested the horizon; there were hooks and patches and little meadows—slogans of woe and joy scribbled with street wall know-how as well as elegance. He had learned from Cy Twombly. His singing or crying many-faceted tapestries whispered, leaning against the wall, all ready to be hung, to become part of the spectacle of the Biennale.

But tidy Novelli, with his little curls and mobile face, had come to a decision. He had to fulfill his political commitment as part of the moment of protest. Gravely and painfully, he took his works, the bright-speaking flags, and, one by one, turned them to the wall. Only

their pale backs were left to show. They were shut up, reduced to mute negation, a pungent protest.

Later that same morning we all went on a boat ride to Torcello— Mimi Gross and Red Grooms; Paul Suttman and his wife, Elisse; and Jack Zajac, the Californian sculptor of goats' heads, and his wife. The launch had been rented by Zajac's dealer, a big, loud Californian who was smoking cigars, hovering in the stern, and looking over us. We floated on the glistening lagoon, riding on white and black slickness under a covered sun.

After landing at Torcello, we walked to the piazza of that once mighty town, which commanded the lagoon long before the rise of Venice. Near its slender Romanesque campanile were two ancient, now lonely, churches. In the cathedral we looked at the Byzantine mosaic of the Last Judgment: fat little bodies of dead people, glittering. They were all the same, all like maggots or mealworms squirming in a jar, all plump, naked grubs, poor little creatures, bare and white. Someone murmured, "Is that all there is to humans in the end?"

Chastened, we climbed back into the aggressively gleaming boat and glided away fast. Before us the lagoon spread wide and empty, as

Byzantine mosaics in the cathedral of the Basilica di Santa Maria Assunta, Torcello, Venice. Photograph by Jacob Burckhardt, 2019

Mimi Gross, Paul and Elisse Suttman, and Edith (standing, left to right). Red Grooms kneeling in front. Piazza San Marco, Venice. Photographer unknown, 1968

white as the summer sky. But a little black boat in the distance seemed to be hanging between sky and water, quite alone, quite still in the middle of nowhere, and as we passed, we saw a man and a woman in it, lying back languidly, their hands trailing in the cool water. They were talking and laughing softly, easy in their hidden little affair, se-

renely lying over pearly water under a silky white sky. I recognized the curly-headed man. It was Novelli. I told the others about what I had seen him do earlier, making a harsh stand in the real world, making a grim decision. "Oh, Italians," mused Mimi. "Oh, Venice. Bless them. They know you can't be on the go all the time. You can take time out from the revolution."

But we had to face the revolution the next day when we found the huge expanse of Piazza San Marco unnegotiable, seething with two distinct masses of people, two hordes, one of boys and girls with lots of hair, the other of young men in tidy uniforms with helmets and shields—the students and the police. One group was motivated and bright, with burning new ideas, the other brought up to stick to tradition.

Screaming their slogans against the bourgeois Biennale, wide phalanxes of protestors advanced against the riot police. When they were nearly face-to-face with the masks, helmets, shields, and sticks, they hesitated, and when they swayed back a few steps, the police went

Demonstration in Piazza San Marco, Venice. Photograph by Vittorio Pavan, 1968

forward a few steps, truly threatening. Then the police went back, and the others went forward again, loudly throwing insults. It was a continuous baiting, the students and the police, like the waves of the sea advancing and retreating. Neither had the guts to attack. In those days in Venice, outright violence was not yet on the slate, but it was close enough. It gave us a scary thrill. The picture of the roiling masses of young people waving back and forth over the great square on the point of colliding with fury went on haunting me for years. It was about something horribly unresolved, the ache of an eternal human question.

But the Biennale went on. Some of us artists, as free hippie rebels, showed our lack of respect for anything organized, holding up blank cardboards and banners—free of slogans of any kind—and marching around and around. This was supposed to be a protest against all the protests. We crashed parties. We crashed private and official openings.

At the Biennale, Venice was bracing and at times fierce and even dangerous. But the Italian summer and that basic taste in your gut, the marvelous honor of the activity of ART, were sparkling everywhere around us.

CONVERSATIONS WITH GIORGIO MORANDI

I don't remember when I first noticed Giorgio Morandi's paintings. My own work had been meandering, and I admired him as one of the few painters who knew how to fuse sentiment with intelligence, who said a lot with few means. In 1960 I saw a large exhibition of his work, and I enjoyed the paintings as one enjoys contemplation in a special place, perhaps as one enjoys nature in the country in the morning.

In the summer of 1961 I was in Milan, acting as an interpreter for a medical student, when he asked me where I was going next. To my astonishment I heard myself say, "To Bologna to visit Morandi."

"How lucky you told me," he said, "because I happen to know Morandi's not there. He always goes to a little village in the mountains in the summer. It's called Grizzana."

Two days later I get out of the train at the classic Italian station, in the middle of nowhere. I see no village, only a bus, and I climb into it with my fellow passengers. It winds its way uphill past broom plants blooming bright yellow, fluting a post-horn warning before each curve, and in the end it drives passed a sign that announces: "Grizzana Summer Vacation Center, 547 Meters." After riding past some scattered farmhouses, we come to a stop in an avenue of pine trees. There is only one pensione. In its entrance, where there is a grinning terra-cotta *putto*, or cherub, and Christmas tinsel dangles over a stagnant pool, a pretty, thirtyish woman takes my things. My folding easel gives me away.

"You are a painter?" Signora Francesca asks.

When I question her innocently, "Are there many other painters here?" she draws herself up and says with emphasis, "We have Morandi."

She climbs to the second floor in front of me.

"Morandi and his sisters used to stay with us. We weren't a regular pensione then, and they managed for themselves. Now they have a house of their own. You should see the fancy people who drive up there." Passing through a room, she throws open the shutters and says, "*His* view!"

It is a green view. Not too ordered, with dark-green clumps of trees in the foreground, it rolls in a green haze to the valley where the trains run, climbing again, very pale green, to the flanks of mountainsides marked by a horizontal beige scar, the new autostrada. On a ridge, like a child's drawing, a tiny church with its bell tower is outlined on the dusky lavender sky.

Later, in my room, a servant's room right under the roof, I have the same view. A moon has come up, and the summer evening is fragrant. Some boys are sitting on a garden wall singing while the priest accompanies them on his concertina. The singing, the strange place, and the

fact that today, July 20, no one has wished me a happy birthday, all make me feel lonely. But the next morning I wake up expectant in my wrought iron bed. I tell Signora Francesca, "I wish to see Morandi."

"Walk on the avenue toward the village. At the crossroads, ask any boy where he lives."

At the crossroads before the village, some boys point to the right, and I follow a dusty road. On my right is a rounded hill, with a farm building here and there, wooded at the top. On my left the ground slopes, then rises gently, dipping again toward the mountains. I walk slowly, enjoying the summer morning. I pick scabious, mullein, and other field flowers at the wayside.

Then I see a brand-new two-story house sitting by the road in a large, empty field. Upstairs a window is open. A tall man stands in it, observing my approach through a spyglass. The house looks suburban and superimposed, like an abstract idea, on the mellow landscape. It stands on uncultivated ground, fenced in by chicken wire. On the roadside there is an iron grill, behind which grow several rosebushes. I ring the bell on one of the gateposts, and the gate opens electronically. Then the front door is opened by a neat lady in a blue silk polka-dotted robe. She is very trim, and her silvery hair is gathered in a bun. She wears pearls. When I ask her if I can see Morandi, she looks at me with that patient, ironic smile of the relatives of the famous, not really approving, but ready to serve his vanity with yet another eccentric admirer.

She hesitates. "I don't know whether he is up—"

"Let her come in!" a voice from upstairs interrupts.

And Giorgio Morandi comes down, tall, stooping, afraid of the draft.

I am not surprised that he is the man from the window. I introduce myself. He introduces me to the lady who has shut the front door. It is his sister Dina. She disappears unobtrusively while he leads me into the *salotto*, or living room.

I expected a dry old man, spinsterish perhaps, or fussy. Instead I find this kind, deliberate one. He is a little ironic, a little tired, but

content in having found his way long ago. Like all Italian middle-class men in the summer, he smells of lavender water, and he wears their kind of high-polished laced boots. His suit is old and formless, the collar ends of his shirt held together under his tie with an old steel safety pin.

His hands, large and rounded, are not particularly sensitive. His face has a round look too, almost owlish, perhaps because of the to-tally round glasses; his skin looks naturally brown, with only a slight tan, not leathery, but even. On his chin is stubble. His silvery hair is cut short and comes to a Brechtian fringe over his forehead. His nose over smoker's teeth is long; the mouth with the pendulous lower lip sometimes looks misanthropic. He does not look straight at me of-ten, but when he does, his eyes, used to a lifetime of putting order in things, stare out coolly: weighing, shrewd, critical.

I don't know exactly what I had in mind when I first thought of visiting him, but I certainly didn't expect such an intense morning. Whether it is his good manners or our common profession, I feel at ease with him at once. He too seems amused and diverted by my visit, almost in spite of himself. It lasts four hours straight, from nine until one.

The chairs in this modern room are upholstered in bright blue, the couch on which I sit is gray. There are no paintings on the walls. And in this Mediterranean country, where even open shutters are suspect, the very windows are flung wide open and there are no curtains at all. Bookcases are filled with the proper books, *The Leopard*, *The Tale of Genji*, for instance; there are volumes on Chinese painting, reviews by Riccardo Bacchelli, Cesare Brandi, some art magazines.

He follows my look: "Those aren't mine," he says. "Almost every-thing here belongs to my sisters. For instance, most of the roses in the front garden, they are *modern* roses. And all those art reviews—I keep very little of what is written about me. I don't read half the reviews."

He puts down the spyglass, which was still in his hand, on a vol-ume of mushrooms and wildflowers. And looking at my handful of

field flowers, he adds, "I like those better than most flowers, except roses."

I describe the alpine flowers I found recently in the Bernese Oberland.

"But the Alpine landscape is too accentuated," he says, "like the blue of its gentian. Near here, in the Apennines, you should pick the gentianella, a tiny blue flower on a tall stalk. It is a soft, beautiful blue. Roses . . . did you see the little pink bush among the others in front? I brought it from Bologna. In my garden there I have two bushes of old-fashioned red roses that Vittorio De Sica gave me. Did you know that white roses seldom have perfume? I took some from the owner of Pensione Italia to Bologna too, and now they don't have any left. Only the priest still has some white roses. I sometimes go to look at them."

I have been wondering about some clumsy vases that seem out of keeping. They are filled with—geraniums.

"Those aren't yours?"

He smiles, saying, "They are my sisters'," and he points to another, which is shaped like the funnel of a kerosene lamp. "I painted that one, but not by itself. Its shape alone was not enough. I don't like the way it ends at the top, so I had some green leaves hanging from its mouth."

I think of some cubes, some funnels not easily explicable in his paintings. "Do you ever invent objects?"

"No. Never. I have always *seen* everything first."

How pedestrian of me to have asked; so perhaps the cubes are cookie cans, some uprights are pestles, bottles, vases—does it matter?

He says, "I still have all my objects. None of them were broken in the war." He shows me the farm across the road. "We stayed there some summers. The road itself was the line between German and Allied forces; they were entrenched on either side for three months in World War II. In the chestnut woods above, you can still find gun platforms . . . and also some partisans' graves . . . We were in Bologna

then. We stayed in the cellar. It was frightening . . . not so much the explosions . . . the motors of the oncoming planes and that terrible thing, a sort of void or wind, just before the bomb hits. The houses on either side were hit; in ours, not a thing was broken."

He continues to talk about his past. His father was a cloth merchant and wanted him to become one too. "But at the age of eighteen I gave up and became a painter. Eventually I taught drawing. My sisters supported me for sixteen years, because on my salary alone I would have starved. They taught school in Tripoli, where they earned double what they would have earned here at the time. Later I began to teach etching and did not stop until a few years ago. Etching at least is a technique, something tangible to teach. Art can't be taught. Oh, all those years . . . I still think of the job as a long illness. In all that time I had maybe four talented students. *In fondo*, in the end, only artists recognize artists. The first who really helped me was Kokoschka. I was already sixty when we met, and he was the first who helped me sell too. But I'm not too interested in that. I never made a contract with a dealer. I never ask much for a picture."

"Don't you think students learn most from each other?" I ask.

"Yes. They also learn most from teachers who are bad artists themselves. Look at Moreau, who taught Matisse and Marquet." He smiles. "Anyway, art schools should be closed."

I wonder if that is a legacy of his Futurist days, but I say nothing.

"I understand the young well," he says.

"You too made the revolution," I say. "I saw one of your etchings in the Futurist show."

"I was still puzzled then, searching . . . They were friends . . . Boccioni was an intelligent man; then there was Severini . . . I was never a Futurist."

He gets up and goes over to the window. "Sometimes they ask me what I think about abstract painting." He points outside. "There, that which is called *il reale*, that is the most abstract."

We talk and talk, and I tell him how I enjoyed the Piero della

Francesca in the Brera, with the inexplicable egg hanging from the vault, and how the cool colors and steady figures remind me of him, and he is pleased.

"The Carpaccios are magnificent and the Bellini *Pietà*—the Ambrogio Lorenzetti," he exclaims. We talk of the Venetians in the Brera. He likes Tiepolo, and likes Canaletto better than Guardi, who he thinks is too facile: "He has all those little tricks."

"But the Guardi with the gray-blue lagoon in the Museo Poldi Pezzoli!" I exclaim, and he admits he too loves that. "But Longhi! And Bellotto!"

He likes the Sienese as much as I do.

"The Uffizi in Florence, with all the *ciceroni*—the guides—making silly explanations. Like sheep, people listen and don't *see*," Morandi says. "Florence makes me nervous—those narrow sidewalks, the cars about to shave your arms off. In Bologna we have arcades. But they are doing good things in Florence: in Santa Croce they have uncovered the Giotto murals so that you can see the Franciscan monks in their original gray habits, not the brown ones they painted over later. You must look for the only medieval still life in the Cappella Peruzzi."

I do so a few days later, but I can't find it. I looked in the Peruzzi Chapel many times after and never could find it. Then one day when I was leafing through the 1967 Rizzoli edition on Giotto, I finally saw it on page xlvi: Morandi in Giotto, a white ornamented pitcher on pale green, simple and monumental.

Morandi's sister Dina comes in with a tray full of letters, telegrams, postcards, and two cups of coffee, and withdraws again.

We drink the coffee and begin to talk about Giorgione. A painting of Giorgione's has gone to London, maybe it was going to the Courtauld. "It has a sunset," Morandi says. "I have never painted a sunset myself. I like something stable before me. Mostly Giorgione does too. That's why in my opinion *The Concert* in the Pitti could never be a Titian. He has a different mentality—he would have painted the activity

of the concert. Giorgione painted the moment when it was over. Everyone is still listening. Looking, you too hear the echo."

Somehow we come to Constable. "He made certain heavy compositions in the studio, how labored, as different as night is from day from those marvelous small landscapes *dal vero*, so fresh, so perfect."

From there it was only a small step to Corot. And Monet, for instance the cathedrals, but not the late Monet.

Matisse? "*È grande*. Some said he was too violent. The German Expressionists were really wild, they were upset. But under Matisse's apparent violence, what calm."

When I tell him how, when I was unhappy, painting had been therapy to me, he objects.

"When I am disturbed," he says, "I couldn't possibly paint."

What does he think of art trends in general these days?

"*In questo momento non si può dire niente*. At the moment one cannot say anything. Anything may happen. One is getting used to expecting art to define and frame things, like photography. The reality in that has made us *see* differently."

Does he, in 1961, when Pop Art is unknown in Italy, already foresee it?

"Once, there were centers of art. Florence was very far from Siena. The art in each town was different from that of the other. Now there are only a few hours between Florence and Bologna, which were once more than a day's ride apart. There are no distances left. Everything is everywhere. Art used to have more of a place; it was needed in daily life. Now we have movies and television instead."

He begins to open some letters and some of the telegrams. Half distracted, half pleased, he excuses himself: "These are congratulations. Yesterday was my birthday."

Now comes the most touching moment of the visit. When I tell him it was mine too, he takes me outdoors, breaks a little sprig from a pearly pink rosebush, and gives it to me, saying, "Happy birthday!"

This is why I arrive at the Pensione Italia in a euphoric mood. Signora Francesca doesn't really have to ask how it went, but she does. She mentions that she discovered that I looped back the curtains in my room in order to see more of the landscape. "Just like him." And when I somehow evade her request to have a look at some of my work, she nods and says, "Just like him," again. "He never wanted us to see his pictures here." She points to some houses in the distance. "He painted those three together. The painting got a prize."

I go back to his house in the afternoon with some photographs of my oils and boxes and some watercolors, as he has asked me to. He says one Maine landscape is too much of an illustration, and that in one still life, "There are certain interesting objects in it."

When he is looking at the watercolors and I say I want to cut off the unsuccessful side of one, he is shocked. He does not like tricks. He thinks my paper is too grainy, pebbly, and so makes for easy effects. "I like smooth French paper," he says. "The other day they brought me a lot of Dutch paper. I haven't done any watercolors in two years. Now we shall see . . . we shall see."

When he sees a photo of one of my boxes, he says, "*Simpatico.*" Then he leafs through an Olivetti calendar of his work until he finds a reproduction of a painting done in 1919 in the so-called Metaphysical period. Pointing to it, he smiles. "Look, I made a box too!"

We come to another painting, where Morandi's signature is exquisitely placed, plumb in the middle. And I say, "*Lei è furbo.*" You are cunning. He laughs.

When we come to a landscape with a white wedge of a house in it, he shows me the same house from the window. "I painted that, often." Of another picture he tells me it is owned by Vittorio De Sica.

"De Sica is a true friend. Once I had to take the Alpen Express, a train that leaves Rome at six thirty in the morning, a terrible hour for De Sica. But he came to see me off nevertheless, a true sacrifice. The kind of life he leads, the kind of life most of my friends lead, I could not stand it for a day. I don't like much agitation. For instance, once

I wanted so much to go to Paris, but I had no money. Now they have even invited me to come to New York. It would have been interesting, but now it is too late. I need quiet. I do not want to produce much. I want to be slow."

He is at the window again, outlined against the landscape, and looking at him, I think that even if I had had no idea who he was, I would have known him for an unusual man. Although he is far from the art centers of the world, he is not provincial. But like his art, he has extraordinary simplicity.

The landscape and he have a lot in common. It is open yet formed, and not ostentatious. In Italy history has passed over everything as water has passed over the stones in a brook, leaving it mellow and wise. He seems to have read my thoughts: "In other countries the landscape is wild. In Italy it is human."

Later, accompanying me to the gate, he says in a serenely fatalistic way, "I forget names. Yours I'll perhaps have forgotten when I see you again. I may not recognize your face. But come and see me when you come to Italy again anyway. Come and see me in Bologna . . . *se ci sarò* . . . if I'm still there."

And he *was* there, in the winter of 1962. A few days before Christmas, coming through Bologna with Jacob, I went to visit him. In the wintry but always hospitable city, we found his apartment in an old thick-walled house over an arcaded street. A little maid showed us into a sort of anteroom, called "office" in European houses. First, sister Dina came in, more cordial than usual, then Morandi himself, who led us into the living room.

It was old-fashioned and of a coziness rare in modern Italy or anywhere in modern times—simple, not overcrowded, comfortable, not picturesque but paintable, like a Vuillard interior. The few inherited Victorian pieces of furniture were a sideboard, a glassed cabinet, and the round table where we sat. An old enameled coffeepot simmered on the coal stove, and there was a smell of wax and warmth and festive expectation.

The presence of Jacob, for once not shy because I was, made it a family visit. Morandi gave him a Bacio Perugina, a chocolate kiss, and Signorina Dina poured us all some coffee. Jacob began to look at the objects in the glass cabinet. Morandi took out a long, rectangular piece of stone, a fossil of a flower, to show him. Then he reached for a small Greek statue with traces of paint on it. For the rest of the visit, his fingers stroked its curves from time to time.

Then I told him of a small round painting of his that I had suddenly come upon at the "modern art" gallery upstairs in the Pitti Palace, how I was alone up there and liked it so much I had to resist stealing it and hiding it under my wide summer skirt.

"You *should* have," he said, smiling.

In the summer of 1968 I looked for that painting in vain. I asked a guard about it. He was evasive at first, then after a while confessed: "One morning we found the wall empty. In place of the picture was a note, written in English: *I love Morandi.*"

After Morandi's death, in 1964, on a train from Venice to Bologna, a railroad conductor sat down in my compartment and told me that all of Bologna had come to Giorgio Morandi's funeral, and added, with that Italian mastery of the apt sentiment, "He died because there was too much poetry in his heart."

I look at his legacy, the reproductions before me, and see homely objects standing together: housewares, boxes, compotes. Flowers of stone or candy grow from vases. Smoky olive trees by plain houses on noonday roads into dense summer. Here a blue vase trembles, and a small, lumpy rose lies on its lip. Marble white, apricot, snow gray, dusty blue, shell pink, butter yellow—necks, ridges, squares, holes—painted with sternness, under sifting light, without artifice of any kind. What are those paintings—a handful of ordinary things huddling together— why do they curdle the heart? Memories, people, shadows, saints? They are order in the wilderness.

MORANDI, MACCARI, AND LOFFREDO

When I first arrived in Rome with Jacob in 1962, we rented rooms with Lola Segré, who was part of the English literary set because of her husband Patrick, a poet. We were across the street from Cy Twombly and his family in Via di Monserrato. We all ate together at Pierluigi's trattoria downstairs, where lots of other foreigners in Rome spent lively evenings.

Next door lived an Italian painter—an early Italian Pop Artist— and his Roman wife. He had a broad, jolly Bolognese accent and was amused by all the visiting New Yorkers he had met on Via Veneto— Marisol, Bill de Kooning and Ruth Kligman, Jack Tworkov. It came out in conversation that his father, who supported him, owned a hotel in Bologna, so when I planned to go to Basel with Jacob to visit his grand- mother at Christmas, I remembered Giorgio Morandi's invitation to call on him in Bologna, which was on the way. I asked our neighbor about his father's hotel, but he became quite cagey and changed the subject. I asked around and found its name and address anyway.

The hotel was conveniently situated near the Bologna central train station, and we left our luggage there and set off to see some of the sights and museums and sample some of the famously delicious pasta. We would visit Morandi the next day. The night in the hotel was dif- ficult. Jacob fell asleep at once, but I didn't because of the intermittent door banging and other noises—voices, music, steps up and down the stairs. I had never been in such a noisy hotel. In the morning when we checked out, I saw a few heavily made up girls lounging half dressed near the desk, and then it dawned on me what all that night traffic had been about. When I later told another friend the name of the hotel in Bologna, he laughed, saying, "The best."

"The best what?" I asked.

"The best cathouse, that's what. And in a town that's famous for the best *casini* [brothels] in Italy, not just its good food and its good Communist Party organization."

I thought of this many decades later, when a new bar opened in Pietrasanta in the marble country. Its walls were graced with charcoal drawings, signed by Mino Maccari, of tough, sloppy girls in lewd poses. I vaguely knew that he was of Morandi's generation, that he did paintings of bordellos and also had done political cartoons that were out of harmony with the Fascist regime, but he'd managed to get away with it. Had this artist anything to do with the nonchalant owner of the bar? Indeed. He was his grandfather. This reminded me of a story a grand personage of the Roman art world once told me about Morandi.

Mino Maccari and Morandi had been part of the Metaphysical movement, which got its name from *la camera metafisica* of Filippo De Pisis in Ferrara. The two very different men were good friends—the gentle, retiring Morandi, and Maccari, who was feared for his sharp wit among sharp wits, played tricks on unsuspecting people, and was notorious as a wicked mischief-maker.

Like Henri de Toulouse-Lautrec, Jules Pascin, Otto Dix, and George Grosz before him, Maccari loved to hang out in bawdy houses, not just to screw and drink, but to observe the goings-on and mark them down with pencil and pen. His sooty sketches were gawky and speedy and funny in a sinister way, but far from the cutting, spiky nastiness of the northerners. The drawings were robust and grotesque, foreshadowing Fellini. In a hidden back room of a gallery in Viareggio, not far from the strand where Shelley's body was washed ashore, I once came upon Maccari's sketches of very sturdy penises, drawn in bitter charcoal and nicely framed. Maccari was a fiend!

When I arrived in Italy in the 1960s, I was surprised that local artists didn't share my enthusiasm for Morandi. Margherita, Alvin's neighbor in Via dell'Orso, a printmaker from Guastalla whose husband was a member of parliament for the Emilia-Romagna Communist Party, explained it this way: "You Americans don't understand. An artist who goes out every morning and tranquilly buys the *Resto del Carlino*, the most conservative newspaper of them all? He isn't even abstract or near it. I don't trust all this quietness."

Maccari too was irritated by Morandi's steadiness and his placid acceptance of life with his stuffy sisters, one of them rumored to be a bit touched. He never had a girlfriend, he rarely caroused with his fellow painters, and he let his sisters, who had helped him out by teaching in foreign parts, build him a brand-new country house in Grizzana, even though he was much happier in their old-fashioned family apartment in Bologna, with its little, cobwebby painting room full of rows and rows of dusty, battered, and cherished objects.

So once a day Morandi went down to get the conventional old paper? So once a month he took the train to Florence, supposedly to study the old masters? Really? Maccari made it his business to find out.

"Listen, Giorgio, *ascoltami bene*," he said when he knew the truth. "Why do you have to take the train through all those tunnels in the mountains *per andare a donne*, to visit a brothel, when right across the street here in Bologna are the finest whorehouses in the land? Why waste time on that trip? Let me treat you. I'll take you to a good place with good girls right here. *Ci penso io!* I'll take care of it."

Eventually Morandi let himself be persuaded, and one night the two painters stalked into Maccari's favorite *locale riscaldato*. Maccari made introductions all around. Just as the reticent Morandi was relaxing, crafty Maccari reached into his pocket and drew out his pearl-handled little revolver. Grinning gleefully, he aimed it at the ceiling. Then he pulled the trigger and began shooting, and in the pandemonium the police came and arrested everyone. Next day it was in all the papers that the two painters had been involved in a fracas in a whorehouse.

But according to Silvio Loffredo, the painter, Morandi continued to travel to Florence to visit museums. Born in Florence, Loffredo grew up in Paris, where they called him *l'Italien*, while back home later they called him *il francese*. He painted innumerable little oils of the *Battistero*, or baptistry, in Florence—that jewel of medieval architecture, that black and white box in marble—where he had studied with Morandi.

When Loffredo visited the Uffizi one day to refresh his view of the

old masters, he noticed Morandi doing the same. "I was too shy to approach him, and I watched him from afar. It was wonderful to see how much we shared our tastes," he said. "When, after much meandering, I finally came to the narrow exit, I suddenly stood next to Morandi. '*Buongiorno, maestro*,' I said.

"'Ah, Loffredo!' Morandi exclaimed. '*Peccato che non si è fatto vivo prima. Si poteva salutare i nostri amici insieme.*' What a pity you didn't say hello sooner. We could have enjoyed greeting our friends together."

So that's what it's all about. We painters go to museums to visit and greet our marvelous old friends with awe, love, and understanding.

MERET OPPENHEIM

Dear Meret,

How did I first meet you? I was sitting in Marie-Suzanne Feigel's gallery in Basel in Switzerland, one of the few modern ones there in 1947. Suddenly a great big canvas walked in. It had two feet and hands. They turned out to be yours.

Then someone explained: "The Miró had some cracks. It had to be restored, and this is our restorer. Meret Oppenheim."

Slender and gawky, an elegant restorer, a tiny bit arrogant, were you really the famous Surrealist Meret Fur-Tea-Cup Oppenheim in person? Were you the maker of those most evocative and historic of all Surrealist objects—the cup, saucer, and spoon sprouting bristly fur at the Museum of Modern Art in New York?

In America, you were already a myth. You had even studied at the Art Students League in New York. But here in Basel you were part of the scene. What struck me first was not your beauty but your innate elegance, not of clothes, but of a cool inner privacy.

Irène Zurkinden, a local celebrity, a flamboyant, wild blonde who

did commissioned portraits in the Impressionist style for the burghers of Basel, told me that you had been school pals. One day you took a train together to Paris when only in your teens. Every self-respecting young artist then had to go to Paris. Eventually the two young girls from Switzerland got to know everyone. Then Irène went back to Basel while you, the mischievous girl of severe beauty, stayed on in Paris to become the toast of the Surrealists.

They took your picture: Man Ray has you sitting, holding a tall glass next to your wonderful profile. It is as perfect as the profiles on Greek vases, one long, neat line from forehead to tip of long nose. He has you standing nonchalantly naked next to an etching press, its handle sticking out as if it were your own male private part.

You became the companion of Max Ernst, with whom you had more in common than with the other Surrealists, who were mostly involved in literature and classic myth. You were born in Berlin of a German-Jewish father and a Swiss mother, and Ernst was born in the Rhineland, so you were both nurtured on the German fairy tale. You both knew about the witchery in the woods and waterfalls, the unpredictable in the great outdoors, the poltergeists in the kitchens and bourgeois drawing rooms. You examined natural and man-made objects with glee and began to turn their meaning and texture inside out with cutting wit but also with dreamy tenderness. But Ernst was older than you, and you did not want to be overwhelmed. So when the fabulous days were over, just before World War II, you left Paris to do something typically perverse: you went back to art school in Basel.

And that is where, a decade later, I met you, the princess of Surrealism, now a restorer. You invited me to visit you. You lived on the wrong side of the Rhine, in slummy Kleinbasel, in a half-abandoned nunnery near a barracks where Rudy, Jean Tinguely, and your future husband had done military service. In this old Romanesque building you had a one-room apartment studio.

You must have shown me some of your work. Then you showed me something special, a little book, a flipbook you had made as a child.

You held it lightly between forefinger and thumb of your left hand and with your right hand you bent it, then made the pages flip by very fast so all the drawings on each page merged into one moving picture, an animated cartoon. What you had carefully drawn in stages on each page with colored crayons ran together as the live story of a bee and a flower. The bee is flying toward the flower, entering and fecundating it. For a moment just the flower is visible; then the bee comes out of its inner sanctum, cleans its hind feet, and goes off again into the wild.

I have a postcard of yours in front of me, dated Basel, February 23, 1948, addressed to me in New York. On its front is a tinted scene of a young man serenading a blonde, both drinking Rhine wine in front of a Rhine castle on a backdrop. Kitsch had not been discovered in the 1940s, but you appreciated it without shame. On the back you thanked me for a card of skyscrapers I had sent you, then went on: "I was very pleased with the greetings from M. Ernst."

This brings back two memories. The first is one of a party in New York. Jean Arp had arrived in America in pursuit of Rudy's sister Helen, whom he was in love with. He asked us to meet him at a gathering in an apartment on Central Park West. Arp was ruefully nursing his thumb, which he had hurt on shipboard, showing it to everyone. When he said he had seen the new painting in New York and found it ugly and without taste, all the others agreed with him. When he turned to Rudy and me, ardent friends and followers of Bill de Kooning, he was quite serious when he said, "The Abstract Expressionists are crude and silly. What is the point of their messes? They are dangerous and can lead us to chaos."

I was astonished and sad.

We shook hands with Duchamp, with Hans Richter, who soon after began filming *Dreams That Money Can Buy*, and then there was the silver-haired Max Ernst, who looked like a leprechaun. I told him how I had just met you, and that is how I sent you his greetings.

On that same postcard in 1948 you wrote, "We just survived the Fasnacht, and I am slowly recovering." This brings back the second

memory, of the Fasnacht, the Basel carnival. We were back in Europe in 1951. Our son, Jacob, had been born a year and a half earlier in New York. A winter in Ischia in a chilly, unheatable palace in a godforsaken village over the sea had made us flee to Switzerland, a country so cold they knew at least how to make the indoors warm and cozy.

Irène Zurkinden and Jacob's godmother, Marie-Eve Kreis, the dancer, gave me your news. They said you were now married, to Wolfgang La Roche, and that you had settled in Bern, which is where I found you, in your own antique shop. You gave me a brown Victorian wicker basket I admired, then took me to your apartment over the arches of one of the many arcaded streets in the center of the old city. But there was no sign of your husband. He had already gone to rest after his own lunch. Irène and Marie-Eve had warned me that he was a little peculiar, that you had to feed him first and alone when your friends came to visit. An array of pillboxes and vials on the dining table told me that he was also a hypochondriac. He had once been an amusing Surrealist, up to all kinds of pranks, then a furniture salesman, and you were a restorer and antique dealer.

Holding your basket, I took the train back to Interlaken, where I was staying. I had filled it with French snails and garlic from one of the many Bern delicatessen stores, together with bunches of violets. Despite the covert stares of the other passengers because of the strange mixture of smells emanating from it, I was happy because we had hatched a scheme for the imminent carnival. You had always been passionately involved in the Basel Fasnacht, but this time you wanted a prize. You knew that masks and costumes based on a timely political topic had the best chance of winning. Then you remembered that Switzerland, with all its modern technical achievements, its pharmaceutical industries, and its famous chocolate, still had no laws for the pasteurization of milk. It was a political scandal; among the country people in the mountains there was a high percentage of tuberculosis contracted from infected cows. At some point you said, "I've got it. We will be three pasteurized cows, you and another friend."

I could not imagine any such costumes, but you could. We sat sewing in Bern, we sat sewing in Basel, snipping and pasting and gluing under your direction for weeks, right through the last night before the Fasnacht. At dawn, in a large hall, the mummers paraded over a stage before the judges, the three of us among them. We were a sight, in green dresses covered with large cow-turd-brown shapes, swaying under enormous masks—long white cow faces with pink nostrils and deep eyes fringed with demure lashes, our golden horns spread wide. Between the horns sprouted a thicket of alpine flora—primroses, jonquils, crocuses, violets, ferns, in all the colors of the rainbow. I had been up for nights, sewing. I could see little through the eye slits, could hardly breathe under the heavy mask, and had never been so close to fainting. I heard the rustle and swish of paper flowers and then a hush in the hall and, just as a waitress pushed a chair under me, a great applause.

The Three Pasteurized Cows had made it. The judges understood the reproach. Tripping and swaying in our green-brown bodies and great animal heads covered with flowers, we approached the judges to receive a prize of five golden francs each. This was only the start of a week of revelry, some of which included overturning cars that had the license plate of the hated city of Zürich, directing traffic with a toilet brush, and similar pranks, but mostly a great deal of drinking and dancing. The mask you invented, Meret, the cow face with its bush of paper flowers between its golden horns, lay for years in the attic of my mother-in-law's house on the Bernoullistrasse.

Rudy and I went back to our life in New York, and I did not see you again until 1961, when I came to Europe for what I thought would be a brief stay of convalescence. You invited me to a New Year's party in Bern, but I never really got near you there. You were surrounded by a group of young admirers, most of them Abstract Expressionists who were talking loudly in incomprehensible Bernese dialect. I was sad because of my private life, and I left early.

You moved to a house near Lake Thun, and when I was nearby in Interlaken a year or so later, I visited you there. The bus took me to a

Meret Oppenheim, Edith, and a friend as Three Pasteurized Cows
in the Basel Fasnacht (carnival), 1951

suburban kind of settlement, a cluster of small villas evenly dispersed
in a grove of slender beech trees. It must have been fall. The light from
the lake was subdued, the villas so quiet they seemed uninhabited,
and the air was still.

We had tea at the kitchen table in your window nook. The long curtains—draped back from the high windows to let in the little light there was—and the cloth on the table were of the same bluish-pink material with a pattern of white damask roses. You followed my look. "They told me at the store that it's mattress ticking, for beds, not windows, but I sewed it just the same."

The effect of the unusual heaviness was beautiful. Then I admired a handmade, darkly polished wooden box on the table that looked as if it ought to hold treasures. You opened it. Its small compartments were stuffed with plastic medicine boxes and bottles, reminding me of the hypochondriac husband I had never seen. Just then the phone rang. It was your husband, and after you had talked to each other for a while, you hung up suddenly. You turned to me, saying, "The nerve of it. You know what he wants? He wants me to go to the butcher's to get something for him and his girlfriend, with whom he is staying for the weekend." You smiled wryly and sighed. "Men," you said. I told you I had been going through some pretty heavy stuff myself lately. You said you were fifty, which at that time seemed unbelievably old to me, which ought to have put you out of action. I looked at your profile, the neat, curving line from forehead to nose, the slightly open lips, the way you sat with such gracefulness, such poise.

"Oh well"—you grinned—"next week I'm off to Paris. What fun. Maybe I'll go get myself a truck driver."

You laughed at the effect this had on me, but then I asked you about a very young art critic I had just met in Basel, a rather silly girl, who told me she had been wearing a dress with a low décolleté at an art opening where you had also been. She had been stunned but flattered when you'd gone straight up to her, taken her breasts in both hands, and kissed them. "You also like women?" I asked. You laughed. "Men, women. Love is love!" The girl also told me about that event you staged, when you spread food all over the naked body of a model lying on a banquet table, delicious strawberries in her navel, and invited your friends to feast from her.

When I first met you in Basel, then in Bern, after the marvelous Paris years, your work had been dormant because you had to settle your personal life. But now you were long over the hump, active everywhere, full of spirit and new ideas. Then, in Thun, I saw your studio in a garage, full of clutter of bits of lumber, new and old objects, tools, and paint. Among the finished things, the first I noticed was a dark structure jutting from the wall. It was put together from pieces of finely turned Victorian table legs, clock tops, tops of beds, bits of an armoire. The chiseled, sentimental curlicues of wood added up to something sinister, a jawlike thing, a trap. You called it *Head of an Animal Demon*. It was a mask, both funny and malignant. Then you pulled out a big white canvas that was almost empty except for a man's silk tie glued down its middle. The tie was patterned with broad diagonal stripes of ugly brown and green. "*Waldweg*," you said nonchalantly. I laughed out loud. What could be simpler. What a way to express a path through the woods—the effect of brown tree trunks and their shadows, the mossy green, and the earth underneath. The mix of the sentimental and the ironic was perfect.

Then you led me to a little thing hanging somewhere else. It moved me even before I knew its name. It was a small collage on a squarish board divided in two—the upper part of a Gauloise-blue sugar paper, the lower of black velvet, making a ragged horizon between them. On the lower velvet surface glinted a scatter of tiny mother-of-pearl buttons straining upward. "*Fruehlingserwachen*. Spring awakening," you said. I was enthralled. So little and so much—dark earth swarming toward the sky. How acute, how tender.

The last time I saw you was about two decades later, at your show at the Pieroni Gallery in Rome in 1982. You had had many shows in galleries and museums in the previous few years and were now well-known everywhere. You looked both fragile and strong, and wise. You were much milder. At the opening you were quietly basking in the gallery fuss, the recognition of the younger visitors. It was nice to see you so pleased, so docile with your success.

Dear Meret, life had pushed you around. The men Surrealists had an easier time of it than you, one of the few women of the movement, and now you were revered more for your personality than for your art. When accepting the art prize of the city of Basel in 1975, you spoke of the lack of awareness of the feminine in men, the masculine in women, throughout history. You were not a feminist in the ordinary sense, but you wanted everyone to take these long-hidden elements in our culture into account, to question preconceived notions about men and women. And in an interview with journalists you were drily realistic.

When asked about your opinions of art and the marketplace, you said, "If you do something, something goes out of you. That means that you do it for others. They can see it or see the reproduction. In this way the work begins its efficacy. If people want to possess a work, they have to pay. Even if they buy art for prestige or investment, they pay for spirit without knowing it. And that is not so bad. Art, the art I mean, has to do with spirit, not decoration."

In your show in Rome, as always, everything was touched on delicately, with enigmatic poetry, nothing rudely explicit. The young Roman art world, breast-fed on Duchamp and long intimate with the Conceptual Art of the 1970s, understood you. You were no longer a Surrealist, and you were also beyond the Conceptual. Surrealism is bound to literature; it illustrates uncertain dream states with the greatest certainty. Conceptualism, with even greater technique, illustrates cerebral questions. In you the split between perception and meaning is left hanging. Everything is paired oddly: weight with lightness, wood with slate, metal with feathers, the dead with the live. One moment you flirt with the kitschy, the next with the refined. There are unfinished, awkward things, corny and old-fashioned elements, ugly and gaudy things, and that wit, that fleeting grace, hovers everywhere.

You always unsettled the art critics. A pencil line to you was a lovely bit of graphite, a paint stroke a bit of juicy old paint—they stand for themselves, not as elements serving an aesthetic whole. Each work

of yours is a beginning, each is different, each stands alone. A show of yours might look like a group show. With you, the logic of art making has gone out the window.

The definite brightness of noon bored you. You rummaged through forgotten corners and in dark forests—veils, glitter, cobwebs, rainbows, and fog—in cahoots with elves as well as hobgoblins, truck drivers as well as little girls, frogs and snakes as well as birds and bees. Blind buttons and mushrooms, the grass-green mantis stalking by on stilts, a beer glass sprouting a squirrel's tail, the iron butterfly alighting on the plastic doily, a swarm of live bees drooping like grapes from the leather saddle of a bicycle, a petal spinning down to the decay of a clearing in moonlight.

One of your last works was a fountain, commissioned for a public square in Zürich—a high column around which ran a down-spiraling incision or runnel that could and did hold ferns and water plants, and, of course, water welling up from the top. It was decidedly phallic. The papers went wild in their headlines after its inauguration. "A prick with garlands," they exclaimed. "Why not?" you, the woodland girl, replied.

Your Berlin father was Jewish, your Swiss mother the daughter of a Protestant pastor. You spent your childhood in meadows and mountains. But Meret, you were a creature of the fields and woods, free to the currents of living things.

A fat bee flies toward a little flower. It alights. It enters. Inside, a mystery is acted out for a moment, light and ephemeral, but it will have consequences. The flower nods. The bee comes out. It wipes its feet and buzzes off, blithely flying on home.

You told a friend that when you were thirty-six, you saw an hourglass in a dream. The sand had run out one way, and then the glass turned over to let the stream of sand rain down in the opposite direction. You understood that when this sand ran out, all would be over for you. You were right. You died, twice thirty-six, on November 15, 1985.

FRANCESCA WOODMAN

After I finished giving a lecture on contemporary Italian art at the Rhode Island School of Design (RISD) in Rome in 1977, she was there, standing out among a crowd of lively students.

"Come with me," she said. All rosy, with a veil of yellow hair, she wore an old pinkish down parka over a long, sprigged flower skirt, and on her feet were those black Chinese Mary Janes that gave the girls of that period a duck-footed ballerina look. She looked at me attentively with her bright eyes and heart-shaped face.

"I went down to the market early," she said. "I bought these eels."

Eels? But I followed her as she ran and ran down the stairs of the Renaissance palace to the huge vaulted basement that had been divided into various spaces for the students to work in as studios. By her easel, in an enamel basin, there they were: a tangle of slithery silver sparks, the live eels.

"Here are the drawings I did of them." She showed me other drawings and paintings, and then many photographs—of the eels, of herself, of fantastically incongruous objects side by side in mysteriously disturbing tableaux. They were in series or groups, something still unusual. In this alone she was already ahead of her time.

After that I saw her often, and then every day, and if I wasn't home, she left cunning drawings stuck to the door, or even, with pastel or pencil, drew directly on it. I soon called her Woodmouse and met her in Maldoror, a bookshop run by Cristiano and Paolo, two thin, slightly tenebrous young men who loved their dusty books on Futurism and Surrealism. I see her still in the doorway there, whispering and whispering with Sabina, an Italian her age. What on earth did these two have to whisper about for hours and hours? Then there was Sloan, another RISD student, with whom she shared an apartment in Piazza San Salvatore in Lauro. And there was the ceramicist Tannenbaum, who came to visit from Bologna so the two of them could go to the Albergo Washington and spend a long night there, photographing

each other in the corridors of the abandoned hotel and against its oval mirrors and Art Nouveau furniture.

She came and went at the Ugo Ferranti Gallery near Maldoror and became friends with its young artists, Giuseppe Gallo, Bruno Ceccobelli, Gianni Dessì, and so on, and she often stayed at their lofts in an old spaghetti factory on Via degli Ausoni (which later became chic and famous) to talk and also work there. Because she grew up in Italy—her parents wintered in Boulder, Colorado, but she spent summers at their farmhouse in the Chianti region near Florence—she had no trouble mingling with young Italian artists her age. In this she was quite different from the other RISD students, who feared to face the Italian reality.

She had her first European solo show in the basement of Maldoror and soon after was in a group show at the Ugo Ferranti Gallery, which rarely showed women. She did not appear at her opening at Maldoror. We waited for her in vain. Who ever heard of an artist not showing up at their own opening, especially their first? Later that night I found her on my stairs with wet eyes, but already smiling, so that I would not re-

Note left by Francesca Woodman. Date unknown

proach her for her lack of professionalism. Then she asked if she could use my phone to call her beau, Benjamin. He had been a student at RISD too and was now in Venice to learn how to blow glass. He had already given her a big top hat made of golden glass. She murmured and murmured on the phone while I was busy in the kitchen. When I went back to the living room, she was gone. There was only the telephone lying on the table, with Benjamin's voice coming through the wires. She had disappeared. None of us saw her for days. Eventually a postcard came from Paestum, with the fresco of the diver on it, asking for forgiveness.

We ate tons of pasta together. "Spaghetti is my *only* religion," she wrote me once from that elegant but cold apartment she shared with Sloan. Then, in my old car, with Alvin, we took Francesca and Benjamin to Tuscany one wintry day before Christmas. When we arrived at Antella, the two of them ran in and out of the little village stores, busy with Saturday-night shopping. Later they ran in and out of the old farmhouse, bringing in loads of wood to fire the stove in our bedroom. It got started all right, but it filled the house with smoke. Next morning, while Francesca made us pancakes, the whole Tuscan landscape seemed enveloped in smoke too. Later we walked in the smoky fog, Francesca running ahead of us, carrying as always camera and tripod.

After a few more days in the heart of old Rome she returned to Providence to finish her RISD years. She wrote: "I've rented an enormous room . . . I feel much comfyier here than I ever did in that hoity-toity place on Via dei Coronari . . . it's just me my bed chair table and eight windows . . ."

On the announcement of her senior show, which had photographs full of flamingos, swans, scientists, and movie stars, she wrote, "Last night was the opening . . . you would have enjoyed it . . . I brought all these bird whistles that one fills with water and they warble, in N.Y. . . . the room was very echoey with these things and I actually enjoyed the opening . . ."

Later, from Providence: "I bought a Polaroid camera for a dol-

lar . . . I've finally started working for real again although the pictures are thus far rather austere and I'm not doing any paintings at all these days . . ." Then she wrote something that has always haunted me: "I'm sorry all my letters have been so prosaic I know we are going to be friends for years and years and years at all kinds of distances so I'd better start more amusing missives soon . . ."

Then she sent several postcards from her visits to Benjamin, who now studied glassblowing at the Pilchuck School in the state of Washington. One had a drawing by Schiele of a peasant girl in felt slippers, looking a bit like her: "Trying to take pictures and daydreaming and repainting our treehouse . . ." "I caught my first salmon," she wrote in another, and then, "Slugs out here are very large and black, beige, or spotted like cows. Eels yes, but no pictures of slugs they are too slimey. I also saw a whale . . ."

Finally she wanted to tackle New York. She imagined she could work as a fashion photographer, but failed. She had a "funny job" as secretary at the Salmagundi Club and various jobs as assistant to successful photographers. At the same time, she pursued her ambition as an artist, getting shown frequently in group shows and beginning to have solos of her extraordinary work.

She wrote of one: "My show looks good to me. The piece covers a whole wall and I was very excited about this temple business all winter . . . it's funny how while I was living in Italy the culture there didn't affect me that much and now I have all this fascination with the architecture etc. . . . Francesca who as a child visited the Acropolis three times and always yawned . . ." And then: "I had dinner with Rackstraw . . . I guess that I made him nervous . . . but we had a nice time it was at the beginning of my infatuation with the temple and my house was crowded with caryatids . . ."

Another time she wrote, "Tonight I'm going to have dinner with the man who represents the estate of Man Ray . . . I met [him] on the train to Philadelphia . . . actually mostly because I feel like I ought to for the

sake of Cristiano and Paolo . . . Underneath I really liked their ideals and interests. Also I read another book called *An Anecdoted Topography of Chance* by Daniel Spoerri. I don't like his work but the book he wrote is lovely and not at all dry." She said that Cristiano wrote in a letter: "What a *bambina viziata* [spoiled girl] I am . . . but I'm starting to think that bratty self-centered quality was one of my best."

In a particularly rich letter of May 12, 1980, she wrote, "Living here alone is so strange I am nervous and scittlery as it becomes more and more evident that this is what I am going to do with my life. Devote it to this serious and very un-Francesca concern of composition and solitude to make art . . . would you have ever thought that your woodmouse would spend her odd hours worrying about symmetry?"

Once, when I was in New York, she invited me over, seeming lonely. But she actually had very many friends, preferring to keep them in special compartments of their own. Again she ran in those black slippers, all rosy, blond wispy hair streaming any old way in the wind. In the supermarket she filled the whole cart with stacks of pasta and all kinds of vegetables. Then we ate supper in her cold-water flat that the previous Puerto Rican tenants had painted pink and green. She called one tiny room the "boudoir" and she used the bathroom, which had a tub with lions' feet, as a darkroom. Everything was bursting with photos, rolls of paper, tripods, canvases, folders, pinned-up postcards.

Then she wrote: "Last week walking up the Bowery at dusk I encountered a big black man who started waving something at me and shouting . . . (It was a winning ticket for a free round trip anywhere in the U.S.) . . . and he was selling it to pay for his rent . . . I didn't believe a word of it but I gave him my last $10 because I was scared of him and actually the thing is perfectly good so I have a free round trip ticket . . ."

Even if she sometimes tried to find new men friends, Benjamin was still her beau, so she used the ticket to visit him at Pilchuck. When

she came back to New York, she was haunted more than ever by her chimeras. At last they overcame her.

The last time I saw her, it was probably in the Central Park South studio of the photographer Marco Franchina, whom she worked for. She said goodbye to me from the darkroom, standing on tiptoe, bent over a pan holding chemical solutions, her round hands in it. Reddish reflections played over her round, attentive face, so vulnerable and so bright.

In the few years that I knew Francesca, she was always like a creature standing on the lookout in the forest, stretched in a fine tension between careless, bright wit and—because she was so very aware of everything that surrounded her—deep moments of hopeless despair. She loved to flirt with the idea of herself as a brat—"my best thing"—but at the same time she was possessed with an instinctive, age-old wisdom. In her work, this sophisticated young woman was ambitious and had a steely will: "If anything I am very stubborn." She was already involved in art as a child—an *enfant prodige* as well as an *enfant terrible*. At nineteen, when I met her, she was already a mature artist. At first I thought that everything was just the drive and freshness of youth, but then I understood that here was the innate touch of genius. She was always running—running away, coming back, going away, and appearing again. Then she vanished for the last time. A rosy and yellow comet appeared on our horizon and left a tail of shining things.

Each of her pictures is a scene of shadow and quicksilver, a lesson, an arranged tableau. Turtles, eels, ribbons, mirrors, black underwear, enormous sheets of blank paper uncurling, Roman pavements made of black-and-white bardiglio, Roman girls crouching in corners, lilies, walls corrugated by mold or lashed by lines like dripping blood—live and dead totally unrelated objects—and then always herself. She, herself, dressed like Alice in New England, and then undressed, stretched, marble-like, or like an angel flying and floating though cases of glass, or like Daphne becoming a birch tree among birches, or devoured by

empty rooms and windows. Making herself an object in the framework of her objects, she stretches her own tender skin and offers it to the impervious eye of her camera, to her quest. Victim of her times and conditions, but in the end as self-sufficient as Athena, she is the bewitching and defying conqueror.

The interiors in these photographs sound with those echoes of velvety dreams that, between one beat of an eyelid and the next, we see in a flash, then hide or forget. But the photographs of Francesca bind them; they are modern, uneasy fairy tales made by a young woman with wings on her feet and eyes open to wonder, full of a fierce poetry.

CY TWOMBLY

I didn't know that Cy's name was Edwin. I was in debt to another Edwin, who taught me how to write about sophisticated, complicated things in ordinary everyday language. But Edwin Parker "Cy" Twombly taught me about a way of painting, putting down ideas about living and dreaming in gobs and driblets of paint simply out of tubes.

When I first arrived in Rome with Jacob in 1962, Bill Weaver, whom I had known at *ARTnews* in New York, found us some rooms with Lola Segré on Via di Monserrato. Her poet husband had left her for England, and my own had also found other shores. It was a melancholy situation. But we found solace in Cy and Tatia's apartment across the street. Said to have once been inhabited by a pope, it had great marble floors, rows of gilded baroque chairs, and wicked emperors' busts on marble columns, as well as choice modern artifacts, for instance a Duchamp spinning disk. There were large antique four-poster beds. A ladder climbed up to Tatia's studio between floors, where she kept her apothecary jars, brimful of dried insects, shells, snails, and other nature finds.

A few years earlier, when I was still an art critic at *ARTnews*, Cy

Twombly had been something of a sensation at the Castelli Gallery, where I had seen rows and rows of charcoaly scrawls, like keening writing, rows and rows leaning in a sideways crowd, as close as stalks on a wheat field or toilet markings, the loose, scrawly technique like writing. I didn't particularly like or dislike them.

Here in Rome, huge canvases hung over us. I looked at them while I listened to art world gossip. Now the writing was much looser, interspersed with feathery, squeaky daubs of paint in petal colors, thumb marks, splotches. After a few noon sittings in the Twomblys' apartment, one day I was caught. These pictures were blazing. They were about an old world and a new one, I could suddenly see with rapture.

On white woven and smoothed fields were fresh bits of paint, crumbly, juicy, smeary, rose pinks, blood reds, larkspur blues, jonquil yellows, bile greens, and death and hell black. Athena with wiggling snakes and owl, Europa riding a beast, bubbling birth of Apollo, Leda and billowing swan, Zeus and Bacchus frolicking in earnest, Danaë embracing clouds of gold, Hero and Leander sinking in a cruel turmoil of purples. All in a vast Mediterranean sky. All those creepy needs of the gods, like everyone else in the grip of domineering, leering flight and tender surrenders. Cy himself sat enthroned under them in smiling appreciation. "I like my last paintings up while I still have a crush on them," he said.

Early on in Rome, when I was stuck with my still lifes in front of Siena or Rome views, Umberto Bignardi, who painted a sort of refined Pop Art, said, "I'm going to show you something Cy showed me." Bignardi produced big sheets of paper and a bunch of half-greasy, half-chalky crayons (in the 1960s, paint sticks made of compressed oil were not yet available). He started to draw haphazard phrases and names on the white paper, rows of scrawly scrawls. Tattery, like the edges of clouds, involved like bumblebee flight. He told me to do the same. We made patterns and patterns and webs. All this was to catch the dabs and dashes of paint, and voilà—the beginning, no, also the end of a picture. This was a lesson I never let go, and I practice it today.

Cy's wife, Tatia, and her brother Giorgio Franchetti were thorough snobs. Still, though arrogant like the rest of their newly aristocratic family, they had the grace to recognize the extraordinary splendor of the young, elegant American traveler they had caught. Franchetti supported the Tartaruga Gallery, run by Plinio De Martiis, brightly alert to the new art of Cy, Bill de Kooning, Franz Kline, Philip Guston, Mark Rothko, and others long before Bischofberger in Cologne and the French Existentialist writers became even faintly aware of them. The Franchetti family had a palazzo on the Grand Canal in Venice, the Ca' d'Oro, chock-full of new art. Giorgio wrote about art, not in convoluted Italian art lingo—no earnest, impenetrable statements like the critics with diplomas in art history and years of severe studies—but in witty sentences, intelligent and direct. I know, as I translated one of them, an introduction to a show of my friend Giulio Turcato, the saturnine Mantuan who was the only one on the Rome scene who acted like a New York Expressionist—rough, grouchy, and straightforward. He painted deep, glowing, truly inventive color and shapes. Giorgio, brief and bright, did him high honor.

In 1987, as a new ploy, the Galleria Arco di Rab, run by friends, hosted a series of shows that featured doubles. One was a well-established artist, the other less known—the lesser introduced by the big shot, so to speak. My friend Gina Spengler had an idea. "Hey, Edith," she said, "you are friends with Cy Twombly, so why don't you ask him to introduce you?"

When I called Cy, he nearly had a fit on the phone. "Oh baby, I can't do that," he wailed. "I have been to these introductions in Germany, so solemn and jabbering. You stand around, drink in hand, waiting to drink it while someone goes on and on, saying perfectly meaningless stuff—"

"Oh, no," I interrupted. "Not that kind of introduction, not a speech, Cy. All I ask is to lend me some of your pictures, to hang alongside my own, to show you support me."

"If that is all . . ." He relaxed at once. "Well, of course," he said with relief. "Just come at once and choose some."

I went over to Piazza de' Ricci to meet him at Pierluigi's, once a simple trattoria where all the poor writers, composers, and painters ate. His apartment was melancholy, the parties gone, the family dispersed. Cy now lived on a farm in Alto Lazio and a palazzo in Gaeta, but the pictures had increased beyond those that hung on the walls. They were stacked and stacked, leaning face to the wall, jammed. All was shadowy and dusty and no longer gay. There was a small, empty room as a kernel, with a bed, some chairs, and a table with writing and drawing materials. "My study when I pass through Rome," he said. It all had a forlorn look, and you could hardly find a passage past all that stacked work. I had to smile. Like the rest of us, Cy had a dirty secret: a surfeit of unsold work.

He turned things over here and there. "Is this all right—that?" Everything is all right, I thought gratefully, and let him choose. He sighed after that and said ruefully, "All that stuff here, it's like the Collyer brothers, isn't it?" He meant the two old men in Harlem who had seemed so poor and starving, but when they died, their brownstone was full to the rafters with over 120 tons of collected junk.

Cy carried several of his unwieldy works, unwrapped, under his arm, trudging across Corso Vittorio Emanuele, past Borromini's lofty Oratorio for San Filippo Neri, past the Chiesa Nuova, where Rubens and Tiepolo looked down, until he came to my apartment in Via del Corallo.

Looking out the kitchen window, he exclaimed at my glassed-in balcony over the humdrum courtyard with the wash lines crisscrossing and weeds on the roof nodding down. "This reminds me of Istanbul," he said, but he hardly looked at the paintings, mine and others on the walls.

He was arrested by my *piattiera*, an antique oak shelving unit I had bargained for at the Porta Portese flea market. It was filled with a row of plates on a yellowish beige clay ground. I had bought them

from a local potter in Viareggio, but the potter had swept green glazes over them. The green wept and ran in fringes and rains and jittery splashes down each one. Pungent and bad, it is called Hooker's green. Cy stared and stared at this green. It was the event of his morning. He had met some sour new being. I saw years later at the Gagosian Gallery that he had absorbed that pungent but thirst-stilling green on a large canvas about an oasis.

A color assaults a painter like an emotion, like a food. It's visceral. The shock brings you delight and despair: red, the squeezed blood of murder or sacrifices or ripe grapes. Green, like the still pond with moss ferns or worms in its depth; violet in waves violently choking abandoned lovers; yellow, running pus or sinking summer sun. It's a taste, leaving something new and full inside you. Was I wrong, or had Hooker's green hooked him in Via del Corallo?

New Yorkers didn't pay much attention to Cy's occasional shows in Rome, considering him not really into things, simply not tough enough, envious that he was living in sunny, chock-full-of-ancient-art Italy. The occasional rumors from Rome had it that Cy was running off to Greece and Egypt with Bob Rauschenberg and Jasper Johns or painting in palazzos—not taking into account that in Italian, *palazzo* simply meant apartment—supported by his new rich in-laws, lounging in a big studio near popular piazzas. Not facing the dirt and hardships of New York was treachery.

We were sitting in a trattoria at the corner of Via Monserrato and Piazza della Moretta, where once the gallows had stood, when I dared to say, "They say you come from the New York Abstract Expressionists."

"I haven't got much to do with them," he replied. "You know, at Black Mountain, I had a teacher who showed me older Germans, before even Nolde. Max Slevogt and Lovis Corinth. I studied those dirty, crumbly, wild crummy paintings, much terrific loose color."

"In New York they think you are too Europeanized," I ventured politely. I meant that the Roman leisurely upper-class life with Tatia and family, the dregs of la dolce vita surrounding him, had estranged

him from New York hardship and roughness—not that his friends Bob and Jasper ever labored too much in that respect. I told him that Rackstraw Downes, the stern realist painter, had said to me, "That Cy is spoiled." At which my companion grinned sheepishly, a forkful of delicious chocolate cream pie poised on his fork. "You mean like this?" he said, gobbling it up with childish delight.

Another day he took Alvin and me to the marvelous Cancelleria Palace, smoothed Renaissance and white, before dinner at Piazza Farnese. In the inner courtyard he attentively considered Vasari's indifferent murals. He aired what he knew about the various sacks of Rome—and he knew a lot—and about Galileo's prison. Much more erudite than most Americans and painters in general, Cy enjoyed teaching Alvin and me a thing or two.

Every time I met him in the neighborhood, he said something enchanting and so memorable that I could not forget it. Once he asked me where I break bread or eat my pasta. "Let's eat at the Pantheon tonight," he said, but then he never came. One Twelfth Night, when I was in a grouchy mood and had refused several other dinner invitations, I had a call from Nicola del Roscio, Cy's partner. "Come to dinner with us," he said. It was an offer I could not refuse. The dinner was amusing and good, but for once Cy was not so amusing, and he and Nicola quibbled over everything like an old married couple.

Cy was wily and savvy, still the unbound American. He could demolish a rave of mine in one instance. "Have you been to the *School of Athens* lately?" he would tease gaily. In those days I still wondered what he saw in Raphael, but we agreed on Poussin's triumphs. I told him how I liked the shepherds at the altar in Arcadia in the exquisitely restrained show Balthus had arranged at the French Academy, and he shared my admiration. "You know I met him," I said. "Just an elegant, small man who I only recognized from his paint-spattered loafers. He told me that Poussin ground the lapis lazuli himself for his blue Roman skies."

Anybody later was not mentioned, and Cy liked to scatter mis-

chief when I raised my modern preferences. I went on about Klee's *Harbour*, which I had seen recently at the Kunstmuseum in Basel. "Oh yeah," he sighed. "I too liked Klee when I was a teenager." And when I mentioned the shows of Piranesi's wallowing etchings of Roman archaeological sites, he said, "Every dentist I know has one in his waiting room." When I talked about a recent Eric Fischl show in New York, he nodded. "Oh yes—a porn Fairfield Porter." That hurt.

Cy had an innate sense of elegance. He wore pale outfits so understated they were extremely elegant. They looked like those clothes featured for a while in certain ads in *The New Yorker* of tall, skinny gentlemen wearing fluttering sat-upon coats artfully wrinkled and threadbare—weathered chic.

One of the last times I saw him, at a Brice Marden opening in Rome, he wore a watchman's cap, like most of the Abstract Expressionists in early times, but his was colorless, undyed. "Brice?" I asked. He grinned, to my surprise loving those dry panels. "He is a friend," he said. That explained it.

When I went to Cy's solo show in Rome, it was vast and brimming. After my hours under his paintings on the walls of Via Monserrato, I was primed. The quivering swirls and clouds and Ledas and Danaës now meant sound and fury. We studied and enjoyed scrawls and quicksand divings and concise signs and portents. Suddenly my friend Lea, an American interior decorator who had been studying a work close up, exclaimed, "Hey, do you see what I see?" I stepped closer. Some unmistakable scrawls, exclamatory staccato under curvaceous double forms in pink, said "Little girl shitting." Oh, Cy, you fiend, I gurgled. The tales of gods and mortals were around us, spidery traces, excrements, pastel pollen, petal smears, rustling, stirring, sweetly funky, milky, or hairy thick, garlands of events screaming and dreaming, funny, daily, wicked or mild, tearing at our innards.

After Cy's death, people sometimes would stop me and ask, "What do you really see in Twombly's work?" The question itself reveals that they don't want to see anything for themselves. So I only replied as

defiantly as I could: "He is the most lyrical painter of our time." To my sorrow, the sophisticated, rich, and instructed think so too. But let them.

When I was little, we had an art teacher, Herr Brodersen. He was frail and silver-haired, and wore a frock coat. When he retired, he gave us tea in the summerhouse where he lived, in the park where Goethe had wooed Lili. He came from the Danish border, Schleswig-Holstein, and lisped in his high accent. He never taught us drawing or painting but in avant-garde Bauhaus fashion distributed colored papers among us, telling us to rip them to shape and paste them down for our images. When a collage image was particularly handsome, he would hold it and cry, *"Oh wie gerissen!"* (Oh how beautifully torn). But if something struck him as ugly, he would shake his head, saying, "I'd rather not meet this one at midnight!" When one of us did something really good, he called out, "Here! Look! A knight without fear and blemish."

Cy rides into the night, a knight without fear and blemish.

Edith Schloss Burckhardt, my mother, was born on July 20, 1919, to a bourgeois Jewish family in Offenbach am Main, Germany. What follows is based on her unpublished writings and my recollections of things told to me by her and her mother.

Edith's mother, Martha, was the daughter of Max Goldschmidt, a horse trader. Martha's grandfather, Jacob Lowenstein, had traveled to the California gold rush just after his bar mitzvah, stayed there for fourteen years, and returned to Offenbach to start a Socialist newspaper. Edith's father, Ludwig Wilhelm, was the grandson of a locksmith (*schlosser*, hence the name). His mother died when he was young, and his father had been committed to an asylum in Frankfurt, so he put himself through *Gymnasium* and schooled himself in Latin and Greek, as well as English and French, and learned the trade of *Portefeller*, leather goods worker. Offenbach was and is still known for its leather goods manufacturing. Before World War I he traveled to France and the United States, and after the war he began working in the firm of Hammel und Rosenfeld, becoming partner when Rosenfeld died, in a factory of about three hundred employees. As members of the educated bourgeoisie, he and his wife traveled to places like Paris, London, and Berlin on business, seeing the great entertainment of the time, such as Josephine Baker, Enrico Caruso,

The Schloss family at Bad Homburg in Germany. From left: Ludwig, her father; Edith; Fritz, her brother; and Martha, her mother. The others are cousins, who did not survive the war. "This is my first encounter with the Roman Empire and I'm trying to look as grim as the emperor." Circa 1929

and *The Threepenny Opera*. Edith's brother, Fritz (known as Fred after he arrived in the United States), was born in 1922.

Edith studied in the local *Volksschule* until she was ten years old. Her father believed that having a command of foreign languages was a great asset for a girl, so between the ages of ten and twelve she was sent to a *pensionnat pour jeunes filles* (girls' boarding school) in Nancy, Meurthe-et-Moselle, France, and then to a private *Studienanstalt*, or institute for studies, until she was about sixteen. She was also sent to learn proper English in London, where she says she was over-

whelmed by its museums. The Greek sculpture in the British Museum reinforced her wish to become an archaeologist, and in the National Gallery and the Tate she was particularly impressed by the paintings of J. M. W. Turner (telling no one at the time, because she thought his work might be considered kitsch).

In 1936 in Germany it became more difficult for a Jewish girl to go to school under National Socialism, so she was sent to Florence as an au pair for the relatives of *Professoressa* Teresita Baldi, who taught her Italian and art. "The Renaissance burst upon me," she writes. "The Uffizi was full of the best fairy tales on earth, of winged messengers, haloed women and young bodies in agony. And what teenager is not moved by the cool tones and gentle stillness of the *Primavera* and *The Birth of Venus*? And in the Forum in Rome among the nodding black-eyed susans, the fallen marble columns and friezes, I felt the pull of the antique again."

Then she continued to Viareggio, on the Tuscan coast, which would later become her summer refuge. While one of her duties as an

Edith Schloss as au pair with her charges, Vanna and Orlando,
in Camaiore, Italy, circa 1936

au pair was teaching the children German, the mother of the family scolded her for spending most of her time learning Italian from her charges.

After she returned home, her father sent her to Holland to learn Dutch. But this engagement was not successful. The family was too strict, locking her out when she came home late. So she found herself in a kind of commune or kibbutz in the Dutch countryside and then back in Amsterdam, house-sitting at a wealthy Dutch Jewish lady's apartment, wondering what to do next—no future in Nazi Germany, she didn't like the Communists ("they were old-fashioned"), and she was savoring being completely on her own, far from home. But she had friends among the Militant Socialist International (MSI) group in London, who, as she wrote, "believed in an intrinsic human sense for justice."

She had a little money, a small suitcase with some basic possessions, and a valid passport. But she was a refugee, and British law required that she exhibit a letter of invitation from a British subject. So she wrote a fake letter. At the port of entry in Dover the British customs agent glanced at her passport, looked at the letter for a routine moment, and then waved her on.

I, a modern helicopter parent, once asked her how her parents could allow her so much independence at the young age of nineteen. She told me that for one thing, she was out of their reach, so there was nothing they could do about it. Moreover, things were so unstable in Europe at the time that they couldn't say she was not doing the right thing. "Already in secret rebellion in Germany, left-wing or otherwise, I wanted to leave home early, and the horribly threatening situation in the early Hitler years made this possible."

When she arrived in London in 1938, she first stayed with her MSI friends, helping them print their broadsheets and handing them out on the streets, but she soon found a paying job as a governess in Shrewsbury with the MacEvoy family, and she went to Shrewsbury Technical College to study nude drawing. Later she went back to London, babysitting for the German émigré cartoonist Walter Trier. "I

went to learn typing at Pitman's college and worked with a Socialist group who followed Johann Gottlieb Fichte and were vegetarians," she wrote. "I met all sorts of German political refugees and became friends with Trotskyites."

In November 1938 she had a long-distance telephone call from her father. Kristallnacht had just happened. Their home had been vandalized (her family wasn't there, having been tipped off by a former employee who had become a brownshirt), and it was clear that they had to leave. Edith was able to contact former business associates of her father's and her former employers the MacEvoys and get them to write letters of invitation for her parents and younger brother, Fritz, who traveled, separately, to England. Edith's mother, Martha, was the last to leave Germany, in August 1939, less than a month before World War II broke out.

Edith's grandmother and other relatives were taken to Theresien-stadt and other camps, where many of them died; two uncles and an aunt survived and came to America after the war.

In England, Martha and Fritz lived with families in Shrewsbury; Edith's father, Ludwig, at first was able to work for a British firm, but when it went bankrupt, he was sent to a camp for enemy nationals (even if he was a Jewish refugee, he was still a German citizen). When he became ill, Edith wrote a letter of appeal to the Queen. A few days later she received a response from a lady-in-waiting, saying there was not much she could do, but shortly after that he was released to a hospital (although later sent back to the camp).

In October 1941, during the Blitz, Edith—sponsored by a Quaker group—left England in a convoy for the United States. Martha traveled to the U.S. in 1943; Fritz came in between, in a ship that narrowly missed being torpedoed. Ludwig had died of a kidney infection in the camp in 1943. The last time Edith saw him was at its gates.

Edith arrived in Brooklyn, but soon after went to Boston. There the Quakers found her a job as a waitress, first at a guesthouse in Groton, then at a coffeehouse in Cambridge, the Window Shop (where she had

to wear a dirndl, which she says made her look fat). She studied at the Boston School of Practical Art.

She met Heinz Langerhans, another refugee, when he gave a talk about his experiences (imprisonment in Sachsenhausen as a Communist, a trial for treason in Germany, where he was acquitted on the evidence of a fake newspaper article, and his escape to Holland). They started living together in Cambridge, and through him she met other German émigrés such as the philosopher Karl Korsch (who kept Mickey Mouse decals on his refrigerator—Surrealism, not kitsch, according to Langerhans). Edith and Heinz moved to New York in 1942.

Heinz Langerhans, circa 1942

They lived on Fifth Street in Brooklyn, and later on West Ninety-Third and Eighty-Second Streets in Manhattan. Edith began studying at the Art Students League in June 1942. Her teachers were Harry Sternberg, Morris Kantor, John Groth, and Will Barnet. About Harry Sternberg she said, "But curiously, though he was a

social-conscious figurative artist, it was from him I learned how to trust my own instincts in art as art. And it was in the air: I liked the figurative less and the abstract more." She would stop studying at the League in the end of 1946.

Edith's Art Students League enrollment card

Among the German refugees in their circle were the photographer Pit Auerbach; Walter Auerbach, also a photographer and painter; Bertolt Brecht (she would later publish a short memoir of her encounter with him); Paul Mattick, a Marxist political activist and former social revolutionary; his "relentlessly flirtatious" girlfriend (and later wife), Ilse Hamm, who became a noted specialist in early childhood development and trauma; and Walter Boelke, a Council Communist colleague of Mattick's.

One day while visiting Boelke in Queens, Edith and Heinz met Fairfield Porter, and they were then invited to dinner with Fairfield and his wife, the poet Anne Channing Porter. In 1927 Fairfield had traveled through Europe all the way to Moscow, where he attended a lecture by Trotsky and, with that and the advent of the Depression, developed an

interest in left-wing politics. Anne would become one of Edith's closest friends, with whom she stayed in touch for the rest of her life, and Fairfield a strong friend and influence both as a painter and as a critic. In Edith's writings one can usually discern a solidarity with the women and a skepticism of the men (especially the "big boys"), but with Anne and Fairfield, only love and admiration.

By 1943 Edith was working various jobs—as a waitress, in factories, as a masker for a photoengraver—while studying at the Art Students League. Among the other students were Helen DeMott and Lucia Vernarelli, who became lifelong friends. Edith would later be proud that the poet Edwin Denby, who had also become a close friend, called them "the Chelsea Girls" long before Andy Warhol used it as a movie title.

She and her German refugee friends, as well as Anne and Fairfield Porter, often met at the New Jersey farmhouse of Fritz Henssler, a sociologist who had, among other things, published a Council Communist magazine in Germany in the early 1930s along with Walter Auerbach and Heinz Langerhans. During one such visit in 1943 or 1944, as Edith wrote, "I noticed a little abstraction on the wall: green, beige, black, and smooth, held in elegant poise. I stood still. I had found something I had been looking for without knowing it." Fairfield offered to take her to meet the artist, and a few days later they met at Pit Auerbach's loft at 116 West Twenty-First Street and he took her across the street for her first meeting with Willem and Elaine de Kooning.

The building at 116 West Twenty-First Street was a three-story brownstone, built in 1920 originally as a residence, now grimy and converted into lofts, with a tool and die maker on the ground floor and another family living upstairs. Lofts were cheap, but illegal to live in. The second-floor loft had a shower built by de Kooning and a toilet in the hall. Fairfield was using it as a studio; and Pit, who had separated from Walter Auerbach, lived there and had a darkroom that she shared with another photographer.

In 1945 Edith took the loft over from Pit, and one day, as she was

bringing in her Matisse plant, she met Rudy Burckhardt, who at that time was living on Twenty-Third Street. Soon they began living together at 116 West Twenty-First. She met other members of the circle, including Edwin Denby (who lived across the street at 145 West Twenty-First), Jack Tworkov, Milton Resnick, Nell Blaine, and her then husband, Bob Bass (the latter two got Edith interested in bebop jazz).

That year Edith published her first article of art criticism for *Deutsche Blätter*, a magazine published by German émigrés in Santiago de Chile from 1943 through 1946. The piece was titled "Europäischer Maler in den USA" ("European painters in the USA"), and she signed it "Edith Schlosz."

In 1945 or 1946 she and Rudy were invited for the first time to Great Spruce Head Island in Penobscot Bay off the coast of Maine, which belongs to the Porter family. It was her first taste of the rough beauty of Maine, with its fog and aromatic pine forests. As she became

Edith's first visit to Great Spruce Head Island, Maine.
Photograph by Rudy Burckhardt, 1945

more involved in the circle of the Porters, Edwin Denby, the de Koonings, and Rudy, she moved away from political art toward "art for art's sake," which became her point of reference for the rest of her life. I have always thought of her as an artist, the way some people are Communists or Buddhists—that art was the core of her life and beliefs, the focus of all that interested her.

Edwin Denby gave cocktail parties in his small white loft on Twenty-First Street, where Edith met many dancers, writers, and musicians. She and Rudy were also invited to parties by Helen Carter, the wife of Elliott Carter, who became a close friend and kind of mentor to Edith and a provider of many pithy quotes, "not because we were useful or famous or Edwin's friends, but because she liked us." She met quite a few famous people there too, of course. In later years, when Edith was living in Rome and came to New York for visits and shows, she would stay at the Carters' apartment on West Twelfth Street or at her mother's in Queens.

In August 1946 Edith became a naturalized U.S. citizen. She also married Rudy Burckhardt that year. "Most of our friends disapproved. They did not think it was necessary." But since Rudy's mother had invited them to visit her in his hometown of Basel, Switzerland, it would make them more respectable there, and it would be easier to get her to buy their tickets.

In March 1947 she had her first one-person show at the Ashby Gallery, and later in the year Edith and Rudy boarded a ship and traveled to Europe for the first time since the war. In Basel she met his family and realized how much they had in common, how she and Rudy had both gone to New York to escape their European bourgeois upbringing. In Paris they met "everybody but Picasso." But the main reason for the trip, according to Edith, was to visit the beautiful places and paintings in Italy, which was "still dazed and exhausted from the recent war." There was not much tourism at the time—people took them for

"a discharged Allied soldier and his war bride" as they traveled from one masterpiece to another on rickety buses and trains. (See *Edith in Ravenna*, figure 14 in the color insert.)

In September 1949 they were back in the United States, where I was born, in New York Hospital. Edith was a practitioner of natural childbirth and breast-feeding, unusual at that time.

Around that time Rudy made a movie titled *Mounting Tension*, a spoof on psychoanalysis and art appreciation, starring Larry Rivers, Jane Freilicher, and John Ashbery. A pregnant Edith appears briefly, and I appear briefly as the baby, when Jane the psychoanalyst asks the patient Larry to start at the beginning.

In 1950–51, when I was a year old, we traveled to Europe, again on my grandmother's tab. At her insistence, I was baptized in a Lutheran church, and my godparents were Lukas, Rudy's younger brother, and Marie-Eve Kreis, the Swiss dancer who first introduced Rudy to Edwin Denby (which had set in motion his immigration to the United States). We spent the winter on the island of Ischia in the Bay of Naples, very primitive and difficult circumstances for a mother with a young baby, and then in Castel Gandolfo, near Rome, less primitive. For much of that time, Rudy was away, traveling with Edwin around Italy and Greece. The results are the book, *Mediterranean Cities*, with photographs by Rudy and poems by Edwin.

In 1953 Rudy made the film *A Day in the Life of a Cleaning Woman*, filmed in the Porter house and grounds in Southampton and featuring Anne Porter in the title role, Larry Rivers, Fairfield Porter, and Edith in one of her biggest film parts, "Her Exigency, Nathalie de Caviar."

In 1949 Thomas B. Hess had become the executive director of *ARTnews*, and he began to champion de Kooning and the new movements in art of the 1940s and 1950s in New York. In 1954 he hired Edith as an editorial associate, and she was listed on the masthead along with Fairfield Porter, Frank O'Hara, Lawrence Campbell, James Schuyler, and

Anne Porter and Edith in a scene from
A Day in the Life of a Cleaning Woman. Photograph by Rudy Burckhardt, 1953

others who mostly contributed to the Reviews and Previews column, which described all the shows in town in a few well-crafted sentences. "I wrote art criticism while steeped in Edwin's limpid prose. He would write slyly about the most ephemeral and delicate, and in the sentences of ordinary daily language . . ." She continued doing this until September 1960.

Although Edith's and Rudy's native tongue was German, they never spoke it at home, and ever since I can remember, they both wrote and spoke English fluently, with only the slightest of accents. They were both fascinated by poetry and American idioms.

In 1957 we went to Europe again, this time to Spain, Gibraltar, and Como, Italy, with of course a visit to the family in Basel. In Barcelona, Edith researched the work of Antoni Gaudí, and in January 1958 her first and only feature article in *ARTnews* was published.

The following year we began spending the summers in a cottage be-

longing to Ernest Barbour on Dow Road in Deer Isle Village, Maine. We would drive up in a secondhand car, sometimes towing a Vespa motor scooter, which Edith used (she couldn't drive a car yet). In those days small villages still had a general store where you could buy necessities. But the whole area of Deer Isle was dry—you had to go up to Bangor to buy liquor. By now Edith was becoming an enthusiastic collector of herbs and mushrooms (later she was proud to say that she introduced John Cage to mycology). (See *Barbours Shore*, by Edith Schloss, figure 10 in the color insert.)

During all these years, Edith participated in various group shows, and her circle of friends kept widening. First with Rudy, then on her own, she visited and became friends with Joseph Cornell.

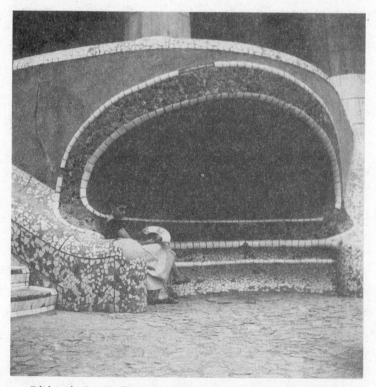

Edith in the Parc Güell, Barcelona. Photograph by Rudy Burckhardt, 1957

She had been making collages and boxes all along and in 1961 was invited to participate in *The Art of Assemblage* at the Museum of Modern Art.

Also in 1961 my parents separated. I was invited to spend the summer in Switzerland with my aunt Henriette, Rudy's sister. Edith, who didn't want to spend the summer by herself in Maine or New York, came along, staying in a farmer's chalet on a Bernese mountainside.

We returned to New York in the fall, but soon after New Year's Day 1962 she and I flew to Rome, "just for a few months." I remember Rome then as cold and dreary. We first stayed in a gloomy pensione that smelled of stale flowers, then at several sublets—one a 135-step walk-up, one an apartment in a palazzo that she found through Cy Twombly, until finally in 1963 she settled in a small apartment in a medieval building on Via della Vetrina in what was then a run-down area in the center of old Rome. I went to international schools there, from the second half of seventh grade through high school.

In 1964 Helen and Elliott Carter arrived at the American Academy in Rome. They had just spent time in Berlin as part of the DAAD (German Academic Exchange Service) with several young American composers, who followed them to Rome. One of them managed to succeed where my father hadn't, in teaching Edith to drive. With another, Alvin Curran, she began a relationship that was to last twenty years, and they remained friends for the rest of her life.

Alvin is both classically trained and a jazz musician, but his music is based on such things as experimental improvisation, real-life sounds, jazz, electronics, etc. He is one of the cofounders of the improvisational electronic music group Musica Elettronica Viva (MEV), and Edith's voice surfaces now and then in his work, as well as me playing the Jew's harp. The first of their many collaborations was *Watercolor Music* (his music, her watercolors) in 1965 at St. Paul's Within the Walls, the Episcopal Church in Rome. They were to take many

trips together, including to Greece and Egypt. She designed many of his album covers and announcements for his and MEV concerts.

Edith lived in Italy for the rest of her life. She spent the summers painting, first in Liguria, in a village called La Serra di Lerici, overlooking the Bay of La Spezia, where she "painted little birds and wildflowers against the blue expanse of the bay of La Spezia where Shelley's last abode was." A theme of many of her paintings there is the bay, with the little lopsided island of Tino and its lighthouse in the distance. (See *On the Ledge*, by Edith Schloss, figure 11 in the color insert.)

She spent one summer in Rignalla, a suburb of Florence—where Alvin had a job playing piano in a nightclub—and she painted a series of bright, blobby flower still lifes. (See *Rignalla*, by Edith Schloss, figure 12 in the color insert.)

From 1982 on, when the house in La Serra became unavailable, she spent the summers in various apartments in Pietrasanta, a town on the shore of Tuscany that was full of marble studios. At that time she discovered (perhaps through Francesca Woodman) the ancient fresco of *The Diver* in Paestum. Her images began to be based on Greco-

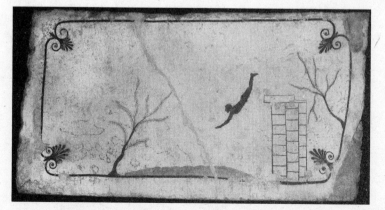

Il Tuffatore, The Diver, 470–480 BCE, from a tomb in Paestum, Italy.
Photograph by Jacob Burckhardt, 2017

Roman myths, but looser than before, more abstract. She became an expert on the history of the marble mountains in the Apuan Alps and the artists who worked there from prehistory to the present.

In the winters she lived in Rome. She was the Italian art correspondent for the *International Herald Tribune* from 1969 to 1986—her 1981 review of the *New York/New Wave* exhibition has the first mention in print of Jean-Michel Basquiat. Over the years she wrote articles for *Art in America, The Village Voice, Ms., The Nation, Redstockings*, and other large and small journals, usually about art exhibits, sometimes about political events in Italy, or memoirs of meetings with memorable people such as the ones included in the last part of this book. In 1986 she began to write regular articles for the monthly magazine *Wanted in Rome*, about current exhibitions of art (of all periods) in Rome and other parts of Italy. She also designed covers and helped curate a successful series called Cover Art, by well-known Italian guest artists.

She got Caspar, her first dachshund, in 1966, and he became the

Drawing from *Caspar and the Cats of Rome*, by Edith Schloss, circa 1965

inspiration for several hand-drawn books, including *Seven Dog Walks in Rome.* He was succeeded by Miles and Ida.

In 1970 she traveled to New York for her first solo show, at the Green Mountain Gallery, and she visited every few years for shows there, and then at the Ingber Gallery. Her last show in New York was at Ingber in 1989. In 1990 she had a show in her hometown of Offenbach, where she even encountered some of her childhood friends. Her work continued to appear in various group shows, and she continued to have solo exhibits every few years in Rome.

In 1984, after she and Alvin had split up, she was able to buy an apartment on Via del Corallo, around the corner from her old place, in a neighborhood that had now become quite gentrified and touristic, with a boutique where the old barbershop was and an ice-cream parlor where the horse meat butcher had been.

Her mother, Martha, who had been living in Queens, died in 1994. The last time Edith came to New York was in November 1999 for the memorial of Rudy Burckhardt, who died earlier that year.

The last time I saw her was in June and July of 2011, when my son, Hugh, and I visited and drove with her up to her summer place in Pietrasanta. That fall she was offered a show of her latest work and her many collaborations with Alvin Curran, which they titled *The Painted Song.* On the night of December 21, 2011, after all the preparations were complete and she was quite happy with them, Edith died.

The show opened the next day. It included four paintings from the summer, based on the myth of Leda and the Swan, and pages of Alvin's scores with her whimsical drawings on them, plus album covers and concert posters. (See *Third Leda,* by Edith Schloss, figure 13 in the color insert.)

Her last article for *Wanted in Rome,* an obituary for Cy Twombly, who had died that summer, was published posthumously. She is buried in the Non-Catholic Cemetery in Rome, behind the Pyramid of Cestius, near the graves of her friend Lola Segré, fellow New Yorker Gregory Corso, and John Keats and Percy Bysshe Shelley.

The famous people whose hand my little hand
has shaken, and with whom I was friends. I guess this is silly
Meret Oppenheimer but Jacob might be amused by it.

Mrs Nixon
Cardinal Marcinkus Karl Korsch
Bertolt Brecht Elisabeth Bergner Heinz Langerhans
Igor Stravinsky Lotte Lenya Gert Valeska
George Balanchine Miró Head Dizzy
 Tanaquil LeClercq Duchamp Gillespie
 Maria Highlower Balthus Lester Young
 Mary MacCarthy Max Ernst Charlie Parker
Dwight Macdonald Hans Richter Bird whistle
 Miles Davis
 Billie Holiday
 Bill De Kooning Juliette Gréco
 Elaine De Kooning
 Leonard Bernstein Pierre Boulez
 Frank O'Hara Peggy Guggenheim
 Kenneth Koch Allen Ginsberg
 John Ashbery Burroughs
 Jimmy Schuyler Denise Leverton
 Stephen Spender Robert Graves
 Jean Steve Lacy
 Bob De Niro Joseph Albers
 Bobby De Niro Annie Albers
 Virginia Admiral Georgio Morandi
 Nell Blaine Luchino Visconti
 Janice Biala James Baldwin
 Daniel Brustlein (Alain) Ulysses Kaye
 Franz Kline Paul Bowles
 Jack Tworkov Jane Bowles
 Philip Guston Giacometti Alexei Haieff
 John Cage Brancusi Giovanni
 Clark Coolidge Dalí John Pin
 Fairfield Porter Dylan Thomas Max Bill
 Anne Channing Porter Isamu Noguchi Morty Feldman
 Meyer Shapiro Giorgio De Chirico Nabokov, composer
 Pollock Jackson Cy Twombly BASQUIAT
 Pollock Charles Gino Turcato Jean Michel
 Norman Rockwell Gerhard Richter Dorazio
 Lady Montague Joseph Beuys Penck
 Herbin, Hélion, Renato Guttuso Nam June Paik
 RASCALI

"Famous people whose hand my little hand has shaken . . . ," by Edith Schloss, 2006

Glossary of Names

Agnello, Baron Francesco (1931–2010). A lifelong supporter of music and especially modern music; from 1973, the President of Amici della Musica di Palermo.

Aikman, Cicely (1923–2013). American painter; studied at the Art Students League between 1942 and 1946; married to the painters Paul Breslin and later Fred Scherer.

Albers, Josef (1888–1976). German-born American abstract painter and influential teacher at Black Mountain College and Yale University.

American Academy in Rome, The. A research and arts institution located on the Gianicolo (Janiculum hill) in Rome.

Arp, Jean (1886–1966). German-French artist (sculptor, painter, collagist, printmaker, poet) and pioneer of abstract art. One of the founders of the Dada movement in Zürich. Also referred to as Hans.

Art of the Assemblage. This groundbreaking 1961 exhibition at the Museum of Modern Art, curated by William C. Seitz, featured work by nearly 140 international artists, including Jean Dubuffet, Pablo Picasso, Marcel Duchamp, Joseph Cornell, Kurt Schwitters, Robert Rauschenberg, and Edith.

Art Students League, The. Founded in 1875 by artists for artists, the Art Students League on West Fifty-Seventh Street in New York remains a venerable and still generative institution. Many American artists who have had a profound impact worldwide have been among its instructors, lecturers, and students.

ARTnews. Important art journal. From 1948 to 1965, under the executive editorship of Thomas B. Hess, *ARTnews* nurtured and defined the New York School and the Abstract Expressionist art movement.

Ashbery, John (1927–2017). Influential American poet and art critic.

Ashby, Carl (1914–2004). American Abstract Expressionist painter.

Auden, Wystan Hugh (1907–1973). Eminent Anglo-American poet. Born in

England, he moved to the United States in 1939. From 1947 to 1957 he spent his summers in Ischia.

Auerbach, Ellen (1906–2004). German-born photographer. In 1937, in Germany she married Walter Auerbach. In 1940, the Auerbachs moved to New York. Referred to by Edith as Pit.

Auerbach, Walter (1908–1966). German-born American photographer, set designer, and printmaker. Before he immigrated to the United States, he was an anti-Nazi activist.

Automat, The, also known as Horn and Hardart. The Automat is a bygone eating experience—cheap self-service food from coin-operated machines at many locations in New York City.

Balanchine, George (1904–1983). An influential Russian-born American choreographer. In 1933, he cofounded the School of American Ballet with Lincoln Kirstein (see page 303), and in 1948, along with Kirstein and Jerome Robbins (see page 307), the New York City Ballet.

Baselitz, Georg (born 1938). German painter.

Basquiat, Jean-Michel (1960–1988). American painter.

Bass, Bob (born 1922, death date unknown). Jazz musician and photographer; husband of Nell Blaine, later divorced. Edith's dual portrait of him and Edwin Denby was the second picture she ever sold.

Bazille, Jean Frédéric (1841–1870). French Impressionist painter.

Becker, John (1901–1982). American poet and novelist; ran an art gallery in New York from 1929 to 1934, showing de Kooning, Arp, Léger, Picasso, Noguchi, and others. College friend of Edwin Denby.

Beckmann, Max (1884–1950). German painter, draftsman, printmaker, and teacher.

Biala, Janice (1903–2000). Polish-born American painter. In 1930 she met the English novelist Ford Madox Ford and lived with him until his death in 1939. Later married to Daniel Brustlein (see page 297), Biala was the sister of the painter Jack Tworkov (see page 309).

Bignardi, Umberto (born 1935). Italian painter.

Bischofberger, Bruno (born 1940). Swiss gallerist specializing in Pop Art, Minimalism, and Conceptual Art, as well as French Nouveau Realisme.

Black Mountain College. Located at Black Mountain near Asheville, North Carolina, from 1933 to 1957. A groundbreaking school/educational experiment, Black Mountain College stressed interdisciplinary activity and open-ended process. Among its faculty were Josef Albers, John Cage, and Willem de Kooning, and among those who attended were Rudy Burckhardt and Robert Rauschenberg.

Blaine, Nell (1922–1996). American painter, occasionally referred to as Nellie. Initially an abstractionist, she later turned to the landscapes and flower paintings for which she is more known.

Boccioni, Umberto (1882–1916). One of the principal Italian Futurist painters.

Bowles, Jane (1917–1973). Born Jane Auer. American novelist and playwright;

married to the writer Paul Bowles. She wrote one novel, one play, and six short stories. Her novel *Two Serious Ladies* appeared in 1943.

Bowles, Paul (1910–1999). A significant American composer prior to his exodus to Morocco and his subsequent career as a novelist and short-story writer. His novel *The Sheltering Sky* was published in 1949.

Brakhage, Stan (1933–2003). American experimental filmmaker.

Brecht, Bertolt (1898–1956). German poet, playwright, and theater director. His views on Marxist dialectic were strongly influenced by Karl Korsch (see page 304). Lived in the United States from 1941 to 1947.

Browner, Juliet (1912–1991). American dancer and model who studied under Martha Graham. She married the artist Man Ray (see page 305) in 1946 and lived with him until his death in 1976.

Brustlein, Daniel (1904–1996). Illustrator and cartoonist for *The New Yorker* (under the pseudonym "Alain"); husband of Janice Biala (see page 296).

Bryant, Allan (1931–2019). Experimental composer and musician, one of the founders of MEV (see page 305).

Bryant, Barbara Mayfield (born 1935). Lived in Rome 1964–1970. Actress, journalist, and art historian. She frequently performed with MEV (see page 305). Married to Allan Bryant (1958–1968). Since 1970, she has lived in New York.

Buchholz Gallery, New York, was the brainstorm of the collector and dealer Curt Valentin (1902–1954). Opened in 1937 behind a bookstore owned by fellow émigré Karl Buchholz, it specialized in art classified as "degenerate" by the Nazis. In 1951, the gallery was renamed the Curt Valentin Gallery.

Burckhardt, Jacob (born 1949). Son of Edith and Rudy Burckhardt. American filmmaker, photographer, and coeditor of this book.

Burckhardt, Lukas (1924–2018). Swiss lawyer, politician, and jazz trumpeter. Army buddy of Jean Tinguely and brother of Rudy.

Burckhardt, Rudy (1914–1999). Swiss-born American photographer, filmmaker, and painter. He married Edith in 1947, and they separated in 1961. His second wife is the American painter Yvonne Jacquette.

Burne-Jones, Sir Edward Coley (1833–1898). British artist and designer associated with the Pre-Raphaelite movement.

Burri, Alberto (1915–1995). Italian painter and sculptor.

Cacciatore, Edoardo (1912–1996). Italian poet and critic. Husband of Vera Cacciatore.

Cacciatore, Vera (1911–2004). Daughter of Olga Signorelli and curator of the Keats-Shelley Memorial House in Rome from 1932 until the 1970s. She was personally responsible for protecting the house and its collection during the German occupation of Rome from 1943 to 1944.

Cage, John (1912–1992). American avant-garde composer, writer, artist, philosopher, and mycologist.

Cage, Xenia (1913–1995). Born Xenia Andreyevna Kashevaroff. Painter, sculp-

tor, musician, designer, bookbinder, and conservator. Ex-wife of the composer John Cage.

Cajori, Charles (1921–2013). American Abstract Expressionist painter. A member of the founding faculty of the Studio School on Eighth Street in New York (not a cofounder, as Edith says).

Campbell Becker, Virginia (1914–2016). Illustrator, painter, marionetteer, and actress who appeared in films with Gary Cooper and Marilyn Monroe. Wife of John Becker (see page 296). Referred to by Edith as Ginny.

Campbell, Gretna (1922–1987). American Abstract Expressionist painter. Married Louis Finkelstein (see page 300) in 1946.

Campbell, Lawrence (1914–1998). American painter and art critic at *ARTnews*; often called Larry.

Canino, Bruno (born 1935). Italian classical pianist and composer.

Cardew, Cornelius (1936–1981). English experimental music composer.

Carrá, Carlo (1881–1966). Italian painter and critic.

Carter, Elliott (1908–2012). American Modernist composer. He studied with Nadia Boulanger (1887–1979) in the 1930s.

Carter, Helen (1907–2003). American sculptor, born Helen Frost-Jones. She married Elliott Carter in 1939.

Cartier-Bresson, Henri (1908–2004). Eminent French photographer.

Castelli, Leo (1907–1999). Eminent Italian-American art dealer.

Ceccobelli, Bruno (born 1952). Italian artist.

Cedar Bar. The legendary hangout in the 1950s for Abstract Expressionist artists and Beat Generation writers.

Chuma, Yoshiko (born 1950). Japanese-born dancer, choreographer, and director of the New York–based School of Hard Knocks. Edith's daughter-in-law.

Club, the (1949–1957 and 1959–1970). Referred to by Edith as the Artists' Club and also known as the Eighth Street Club. A center for the downtown art scene as well as many important midcentury artists and thinkers, the Club was an important factor in the shift of the center of the Art World from Paris to New York. Known for its panel discussions, lectures, and dancing.

Coggeshall, Calvert (1907–1990). American painter and designer.

Colonna, Vittoria (1490–1547), Marchioness of Pescara. An Italian poet, she lived in Ischia from 1501 to 1511. In 1536 she began a passionate friendship with Michelangelo Buonarroti (1475–1564).

Comisso, Giovanni (1895–1969). Italian novelist, short-story writer, and reporter.

Coolidge, Clark (born 1939). American poet.

Copland, Aaron (1900–1990). American composer, composition teacher, writer, and conductor.

Corinth, Lovis (1858–1925). German painter and printmaker. Member of the Berlin Secession.

Cornell, Joseph (1903–1972). American Surrealist known for his intricately

constructed boxes, one of the pioneers of assemblage, and also an experimental filmmaker.

Corso, Gregory (1930–2001). American Beat poet. Buried near Edith in the Non-Catholic Cemetery in Rome.

Cotten, Joseph (1905–1994). American film, stage, and television actor.

Council Communists. A small group, originally based in Chicago, whose major activity was producing the journal *International Council Correspondence* (later renamed *Living Marxism* and then *New Essays*). Its leading contributors included Paul Mattick (see page 305) and Karl Korsch (see page 304), and others who were involved with and sympathetic to egalitarian socialism and workers' councils.

Craig, Martin (born 1906, death date unknown). American sculptor.

Crehan, Hubert (1917–1984). American painter and art critic.

Croce, Benedetto (1866–1952). Italian philosopher, literary critic, and theorist.

Cross, Jenny (1919–1964). Daughter of the poet and novelist Robert Graves.

Crumb, Robert (born 1943). American cartoonist.

Cunningham, Merce (1919–2009). American modern dancer and choreographer. The lifetime partner and collaborator of the composer John Cage.

Curran, Alvin (born 1938). Experimental composer, one of the founders of MEV (see 305). Lived with Edith from 1965 to 1985.

Davis, George (1906–1957). American fiction editor and novelist. He died of a heart attack in Berlin where he was assisting his wife, Lotte Lenya, in making recordings.

de Kooning, Elaine (1918–1989). Born Elaine Fried. American painter, teacher, and writer on art; married Willem de Kooning in 1943.

de Kooning, Lisa (1956–2012). Daughter of Willem de Kooning and Joan Ward (see page 310).

de Kooning, Willem (1904–1997). Dutch-born American painter and a leading Abstract Expressionist.

De Martiis, Plinio (1920–2004). Italian gallerist and photographer. Founded Galleria La Tartaruga in 1954.

DeMott, Helen (1920–1997). Painter and poet. Close friend of Edith. She and Edith and Lucia Vernarelli (see page 310) were "the Chelsea Girls."

Denby, Edwin (1903–1983). Poet, dance critic, close friend of Rudy Burckhardt.

De Niro, Robert, Sr. (1922–1993). American painter, father of the screen actor Robert De Niro. Referred to by Edith as Bob.

De Pisis, Filippo (1896–1956). Born Luigi Filippo Tibertelli. Italian painter.

de Saint Phalle, Niki (1930–2002). Sculptor, painter, and filmmaker. Wife of Harry Mathews (see page 305) and later Jean Tinguely (see page 309).

De Sica, Vittorio (1901–1974). Eminent Italian movie director and actor; a leading figure in the Neorealist movement.

Dessì, Gianni (born 1955). Italian painter, sculptor, and set designer.

Diaz, Virginia (dates unknown). Circus performer and girlfriend of Willem de

Kooning from the late 1920s to the mid-1930s, prior to his meeting Elaine Fried (see Elaine de Kooning above). Referred to by Edith as Nini.

Dine, Jim (born 1935). American artist.

Dodd, Lois (born 1927). American painter.

Downes, Rackstraw (born 1939). English-born painter and art critic.

Duchamp, Marcel (1887–1967). French-American painter, sculptor, writer, theorist, and inventor of the readymade.

Durkee, Stephen (born 1938–2020). Multimedia artist, spiritual seeker, and Muslim scholar, teacher, and educator. Currently known as Abdullah Noorud-deen Durkee.

Edgar, Natalie (born 1932). Critic at *ARTnews* and Abstract Expressionist painter, wife of the painter and sculptor Philip Pavia (see page 306).

Egan, Charles (1912–1993). New York gallery owner, the first to exhibit Willem de Kooning, and an early exhibitor of Joseph Cornell.

Eilshemius, Louis (1864–1941). American painter.

Escobar, Marisol (1930–2016). Paris-born sculptor of Venezuelan descent, worked in New York since 1950.

Farber, Manny (1917–2008). American painter, film critic, and writer.

Feigel, Marie-Suzanne (1916–2006). Founded the Galerie d'Art Moderne in Basel, Switzerland, in 1945 and ran it until 1993.

Feldman, Morton (1926–1987). American composer. Referred to by Edith as Morty.

Fichte, Johann (1762–1814). German philosopher; a founder of the movement known as German Idealism.

Finkelstein, Louis (1923–2000). American painter and educator. Married to Gretna Campbell (see page 298).

Fizdale, Robert (1920–1995). With his partner Arthur Gold (see page 301), an important American two-piano ensemble.

Fourcade, Xavier (1926–1987). New York gallery owner who represented Willem de Kooning late in his career.

Francés, Esteban (1913–1976). Spanish Surrealist painter.

Franchetti, Giorgio (1925–2006). Art collector and brother-in-law of Cy Twombly. Nephew of the Barone Giorgio Franchetti, who founded the Franchetti Gallery at the Ca' d'Oro in Venice.

Frankenthaler, Helen (1928–2011). American Abstract Expressionist painter. From 1958 to 1971 married to the painter Robert Motherwell (see page 305).

Frankfurter, Alfred M. (1906–1965). Editor of *ARTnews* from 1936 to 1965.

Freilicher, Jane (1924–2014). American painter. Married to Joe Hazan (see page 302).

Fried, Theo (1902–1980). Hungarian-born painter who worked in Vienna, Paris, and New York.

Friedman, Arnold (1874–1946). American Modernist painter.

Friedman, Leo (dates unknown). German émigré, member of the Council Communist group that included Heinz Langerhans (see page 304), Walter Auerbach (see page 296), and Fritz Henssler (see page 302).

Fuller, R. Buckminster (1895–1983). American twentieth-century visionary, architect, systems theorist, author, and designer. Inventor of the geodesic dome.

Galleria Maldoror. Roman gallery founded in 1977. At various times showed works by Edith Schloss and Francesca Woodman.

Gallo, Giuseppe (born 1954). Italian artist.

Geist, Sidney (1914–2005). Sculptor and art writer, an expert on Brancusi.

Genauer, Emily (1911–2002). Pulitzer Prize–winning American art critic who championed twentieth-century painting and sculpture in *The New York World*, the *New York Herald Tribune*, and other publications.

Gendel, Milton (1918–2018). Photographer and art critic; lived in Rome from 1949 onward.

Getz, Ilse (1917–1992). German-born American assemblage artist.

Ginsberg, Allen (1926–1997). American poet.

Gnoli, Domenico (1933–1970). Italian painter and stage designer.

Gold, Arthur (1917–1990). See Robert Fizdale (page 300).

Goldberg, Michael (1924–2007). American Abstract Expressionist artist.

Goodman, Mitch (1923–1997). American writer, teacher, and activist. Married to Denise Levertov (see page 304).

Gorky, Arshile (c. 1902–1948). Armenian-born painter (born Vosdanig Adoian). A founding father of Abstract Expressionism and close friend of Willem de Kooning.

Graham, John (1886–1961). Ukrainian-born (born Ivan Gratianovitch Dombrowsky) American painter and theorist. Married to the mother of Ileana Sonnabend (see page 308).

Graham, Martha (1894–1991). American modern dancer and choreographer.

Graves, Robert (1895–1985). English poet, novelist, critic, and classicist.

Green Mountain Gallery (1968–1979). Founded in New York by Lucien Day, precursor to the Blue Mountain Gallery. Edith exhibited here in 1970, 1972, and 1974.

Greenberg, Clement (1909–1994). American essayist and art critic; early supporter of Abstract Expressionism, in particular the work of Jackson Pollock.

Greuel, Louise (1918–2004). American dancer; wife of Richard Lippold.

Gris, Juan (1887–1927). Spanish-born painter and sculptor. His artistic career was spent almost exclusively in France, where he became recognized as one of the leading Cubist painters.

Grooms, Red (born 1937). American multimedia artist known for his colorful Pop Art 3D constructions. Lived and worked with Mimi Gross from 1960 to 1986.

Gross, Mimi (born 1940). American painter and set and costume designer.

Grosser, Maurice (1903–2006). Painter, author, art critic, set designer. Created

sets for two Virgil Thomson/Gertrude Stein operas: *Four Saints in Three Acts* (1934) and *The Mother of Us All* (1947).

Grosz, George (1893–1959). German-born painter, draftsman, and illustrator. He immigrated to the United States in 1933.

Grottanelli de' Santi, Giovanni (born 1928). Eminent constitutional lawyer and scholar; professor in the Faculty of Law at the University of Siena.

Guest, Barbara (1920–2006). American poet who was a member of the New York school of poetry. She was awarded the Frost medal in 1999 for her lifetime achievement.

Guggenheim Fellowships, The John Simon. Established in 1925 as the initial declaration proclaimed to "add to the educational, literary, artistic, and scientific power of [the United States], and also to provide for the cause of better international understanding."

Guggenheim, Peggy (1898–1979). American art collector and socialite. In 1942 she founded the Art of This Century gallery in New York, which closed in 1947. In 1949 she settled in Venice and exhibited her collection there.

Guston, Philip (1913–1980). American painter, one of the first generation of Abstract Expressionist painters.

Guzzi, Beppe (1902–1982). Italian painter and art teacher.

Hacker, Ernst (1917–1987). Austrian-born printmaker and photographer who fled Vienna in 1938 to study in New York at the left-leaning American Artists School. Husband of Edith's close friend Lucia Vernarelli (see page 310).

Haieff, Alexei (1914–1994). American composer.

Hartl, Leon (1889–1973). French-born American painter. Fairfield Porter's essay "Hartl Paints a Picture" appeared in *ARTnews*, November 1952. Husband of Fanny Engel.

Hayes, Bartlett (1904–1988). Director of the Addison Gallery of American Art, 1940–1969; director of the American Academy in Rome, 1970–1988.

Hazan, Joe (1918–2014). American dancer, businessman, and painter. Friend of the playwright Tennessee Williams, married Jane Freilicher (see page 300) in 1957.

Hélion, Jean (1904–1987). French abstract painter, but his mid-career rejection of abstraction was followed by nearly five decades as a figurative painter. John Ashbery's article about him, "Hélion Paints a Series of Portraits," appeared in *ARTnews*, February 1960.

Henssler, Fritz (1903–1986). German-born sociologist. An active anti-Fascist, he fled the Nazis in 1936, living near Flemington, New Jersey, at the time Edith met him.

Herald Tribune. The *New York Herald Tribune*, which started publication in 1924 and closed in 1966, published Edwin Denby's dance reviews. The *Paris Herald Tribune* was published from 1924 to 1967, when it changed its ownership and name to the *International Herald Tribune*, to which Edith contributed several articles. It ceased publishing in 2013. Edith refers to these newspapers as "the *Trib*."

Herriman, George (1880–1944). American cartoonist, best known for the comic strip *Krazy Kat* (1913–1944).

Hess, Thomas B. (1920–1978). Executive editor at *ARTnews* and art critic. Referred to by Edith as Tom.

Higgins, Trumbull (1920–1990). Military historian; husband of poet and art writer Barbara Guest.

Hofmann, Hans (1880–1966). German-born American abstract painter and influential teacher.

Holtzman, Harry (1912–1987). American painter; founding member of the American Abstract Artists Group.

Ingber Gallery. Founded by Barbara Ingber in 1972. Edith's first of several shows there was in 1974.

Janis, Sidney (1896–1989). Gallery owner. The Sidney Janis Gallery first opened in New York in 1948.

Johns, Jasper (born 1930). American painter and printmaker.

Kaldis, Aristodimos (1899–1979). Born in Dikeli, Asia Minor, Greek-American painter, and lifelong left-wing activist. During the 1940s, he gave lectures on art and archeology in a room at Carnegie Hall, accompanied by Willem de Kooning working the slide projector.

Kallman, Chester (1921–1975). American poet, librettist, and translator, companion to and collaborator with the poet W. H. Auden (see page 295).

Kantor, Morris (1896–1904). Russian-born American painter and instructor at the Art Students League and the Cooper Union.

Katz, Alex (born 1927). American figurative painter.

Keats-Shelley house. A museum in Rome dedicated to the English Romantic poets where in 2006 Edith had a show titled *In the Bay of Lerici and Versilia*.

Kerkam, Earl (1891–1965). American painter who worked in both Paris and New York.

Kiesler, Frederick (1890–1965). Austrian-American architect, theoretician, theater designer, artist, and sculptor.

Kirstein, Lincoln (1907–1996). Arts patron, cofounder with George Balanchine (see page 296) of the School of American Ballet and, in 1948, with Balanchine and Jerome Robbins (see page 307), of the New York City Ballet.

Klee, Paul (1879–1940). Swiss-born modernist painter.

S. Klein on the Square. A landmark popular-priced department store chain, now defunct. Union Square, New York, was its primary location.

Klerr, Paul (1937–2017). American-born Italian sculptor.

Kligman, Ruth (1930–2010). American abstract painter. Her memoir *Love Story* concerns her affair with Jackson Pollock. She was the lone survivor of the car crash when he died. She was also the girlfriend of Willem de Kooning.

Kline, Franz (1910–1962). American Abstract Expressionist painter.

Koch, Kenneth (1925–2002). American poet.

Korsch, Karl (1886–1961). German Marxist theoretician. His concept of Marxism was a great influence on Bertolt Brecht (see page 297). Edith briefly studied under him.

Kosugi, Takehisa (1938–2018). Japanese composer and violinist; associated with the Fluxus group.

Kresch, Albert (born 1922). American painter. Referred to by Edith as Al.

Labiche, Eugène (1815–1888). French playwright.

La Roche, Wolfgang (1900–1967). Husband of Meret Oppenheim.

Langerhans, Heinz (1904–1976). German political and social scientist. He lived in exile in Boston and New York during the war years. He and Edith lived as a couple during her early years in America.

Lassaw, Ibram (1913–2003). American sculptor.

La Touche, John (1914–1956). Lyricist and bookwriter in American musical theater.

Lebel, Jean-Jacques (born 1936). French painter, poet, political activist, and instigator of Happenings.

Le Clercq, Tanaquil (1929–2000). A principal dancer in the New York City Ballet under George Balanchine, to whom she was married from 1952 to 1969.

Lederman, Minna (1896–1995). Founder and editor of the influential magazine *Modern Music* (1925–1946). Edwin Denby became the dance critic for *Modern Music* in 1936.

Lenya, Lotte (1898–1981). Austrian-born singer and actress who created the part of Pirate Jenny in *The Threepenny Opera* in Berlin. She moved to New York with her husband, composer Kurt Weill (see page 310), in 1935. After Weill's death in 1950, she married George Davis (see page 299) until he died in 1957. She married for a third time to Russell Detwiler.

Levertov, Denise (1923–1997). British-born American poet and activist. Married to Mitch Goodman (see page 301).

Levy, Julian (1906–1981). Art dealer and gallery owner in New York; the first to show Joseph Cornell.

Lewitin, Landes (1892–1966). American painter, Tenth Street gallery artist, and senior member of the Artists' Club.

Lippold, Richard (1915–2002). American sculptor known for geometric constructions using wire.

Locus Solus. A journal of poetry and prose. Four issues were published in 1961 and 1962, edited by the poet/experimentalist Harry Mathews and the poets John Ashbery, Kenneth Koch, and James Schuyler, all of whom were contributors. (See entries for each of these writers in this glossary.)

Loffredo, Silvio (1920–2013). Italian Post-Expressionist painter.

Maccari, Mino (1898–1989). Italian figurative painter and author.

Malina, Judith (1926–2015). German-born American actor, writer, and director. She cofounded the experimental theater company The Living Theatre with her husband Julian Beck (1925–1985).

Mallary, Robert (1917–1997). American sculptor and "junk art" assemblage artist.

Man Ray (1890–1976). American-born painter and photographer; contributor to both the Dada and Surrealist movements. Born Emmanuel Radnitzky.

Manzoni, Piero (1933–1963). Italian artist known for his ironic approach to avant-garde art.

Marchowsky, Marie (1919–1997). Dancer, choreographer and teacher, a member of the Martha Graham Dance Company in the 1930s.

Mardersteig, Giovanni (1892–1977). Publisher, printer, typographer, and historian. He established the Officina Bodoni in 1922 and in 1948 the Stamperia Valdonegra.

Marin, John (1870–1953). American painter. Showed many times at Alfred Stieglitz's 291 gallery in New York. From 1914 on, the rocky coast of Maine was a favorite subject.

Marlborough Gallery. An international art gallery, opened in London in 1946, in Rome in 1960, and in New York in 1963.

Martin, Agnes (1912–2004). Canadian-born American abstract painter.

Martory, Pierre (1920–1998). A French poet who had a profound influence on the New York School of Poets.

Mathews, Harry (1930–2017). Author of experimental novels, poetry, short fiction, and essays. Married to Niki de Saint Phalle (see page 299).

Matta, Roberto (1911–2002). Chilean surrealist and Abstract Expressionist painter. Father of the American artist Gordon Matta-Clark.

Matter, Mercedes (1913–2001). American painter. Cofounder, with Charles Cajori (see page 298), of the New York Studio School. Married to Herbert Matter (1907–1984).

Mattick, Paul (1904–1981). German-born Marxist political writer who immigrated to the United States in 1926.

Mediterranean Cities (Wittenborn, 1956.) A book of photographs by Rudy Burckhardt accompanied by sonnets by Edwin Denby.

MEV (Musica Elettronica Viva). A live acoustic/electronic improvisational group founded in Rome in 1966. Its original members were Alvin Curran, Frederic Rzewski, Richard Teitelbaum, Allan Bryant, John Phetteplace, Carol Plantamura, and Ivan Vandor.

Milhaud, Darius (1892–1974). French composer and teacher. He was a member of Les Six (also known as the Group of Six).

Miró, Joan (1893–1983). Catalan Spanish painter, sculptor, and ceramacist.

Mondrian, Piet (1872–1944). Dutch painter. A contributor to the De Stijl art movement.

Morandi, Giorgio (1890–1964). Italian painter and printmaker who specialized in still lifes.

Morrison, George (1919–2000). American painter and sculptor.

Motherwell, Robert (1915–1991). American Abstract Expressionist painter,

printmaker, theorist, and editor. From 1958 to 1971 he was married to the painter Helen Frankenthaler (see page 300).

Myers, John Bernard (1920–1987). Art dealer, puppeteer, and writer. From 1951 to 1970 partner in the Tibor de Nagy Gallery. Referred to by Edith as Johnny.

Nakian, Reuben (1897–1986). American sculptor.

Needle Trades, Central High School of. Opened in 1940 on West Twenty-Fourth Street in New York, its building was a fine example of the Art Deco movement. The Ballet Society, a forerunner of the New York City Ballet, made its debut there in 1946.

Newman, Barnett (1905–1970). American Abstract Expressionist painter and one of the foremost of the "color field" painters. Referred to by Edith as Barney.

Noguchi, Isamu (1904–1988). Japanese-American sculptor and landscape artist. He designed stage sets for several Martha Graham dance productions.

Noland, Kenneth (1924–2010). American painter.

Nolde, Emil (1867–1956). German Expressionist painter, printmaker, and watercolorist.

Novelli, Gastone (1925–1968). Italian painter.

O'Hara, Frank (1926–1966). American poet and art critic.

Oppenheim, Meret (1913–1985). German-born Swiss surrealist and photographer.

Orozco, José Clemente (1883–1949). Mexican muralist; one of the "Big Three" in Mexican muralism, along with Diego Rivera and David Alfaro Siquieros.

Ozenfant, Amédée (1886–1966). French painter, art theoretician, and teacher. He and Charles-Edouard Jeanneret (Le Corbusier, 1887–1965) founded the Purist movement.

Parker, Helen (1920–1993). Journalist, publisher, friend of many writers, and girlfriend of Allen Ginsberg in 1950.

Parsons, Betty (1900–1982). Gallery owner. The Betty Parsons Gallery opened in New York in 1946 and closed in 1982.

Pascali, Pino (1935–1968). Italian sculptor, set designer, and performer.

Pasilis, Felix (born 1922). American abstract painter.

Pavia, Philip (1915–2005). American sculptor; founder of the Artists' Club. Married to Natalie Edgar (see page 300).

Pearlstein, Dorothy (1928–2018). Née Dorothy Cantor, American painter, and wife of the painter Philip Pearlstein.

Pearlstein, Philip (born 1924). American painter; a leading figure since the 1960s in figurative realism.

Pietrasanta. A Tuscan town on the west coast of Italy where Edith spent her summers.

Pollock, Jackson (1912–1956). American Abstract Expressionist painter.

Porter, Anne Channing (1911–2011). American poet; wife of the painter Fairfield Porter.

Porter Balzer, Elizabeth (born 1956). Daughter of Fairfield and Anne Porter; subject of Fairfield's painting *The Mirror (1966)*. Referred to by Edith as Lizzie.

Porter, Fairfield (1907–1975). American painter and art critic.

Porter, Katherine (born 1949). American psychiatrist; daughter of Fairfield and Anne Porter; known to Edith as Katie.

Pyramid Group (1947–1954). An artist-run organization whose purpose was providing exhibition opportunities.

Rauschenberg, Christopher (born 1951). Photographer; son of the artists Robert Rauschenberg and Susan Weil.

Rauschenberg, Robert (1925–2008). American painter, sculptor, assemblage artist, photographer, printmaker, and performance artist. Known for his collaborations with artists in many disciplines in all parts of the world.

Resnick, Milton (1917–2004). Abstract Expressionist painter and one of the founding members of the Artists' Club. Married to Pat Passloff (1928–2011).

Richter, Hans (1888–1976). German painter, graphic artist, and filmmaker.

Rieti, Vittorio (1898–1994). Italian composer who immigrated to the United States in 1940.

Rivers, Larry (1923–2002). American painter and jazz saxophonist.

Riverside Museum. A museum in New York originally dedicated to Russian-born artist, diplomat, explorer, and spiritual leader Nicholas Roerich (1874–1947).

Robbins, Jerome (1918–1998). American theater producer, director, and choreographer. Referred to by Edith as Jerry.

Rockwell, Norman (1894–1978). American painter and illustrator who gained broad popular appeal for his cover illustrations for *The Saturday Evening Post*.

Rockwell, Peter (1936–2020). American sculptor who lived in Rome, close friend of Edith's. Son of Norman Rockwell.

Rorem, Ned (born 1923). American composer and essayist.

Rosen, Charles (1927–2012). American pianist and writer on music.

Rosenberg, Harold (1906–1978). American writer, educator, philosopher, and art critic. Married to May Natalie Tabak (see page 309).

Rosenfeld, Paul (1890–1946). A literary, art, and music critic.

Rothko, Mark (1903–1970). American Abstract Expressionist painter of Russian-Jewish descent.

Roussel, Raymond (1877–1933). French poet, novelist, playwright, musician, and chess enthusiast.

Ryman, Robert (1930–2019). American painter.

Rzewski, Frederic (1938–2021). American composer and pianist; one of the founders of MEV (see page 305).

Safford, Frank (1900–1983). A New York–based pioneer in rehabilitation medicine for the World Health Organization and a family doctor, he befriended and treated many leading artists. Friend of Edwin Denby.

St. Paul's Within the Walls. The American Episcopal Church in Rome.

Sandler, Irving (1925–2018). American art critic, art historian, and educator.

Sargentini, Fabio (born 1939). Italian gallery dealer, actor, director, and writer.

Savelli, Angelo (1911–1995). Italian painter who moved to New York in 1953.

Scarpitta, Salvatore (1919–2007). Italian-American painter and sculptor.

Scelsi, Giacinto (1905–1988). Italian composer who also wrote Surrealist poetry in French.

Schapiro, Meyer (1904–1996). Lithuanian-born critic, teacher, and art historian. A professor at Columbia University (1928–1973), he also taught at the New School for Social Research (1936–1952), giving the slide lectures that Edith refers to.

Schifano, Mario (1934–1998). Italian Postmodernist painter, collagist, and filmmaker.

Schoenberg, Arnold (1874–1951). Austrian-American composer and music teacher. Inventor of twelve-tone composition.

Schuyler, James (1923–1991). American poet, novelist, diarist, and art critic. Referred to by Edith as Jimmy.

Segré, Lola (1930–1962). Jamaican-born friend of Edith in Rome.

Seitz, William (1914–1960). Curator of the Museum of Modern Art in the 1960s, known for the exhibition *The Art of Assemblage*, which included one of Edith's works, as well as for his early text on Abstract Expressionism.

Sekula, Sonja (1918–1963). Swiss-born painter who lived in America from 1936 to 1955. She returned to Switzerland and died by suicide in 1963.

Severini, Gino (1883–1966). A leading Italian Futurist painter.

Signorelli, Angelo (1878–1952). Italian poet and doctor; lived with but never married Olga Signorelli.

Signorelli, Olga Resnevič (1883–1973). Russian-born, Italy-based journalist, biographer, author, and translator.

Siqueiros, David Alfaro (1896–1974). Mexican Social Realist painter, known for his large frescos.

Slevogt, Max (1868–1932). German Impressionist painter.

Smith, Oliver (1918–1994). American scenic designer. Codirector of the American Ballet Theater with Lucia Chase from 1945 to 1980.

Sonnabend, Ileana (1914–2007). Romanian-born gallerist who married Leo Castelli (see page 298) in 1932. After their divorce she married Michael Sonnabend and founded the Ileana Sonnabend Gallery in 1962, located first in Paris and later in New York.

Sonnabend, Michael (1900–2001). Polish-born Michelangelo and Dante Alighieri scholar.

Soutine, Chaim (1893–1943). French painter of Belarusian origin, pioneering Expressionist.

Spartakusbund. Marxist revolutionary movement organized in Germany during World War I.

Spoleto Festival. The Festival dei Due Mondi (Festival of Two Worlds) is a music and opera festival held annually in Spoleto, Italy, since 1958, founded by the composer Gian Carlo Menotti (1911–2007).

Stein, Gertrude (1874–1946). American experimental writer, literary modernist, and art collector who lived in France from 1903 until her death.

Sternberg, Harry (1904–2001). American painter, printmaker, and educator. Student at the Art Students League from 1922 to 1926, and instructor from 1933 to 1968. Edith studied with him from 1943 to 1944.

Suttman, Paul (1933–1993). American sculptor. Lived in Italy beginning in 1960.

Suzuki, D. T. (1870–1966). Important exponent of Zen Buddhism in the West. Gave influential series of seminars at Columbia University in the early 1950s.

Sylvester, David (1924–2001). British art critic and curator.

Tabak, May Natalie (1910–1993). Teacher, social worker, and novelist; wife of Harold Rosenberg (see page 307).

Taeuber-Arp, Sophie (1889–1943). Swiss painter, Dadaist, sculptor, and textile designer. Married to Jean Arp (see page 295).

Tanguy, Yves (1900–1955). French-born American Surrealist painter.

Tchelitchew, Pavel (1898–1957). Russian-born Surrealist painter.

Tenth Street Galleries. A collective term for the mostly artist-run cooperative galleries that proliferated in the East Village in New York in the 1950s and early 1960s.

Terry, Walter (1913–1982). Dance critic for the *New York Herald Tribune* and the *Saturday Review*.

Thomson, Virgil (1896–1989). American composer and music critic, friend of Edwin Denby. Collaborated with Gertrude Stein on two operas, *Four Saints In Three Acts* (1934) and *The Mother of Us All* (1947).

Tillim, Sidney (1925–2001). American painter and art critic.

Tinguely, Jean (1925–1991). Swiss painter and sculptor, best known for his sculptural machines or kinetic art, in the Dada tradition. Army buddy of Lukas Burckhardt, Edith's brother-in-law (see page 297).

Tofano, Gilberto (1929–2020). Italian film and theater director, son of Sergio Tofano.

Tofano, Sergio (1883–1973). Italian actor, director, playwright, scene designer, and illustrator.

Twombly, Cy (1928–2011). American painter and friend of Edith's during her years in Rome.

Tworkov, Jack (1900–1982). Polish-born New York–based Abstract Expressionist painter, brother of Janice Biala (see page 296), and one of the leading figures of the movement. In 1935 he married Rachel "Wally" Wolodofsky (1916–1991).

Ugo Ferranti Gallery (1974–2014), a gallery in Rome specializing in minimalist and conceptual art.

Valdes, Gregorio (1879–1939). Cuban-born American painter based in Key

West, Florida. The poets Elizabeth Bishop (1911–1979) and Edwin Denby (see page 299) were collectors and supporters.

Valentin, Curt (1902–1954). German-born American art dealer (see page 297, Buchholz Gallery).

van Houten, Georges (1888–1964). Belgian representational painter.

Vasilieff, Nicholas (1892–1970). Russian-born American painter.

Vernarelli, Lucia (1920–1995). American painter, collagist, designer, activist, close confidante of Edith; along with Helen DeMott (see page 299), one of "the Chelsea Girls." Married to Ernst Hacker (see page 302).

Walton, William (1902–1983). English composer.

Wanted in Rome. Fortnightly periodical in English for expatriates in Rome, founded in 1985. Edith wrote extensively for it up until her death in 2011, and was the magazine's principal art critic.

Ward, Joan (1927–2005). Illustrator, commercial artist, mother of Willem de Kooning's only daughter, Lisa (see page 299).

Weil, Susan (born 1930). Painter and collagist; from 1950 to 1953, married to Robert Rauschenberg (see page 307), whom she met at Black Mountain College.

Weill, Kurt (1900–1950). German-born composer, relocated to America, perhaps best known for his collaborations with Bertolt Brecht (see page 297) in such productions as *The Threepenny Opera.* Husband of Lotte Lenya (see page 304).

Wilson, Robert (born 1941). American experimental theater director, multimedia artist, performer, painter, sculptor, video artist, and lighting designer.

Wirtschafter, Bud (1924–1988). American painter and filmmaker.

Woodhams, Wilbur Charles (1917–2006). Rector of St. Paul's Within the Walls (see page 307) in Rome and later a Jungian analyst.

Woodman, Francesca (1958–1981). American photographer.

Wright, Clifford (1919–1999). American painter who came to New York in 1946 and moved to Sweden in 1956.

Wyeth, Andrew (1917–2009). American realist painter.

York, Albert (1929–2009). American painter.

Zajac, Jack (born 1929). American sculptor and painter.

Zogbaum, Elizabeth Ross (1912–2005). Wife of Wilfrid Zogbaum. Executor of Franz Kline's estate.

Zogbaum, Wilfred (1916–1965). American sculptor.

Illustration Credits

170 © 1960 The Estate of John Cohen, Courtesy of L. Parker Stephenson Photographs, NYC

173 © 1959 The Estate of Rudy Burckhardt / Artists Rights Society (ARS), New York

183 © 1959 The Estate of John Cohen, Courtesy of L. Parker Stephenson Photographs, NYC

189 © 1955 The Estate of Rudy Burckhardt / Artists Rights Society (ARS), New York

196 © 2014 Silvia Stucky, Rome

206 © 1953 The Estate of Rudy Burckhardt / Artists Rights Society (ARS), New York

215 © 1951 The Estate of Rudy Burckhardt / Artists Rights Society (ARS), New York

232 © 1964 Ugo Mulas Heirs. All rights reserved

235 Photograph © 2019 Jacob Burckhardt

236 Unknown street photographer, 1968. Collection of Mimi Gross

237 © 1968 Archivio Cameraphoto / Vittorio Pavan

257 Photographer unknown, circa 1951. The Estate of Edith Schloss Burckhardt

263 © 2021 Woodman Family Foundation / Artists Rights Society (ARS), New York

278 Photographer unknown, circa 1929. The Estate of Edith Schloss Burckhardt

279 Photographer unknown, circa 1936. The Estate of Edith Schloss Burckhardt

282 Photographer unknown, circa 1942. The Estate of Edith Schloss Burckhardt

283 Courtesy of the Art Students League

285 © 1945 The Estate of Rudy Burckhardt / Artists Rights Society (ARS), New York

288 © 1953 The Estate of Rudy Burckhardt / Artists Rights Society (ARS), New York

289 © 1957 The Estate of Rudy Burckhardt / Artists Rights Society (ARS), New York

291 Photograph © 2017 Jacob Burckhardt

292 © 2011 The Estate of Edith Schloss Burckhardt. Photograph by Jacob Burckhardt

294 © 2006 The Estate of Edith Schloss Burckhardt. Photograph by Jacob Burckhardt